The Essential Painting Guide

The Essential Painting Guide

PAUL TAGGART

Grange BOOKS

This edition published in 2001 by
Grange Books, an imprint of Grange Books PLC,
The Grange, Kingsnorth Industrial Estate
Hoo, nr. Rochester, Kent
ME3 9ND

Produced by PRC Publishing Ltd,
8–10 Blenheim Court, Brewery Road, London N7 9NY
A member of the Chrysalis Group plc

ISBN 1 84013 429 1

Printed and bound in Hong Kong

CONTENTS

7

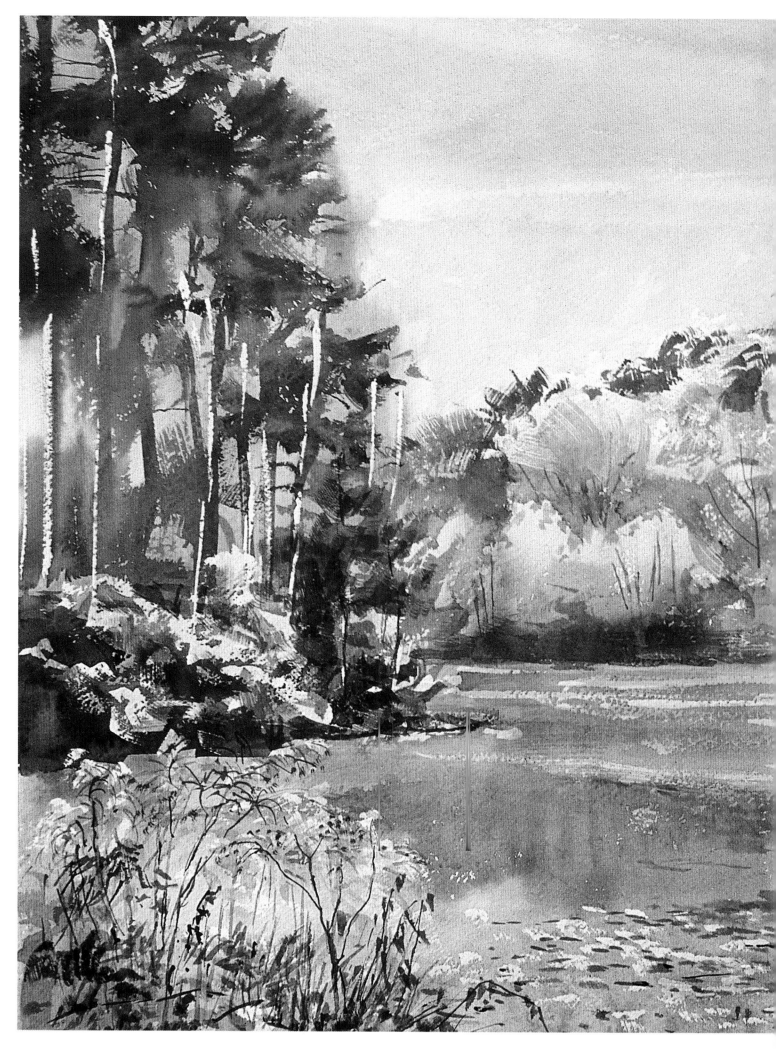

The Essential Painting Guide

Introduction

Suddenly I was transported back to my very early school days and a memory of the new box of paints—my brush rubbing across the surface of the dry blocks of color, so clean, pure, and magical. These colors vibrated as they were painted between the thick black lines of my exercise book. Even though the paper was cheap and absorbent, the joy of coloring was exquisite.

It is the smell of paint that triggers these evocative memories, and on this occasion I was overwhelmed from opening box after box in a warehouse crammed full of art materials—an Aladdin's cave promising creative delights to all ages. The child's painting set in my hands brought to mind the distinctive powdered paints in large tins of those long-ago school art classes. The various powders were spooned out into deep-welled palettes, mixed with water into fluid color, and we children would liberally apply them to our surface with thick bristle brushes. Although crude, these vividly colored works of art were spontaneously created, without reservation. They were painted with the clarity of a child's mind.

While my love affair with art continued from then, it did not occur to me in those earlier years that it would become my vocation. Yet it did, thanks to the encouragement I received and still receive from my parents, one teacher in particular, friends, collectors of my work, and those coming to me for help in their desire to paint.

Many a painter that comes to me for tuition delights in sharing their passion with family members, often bringing in the work of younger members to show fellow painters in the group. I love to see children's work; its innocence is magical. Several examples adorn my studio walls, thank-yous from children who have attended demonstrations or won prizes in the art competitions my partner and I have organized over the years. These evocative memories are not unique to me; they are something with which most of those who take up painting identify.

The reasons for anyone taking up painting are varied, but one stands out from the rest and is that which I hear most frequently—the fondly

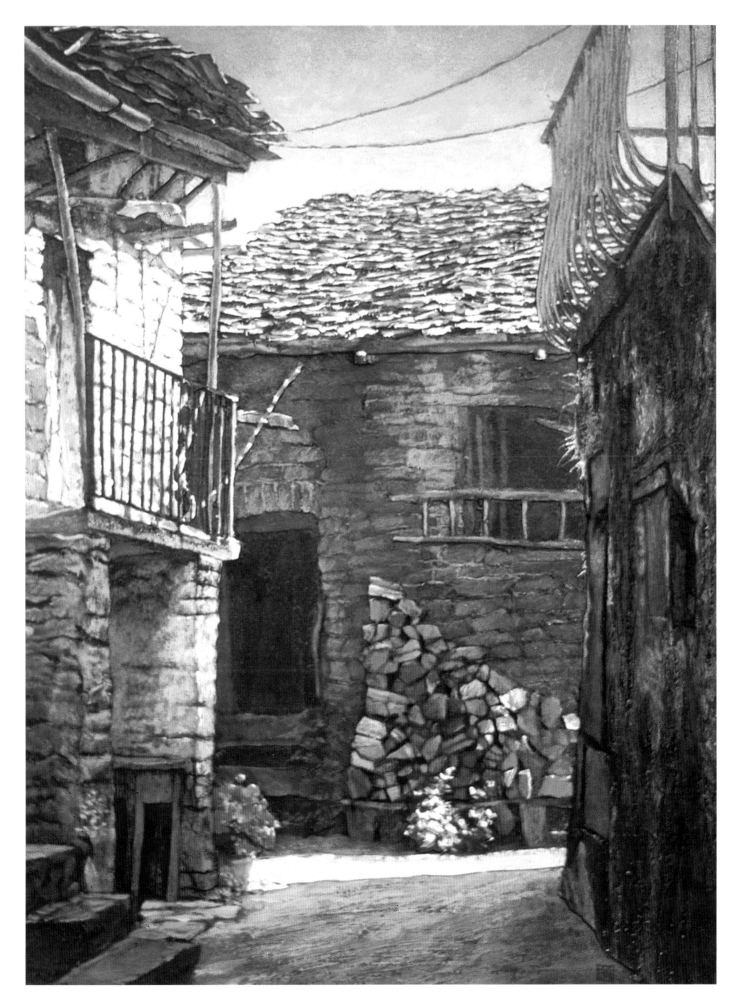

remembered pleasure that painting brought in the school art class. This can, however, also evoke mixed memories, especially if drawing lifeless objects marred the otherwise enjoyable experience.

For many a group of would-be painters, the term "drawing" can strike terror in the heart and bring a look of horror to the eyes. "Can't I paint without having to draw first?" is a common plea from those having a go for the first time. Yet it needn't be so, for it is all a matter of perception and approach. Anyone who has doodled on a scrap piece of paper, while their mind has been on something else, has begun to draw.

It is possible to get started on painting without the need to be proficient in drawing. However, if approached in the right way, drawing may not only be an enriching experience in its own right, but will lead naturally into the practice of handling a brush.

Many avenues in drawing have direct links to painting. Through following just one of these, painters move into painting without realizing it. The misunderstanding of this simple truth has put so many on the wrong track. This barrier, which beginners usually find so difficult to overcome, should never be there in the first place. They are not shown and so cannot see, that by using a pencil so much could be learned about structure, tone, balance, composition, etc., all of which could then be applied directly to the use of paint. The method of holding a pencil, its angle to the surface, and the pressure applied, all help painters to use a brush efficiently. There really is no difference between drawing and painting, for when someone is painting they are still drawing.

Would-be painters have many concerns when first starting out, most of which are issues of confidence. The most common questions are, "Do my paintings work?", "What's wrong with my painting?", and "Is my painting good enough?"

To the first, I respond that it is more a matter of what works for you.

For the second, I encourage the painter to identify what it is that makes them unhappy with the painting. For it is only through establishing what you feel is wrong with you own work, that you can begin to identify problems and correct them. Helping painters to rectify their problems is simple, as many are common to every artist.

As to the last concern, my answer is always, "Good enough for whom?" For I firmly believe that the results of painting are a matter of personal taste.

On the subject of what to paint, no one can determine this other than the individual, for what may excite one painter, could well be off-putting for another. Neither, for that matter, can anyone determine which medium should be taken up by the would-be painter. However, I do advise painters not to turn away from any medium on the basis of hearsay and other people's bad experiences, for what could suit one person, may not suit another. For those who already paint in one particular medium, extending one's repertoire into other media can only bring added enjoyment, not to mention the opportunity to develop further.

This book covers the four principal media that are taken up by painters, demonstrating how they can work on their own and in conjunction with each other. Each project within these four sections features workshops that include detailed Artstrips © which I developed many years ago as basic guides. An accompanying step-by-step tutorial leads painters through the process of one composition, from beginning to end. Finally, there are regular sections—Tricks of The Trade and Common Problems—which are based on those aspects most commonly raised or encountered by would-be painters, and those who already do so.

Paul Taggart

Pencil to Palette

Drawing as a painting tool

"You must be able to draw before you can paint." How many people have been discouraged from taking up painting because they have heard that opinion expressed? It suggests technical ability in drawing is required before one is allowed to enjoy the riches of painting. This is simply not true and what's more, drawing can be very enjoyable. However, for many people early experiences can lead to a fear that it is boring, isolated from painting, and that it will expose the inadequacies of the potential beginner.

IF YOU CAN HOLD A PENCIL OR BRUSH YOU CAN DRAW

The act of drawing is simply making marks in response to what we see with our eyes or in our mind. It is multi-faceted, ranging from a scribble to a complete work of art. Through it we communicate our experiences, either to pass on to others, or as reference for use in the future.

The drawing that you complete to gather information is not in itself important; it is what has inspired it that is important—the looking and learning process as you study the subject. The looking must be intense, if you are to translate what you see into marks on paper.

When selecting a subject to paint, I always start with a scribbly drawing, trying not to create a finished piece, as that will be the function of my painting. However, by making marks on a piece of paper I am inspired and have something tangible with which to play around. Changes can be incorporated as I pick up more information from the subject.

When we work from nature, our gaze becomes intense. You may have seen a tree in your garden or your close friend a thousand times before, but when you start to draw, it is as if you are seeing them for the first time. As you examine and explore the subject, your brain builds up a mental record and a deeper understanding of what you are seeing

Many people are discouraged by the mistaken belief that drawing is restricted to the realm of pencil. Are you one of those who have labored with a pencil to produce a drawing, finding it slow and unexciting in comparison to splashing around with paint?

Some, of course, enjoy the measured build up of pencil lead on paper. Others do not and so don't do it, throwing out, along with pencil drawing, the chance to experience a whole range of other drawing possibilities—such as using chalk, charcoal, pastel, ink, watercolor, oils, and so on. In fact, if what you are holding in your hand makes a mark, it can be used as a drawing tool.

Drawing is comparable to painting and should be executed with the same fluidity of expression. The differing ways in which a pencil, graphite stick, pastel, or brush is held will create a multitudinous range of marks on a surface.

Pencil to Palette

Basic drawing kit

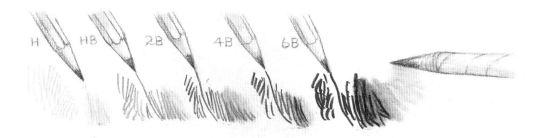

The standard graphite pencil with wooden sheath is available in a variety of degrees (softness). For drawing purposes the range between HB and 6B is the most useful. While the harder pencils—H, 2H, etc—can be used for very light renditions, they tend to score paper should any pressure be applied.

For sketching-in the main elements of a drawing I use an HB or 2B. Line shading, such as hatching or cross-hatching, is equally well defined using these two degrees.

The softer pencils, applied using the side of the lead to speed up the process, are best where areas of softer shading are required. These can then be further spread with a paper wiper, which is particularly important in cases where you are working on textured paper.

Quality manufacturing processes, such as in the gluing, can produce pencils whose leads are less likely to break if you drop the pencil. There is nothing more frustrating and wasteful than sharpening your pencil, only to find that the lead keeps falling out due to internal breaks hidden by the sheath.

Quality wooden sheaths also make a considerable difference when sharpening your pencil. If the sheath is too hard or crumbles, it may not match the density of the lead. This will probably result in the lead snapping as you try to control the cut of the knife or sharpener.

The lead in a pencil is composed of graphite bound together with wax. Wax resists water; hence you are less likely to dissolve pencil marks using water. However, you can easily dissolve this wax using a thinner such as Artists' Distilled Turpentine or white spirit to achieve paint-like effects on pencil drawings. Dip a watercolor brush in the thinner, working it over the already applied pencil. This effectively spreads the graphite in brush strokes, a technique that can be used on either black or colored pencils.

Wooden pencils, however, have one distinct disadvantage: the entire pencil gets shorter as it is used, which makes handling a pencil progressively more difficult. Although they do cost more initially, mechanical pencils get over this problem and will feed lead through to the tip even when it is very short.

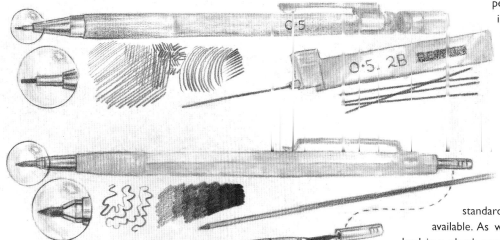

The automatic or fine line pencil takes a needle-thin lead in 0.3 mm, 0.5 mm, 0.7 mm, or 0.9 mm thickness. The 0.5 mm makes an excellent choice. It doesn't need sharpening and with 2B leads creates excellent line detail, hatching or cross-hatching even under watercolor.

Then there is the clutch pencil, which takes a 2 mm lead, equivalent to a standard pencil. Again 2B leads are available. As with the standard pencil the lead in a clutch pencil can be used point-on or side-on, to achieve line and shading, respectively.

Another essential is the graphite stick, available in many forms. The two that I use most commonly are the lead that is encased in plastic (to prevent soiling of hands) and the uncovered graphite leads, which I fit into a chunkier version

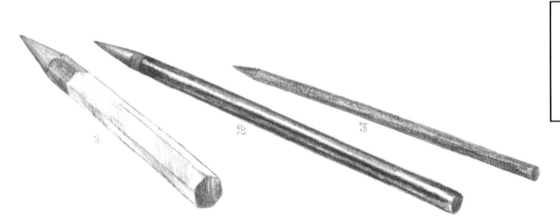

QUALITY COUNTS
You will find that pencils vary considerably in price, however; quality is important here.

of the clutch pencil. Generally referred to as a "Charcoal Holder," this works in exactly the same way as the clutch pencil and enables me to use the lead point-on or side-on. Again, while I prefer to work with a 2B lead, the degrees of lead softness range from HB to 6B.

Erasing is an important element of drawing. Knowing that corrections can be made makes it easier to draw with more confidence in the first place. To make changes in pencil drawing, it is essential to possess a good eraser, the most useful being a kneadable putty rubber. The different makes vary in pliability. All will soften more if held in the palm of your hand to warm. All will dry out if left open to the air between working sessions.

I keep mine in a tin, but you could use any airtight container or wrap it in cling film or plastic wrap. In use the rubber picks up the graphite and you will frequently need to turn it in on itself to expose a clean bit. Don't pull off the dirty piece and throw it away, or the rubber will only shrink in size, and become considerably more difficult to work with.

Keep an eye on the cleanliness of the rubber and remember to replace it with a new one before it starts to leave dirty marks on your work, instead of removing any unwanted graphite.

Graphite can be worked or "softened" into the paper surface with a stump. Also called a stub or a paper wiper, this is made from rolled or compressed paper. The compressed variety enables one to be quite aggressive, while the rolled version is more akin to using a soft brush in painting. Rolling your own from a variety of thicknesses of paper will enable you to build up quite a collection of different point sizes—again, not dissimilar to a collection of different size brush heads.

For drawing, paper should be smooth. A good quality cartridge will be sufficient for most drawings, but as a general guide, the thicker the paper, the less underlying textures (such as wood grain from your drawing board) will intrude into your work. You can, of course, buy a smooth drawing board, perhaps melamine-covered, or you can pad your drawing underneath with several layers of paper. Bristol board provides a stronger surface, available in various weights (thicknesses). Hot-pressed watercolor paper is also a possibility, but beware: some makes can be a little soft for pencil work, especially if you expect a lot of erasing.

ERASING TOOL
A rubber is not only used for correcting, it is also a very valuable drawing tool in its own right. I use my putty rubber every bit as much for creating negative marks in a drawing (white marks on a dark ground), as I use a lead for creating positive marks (dark on white).

Pencil to Palette

Basic drawing kit

Don't allow pencil to become blunt. If you do, linework becomes clumsy and the wood shaft can scratch paper.

A point like this doesn't blunt quickly. Different pressures result in "descriptive" linework. Also too heavy linework . . .

. . . that could indent surface and prove difficult to erase is prevented because the point snaps with too heavy pressure.

This longer point allows for a shallow pencil angle for shading. Shading keeps the point sharp.

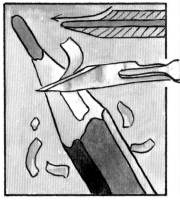
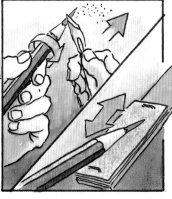
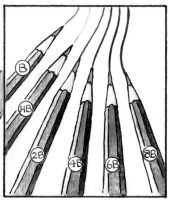
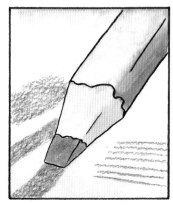

To sharpen, cut wood at flat angle to graphite with a sharp blade, "exposing" lead.

Now sharpen lead independently while revolving the pencil—or use sanding sheet

Try out full range of drawing pencils with differing degrees (hard to soft).

Sketching pencils with "flat" leads allow fast shading in one direction and hatching in another (like a flat brush).

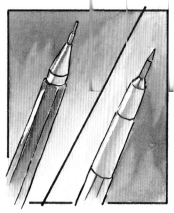
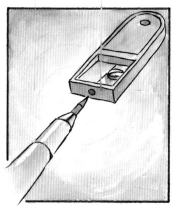
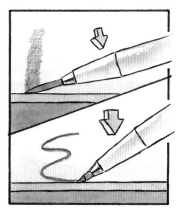

Be prepared on sketching out and about. The more variety you take, the more you can react to differing subjects.

Automatic pencils (left) or clutch pencils (right) provide further alternatives.

Clutch pencils feature a traditional (2 mm) lead thickness. For these there are special sharpeners.

Lead can be extended for shading (top) or retracted to avoid snapping during stronger linework.

SAFETY FIRST

When sharpening pencils or any other object with a knife
 it is essential that you protect yourself from harm.

Never have the blade facing you.

Always use a cutting motion away from the body.

Never hold the knife anywhere near your face.

Keep your distance from other people to ensure you do
 not accidentally cut someone else.

Children should never be allowed to use a sharp knife.

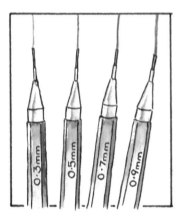

Automatic pencils have finer leads—so thin that they require no sharpening.

Overly heavy pressure, which could cause paper damage, results in lead snapping.

With no need for sharpening, linework can be free and unrestricted.

As these mechanical pencil casings don't grow shorter, this guarantees continuous, even handling, of the instrument.

Kneadable putty rubber can be flattened on one corner into a wedge.

Rubbing or dabbing on the surface lifts graphite easily. Dabbing is the most gentle, for softer, easily damaged papers.

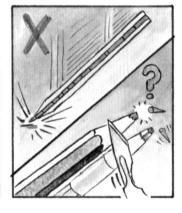

Try not to drop pencils. Leads break internally as you discover on sharpening or extending (mechanical).

For fast scribbles or laying down of loose forms, hold the pencil gently by its end . . .

. . . to allow for a loose and flexible approach with freedom of wrist movement.

To apply more pressure and/or control, move grip progressively down shaft . . .

. . . until finally close to the point. This gives the extra pressure and contact needed for accents and detail work.

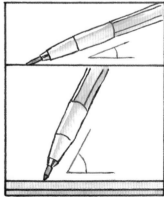

It is natural to adjust the angle of application for coverage (top) or detail (bottom).

Project 1

Building up from light to dark

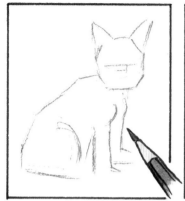

STEP 1 With point of pencil, sketch in simplified shapes of subject.

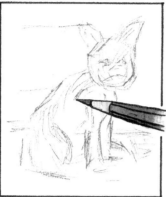

Keeping approach loose and scribbly, suggest position of further detail.

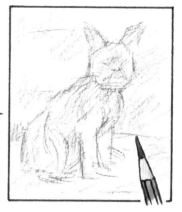

Gently shade using side of pencil lead.

Extra layers or increased pressure build up middle tones (darks).

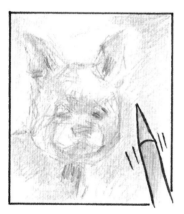

Use stump to soften or blend pencil strokes together and into the background.

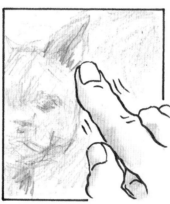

You can use your finger for this purpose, although it does not have the same accuracy.

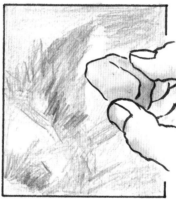

Use putty rubber to clean off excessive linework or re-establish highlighted areas.

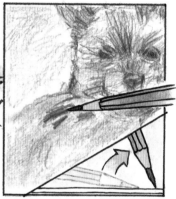

STEP 2 2B pencil. By increasing angle of pencil to surface, density and sharpness of line is increased.

STEP 3 5B pencil. Darkest accents applied broadly at shallow angle. Blend at the same inclination to soften.

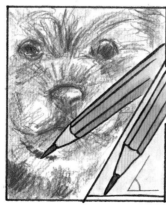

Final linework applied at steep angle is sharp and accurate, creating "focus."

Fine controlled blending can be employed using very point of stump.

Final highlights established with kneadable putty rubber.

MATERIALS
Cartridge Paper
medium thickness
Pencils
3H, HB, 2B, and 5B
Stump
Kneadable Putty
Rubber

LINK TO PAINTING
Working with and holding your pencil at differing angles will really help with your brushwork in painting. Use the side of the brush head for swift bold coverage of the surface and the point of the brush for detail.

STEP 1

For a more complex drawing that requires a greater subtlety of tone, a wider range of softness could easily be used. However, for this exercise, the selected range will be more than adequate. The 3H, a very hard pencil, is used at this stage to define the texture of the fur across the dog's back and around the muzzle. Here the strength of the tone is of less importance than the grooves created in the paper surface, into which subsequent pencil shading will not penetrate. Note "abstraction" of the background into subtle light and dark masses.

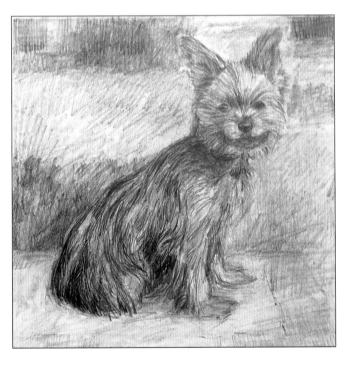

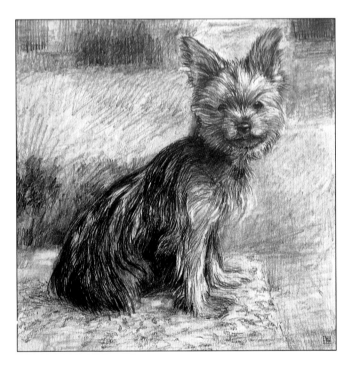

STEP 2

As soon as the softer 2B pencil is applied, the 3H line begins to be revealed. The dark on the dog's back and the dark spot on his collar are good points to see this effect. Soft shading (edge of point) is followed by softening once again with the stump. Now the hatching and cross-hatching are strengthened, reinforcing the texture of the dog's coat and also adding structure and character to the tones of the background.

STEP 3

The final darks and restored highlights are created in the final layer. Two things are worth noting here. First, the accents and highlights of the subject are stronger than those of the background, naturally holding one's eye on them. Second, the idea of varying the angle at which the pencil is presented has direct links to painting. It is good practice to start using the side of the pencil lead for swift bold coverage of the surface. The point of the pencil is employed for detail only.

Project 2
Hatching and cross-hatching

Different pressure applied to pencil yields differing line strengths.

Can be used creatively, by using its variety to suggest a three-dimensional form, thus making line descriptive.

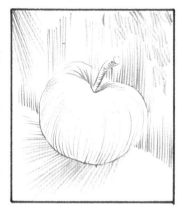

Line can also be used for shading—hatching.

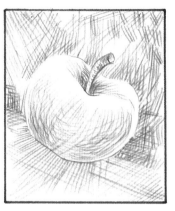

Layers of line shading built up—cross-hatching.

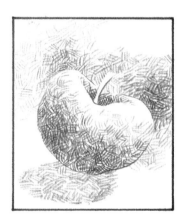

Cross-hatching can be rendered in a very mechanical way . . .

. . . or can be fresh, loose, and scribbly.

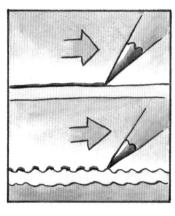

Texture of paper will affect line quality.

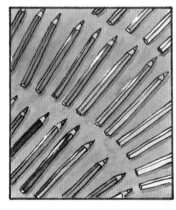

Colored pencils are a good way to start using color. Artists' Quality are usually most lightfast.

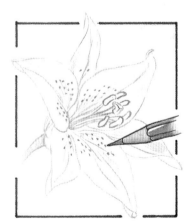

Now you can use colored linework . . .

. . . and you can use the pencils to hatch and cross-hatch.

Colors can be mixed visually by layering strokes or lines of color next to, or over, one another.

Colored pencils can usually be purchased individually but it is useful to have a tin in which to organize or carry them.

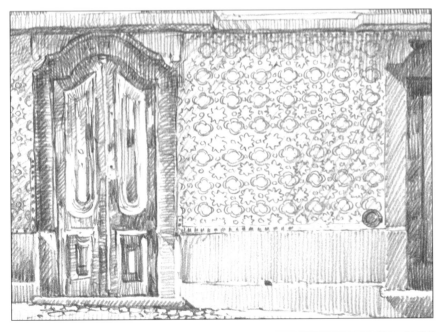

DRAWING 1

Using a 2 mm clutch pencil with a 2B lead, this Portuguese door is rendered using rather tight cross-hatching and linework. This gives a very solid feel to the hard surface of wood, stone, and tile. It is hard not to overwork this type of drawing, but it must be remembered that we are trying to preserve the line in the textures—no matter how dark the areas become.

MATERIALS
Cartridge Paper
medium thickness
Pencils
2B clutch pencil
small tin colored pencils
Kneadable Putty Rubber

DRAWING 2

The hatching and cross-hatching are now much looser. This feels more relaxed throughout the rendering, although by the same token this freedom tends to allow the line to go where sometimes it should not. Don't be afraid to re-establish highlights with a putty rubber. There are pros and cons to each approach. Your subject matter will often dictate the approach you select and in some cases you would want to combine both.

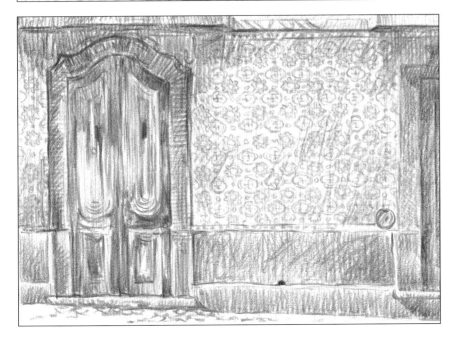

DRAWING 3

Here the hatching is completed in colored pencil. Not only can texture be built up, overlaid colors mix visually on the surface—one way in which to extend your limited palette. Keep the hatching sharp by ensuring pencils are well pointed at all times. Color definition yields more detail.

PRACTICE EXERCISES

The purpose of these exercises is not to produce perfect drawings. Use them purely to explore the possibilities with hatching and cross-hatching and mixing colors on the paper.

Project 3

"Painting" with thinners

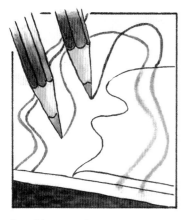

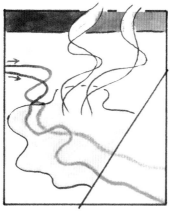

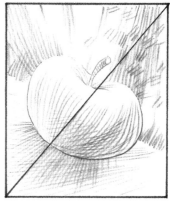

Pencil lines can be dissolved with thinner, allowing the graphite or pigment to spread.

Paper will temporarily darken but thinner will rapidly evaporate to leave paper normal.

Artists' distilled turpentine or odorless thinners leave no stain—cheaper materials can.

Thinner spreads some of the graphite into gaps between linework—increasing solidity.

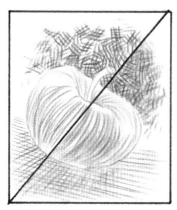

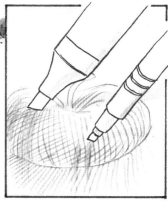

Try to make corrections before adding thinner as some pigment migrates into paper fibers making erasing difficult.

Colors laid next to and over each other will mix on the surface.

Round watercolor brushes are excellent for softly dissolving pencil with thinner.

Correction markers also contain thinners that dissolve pencil.

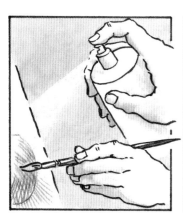

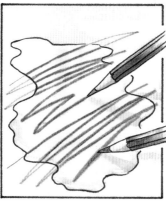

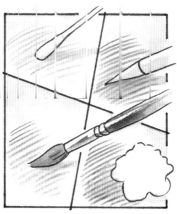

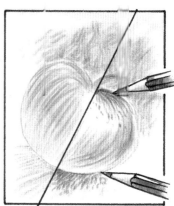

Professional line solvent dissolves the pencil, which can then be spread.

Try working into the wet patch of solvent. Always ensure adequate ventilation when using solvents.

Spread graphite/pigment with brush, cotton swab (cotton wool), paper wiper, or cotton ball (cotton wool bud).

Sharpen up softened image with more pencil work at focal points.

MATERIALS
Cartridge Paper
medium thickness
**Small Tin Colored
Pencils**
**Round Watercolor
Brush**
**Kneadable Putty
Rubber**
Quality Thinners

TIP
Always work from the top down
to avoid smearing colors with the
heel of the hand.

STEP 1

*Sketch in simplified shapes of main masses of subject
using a medium blue colored pencil. Blue is less likely
to dirty subsequent colors, whereas a black definitely
would. Apply first layer of highlight color for each area.
Keep pressure on the pencil gentle to avoid darkening
too early on. The intention is to work with a very limit-
ed range of colors, as one might working on the spot.
Colors are, therefore, often mixed on the paper, e.g.
cross-hatching of yellow and green to produce the
light yellow-greens one associates with sunlight on
foliage.*

STEP 2

*Here the colors were spread onto the surface with
both a correction marker and a thinner using a brush.
This softens the lines making them appear more
dense and out of focus. There is some spreading of
the pigment filling spaces between lines, but the "feel"
is more of a stain than a watercolor. The thinner used
was artists' distilled turpentine. If using a correction
marker, avoid contamination (i.e. build up of pigment)
by wiping frequently on a clean tissue. If this is not
done, it will start to transfer colors—not unpleasant
but if it is not what you want, it can be irritating.*

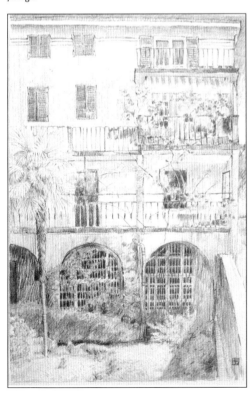

STEP 3

*Apply the middle to dark values. At this stage there is
no further blending of colors with thinners, although
limited softening is acceptable. Here I wanted the feel
of the pencil line left intact. Use like colors of the
same family as used on the first layer—e.g. palm
leaves—or complementary contrasts (see Color
Mixing), e.g. brown over green in windows. Apply
linework along edges in both cool (blue) and warm
(brown) accents. Again, avoid black here as it could
overpower the gentle clean colors. Employ hatching to
mix colors and create texture. The putty rubber can
be used throughout the process for corrections, but
areas that have been worked with thinners are more
difficult, though not impossible, to lift off.*

SAFETY FIRST
**Ensure that you have
adequate ventilation
when using
thinners/solvents.
Always follow the
manufacturer's
instructions on
ventilation.
Thinners/solvents must
not be used by children
unsupervised.**

Project 4

Colored pencils / Mixed media

Carefully remove a photo from a newsprint magazine—leave border.

Soak in thinner (artists' quality distilled turpentine or odorless thinner).

Drain and place face down on paper supported by a smooth drawing board.

Pin down along one of the borders.

Rub down vigorously with back of teaspoon.

If you are afraid of movement or tearing, don't pin—instead cover with another piece of paper.

Tape down one edge with low tack masking tape.

During rubbing down, periodically peel back carefully to check result.

Remove papers. Leave transferred image overnight to dry completely.

Tape the photo to a board; position at an angle in front of a mirror.

Adjust angle until you see the reflected image the same way round as your rubbing.

Now you can add as much colored pencil drawing to the rubbing as you feel it needs.

PENCIL INSPIRATIONS
Here we see a progression
of mixed media executions,
originally inspired by a
photograph of a vase of
flowers from a newsprint
magazine. Each takes as its
base medium a tin of
ordinary colored pencils.

MATERIALS
Smooth Watercolor Paper
Colored Paper
Small Tin Colored Pencils
Selection of Watercolor
Paints
Round Watercolor Brush
Kneadable Putty Rubber

DRAWING I

*The transferred image, created by rubbing down, is soft with
a sense of mystery. Try not to lose the quality as you develop
or emphasise the sections that you like. There is an abstract
quality about the rubbing and it is even possible to
incorporate the rubbing strokes into the overall character.
Don't use too many colors or too much color. Now take this
completed piece as your inspiration for the next mixed
media treatment.*

DRAWING 2

*This drawing is produced in pencil and watercolors. Faintly draw in the
initial composition, using a blue pencil. This is easily lost under
subsequent drawing and painting. You can take advantage of starting
again to alter the proportions of the rectangle or its contents to
achieve a more pleasing balance. During the drawing, alterations can
be made constantly with a kneadable putty rubber. Overpainted
watercolor gives solidity and more permanence to the pencil line
beneath. Final drawing can be applied over the color to tighten it up.*

DRAWING 3

*Trace the shapes from the previous drawing and transfer them to a
piece of cartridge paper. By cutting out these forms you can create
stencils through which to apply the pencil. This time use a colored
paper so that the white pencil can be used as a color. The drawing
becomes full of texture as the pencil strokes begin to overlap. For the
table, I used a technique known as "Frottage" (from the French verb
frotter, to rub). I placed a doily between the paper and the drawing
board, in this case under the area of the table in the composition—
the pencil was then applied on the surface, picking up the outline of
the doily underneath (similar to brass rubbing).*

Basic Drawing Kit

Tips and techniques with graphite

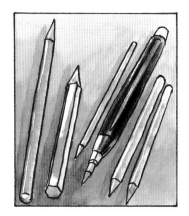

Graphite lead also comes in the form of sticks.

These are available in different degrees of softness from HB to 9B.

When sharpened smoothly, the point provides excellent shading (top). Note angle of application utilizing chamfered edge.

Differing paper surfaces result in a variety of graphite textures.

Stick held in "normal" pencil grip will present point to the surface.

Try overhand hold with chamfered edge on surface to achieve fast coverage.

Being "fat" the point blunts easily, but is nevertheless sensitive to variation of pressure.

Some sticks have a plastic coating to prevent fingers soiling (top). This can scratch paper surface.

Gently press sharp blade through the skin and rotate stick, cutting a collar of plastic free.

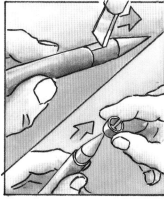

Support stick on a hard surface and split plastic collar lengthwise (top), then ease off (bottom).

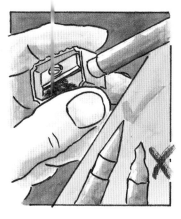

Sharpen point with pencil sharpener—not a knife—to provide a smooth chamfered edge for shading.

Save graphite (top). Special sharpeners for both sticks and clutch pencils store graphite automatically (bottom).

SAFETY FIRST

When sharpening pencils or any other object with a knife, it is essential that you protect yourself from harm. Never have the blade facing you. Always use a cutting motion away from the body. Never hold the knife anywhere near your face.

Keep your distance from other people to ensure you do not accidentally cut someone else. Children should never be allowed to use a sharp knife.

Uncoated graphite soils your hand, which inevitably transfers to the drawing.

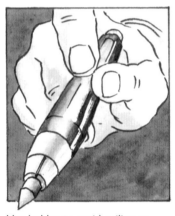

Use holder to avoid soiling or breakage. It holds leads of varying degrees and thickness.

In holder, stick can be used down to within 12 mm of its end without losing flexibility of movement.

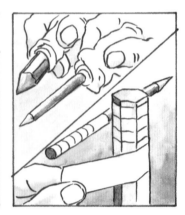

Wind unsealed sticks in tissue or masking tape. Apply tape from base to allow unwinding as stick is used.

Graphite shavings collected earlier can be reused. Scoop into folded piece of paper.

Tap gently over drawing paper and distribute an even layer.

Work into surface with cotton ball (cotton wool) to achieve soft gray base tone.

Add extra graphite by scraping directly from an unsealed graphite stick with a sharp knife.

Use a cotton swab (cotton wool bud) to pick up graphite . . .

. . . for transferring to small areas which require shading.

Try laying graphite along the top of your paper only . . .

. . . now work this in and down with a cotton ball (cotton wool). As graphite diminishes, tone lightens—giving a graduated tone.

Basic Drawing Kit

Tips and techniques with graphite

Use a sharp knife to cut a stencil from thick cartridge paper. Protect table underneath!

Place stencil over top section of graduated graphite tone.

Dust more graphite along its lower edge.

Work this extra graphite into the surface with a cotton ball (cotton wool) or cotton swab (cotton wool bud).

Remove stencil to reveal sharp horizon line between tones. This is a "positive" stencil.

Repeat several times, progressively darkening the tones. This effectively suggests distance—aerial perspective.

Knead corner of kneadable putty rubber into a wedge.

Use "edge-on" to remove fine lines or detail from laid graphite tone . . .

. . . or "flat-on" to soften, lighten or remove larger areas.

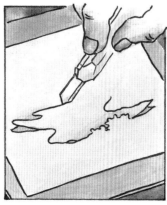

Cut another stencil from the center of a piece of cartridge paper.

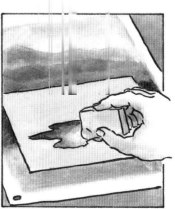

Erase graphite through the aperture with the kneadable putty rubber . . .

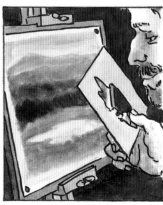

. . . to expose sharply defined area of clean white paper. This is a "negative" stencil.

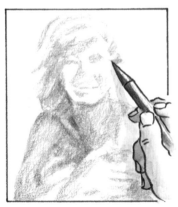

Having built up soft layers of graphite tone . . .

. . . you can accent them with a 2 mm clutch pencil . . .

. . . using shading (top), cross-hatching (left) or linework (right)—or a combination of all three.

Finally, fine linework can be added with the 0.5 mm automatic pencil.

It is natural to want to use a finger to smear and soften graphite marks on your drawing.

However, it is difficult to be accurate or to produce really dark accents this way.

A stub (stump, paper wiper) is just the thing for this.

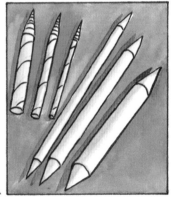

They are available in a variety of sizes and are made from rolled (left) or compressed paper (right) . . .

. . . or you can roll your own.

Different papers produce stubs of varying strengths and points—cartridge (top), sugar (middle), blotting paper (bottom).

The stub will eventually pick up graphite and transfer it to other areas, not unlike a brush with paint.

If this is unnecessary, remove excess graphite frequently on a clean tissue (like cleaning a brush).

Project 5

Techniques with graphite

STEP 1 Draw out rectangle on smooth paper. Drop graphite shavings onto paper strip butted up to one edge of rectangle.

Rub graphite toward center with a cotton ball (cotton wool).

Complete all four sides to produce a gray rectangle of graphite shading.

Sketch composition just strongly enough to be visible (top). Rub over with a cotton ball (cotton wool) to correct (bottom).

STEP 2 Warm putty rubber in palm of hand and knead into "chisel" shape.

This will lift graphite as line [A] or mass [B], with a dabbing [C] or rolling action [D]. Experiment.

Take strokes across each other (cross-hatching) [A]. Vary pressure: light [B]—heavy [C].

Soften edges with your finger [A] or paper wiper [B]. Blend pencil lines or spread graphite.

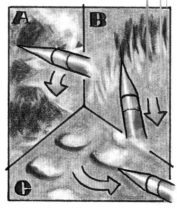

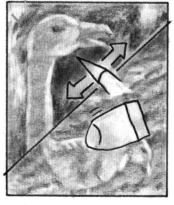

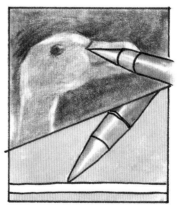

STEP 3 Sharpen graphite stick and use smooth sharpened shoulder for fast blocking-in of darks and accents.

This versatile tool can create side strokes [A], jagged lengthways strokes [B], or varied pressure marks [C].

Blending with paper wiper gives softness and depth to graphite strokes (top). Final highlights lifted (bottom).

Final details and accents can be added with point of graphite stick.

STEP 1

This drawing technique is especially useful for those who are a little frightened of making their first marks on a pure white surface. Here the white is totally eliminated with soft graphite shading. Initial drawing is completed with the shoulder of the point of a 2B 2 mm (regular lead thickness) pencil with plenty of opportunity to correct the proportions until one is happy to commit to stronger pencil detail.

TIP
Keep your graphite stick sharp and don't forget to collect the shavings for your next piece.

STEP 2

Wielding the putty rubber is akin to using a brush with white paint—this really feels like painting. Directional strokes play a large part in developing structure and volume. The drama is very exciting and you should move swiftly across the surface. The aim is not to finish any area, but to let the lights and highlights slowly develop across the whole composition.

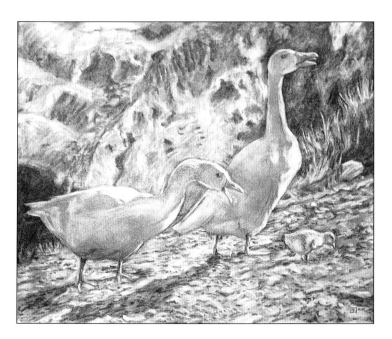

STEP 3

Don't try to copy every detail. Take the rocks, for example; observe carefully how the surface changes, but also exploit the marks you have already made over this area. Work across the white surface with the graphite stick before blending. This will ensure a dynamic positive approach, keeping detail suggestive. Softening of the graphite strokes can then be completed with regard to the balance of focus across the whole composition.

Links to Painting

While pencil drawing is an excellent medium in its own right, it is invaluable as a bridge into painting for both the beginner and the more experienced artist. Here we look at the ways that pencil drawing techniques are echoed in painting and how the two media can be combined to create unique effects.

Using the point of a pencil for detail and linework and the side of the pencil for shading and faster coverage . . .

. . . prepares the way for using the point and side of the brush for the same purpose in painting. One round brush applied at different angles can serve many purposes.

Using a kneadable putty rubber to lift off pencil shading, with or without a paper mask, is a useful method of creating highlights . . .

. . . and is echoed in watercolor painting, by removing highlights with a damp flat nylon brush and a tissue—known as lift-off—with or without a paper mask.

Hatching and cross-hatching create a variety of tones and textures in pencil drawing. Automatic and clutch pencils are designed for the job.

Paint, too, can exploit the technique with a special Rigger brush. Look at the work of the great masters of the Renaissance at close quarters and you will find it in highlights as well as in shadows.

Colored pencils can be mixed on the surface either with shading or hatching. Creating colors this way often yields more exciting results than having a color of the correct hue in the first place.

Mixing watercolor, inks, or transparent acrylic layers on the surface also creates exciting and varied results. The irregularity of the colors this produces is more exciting to the eye than a premixed color.

There is an obvious shape link between the sketching pencil and the "flat" brush. The chisel brush, although round in cross section, also produces a sharp flat edge with which to paint. Drawing with the pencil provides invaluable experience of what this shape can produce. When you move on to either of the brushes you will already have gained considerable confidence and ability, making the step from drawing to painting a natural one.

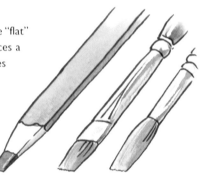

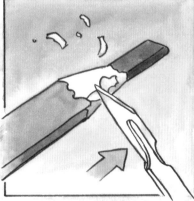
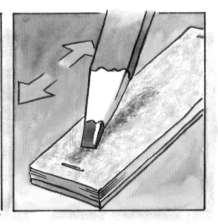

Don't allow the sketching pencil to blunt. Exploit its unique drawing potential.

Gently whittle away the wood avoiding the lead . . .

. . . then sharpen the lead on a sanding block.

The versatility of both the pencil and the brush is an invaluable addition to your repertoire of techniques.

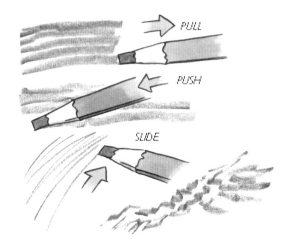

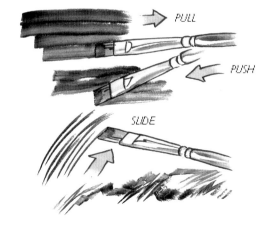

PENCILS USED WITH PAINT

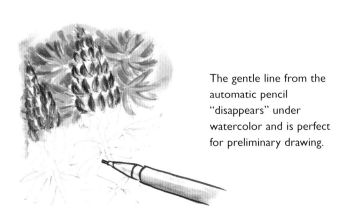

The gentle line from the automatic pencil "disappears" under watercolor and is perfect for preliminary drawing.

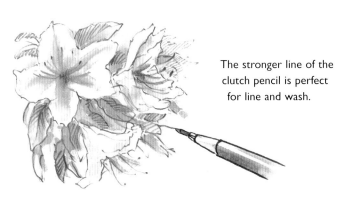

The stronger line of the clutch pencil is perfect for line and wash.

Study this visual comparison and association between the sketching pencil and the flat brush, where only one pencil and one brush have been used throughout the sketches. Great effort was made to exploit the variety of strokes available from each.

STEP 1

Establishes general rhythms and masses.

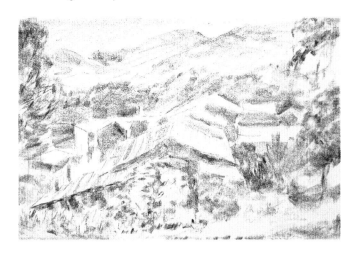

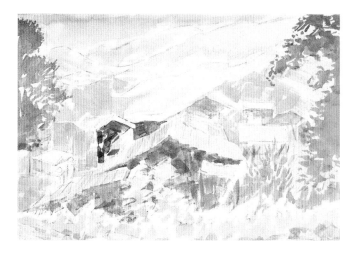

STEP 2

Concentrates on textures and establishing a wider range of tones (light to mid-darks).

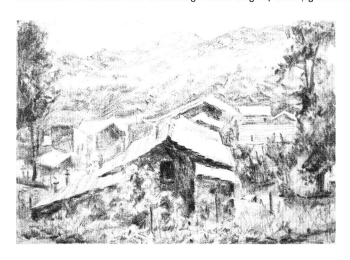

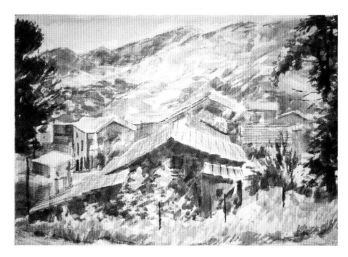

STEP 3

Final accents (really dark areas) and linework using the edge of the pencil or brush.

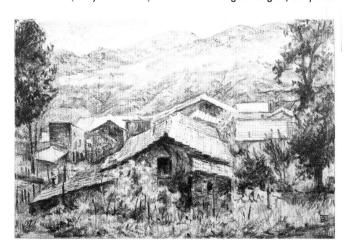

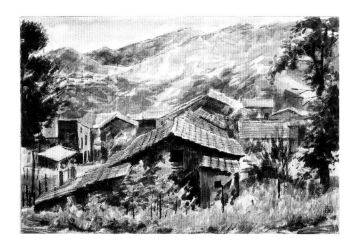

Chinagraph (glass writer) pencils are waxy and give a soft, yet dense, textured line.

Cut away wood gently exposing the "lead." Sharpen point. Some have a "peel away" paper shaft.

Drawn line will "resist" watercolor—a quality you can exploit.

STEP 1

Silhouettes of the masses are gently established first, as heavier work and shading would be more difficult to correct. Draw simplified outline with gentle pencil marks. Reinforce with the softer Chinagraph.

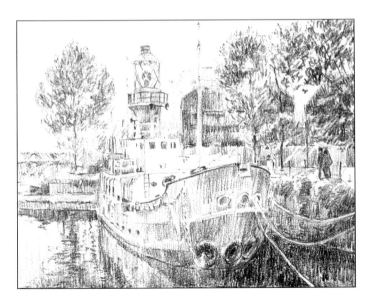

STEP 2

Establish more positive shading with hatching and cross-hatching. This type of shading leaves white paper between the strokes, ensuring that subsequently applied paint colors remain bright.

STEP 3

Apply washes of watercolor, but keep them very simple to enhance the mood and vitality of the work. This method separates the problems of value (shading) from color mixing and is excellent for those taking the first steps between drawing and painting.

Links to Painting

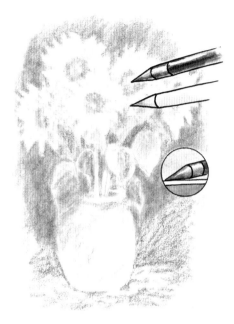

The following exercise demonstrates that drawing with graphite possesses many of the qualities of painting. It helps in overcoming many of the problems encountered in painting before the paint brush is even lifted.

FIRST LAYER

The purpose of this layer is to block out most of the white and establish the large masses. Begin the drawing with a graphite stick. Note the flat angle of graphite point presented to the surface for fast, even coverage (inset circle). Edges are kept soft at this point by using the paper wipers to blend the tones gently into one another. Apply a light to middling layer of graphite at this stage (light to middle tones) leaving you with plenty of scope for more work and the possibility of darker accents to come. Do not attempt any detail yet as the shapes will slowly solidify. In this way, much of the final drawing may be left out of focus and to the imagination. It is often what you leave out of a drawing that makes it work.

SECOND LAYER

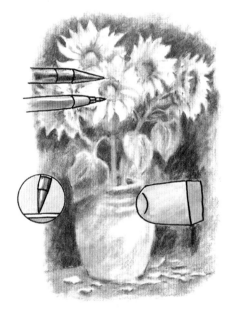

Continue to use the graphite stick. However, as we are now looking for smaller, darker, more controlled strokes, the angle of the point to the surface increases so that a smaller area is in contact with the paper (inset circle). To increase control and the degree of pressure applied, move your grip on the pencil closer to the point. Use a 2 mm clutch pencil for smaller areas. This is used flat to the surface for shading or at a steep angle for detail or texture. Continue to blend both the pencil and the graphite stick into the underlying layer of graphite. By applying these darker tones and accents you will find that you are creating volume. However, there is still no focus to the overall subject. Keep this quality as long as possible and you will begin to suggest detail. Use a kneadable putty rubber (shown to right of illustration) to lift off back to the white paper, creating soft-edged highlights. The putty rubber is not only used to correct mistakes, it can be used as a technique in its own right to harness its individual character to create different effects on the surface.

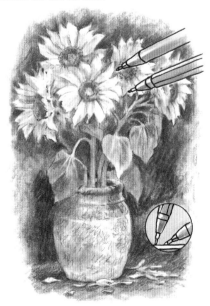

THIRD LAYER

It is with this final layer that detail and focus can be tackled. The degree of this is down to you and how you wish to interpret the subject. Is this a study in which every element requires clarity or can it be more painterly or impressionistic? Those areas that do not need focus simply do not need further work. For those that do, the point of the graphite stick will do the job, but it does blunt swiftly. It is useful therefore to exploit both the 2 mm pencil (standard wood or clutch) and an automatic pencil (which comes in a variety of lead thicknesses, e.g. 0.3 mm, 0.5 mm, or 0.7 mm). Generally both pencils will be held at a sharp angle to the surface for fine detail or linework (inset circle). Blending of the strokes into the underlying tones using the paper wiper is now very selective. The hard edges and linework that are not softened in this way become the areas on which the eye can focus.

Working with the watercolor technique of Wet on Wet creates brush marks that are soft-edged and thus are seemingly out of focus. This is an excellent way to begin a watercolor as one can block in the whole composition without being constrained by this first set of color masses. Watercolor painting is about working from light to dark, as you will experience in this exercise.

> **Building up pencil layers in this way can be echoed almost exactly in watercolor. Not only will you have worked out a sequence for dealing with paint, you will have sorted out the tonal pattern and balance of the composition. It is this range of tones (values in color) that is so important in creating light, volume, and depth.**

FIRST LAYER

With a Hake brush, wet the entire surface of the previously stretched paper and leave to soak in. Wet again just before painting. Use a large round watercolor brush (No. 10 or 12) to complete the majority of the painting. Apply the first layer, which provides the highlight colors for each area. Keep strength of color within the light to middle range, leaving plenty of scope for further work. While you are establishing the main masses, you need to bear in mind that they will be dominated by the stronger colors to come. With the knowledge that they can easily be overpainted comes the confidence to apply them rapidly. Working with the brush side (inset circle) allows for swift coverage of the surface. At this stage you must look below the surface of the subject to discover the simple structures beneath the detail.

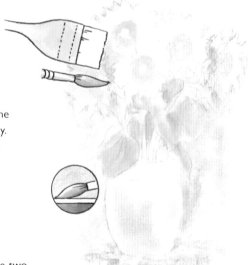

SECOND LAYER

Continue to work with the same two brushes. However, you will now be using the Hake to wet only small areas at any one time.

Progressively work through the painting, wetting a small area first, before then working into this wet area with your paint. With the round brush, pick out smaller areas of stronger color so that light and volume emerge. Work at a steeper angle, to utilize the point for finer detail (inset circle). You may find you need to shift your grip closer to the brush head for greater control. The soft dark accents achieved at this point are the hallmark of the wet-on-wet technique. They dry rich and even when successfully applied to the still-wet surface. No other watercolor technique equals these qualities. They also match exactly the darks of blended graphite we see at this layer on the opposite page. Once the whole surface has dried, color can be lifted off by wetting with a flat nylon brush and dabbing away with an absorbent tissue (paper towel is best). As with the kneadable putty rubber, this can be used to correct mistakes or as a technique in its own right. As its edges are soft, they match the soft edges of the paint at this stage.

THIRD LAYER

Now you can add sharp detail for this final layer. By building up the layers of pigment to this point you have had the chance to select exactly where detail and focus need to be. To achieve this the points of the brushes are used (inset circle). Larger brushes hold more color and therefore can deliver paint over a longer period. Smaller sizes can be introduced and even different shapes for line and/or texture (Rigger, flat, wash, fan, etc.). For this third layer you need to switch to the Wet on Dry technique, where the paint is applied to a dry surface, resulting in sharp, focused brush marks. Have a damp second brush on hand to soften some of these hard edges, blending them into the color beneath. This helps to hold together the soft, wet-on-wet brush marks and the hard, wet-on-dry ones, making the subject cohesive, while going in and out of focus throughout. The degree of focus and detail sought by the artist is one of individual choice. Generally, the more focus introduced in the subject, the less is left to the imagination of the viewer. Your initial graphite drawing will help you to arrive at that decision, and should help prevent you overworking the more delicately painted areas.

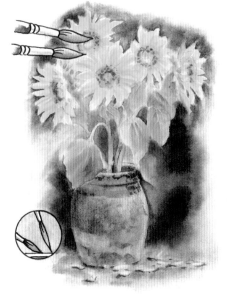

Color Mixing

Understanding the basics

COLOR REFERENCES
Yellow-orange [Yo]
Yellow-green [Yg]
Red-orange [Ro]
Red-purple [Rp]
Blue-purple [Bp]
Blue-green [Bg]

If asked for an honest answer, most painters would admit that they avoided learning the theory of color mixing at first. The urge to get on and paint being infinitely preferable to being held back by something that, on the face of it, appears to be rather academic.

Some will have muddled along for as long as possible, adding a bit of this color to a bit of that. Others may have bought the necessary color in pre-mixed form, adding more and more tubes or pans to their ever-growing collection of individual colors.

This approach has its problems for, ultimately, it is very limiting

• To fulfil your requirements you will have to purchase a sizeable range of premixed colors.
• A sizeable range is not easy to transport when painting out and about.
• Infrequently used colors tend to dry out, leading to further complications.

The solution is simple—learn to mix most of the colors you will require on a day-to-day basis from a basic palette of six colors. Your enjoyment of painting will improve accordingly.

• Minimizing the basic palette reduces the overall cost of your materials.
• With only six colors, you can take a small painting kit with you wherever you go.
• The frustration of paints drying out no longer complicates your painting life.

There are added benefits:

• You will be able to identify and mix every color you need.
• You will be able to balance the colors across your composition.

Colors will start to work for you by adding mood, depth, and dynamism to your paintings.

Once you actually get to grips with color mixing, it is not as difficult as at first imagined. Having absorbed a few simple principles, the rest develops through practice and use.

CONCEPT

This starts with the basic theory that the three primary colors—red, yellow, and blue—can be mixed to produce the secondary colors—orange, green, and purple.

It is at this point however, that disappointment and frustration sets in, for these simple mixes do not produce many of the colors required. Quite simply, the primary colors are not pure enough to do the job.

TERMS ESSENTIAL TO UNDERSTANDING COLOR MIXING

HUES
Bright primary and secondary colors
are known as hues.
VALUE
Some hues are very light,
while others are dark = different values.
INTENSITY
Dull colors have a lower intensity
than the bright ones.
TONE
The degree of lightness or darkness of a neutral gray.

The solution is to use primary colors with a bias toward the secondary color with which they are going to be mixed.

BASIC PRINCIPLE [A]

For RED a red-orange and a red-purple are required.
For BLUE a blue-green and a blue-purple are required.
For YELLOW a yellow-orange and a yellow-green are required.
This is the basis of the limited palette that is suggested throughout the book for use in watercolors, oils, and acrylics.

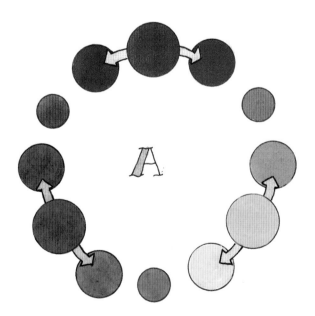

SECONDARY COLOR MIXING

Take any two of the six limited palette primary colors—e.g. blue-green [Bg] and yellow-green [Yg]. We know that blue and yellow mix to make green and we won't be disappointed with the resultant color when we mix these as they both have a bias towards green—diagram B.

Mixing the blue-purple [Bp] and yellow-orange [Yo] will, however, result in a much duller green, because the bias in each color is not toward green—diagram C.

From this exercise you will understand why some of the mixes that you made in the past simply didn't work.

> COLOR MIXING
> Where the prefix letter is shown in capitals this denotes a larger quantity of that particular color. Conversely, where the prefix letter is shown in a lower case, this denotes a smaller quantity of that particular color.
>
> Bp = large amount of blue-purple.
> bp = small amount of blue-purple.

Learn the subtleties of color mixing and your enjoyment of painting will be enhanced all the more.

COMPLEMENTARY COLOR MIXING

The simplest solution to darkening a color would seem to be the addition of black or gray. This works, but only to a degree. Undoubtedly black will darken a color, but often it deadens or dirties the mix, resulting in another color entirely. Add black to yellow and you are likely to achieve a dull green. While these black mixes have their use on occasion, they can, when overused, kill the potential richness in a painting. The answer is complementary mixing.

Complementaries lie opposite each other on the color circle—diagram D.
Opposite RED lies GREEN.
Opposite YELLOW lies PURPLE.
Opposite BLUE lies ORANGE.

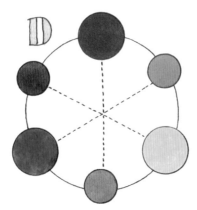

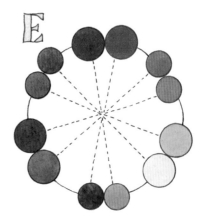

In theory, mix two complementaries together and they will dull each other down until you arrive at gray or black. However, as with mixing primary colors, there is a catch. To achieve a true gray, the complementaries have to be exactly opposite each other. Since there are six mixing primaries, each hue must be considered and its true opposite or complementary [diagram E]. This process is explained in the following pages.

THREE STEPS TO MIXING A SPECIFIC COLOR

1. Decide on its **Hue**. It must lie on the color circle, so what is its position?
2. Decide on its **Value**. How light or dark does it need to be? Add water or white paint to lighten, another color or complementary to darken.
3. Decide on its **Intensity**. Dull colors have a lower intensity than the bright ones. Either use a pure hue (bright) or add a complementary (dull color) to achieve a reduced intensity.

> **COLOR ACCURACY**
> **While every effort has been made in the printing to achieve correct colors, changes can occur in the printing process—especially in relation to subtle colors and color changes. We therefore advise that you use these pages purely as a step-by-step guide while you carry out the exercise for yourself.**
> **You will learn and remember so much about color mixing in the process, that it is well worth the time and effort spent.**

Color Mixing

How light and pigment work

An important aspect of color mixing is to know what a pigment does to light that falls across its surface. This may seem a little scientific, but once you understand the simple mechanisms at work, color mixing makes more sense.

Imagine a big block of blue pigment on a surface. White light that falls contains all the colors of the spectrum. When it hits the block of pigment, the block acts like a sponge and all the colors except blue are absorbed. The blue that is reflected back reaches our eyes and we perceive blue. In other words, the pigment **TAKES COLOR OUT OF WHITE LIGHT**. The blue we see is the color that it rejects. This simple fact is of the outmost importance, for if we add other pigment blocks to the mix, we absorb more colors from light. Thus when we mix pigments it is known as **SUBTRACTIVE COLOR MIXING**.

CREATING A SECONDARY BY MIXING YELLOW WITH BLUE

Here we have two "light" sponges or blocks of pigment. On the left a blue-green (Prussian Blue). On the right a yellow-green (Lemon Yellow).

When these are mixed together in the center, the blue-green absorbs everything but blue-green, including the yellow of the yellow-green. The yellow-green absorbs everything but the yellow-green, including the blue of the blue-green. The only color left to reflect is the green, as we can see in the middle. Hence blue + yellow = green.

MIXING A COMPLEMENTARY ORANGE WITH BLUE

Here our light "sponges" or pigment blocks are blue-purple (Ultramarine) on the left and orange (Cadmium Red + Cadmium Yellow) on the right. When mixed in the center the blue-purple absorbs everything except the blue-purple, including all yellows and oranges. The orange absorbs everything except the orange, including all blues and purples. There is now no color left to reflect. This is TOTAL COLOR ABSORPTION and thus we have a surface that appears gray or black depending on the density of the pigment.

WHY IS THIS IMPORTANT?

By working your way through the process of mixing blue as above, you will realize that whenever two colors are mixed, the resultant color is always duller and darker than those which were used in its creation. This is true no matter how compatible the colors are to each other. Even when you mix Ultramarine Blue [Bp] with Crimson [Rp] the resultant purple, while bright, will NOT BE AS BRIGHT AS A PURPLE STRAIGHT FROM A TUBE. When you need a really bright secondary color, it is sometimes better to get it from a tube rather than mix two primaries.

Blue can be mixed with black. This is known as a shade, and the color becomes dark and very dull. Nevertheless shades of blue can provide a very successful contrast to brighter colors.

Blue, being a complementary to orange, can alter the appearance of the latter when placed alongside it.

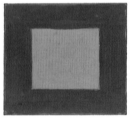

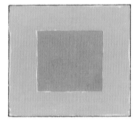

The natural orange.

Against blue the orange seems to glow.

Against a blue shade the contrast is intensified.

Against a complementary mixture (blue-colored gray) a slightly different effect.

Here Phthalocyanine blue (a perfect color for summer skies) is shown against a range of differing oranges and as above we can see the way it changes visually by the contrast. TIP: Phthalo blue is a good substitute for Prussian blue, especially with acrylics where the latter is not available.

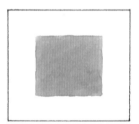

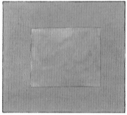

The natural Phthalo Blue.

Against orange the blue seems to glow.

Against an orange shade the contrast is intensified.

Against a complementary mixture (orange-colored gray) a slightly different effect.

By mixing differing amounts of water or complementary color with the orange, the nature of the blue seems to change even though each blue square is in fact the same color.

These examples show that a color can be changed not only by mixing other colors with it, but also by placing it alongside other colors. A color mix can only truly be judged against the colors alongside which it will sit.

So, you will never know if a color is completely right until you place a little on the painting itself.

Color Mixing

Mixing grays for rocks

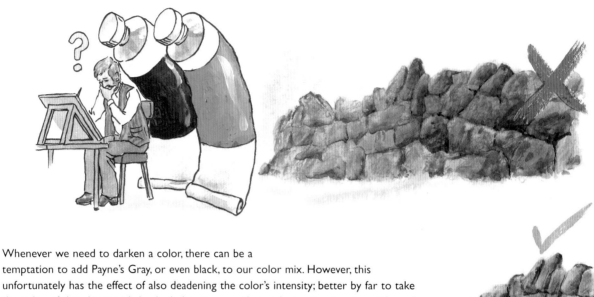

Whenever we need to darken a color, there can be a temptation to add Payne's Gray, or even black, to our color mix. However, this unfortunately has the effect of also deadening the color's intensity; better by far to take the color of the object and slowly darken its tone, thus reducing its intensity until you have a suitable "gray" version of your color. I term these "colored grays," for they still carry their primary color and are therefore much more exciting within your painting.

All of the colors around the outside of the color circle are bright and known as hues.

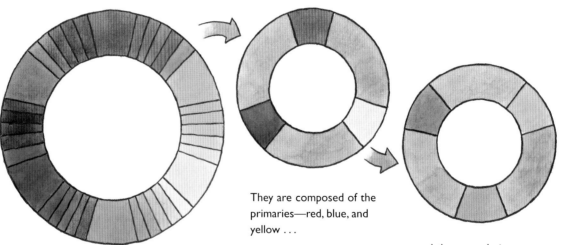

They are composed of the primaries—red, blue, and yellow . . .

. . . and the secondaries— orange, green, and purple.

Mix the right quantities of any primary with its opposite secondary and each will neutralize the other— resulting in a dull, dark color, theoretically black.

Add water (in watercolor painting) or white (in oil painting) and the result is a gray. This is a "colored gray" mixed from three primaries (primary and secondary). This is known as complementary mixing.

Before the color is totally neutralized to a gray or black by its complementary, it goes through
a succession of decreasing intensities and darkening values.

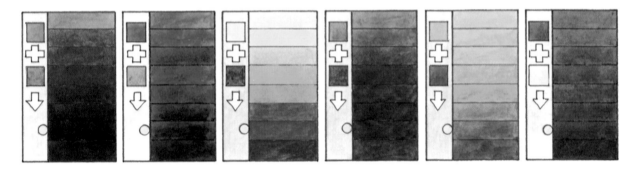

By choosing a stage in this change (marked with a ◯) and adding water (watercolor painting) or
white (oil painting), a series of values of a single intensity can be created (colored grays).

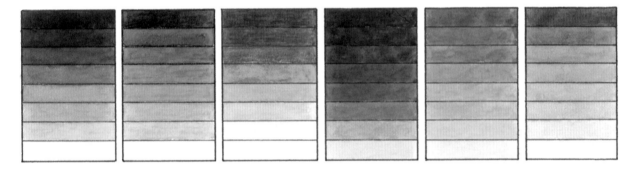

These are the colors you will need for rocks and stones. But beware, in watercolor, always
keep your colors brighter, for they will fade and reduce when dried on the paper.

An alternative to mixing colors on your palette is to overlap layers of
complementary colors on the surface, again creating colored grays.

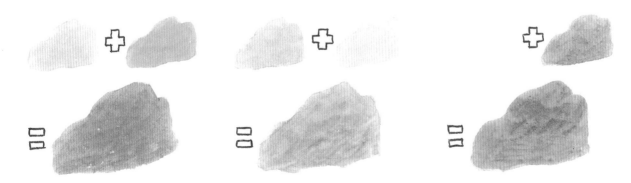

Color Mixing

Using complementary accents and contrasts

Complementary accents are widely found in nature. Complementary colors are those opposite one another on the color circle. Placing them next to each other creates extreme color contrasts, which can stimulate the eye.

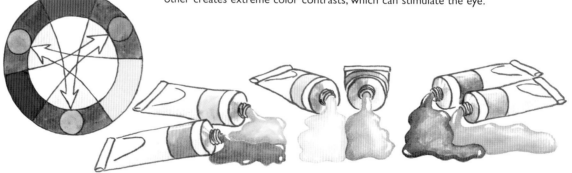

Artists have used complementary accents as part of their repertoire of techniques for generations. In this section, simulated from Constable's "Leaping Horse," Constable uses tiny splashes of red to give the large areas of green a boost. How does this work?

The eye is always trying to save energy. After looking at a color for any length of time [A] it begins to shut off the receptors for that color [B]. To all purposes the eye becomes blind to more and more of that color (e.g. green in diagram). The complementary color sparks them back into life, preserving the apparent richness and intensity of the first color.

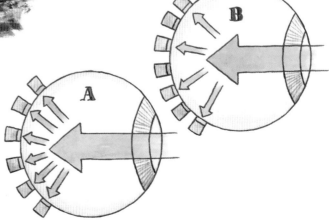

TRY THE FOLLOWING TESTS

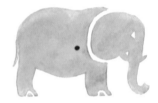

Stare at the dot at the center of the green elephant for about 20 seconds; then look at the dot immediately to the right of the elephant. Do not worry if you started seeing pink elephants. Some of the receptors at the back of your eye closed down and when you looked at the white light reflected by the blank paper—light made up of the primaries—you saw the color of the predominant receptors remaining, the opposite of green being red.

This test with the flag is even more exciting. Again, stare at the dot at the center of the flag for about 20 seconds; then look at the dot immediately to the right of it. Note how the black appears white on the after-image, indicating that tonal contrasts, as well as color contrasts are important to keep our eye receptors active.

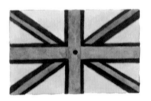

Complementary contrasts—here you can immediately see the difference between placing the flower against a background of the same family, as against a background of complementary orange.

On the left rose the background is composed of colors of the same family. On the right, the complementary green is dulled by the addition of some red + water.

Here the complementary background is dulled and darkened. Now you can see that it is possible to lighten and/or intensify a color without changing it, but by changing its surrounding color.

Color Mixing

Mixing green for trees in watercolors

Green often causes the artist a great deal of frustration, especially when using a limited palette. The landscape painter particularly, can easily find all of his/her greens looking too similar. While extra greens can be useful for bright areas, the majority of greens you observe, even on a sunny day, will be dark, dull, or both. It is far more important to achieve more from the color mixes you already have at your disposal. Work through the examples shown here. Mix the colors yourself and you will start to enjoy the greens in your painting.

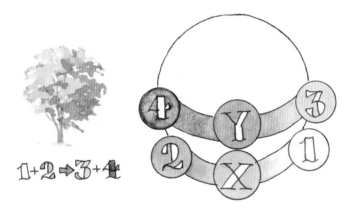

$1+2 \Rightarrow 3+4$

Green, as we all know, is mixed from the primary colors blue and yellow. The blues I recommend are • Prussian (blue-green Bg) • Ultramarine [blue-purple—Bp] and the yellows are • Cadmium Yellow [yellow-orange—Yo] • Lemon Yellow/ Primary Yellow [yellow-green—Yg].

Prussian Blue [Bg—2] and Lemon Yellow [Yg—1] both have a green bias and will mix to create an intense color [X]. The other blue [Bp—4] and yellow [Yo—3] have a bias away from green and will therefore mix to a dull color [Y]. A mix of one color bias to, and one away from green, will result in a middle intensity.

Differing amounts of yellow or blue will make the color cool or warm—useful to suggest sunlight and shadow. Yg (1) and Bg (2) yield bright greens for sun and shade in tree. Yo (3) and Bp (4) yield dull greens for sun and shade in tree. Up to this point we have been secondary mixing—green is a secondary color—and you will see from your exercise that you are already beginning to create variety. Adding a complementary color (that

which appears directly opposite on the color wheel), in this case red, always dulls and darkens color mixes. Here we have two possibilities, Cadmium Red [Ro—5] and Crimson Red [Rp—6].

The true opposite of Yg is Rp [6] and of Bg is Ro [5] and in each case the opposites will gray down and darken each other most effectively.

In practice however, Ro [5] is probably the most commonly used red added to greens. The yellow in the orange is compatible with the yellow in the green and tends to take the green toward an olive mix. The addition of Rp [6] however, is most effective in turning the green towards gray. This is useful for foliage whose local (normal) color is gray green or for foliage in very dull light, such as on a misty day.

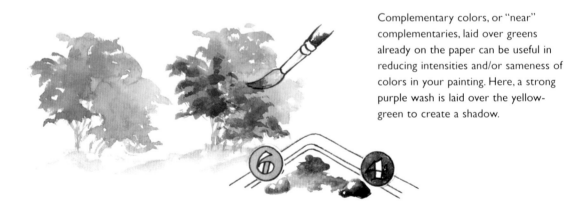

Complementary colors, or "near" complementaries, laid over greens already on the paper can be useful in reducing intensities and/or sameness of colors in your painting. Here, a strong purple wash is laid over the yellow-green to create a shadow.

Now look at the variety of greens you can achieve with only six colors!

The Essential
Watercolor Painting Guide

Introduction

Watercolor painting is a vast subject covering a welter of possible techniques, each with their own particular delights. Some years ago, when preparing my first book on the subject, I looked at this medium with fresh eyes to see if there was a way in which I could group some of these techniques together. This I felt would help to deconstruct the subject into more easily understood modules.

The three principal techniques at which I arrived were Line and Wash, Wet on Dry, and Wet on Wet, and these have remained the mainstay of my tutoring approach.

However, while these simplify the means through which to learn the principles of watercolor painting, they would be extremely limiting in practice, where a combination of techniques is by far the ideal. Nevertheless, it is only through understanding and practicing the essentials of these three techniques that anyone can develop their watercolor painting repertoire. The ultimate aim should always be to arrive at a style that is comfortable for, and unique to, the individual artist. There are no rights and wrongs here, only discovery of what makes better sense for the painter.

This guide features workshops and tutorials demonstrated for the purpose of understanding and practicing a particular technique. What has been completed in one technique can just as easily be executed in another, or a combination of any. It sets out to introduce painters to the medium on the simplest level of Line and Wash, progressing through Wet on Dry and Wet on Wet to combinations.

Line and Wash is the first rung of the ladder, but its simplicity should not obscure the inherent beauty of this technique. In order to allow those new to the subject to visualize its nature, I describe this technique as line drawing with simple color washes. Many artists would take me to task for this, saying that I was underestimating its potential, for the line involved can be as fine as a spider's web, or as strong as the dark filigree structure of a stained glass window. For the beginner it could mean adding a few colors to an already completed drawing, while for the enthusiast it can be an elaborate mesh of vibrating color.

My description is used purely to emphasize the importance of the line, for it is this that carries all the information. The washes add solidity and color, but should never impinge on the clarity of the line. As soon as the line starts to become obscured, the painting is no longer Line and Wash, it is purely wash, borne of the presence of pure watercolor.

The Wet on Dry technique applies when the linework disappears and the edges of colors and objects within the composition become defined by the edges of the color

washes alone. As its name implies, this technique relies on the paint being applied to a dry surface. The sharp edges bring focus, and to prevent them from becoming over-dominant or static, they must be tackled in one of two ways.

First, the approach must be lively and loose. Edges that dry sharp will then create a pattern or a series of rhythms which carry the eye across the surface in a visual dance. This will not happen unless the painter is in the right frame of mind from the outset, with loosened wrist and inhibitions, so that they can go with the flow.

Second, the artist must soften or lose edges before they dry. Detailed descriptions of how this is best achieved are contained within the workshops and tutorials that follow.

In the Wet on Wet technique, painters need to learn how to control brush marks and the flow of fluid paint applied to a wet surface. This I think of as the ultimate watercolor technique. Once mastered, painters are able to create soft darks and areas of depth that are out of focus. The surface of a painting takes on a three-dimensional quality and blurred edges can also be exploited to suggest movement. For me the most important effect of an area of soft or blurred paint is that the eye will not rest on it. A whole area painted in this manner will not demand attention. This is so important for directing the viewer's eye toward areas that do.

For example, let us take a composition in which a large tree or a building stands to one side. While they should not be the focal point, their complete removal would take away the identity of the view. This is where Wet on Wet comes into its own. The tree and building would be painted quite strongly, but in soft focus. The viewer's eye would then pass swiftly over the area, moving to the sharper edges of Wet on Dry at the focal point of the painting.

Through this example, it can now be appreciated that the use of Wet on Wet not only affords the painter control of depth and movement, but also control of the viewer. No photographer can achieve this with a camera; it is an opportunity that lies purely in the hands of the painter.

Having worked gradually through these three principal techniques, the painter is in a position to make an informed decision as to which will best suit the nature of the composition. Once mastered, they can be mixed and matched.

Too many artists concern themselves with creating a unique style at an early stage in their development. Often this leads to imitation of the style of others, simply through lack of direction. Armed with the principal watercolor techniques, however, painters need not worry about this. As each is mastered, it will take the painter down a path that in turn leads to another. A personal style will naturally emerge through this journey.

Equipment Focus

Watercolor brushes

All too often painters blame their lack of ability, when their problem could simply be a matter of using the wrong materials. Working with watercolor is about speed and fluidity of brush marks—using the correct brush will make all the difference. It will save you time, frustration, and even money in the long run.

ROUND

This denotes the shape of both the cross section of the brush head and the ferule, the metal collar which holds the hairs firm to the shaft [A].

The flexibility and softness of the hairs ensure that a regular non-textured layer, or smooth wash of color, can be applied [B].

The tapering of each filament ensures that when the dry brush [C] is wet and the filaments cling together, the brush will "point" naturally [D].

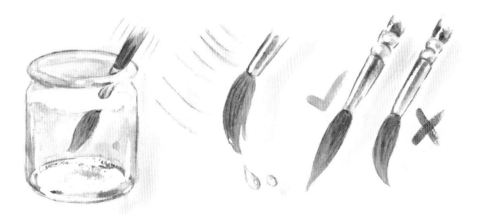

STARTING OFF

If you are new to painting and don't want to make an immediate investment in a sable brush until you feel your ability justifies the cost then compromise with a sable/nylon mix. Remember, it is easy to blame bad results on your technique when it is your equipment that could be at fault.

TIP

WHEN BUYING BRUSHES

Most shops will provide a jar with water in which you can wet the brush. Flick out surplus moisture and check the shape. The brush head should bounce back into shape and point naturally. The better the natural behavior of the brush head under these conditions, the greater the degree of control you will have over your brush in use.

BRUSH SIZE

Smaller brushes have their place but they will not hold much color, and the shorter length of the head can sometimes lead them to point less well than their larger counterparts, even when wet.

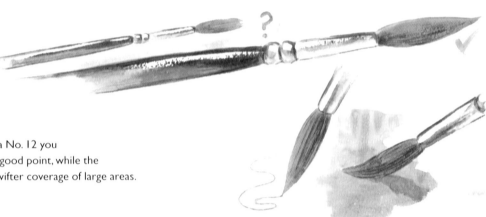

Even with a large brush such as a No. 12 you can achieve significant detail with a good point, while the side of the brush can be used for swifter coverage of large areas.

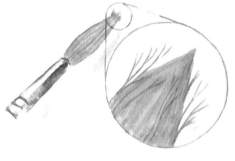

SABLE OR NYLON?

There are two reasons why it is to your advantage eventually to invest in sable brushes.

First, longevity—many nylon brushes inevitably wear at their tips, or the fibers/hairs themselves split. Deterioration in the head leads to deterioration in the ability to produce fine detail.

Second, the structure of the natural hair sloughs off paint more easily. Nylon brushes need that extra bit of cleaning to remove the color. This takes time and often in watercolor, where speed is of the essence, this is a disadvantage.

NOTE: Bad handling or cleaning of sable brushes will also result in snapped or broken hairs!

Sable

Nylon

HAKE

An essential for wet-on-wet painting, the secret is in the softness of the Hake's hairs, which not only take up a tremendous amount of fluid, but also deposit it again on your painting so gently that it will not lift-off color already dried there. When buying a Hake, make sure it is the genuine article, made with soft goat's hair. Even stores make the mistake of offering a bristle brush instead. The original Hake is still the best, with hairs set into a split wooden shaft (flat), bound with string. The hair is long and the head soon develops a sharp edge when wet. It is the sharpness of this edge that provides control during the use of the brush.

Equipment Focus

Understanding watercolor paper

In watercolor painting, getting the right paper to meet your requirements is vitally important. Understanding something of how watercolor papers are made will help you to make the right choice for your particular needs.

SIZE

Handmade watercolor paper is made from a solution of fibers (pulp) sieved through a mold into sheets. Size is added to the pulp as a glue to hold the fibers together upon drying. More "internal" size equals greater resistance to damage in the final sheet of paper. It also reduces absorbency and therefore prolongs drying time when painting.

FINISHES
ROUGH PAPER

Paper dried between felt blankets picks up the texture of the blankets, resulting in a "rough" surface.

> ### ROUGH
> Chosen by those who enjoy the vitality of the textured brush mark, which results from working on this surface.
>
> ### NOT/COLD-PRESSED
> Favored by those who want some texture, but do not wish to be dominated by it.
>
> ### HOT-PRESSED
> More suitable for those requiring fine detail and linework.

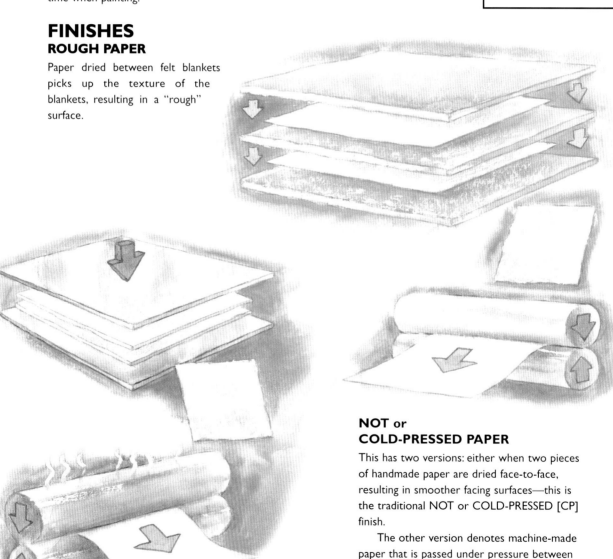

NOT or COLD-PRESSED PAPER

This has two versions: either when two pieces of handmade paper are dried face-to-face, resulting in smoother facing surfaces—this is the traditional NOT or COLD-PRESSED [CP] finish.

The other version denotes machine-made paper that is passed under pressure between two cold steel rollers. This is also referred to as NOT [not hot pressed] or CP finish.

HOT-PRESSED PAPER

Machine-made paper that is passed between heated rollers resulting in a very smooth surface known as HOT-PRESSED.

CHARACTERISTICS

• HANDMADE PAPERS usually have four deckle edges with an irregular edge.

• MOLD-MADE PAPERS produced on cylinder mold machines can have two or four deckle edges. They are durable and stable in use. Similar to handmade.

• MACHINE-MADE PAPERS are much cheaper. Surfaces are uniformly regular. Less strong, they can distort when wet. A good choice for beginners or for practicing techniques where starting again and wastage occurs more often.

TUB SIZING

Some of the more expensive papers are given an extra dip in a bath of size. This adds surface size, for strength and color purity when painted. Once dipped they can be hung up to dry naturally. This treatment adds character to the paper, but does, of course, add to the cost.

WEIGHTS OF PAPER

The traditional weights referred to the number of pounds in a ream (500 sheets) of paper. Thus, the higher the number (below), the thicker the paper. The metric equivalent is gsm, or grams per square meter; again, the higher numbers indicate thicker paper.

The thicker the paper, the more water it can absorb, so it will stay wet longer. The thinner the paper, the more cockling when wet. This can cause pooling, increasing the problem (below right). Applying color is then difficult and the surface dries unevenly, causing unwanted hard edges in the painting.

No	Metric	Imperial
(1)	150 gsm	72 lbs.
(2)	200 gsm	90 lbs.
(3)	300 gsm	140 lbs.
(4)	425 gsm	200 lbs.
(5)	535 gsm	250 lbs.
(6)	600 gsm	300 lbs.

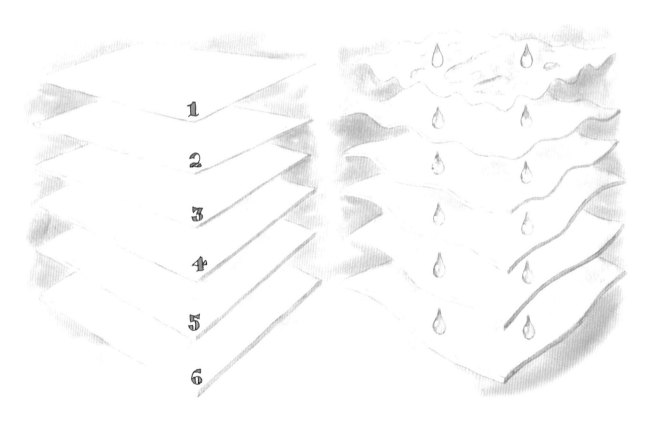

Equipment Focus

Working with watercolor paper

Getting the right paper to meet your requirements in watercolor painting is the first step towards getting better results in your work. Knowing how watercolor papers work will make all the difference when you paint. A few simple pointers can remove many of the frustrations experienced by beginners and enthusiasts alike.

APPLYING PAINT

Size, added to the pulp, is the glue that holds the paper fibers together (central section in diagram) and gives the paper its strength.

- The quantity of size added to the pulp determines the strength and stiffness of the paper. This is known as Internal or Engine Size [A].
- When paint is applied the external size ens, trapping the pigment within [E].
- Excess color tends to lie on the surface [D].
- Very powerful pigments can actually dye some of the paper fibers [F].

- An outer layer of size may exist as the result of internal size migrating to the surface and/or because an extra layer of size has been applied after the paper has dried. This is known as External Size [B].

- When the paper is immersed in water [G] the size softens but will not release the color. Only the color lying unprotected on the surface floats away.

REMOVING PAINT

Only when friction is applied will the jelly-like wet size move, taking with it the color [H]. The fibers, however, retain their pigment.

Excessive rubbing with the brush will cause paper damage as the surface disintegrates into balls of fiber [J]. Damaging the paper is the only way to remove stained fibers.

Damaged paper [K] will absorb subsequent washes into its surface.
These will stain the fibers permanently.

INTENTIONAL DAMAGE

Fiber damage can either be a problem or a technique— these two techniques will come in useful as part of your repertoire.

- Damp paper (below left) scratched with the brush shaft will display these damage marks on washing with color.

- Dry washes (below right) can be scratched with a sharp knife or scalpel. The fibers are raised, creating sparkling highlights.

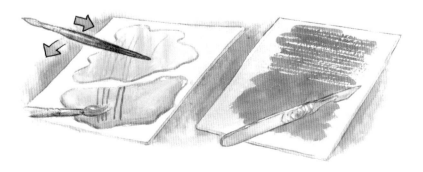

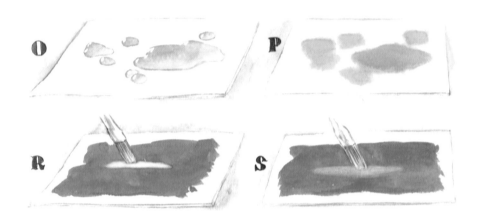

LIFT-OFF

Heavily sized papers can be resilient to application of watercolor, but dried color remains near the surface and is bright [O].

Gently sized papers absorb color as a stain—but dried colors are less bright [P].

Properly surface-sized papers lift-off well—almost to the original white [R].

Gently surface-sized papers can either resist lift-off entirely or retain more color in their fibers [S].

REMOVING AND ADDING SIZE

To remove size, wash gently with a damp natural (artist's) sponge. This can be done several times, but allow to dry between washes.

To add size, dissolve gelatine granules in water and paint across the surface. Allow to dry thoroughly before use. Dry flat.

BUYING, CARRYING, AND STORING PAPER

Cellulose (wood)-based paper contains acids which naturally yellow or make paper brittle. All good watercolor paper is ACID FREE—made from acid free materials such as cotton, while some are buffered with calcium carbonate against the acids in the air.

Before you commit yourself to a large purchase, you will often find that manufacturers will send you swatches you can test [1]. Alternatively buy a trial pouchette of paper and try different weights and surfaces [2].

The cheapest way of buying paper is in sheets. They should be stored flat, in a portfolio or studio case [3]. For short-term transport, they can be rolled in a plastic carrying tube [4].

Spiral-bound sketch pads don't fall apart if you remove a sheet [5]. Watercolor blocks [6] are several sheets glued together along their edges and fixed to a stiff backing board. Watercolor boards [7] have a sheet of watercolor paper glued to a strong backing board to remove the necessity of stretching.

Starting Off

Working on the spot

Working outdoors can be great fun but it can also be a little intimidating at first. No longer is the viewed framed by the edges of the photograph and each time you move about, even a little, shapes change and perspectives alter. Painting from nature is all about elimination. Basically, you have to decide what to cut out. This is exactly why it is so exciting. No longer are you questioning what to paint, but now you almost have too much. To help you make the choices there are several techniques which artists over the generations have employed to get them started.

SHAPE AND CONTENT OF THE COMPOSITION

The proportion of the outer rectangle of the composition is one of the most important decisions you have to make. As soon as you put your first mount over a watercolor you will see what a difference this strong rectangle makes to the painted shapes within. The question is—how do you decide?

GRID

Cut out a rectangle from the center of a piece of paper. Holding this frame before your eyes you can now use it like the viewfinder of a camera, to find a good composition. An improvement on this would be to make the viewfinder from a stronger piece of card. Mark the edges into equal lengths and stretch a piece of black thread across the central space, fixing the ends with tape. Now your rectangle has a grid, which will help you transfer detail to your drawing surface.

Another option is to save some transparent cellophane from packaging. Tape this over the rectangular cut out. Ink in the corresponding lines up and down to form your grid. You could, of course, buy this sort of grid viewfinder, but making your own allows you to customise it—choosing the shape and spaces in between the grid lines or ovals and circles etc.

FLEXIBLE FRAME

Many artists prefer to use a more flexible method—two "L" shaped pieces of card. There is one small snag; they require two hands to hold them up. However, all you need do is gently tape the pieces together once you have decided on your rectangle. Then you can transfer the information to your surface.

INSTANT FRAME

The simplest method is to use your hands. If you are close to the subject, or simply want more of it, you can open your hands to encompass all of it and imagine the lines linking your fingers and thumbs. This is the method I prefer, simply because of its simplicity. As I am not using an accurate measuring device it also reminds me that this is merely a guide to getting started. The real balancing act between border and subject takes place on the paper when you get into your thumbnails.

THUMBNAILS

Thumbnails are the most helpful method for deciding on the composition, whether working on the spot or from photographs. These simple, scribbly sketches, produced in a matter of seconds, force the painter to study the view and absorb as much information as possible. Keeping them small in scale prevents detailed drawings from being produced, ensuring that the outer rectangle and principal components are worked out.

There is, however, no limit to the number of thumbnails you can draw. You may produce a dozen and then come back to the third. The important thing is to weigh up all the possibilities and come up with something unique to you. Keep the thumbnails simple and they will not take too long to complete.

THUMBNAILS IN PRACTICE

Compare the set of thumbnails taken from a very old reference photograph—both shown below—with the second set carried out on the same spot many years later, after the gasometer had disappeared completely and mature trees now lined the banks (see page 62).

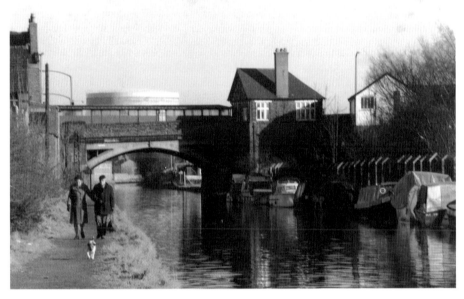

At first glance this old photograph seems uninspiring. What can be made of it as a composition?

[1] = Building
[2] = Bridge
[3] = Station
[4] = Building
[5] = Towpath
[6] = Canal
[7] = Bank
[8] = Sky
[9] = Figures

Thumbnail 1 Initially the proportions are influenced by the shape of the photograph. The main elements are simplified into outline shapes as per the key.

Thumbnail 2 A simple foil, such as dropping the base, can make all the difference.

Thumbnail 3 Dropping the base line even further doesn't really work.

Thumbnail 4 Better. But the bridge is a little wide and the sky has somehow grown larger again.

Thumbnail 5 The final choice. A nicer shape for the sky, the right amount of water, and the figures are well balanced. You may disagree: you would be right to do so, for this is my personal choice. You should, and must, come up with your own ideas.

Being on the spot has its added advantages. Not being restricted to the elements contained within a photograph, the composition can be framed in whichever way you chose. Elements within the rectangle can be enlarged or shrunk to achieve a pleasing balance. This pushing and pulling of the content can continue until you begin to get the feel of the picture as a whole. This feel is absolutely essential to the successful outcome of your final painting.

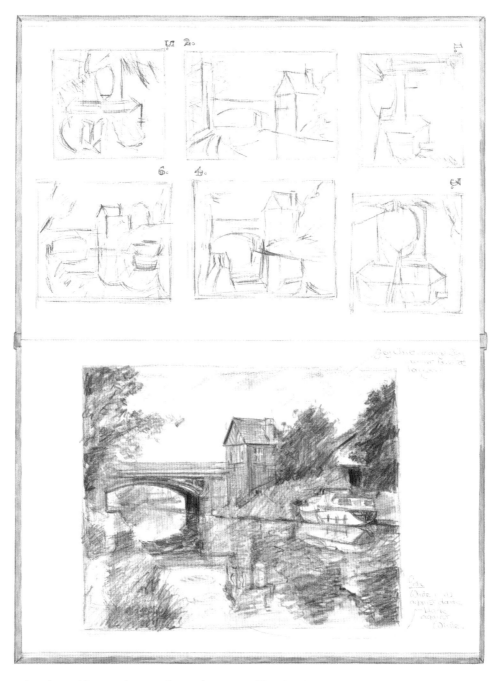

The six thumbnails produced on this occasion are featured in my sketchbook. Some of them lie on their sides. The reason for this is simply that the opposite page was earmarked for a more detailed reference drawing—important if you are not taking a reference photograph, useful even if you are. It was best to orientate the lie of the thumbnail to mirror the proportion of the second page. In other words, it was easier to transfer the drawing if the thumbnail was the same way up when I was looking at the second page (wide thumbnail/wide page—tall thumbnail/tall page).

Thumbnails 1 & 2 These were completed quite close to the bridge and, because I was looking up at the building, capture a large expanse of sky.

Thumbnails 3 & 4 A little further back and I began to realize the importance of the reflection. I was tempted by No. 4, but there were some boats reflecting in the water, which didn't fit in this.

Thumbnails 5 & 6 These were incorporated and the light contrast against the dark was too much to reject, so I finally decided on No. 6.

I completed a more detailed sketch with shading, using not only the edge of my pencil lead, but also a graphite stick for faster coverage. As I completed this drawing my understanding of the overall composition became much more powerful. I began to understand the balance of values (lights and darks). Color also began to demand attention and I made note of certain unusual hues in the margin.

Elements such as details of the reflected boats, foreground grasses, and perhaps even passing boats could be sketched separately or even photographed. If you have time this drawing can become so detailed that a photograph is unnecessary. But if you do not have time, don't feel that you should not take a snapshot as part of your information gathering. There will be no danger of you copying it slavishly now. Your thumbnails will show you exactly what to photograph leaving no possibility that you will miss an important element which may not be there if you have to return.

MEASURING A DRAWING TO FIT YOUR SKETCHBOOK

It is a good idea to carry a small sketchbook with you, one that fits in your pocket or handbag. The inspiration for a painting, the one you are certain will never be forgotten, is all too often gone by the next day. Not to mention the figure you suddenly see, leaning against the fence, which will fit ideally into your latest composition. You desperately try to commit the stance to memory. By the time you get back to your work, that memory fails you and the image has become too vague to translate.

While a small sketchbook does have the advantage of its size for tucking discreetly away, its very lack of size can be perceived as a disadvantage when it comes to sketching something a little bigger than a flower head. What do you do when your subject is much larger, such as a bridge, or a plane, or a boat? There is however no reason why these larger objects should fall off the edge of your page [A].

What you need is a simple method that ensures you get the entire drawing on the page.

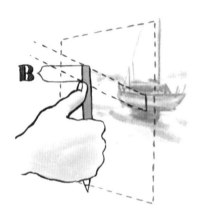

Don't bend your drawing arm while completing the process, as this would alter the measurements. Before proceeding, decide which way up your sketchbook needs to be to accommodate the proportions of your subject—is it landscape (horizontal) or portrait (vertical)?

STEP 1. Look at your subject and imagine that you are looking at a large photograph.
STEP 2. Extend your drawing hand, holding pencil against the surface of this "photograph" [B].
STEP 3. With your thumb, mark off a measurement down the pencil.
STEP 4. Once you have this measurement, find out how many make up the total height of your subject [D]. Do the same for its width [E]. Make a note of these proportions if necessary—for the example illustrated, 11 and 6.

TIP
Find a controllable measure in/on your subject—one that fits easily on to your pencil and to which you can easily return for checking against [C].

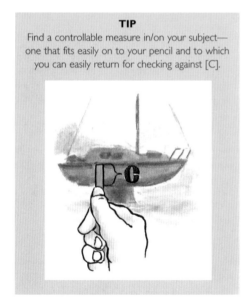

STEP 5. Taking the longest dimension, decide how long it should be on your page and then divide this by the number of measurements you arrived at in STEP 4—for the example illustrated here it is 11 [F]. Do the same for the shortest dimension [G].
STEP 6. Now draw a frame (box) in which you can plot more detail, using this same measuring device wherever necessary [H].

Any subject can be dealt with in this simple way.

NOTE
While this method is invaluable in making sure you get your entire subject on a page, do keep measurements to a minimum. If you start every drawing with measurements, you will find it tiresome and boring. Only use this method when your drawing is going wrong or you feel unsure—when you need some guidance to bring it into line. Use your eye wherever possible and improve your judgement—by far the best way and more spontaneous.

Project 1

Line and Wash—linking drawing to painting

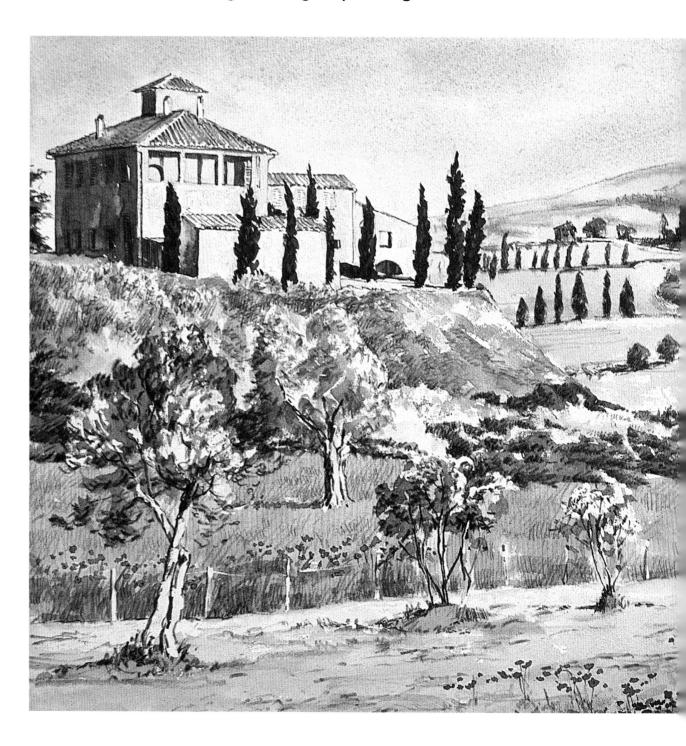

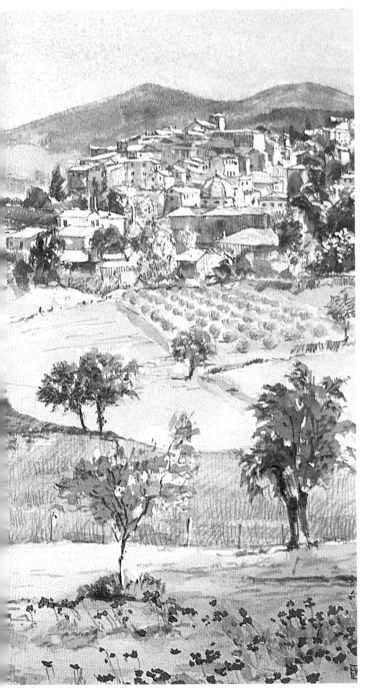

Pencil linework is one of the most gentle available to the artist. So gentle in fact, that it can be washed away or covered by watercolor. However, the soft, neutral gray of graphite provides, on occasion, a delicate contrast to the watercolor, bringing out its tender hues.

Detail and line shading are easily accomplished using the fine point of a pencil. It is more direct than the paint and being such a commonly available medium, most people are well acquainted with its use.

Watercolors can be used delicately or with full strength and when combined with pencil their power must be modified so as not to overpower the latter. This reining-in of the watercolor is by no means a negative virtue. Pencil line and wash, having been forced into delicate realms, can be one of the most beautiful of the watercolor techniques.

Thin watercolor washes are the most transparent and this allows light to reflect from the paper, bringing out the full luminosity of the pigments. When using differing degrees of pencil, each strength of line can be matched with an equivalent strength of wash.

Early exploratory pencil work, if kept light, may simply be painted over, without the need for erasure. The softer and/or thinner the pencil lead, the less likely it will be to score into the surface of the paper. Harder pencils come into their own for more confident, deliberate, and long-lasting pencil strokes.

Flat pencil shading does not sit at all well with watercolor. Shading will sully the whiteness of the paper, thus diminishing the purity of the color washes to follow. Line textures and shading—such as hatching, cross-hatching, slashes, or dots—will provide a multitude of exciting possibilities that are an excellent foil to the pure simplicity of the watercolor.

For those beginning in watercolor, I always recommend pencil line and wash. The pencil drawing gives all the structure and detail you require and the color can be kept at a simple level, both in the mixing and layering. Once your confidence grows, you soon discover that pencil line and wash holds a world of possibilities.

Through the technique of line and wash we have one of the most direct routes from drawing into painting. One that leads on to many an exciting journey.

Project 1 Workshop
Line and Wash (pencil)

Sketch each flower as a "cocoon" of gentle pencil lines (0.5 mm, 2B automatic pencil).

Clean up with kneadable putty rubber before adding masking fluid to highlight areas.

POPPIES—wet surface with Hake brush before applying soft color. No need to be constrained by linework.

Start with background so that when flowers are painted it pushes away the first color.

When dry, remove mask with putty rubber and apply highlights wet-on-wet.

Final "descriptive" linework, while darker than the color, is kept simple (no hatching).

CACTUS—painted wet-on-dry. After first wash, color becomes easier and smoother to apply.

Stronger washes take stronger linework (2 mm, 2B clutch pencil). Vary direction and pressure of pencil strokes.

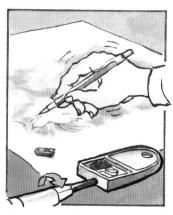

Draw edges first. Only place line shading where essential for contrast. Excess pencil work will dull color!

IRISES—yellow-greens and blue-greens [A] of background are given definition at edges by overpainting purple [B] wet-on-dry.

White has both sunlight [A] [yo+yg+water] and shadow [B] [yg+rp+bp+water] as well as pure white highlights [C] (masked paper).

Keep point of 2 mm clutch pencil well sharpened to allow scope for fluid expression as linework is applied.

EXERCISE I

Watercolors don't come much more gentle and transparent than this. Apply the pencil line with discretion—just enough to suggest the fragile petals and stems. Notice how the color does not necessarily follow the line. Instead, it softly haloes the linework, suggesting solidity and providing only a whisper of detail. This technique suits the fragility of the subject well and the subtle volume of its color.

PENCIL INSPIRATIONS

Three differing approaches to pencil line and wash, which suggest the beauty of the medium. They provide an excellent starting point for those new to watercolor while, at the same time, a range of exciting possibilities for even the most experienced artist.

EXERCISE 2

The cactus plant is more robust, with an incredibly intense colored flower and so the technique employed can be more vigorous. Wet-on-dry watercolor tends to provide washes with more density. The linework can echo this strength. Note, however, how the linework is kept to the silhouette on the flower itself. Pencil here could reduce the intensity and clarity of the washes and thus diminish the impact the color requires to record fully the bright flower head.

EXERCISE 3

Combining the techniques produces a range of contrasts within the color and line that is strong enough to render the white of the flowers. Linework starts to become more fluid and rhythmic. The illustrative quality of the line and wash begins to dissipate as a more sensuous approach is taken. The flowing elements within petal and leaf are utilized as the sinuous line begins to writhe about the subject. Once you have reached this point you may feel yourself ready to see how far this technique can take you. For more inspiration look at other artists' work to see how they have used line in their drawing and painting— Beardsley, Blake, Klee, Klimt, Picasso, and Rembrandt to name but a few.

Project 1 Tutorial

Linking drawing to painting

PENCIL LINE AND WASH TUTORIAL

This delightful building is typical of the remote hills in northern Tuscany, Italy—an area that yielded a wealth of reference material both for a collection of paintings on which I was working and step-by-step tutorials for publication in books and magazines. The subject is full of detail and is perfect for practicing the line and wash technique with a pencil and paint sketch.

COMPOSITION

I produced a series of rapid thumbnails in situ to ascertain the format for the composition. As the building was tall, it initially seemed most appropriate to produce a portrait rectangle. The thumbnails soon proved this groundless and a wide landscape format was finally decided upon.

Thumbnail 1	Thumbnail 2	Thumbnail 3	Thumbnail 4	Thumbnail 5

 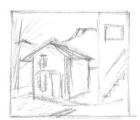

Portrait format—too much sky.

Square format—reasonable proportions but cuts through right-hand window with shutters.

A little more width—landscape format—allows more of shuttered window.

Building shrunk and moved to the right—too much sky again.

Just right—window and steps fully visible, small amount of sky, building large.

STEP 1—STARTING OFF

Transfer the outline masses from your chosen thumbnail to stretched watercolor paper using a 2B pencil. The drawing should be as loose and scribbly as you can manage, to prevent the pencil from being applied too heavily. This allows corrections to be made easily. It also stops you from falling into the trap of rendering perspective drawings in a technical manner. Should this occur, tightening up of style would inevitably result in a rigid and static interpretation of the subject. Drawing buildings should be fun, after all.

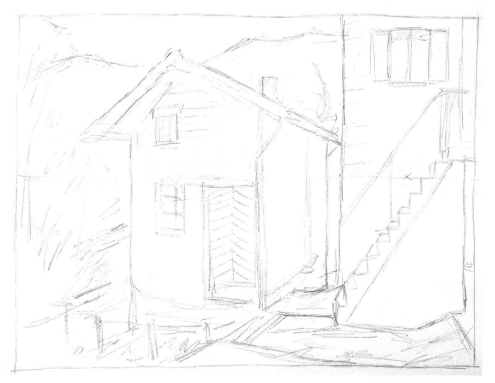

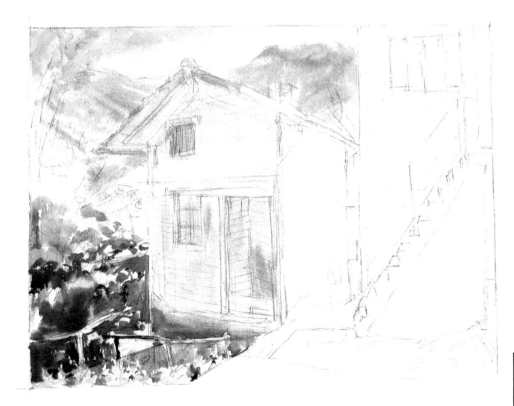

STEP 2—FIRST LAYER WASH

Starting from the sky at the top, swiftly apply gentle highlight colors with a large round brush. Don't get fussy at this stage, which should be viewed as a filling-in of color. You are not aiming for texture or strong contrast. Note how, around the trees to the left, bits of white paper are left unpainted. These will become the sparkling highlights on the leaves at a later stage. Try to use just one size of brush at this point. Changing brushes takes time and you need to be swift here. Exploit all the potential of the one brush by using its side for fast coverage and the point for detail.

MATERIALS
Cartridge Paper for Thumbnails
Smooth Watercolor Paper
Pencils
automatic 0.5 mm, 2B
clutch 2 mm, 2B
sketching 4B
Large Round Watercolor Brush
Watercolor Paints
Salt

STEP 3—ADDING SELECTIVE TEXTURE

The painting on the right-hand side begins with the drawing board laid level on the table. After applying the colors on the wall, table salt is sprinkled on, while the paint is still wet. The textures you see develop naturally. At this point you must be patient—give the textures time to appear fully. When the surface is completely dry, any excess salt should be brushed away and the painting of the window, doors, etc. continued in an upright position.

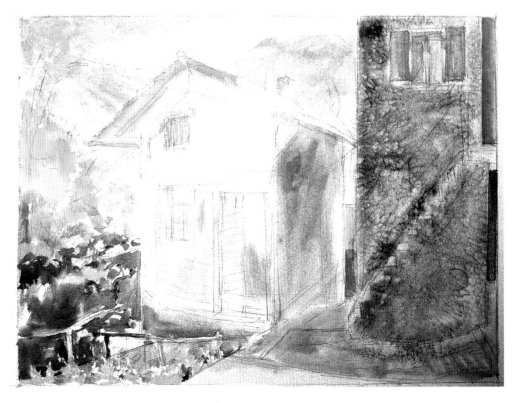

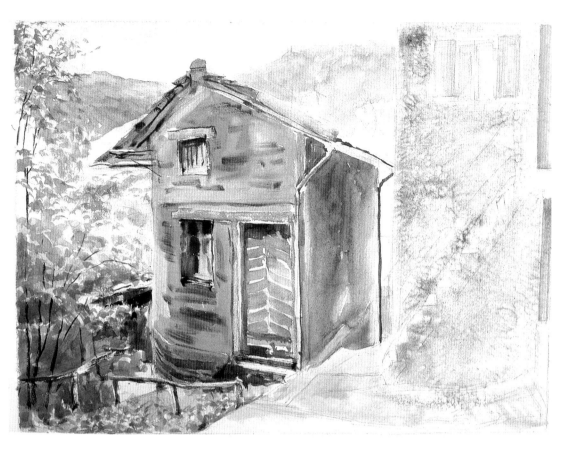

STEP 4—SECOND LAYER OF PAINT

The strength of the second layer of paint is controlled by the visibility of the pencil line underneath. In this instance the linework is completed with a very soft dense pencil to produce a stronger line than that used to this point. Aim for a strength of color that will allow the first pencil line to be just visible—this ensures that the pencil line to come will have transparent color to work against. Keep brush strokes as speedy and fluid as possible. Some thicker paint is worked into the large areas of wash, while the latter is still wet (building).

TIP

Work from the top left to bottom right to avoid smearing the paint with the heel of the hand as work progresses.

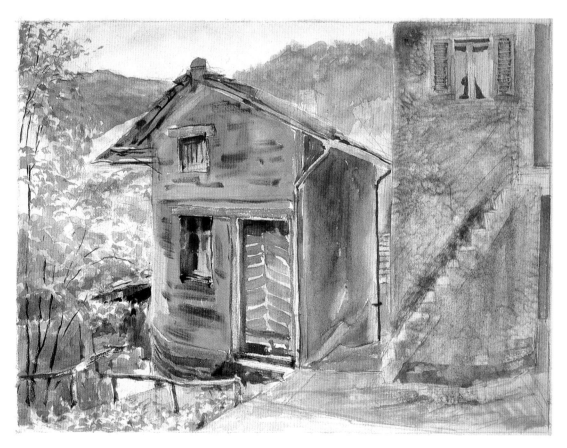

STEP 5— ENHANCING FEATURES

In order to preserve the maximum amount of salt texture, keep work to a minimum on the right-hand side. The edge of the wall is gently enhanced with some counterchange (creating dark against light and light against dark). Lighten the top of the steps by painting some contrast on the wall between them. Now scuff a gentle texture across the bottom of the wall and the broken concrete ground beneath. Leave the right-hand side looking unfinished to bring out the railings with the pencil line.

STEP 6—STRENGTHENING LINE AND COLOR

Using a 4B sketching pencil lay in the first batch of line work. Do not overwork the line to ensure the watercolor remains clean. Keep the line work to the outside edge or silhouette of objects. Do not be tempted to shade, but move over the painting rapidly, varying the pressure on the pencil to add to the "descriptive" quality of the line. Completing this stage made me aware of three areas in need of stronger color. These were washed in as shadow under the house and over the two doors glimpsed to the right hand side of the painting.

STEP 7—FINISHING OFF

Complete the study by adding line shading with the sketching pencil, which is soft and dark, and so very sensitive to changes of pressure during application. It is important regularly to stand back from the piece to prevent overworking. Line shading is completed using only the point of the pencil to avoid solid shading. The hatching and cross-hatching of the lines and textures thus provide all the required tones. As the point became blunt I used it in areas requiring softer qualities (notice the differing sharpness of the line on the wall to the right). The textures applied were influenced not only by the reference material, but also by the nature of the watercolor already applied.

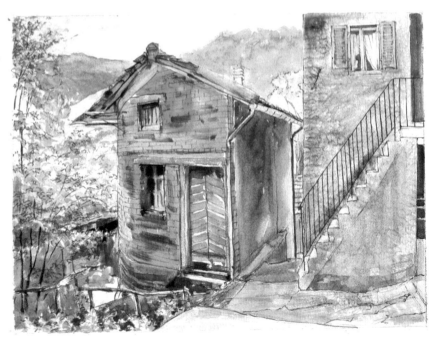

Project I Tutorial

Linking drawing to painting

COLOR
REFERENCES
Yellow-orange [Yo]
Yellow-green [Yg]
Red-orange [Ro]
Red-purple [Rp]
Blue-purple [Bp]
Blue-green [Bg]

INK LINE AND WASH TUTORIAL

A long list of possible subjects resulted from a detailed tour of Shakespeare Country, particularly Henley-in-Arden. This view was selected to demonstrate that a line and wash painting could feature a loose and flowing composition. A soft, muted mix of colors was chosen to evoke those inherent in the warm stone from which some of the earliest buildings are constructed.

STEP I—COMPOSITION

Keep pencil line of transferred drawing very soft. The perspective of the angles of the stones of the monument are very powerful and could easily distract the eye—I elected, therefore, to concentrate on the rhythms of the flowers instead. You can lessen the worries in drawing a building by disassociating yourself from it. Try looking at it as a series of shapes and texture. Don't worry about "scribbling" away at this stage, as you will be applying an ink line over this and any overworking can be erased later.

STEP 2—INK LINEWORK

Selectively overdraw with ink—try to ignore detail and concentrate on silhouettes. I had anticipated producing a vignette study, but the wealth of detail caused my pen to work right to the edges of the composition! As with the monument, I underplayed the angles in the building, again to stop the eye from being drawn to the left. This resulted in the buildings being slightly flattened but, I feel, justifiably so. Now erase the pencil work and apply masking fluid where highlights and the flowers are going to appear. Even though the day was peppered with showers, I felt the monument could be more simply seen in sunlight against the cool shadow of the buildings behind. Masking fluid was, therefore, applied to protect areas of sunlight in the foreground and on the roof of the buildings behind.

STEP 3—INK SHADING

Apply the first layer of ink shading Wet on Wet, having first laid a layer of water with the Hake. As usually happens when completing this action outdoors, it began to rain. Some interesting effects occurred as the droplets mixed with my washes! As the surface begins to dry, apply some denser, sharp-edged areas to some timbers, stonework, and sections of the foliage. Allow the painting to dry and then remove the masking fluid.

MATERIALS
Not-Watercolor Paper
140 lbs.
Automatic Pencil
0.5 mm, 2B
Brushes
watercolor round No. 12
nylon Rigger No. 3
Hake 44 mm
Masking Fluid
Basic Set of 6 Watercolor
Paints
Kneadable Putty Rubber
Waterproof Drawing Ink
burnt orange

STEP 4—FIRST LAYER WASH

The drawing ink applied to this point is waterproof and so the ensuing watercolor is modified by it—although, of course, it cannot mix with it. This is very advantageous. Lay gentle washes of yellow-orange over the areas across which sunlight could fall. On the other hand, the buildings, in shadow, are given an equally light wash of blue-purple. Immediately, through these washes not only does sunlight appear, but also a sense of depth, through the contrast of these warm and cool areas.

STEP 5—ADDING SELECTIVE TEXTURE AND COLOR

Scumble warm textures across some of the roof and brick areas of the buildings, and the first indication of cool (blue) shadow in the windows and on some timbers. The green of the foliage is a real complementary accent to all of the preceding warm colors, but is itself modified by the purples that underlay some areas. Here I tested a little of the bright yellow to see how this color would fare against the color balance already achieved, and I was happy as it stood out well without dominating.

STEP 6—ADDING SELECTIVE TEXTURE AND COLOR

The yellow flowers were added with gusto, on occasion even putting two different yellows on the same brush, in the old Chinese tradition. The rhythms of these flower masses are very important as they flow across the underplayed stonework of the monument. Scumble some reds over the brickwork to add a little richness to these areas.

STEP 7—FINISHING TOUCHES

Using the ink, add a little linework around the monument and the stones in the foreground, the central doorway and the windows. Delineate the panes of these windows with a deeper blue. This final wash on the central house creates the central focus I had planned at the beginning of the piece. A gentle green wash solidifies the tree at the far left—providing a gentle complementary contrast to the reds of the painting and thus enhancing their color.

Tricks of the Trade

Masking fluid

Masking fluid (a rubber latex solution) is used temporarily to protect and mask-off areas of virgin paper, or layers of paint, from subsequently applied layers of paint. It is one of the most maligned tools at the artist's disposal. Here I dispel the myths that result in many painters being warned off using it at all.

• Using masking fluid is cheating.

I don't subscribe to the term "cheating" for I feel that the results justify the means. Even if there were such a thing as cheating, this would suggest the wrongful use of a material or an unpleasant, nonartistic result. Far from this, masking fluid is designed for the purpose; it does the job well and achieves results that could not be obtained in any other way. Most importantly, it is rubbed off at the end of the day and has no adverse effect on the transparency of the medium.

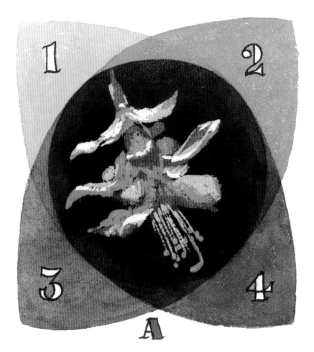

• Using masking fluid destroys brushes.

This view suggests that if you are ever silly enough to use masking fluid, you should only do so in conjunction with an old, worn brush you care nothing about. To begin with, brushes can be cared for during use so that masking fluid will not damage them. Second, masking fluid creates marks, even when scuffed on, which have hard edges. Hard edges mean focus and if you are going to create sharp focus or details with your worst brush you are heading for trouble. I use my finest sables but take great care to keep them free of drying latex.

Think of masking fluid as one of your paints—a transparent "paint" to be used in situations where you need a white highlight, a clean unmixed color, or mixtures where a white would predominate. In watercolor or thin acrylic used like watercolor, I wouldn't normally use white paint; choosing masking fluid instead to protect my surface paper, which forms a natural white.

• Use masking fluid to protect areas of paper or light washes from subsequent washes.

In [A] four colored washes are laid over one another (layering). In each case the dry surface is first given a layer of masking fluid so that as the work progresses, it protects each new layer of color—layers 1 to 4. When the final work is dry, the mask is removed exposing all layers previously protected, yielding fresh clean colors at each layer. The "white" highlights are not white paint, but the white of the paper, which was protected in the first place. This exercise also shows quite clearly the method of working from light to dark which is synonymous with watercolor painting.

• The edges of a masked area are always sharp.

Even with a scuff [B], the edges are sharp, but both sets of edges can be softened by lift-off [C]. Once the mask is removed the exposed paper is untouched and can be painted in the usual manner, either wet-on-dry [D] or wet-on-wet [E].

TIP 1

Wash painted onto masking fluid can take extra time to dry and can collect on the surface in droplets [F]. Be sure these are fully dry before attempting to remove the mask or you will smear the color.

PROTECTING BRUSHES WHEN USING MASKING FLUID

To stop masking fluid from drying on a brush while painting, before use, work up a lather on a bar of soap and work this gently into the base of the brush head with your fingernails. Wipe away excess soap on clean tissue and use the brush as normally. The idea is to leave soap inside the brush. This will slow down the drying of the masking fluid in the brush.

You'll be able to tell if drying begins because the brush starts to drag on the surface, a color change occurs in the fluid and the brush eventually sticks. Make sure you stop before this happens!

Clean your brush thoroughly in water, pushing it against the side of the jar to remove the masking fluid. More soap helps removal. If the mask has dried in the brush, don't pull at it or the brush hairs. Wash it in a thinner—such as turpentine—then with soap and water.

TIP 2

If the paper is weak (little external size), or if the mask is lifted too aggressively by pulling [G], the surface of the paper may damage. Instead, rub off masking fluid gently with a putty rubber.

Masking fluid is a wonderful addition to your painting equipment. Look at [H]. Here you see the contrast achieved when masking fluid has been carefully and thoughtfully applied as a means of producing sharp edged details, such as the leaves, as a foil against the soft qualities of wet-on-wet painting.

Add a few drops of waterproof ink to your masking fluid so that you can see it more easily against the white paper.

Don't add watercolor to the fluid or let it near your palette, as on mixing, both will solidify immediately.

Instead, use a separate palette with several wells. You should never refill over already dry, or drying, masking fluid.

Common Problems

Working out of doors

QUERY
"Do I need an easel for working outdoors?"

ANSWER
For your own comfort an easel is an essential piece of equipment. Without one you will have to balance your work on your knees, a chair, a rock, or another make do support. Without one, you will be preoccupied with steadying the surface you're working on. You could also feel discomfort in your neck and back from working at the wrong angle, as you will of course be predominantly bending over. With an easel your work can be at eye level, so that all you have to do is glance from surface to subject—no headache, neckache, or backache! Additionally, most easels, when taken down, act as the carrier for your wet painting—another problem solved.

TIP 1—When buying your easel, check in the store that it is fully stable when erected. Give the central portion, which holds the drawing board, a good shake to see if it or the legs rattle or involuntarily fold up. Better for this to happen before you leave the store, than in a wind with your painting on it!

TIP 2—Always carry a length of nylon rope with a stake attached to either end (preferably metal). Wrapped around the central portion of your easel and then drive each end into the ground on either side, this will save much heartache in blustery conditions. If the ground is too hard for the stakes to be driven in, then wrap the rope around rocks or your bags.

PROBLEM
"When I use watercolors in a sunny climate, it is very difficult to keep the paper surface wet and workable in the heat."

SOLUTION
It is often difficult in hot climates to use techniques such as Wet on Wet because of the fast drying condition. There are a number of precautions you can take. Position your paint in the shade and well out of the heat and, more particularly, out of the way of warm breezes. Ensure that when wetting the paper you do so rather generously. Wet several times if necessary so that the paper fibers can absorb the water, not simply relying on that which lies on the surface. Help is at hand with a new blending medium that is used to "slow the drying rate of watercolors." This can be added either to the water supply or to the paint mix. For the latter, fill one of the wells in your palette with the medium, or have a small jar or wide rimmed pot nearby, filled ready for use. It is even possible to paint the medium directly onto the paper's surface before you begin the painting. A flat wash brush or Hake will do this swiftly and effectively. The amount of medium added will directly affect the drying rate of the mix. Once the surface has dried it reacts normally to overpainting or lifting-off and you can add more medium to subsequent layers.

PROBLEM

"I am always dropping my brushes and pencils when I paint out of doors and having to constantly keep an eye on them disrupts my concentration when painting."

SOLUTION

It is always best to keep the number of brushes you use to a minimum when working outdoors. These can be held in the grip of a flat palette [A], although this can also prove to be an irritation over a long working period. Both pencils and brushes can be held quite firmly and close at hand in pocket clips [B]. While these are actually designed to hold a pencil stable in a pocket [C], they work equally well clipped over the inner partition of a box easel [D] or to the edge of a thin drawing board [E]. Other ideas—use a thin ¼ in. (6 mm) piece of plywood as a light, easily carried drawing board (sand the edges well). Two large elastic bands will hold the paper in place. Use a third band [F] between which brushes or pencils can be held. Drawing board clips can also hold brushes and pencils [G] as can bulldog clips [H].

TIP

Many painters will know the feeling of having left the important thing behind—we have all done it at some point or another! A checklist is the only solution. Do include nonart essentials to make life comfortable. Items such as sun block, insect repellent, sun hat, umbrella, flask of hot drink, cold drinks to ensure you don't dehydrate, and moist wipes for cleaning yourself off occasionally.

Project 2

Wet on Dry—painting sketches and studies

Running a wet brush across a dry piece of paper creates the simplest of watercolor strokes. The dry edge along each stroke is affected by the amount of paint deposited and the type of surface on which it is laid. It is so easy for the eye to read these qualities and thus interpret the nature of the artist's reaction to both what he sees and the way in which the materials are performing. This sharp edge, and the degree of focus it ensures, can be a blessing or a curse. You must be constantly aware of its presence and power, in order to ensure that it is working for you and not against you.

Each of the different brush shapes will produce a unique mark. Every brush can be presented to the surface in a different way. The vocabulary of possibilities is endless and offers every painter a personal combination, which adds character to the work. You can decide to focus on the use of one brush, or several in combination.

One of the most basic techniques to learn is that of losing an edge. Running a damp or wet brush along the edge of a newly laid brush stroke allows that edge to run or soften, providing volume and/or movement to the static mark.

Deep, pooled strokes dry quite differently from thin, dry ones. Very dry strokes begin to break up or scumble as they are dragged across the surface of the watercolor paper, providing texture.

Still-wet strokes can be painted into with other or deeper colors. This is a version of Wet on Wet, but one that is controlled by the sharp edges of the first stroke.

The resulting pattern of brush strokes that is natural to the Wet on Dry technique is an important aspect of its beauty. Strokes together can build into rhythms or movements that flow over the surface, taking our eye with them. Being aware of this movement allows you to exploit it as an exciting element in your painting repertoire.

The Wet on Dry technique is suitable for any subject and for either a fast sketch or a more finished piece over which you would like to spend more time and effort.

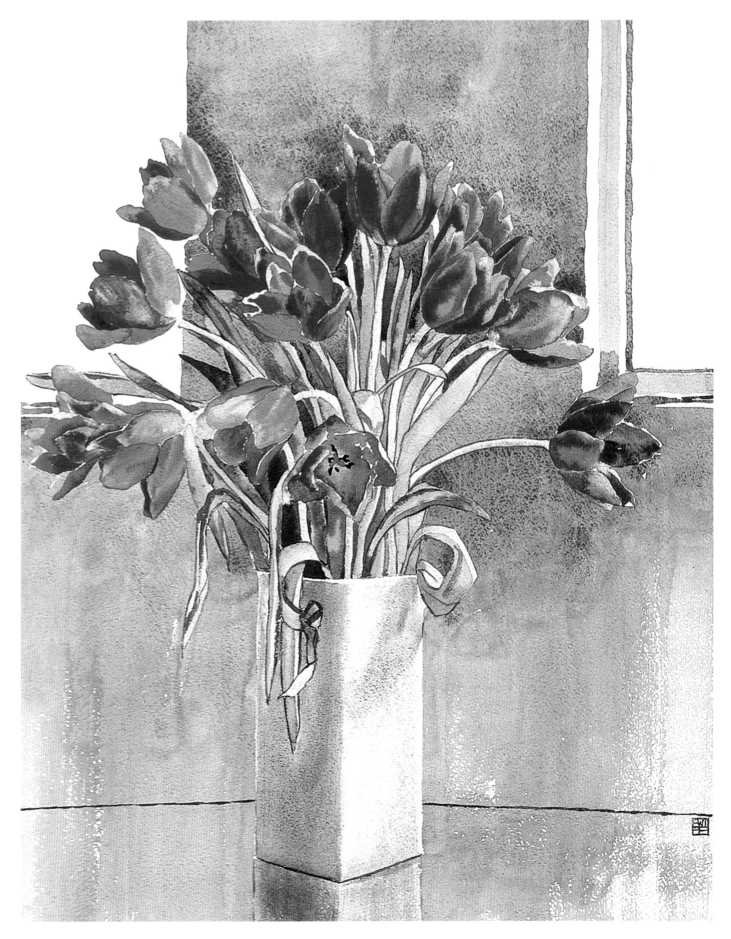

Project 2 Workshop

Wet on Dry—painting sketch

Keep pencil structure gentle so cleaning off later is easier.

Practice long strokes, lifting toward the end for graduated thickness.

The direction in which the brush is pulled helps develop this stroke.

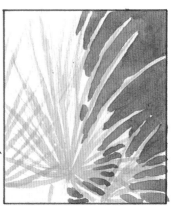

Counterchange is used for variety. See how the leaf can be dark or light, depending on background.

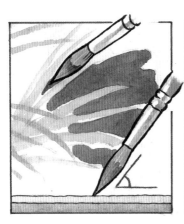

Use tip of brush to place color between leaves . . .

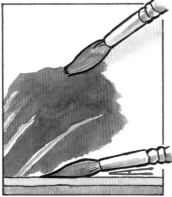

. . . but flatten on its side for bolder coverage.

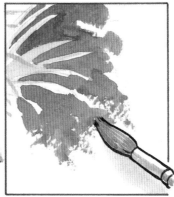

As the brush runs out of paint it begins to drag (scumbling), which breaks the edge.

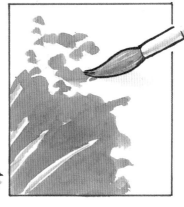

Dabbed strokes also break a solid edge.

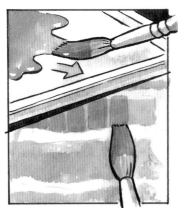

Flatten brush across the palette (top) for square ended strokes (bottom).

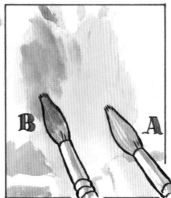

Block in yellow sunlight [A], followed immediately by stiffer, wet-in-wet strokes [B].

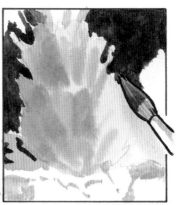

When dry, mass is reshaped by painting background.

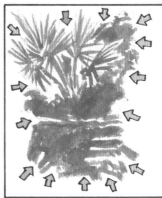

Finished piece has very irregular silhouette. This draws the eye.

MATERIALS
Watercolor Pad
Automatic Pencil 0.5 mm, 2B
Watercolor Paints
Round Watercolor Brush

Wet-on-dry is ideal for sketching when out and about, and for recording references to build up for future paintings back in the studio. This watercolor reference sketch was one of many produced on a trip to Andalucia in Spain. The secret of these sketches is spontaneity, so keep them loose by not laboring the execution and the result will be fresh and vibrant.

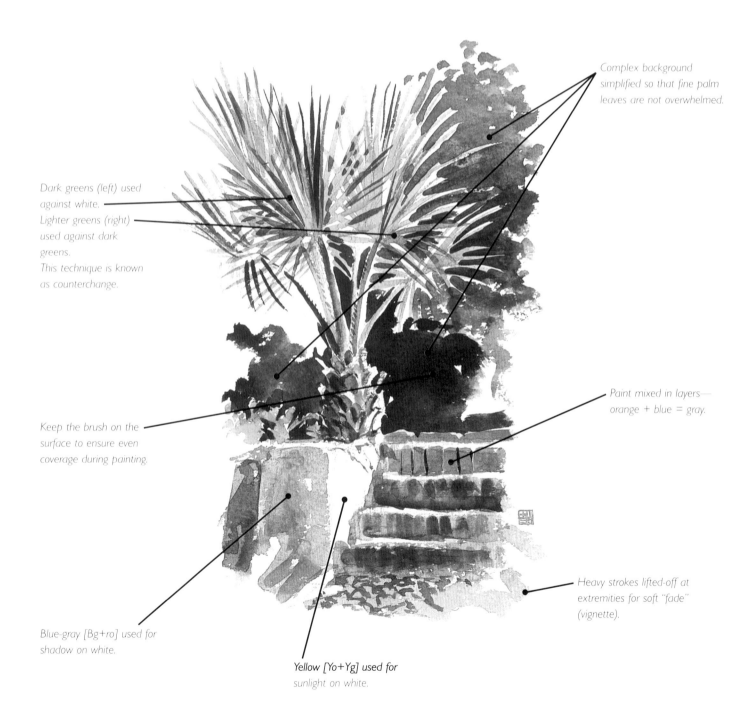

Complex background simplified so that fine palm leaves are not overwhelmed.

Dark greens (left) used against white.
Lighter greens (right) used against dark greens.
This technique is known as counterchange.

Keep the brush on the surface to ensure even coverage during painting.

Paint mixed in layers— orange + blue = gray.

Blue-gray [Bg+ro] used for shadow on white.

Yellow [Yo+Yg] used for sunlight on white.

Heavy strokes lifted-off at extremities for soft "fade" (vignette).

Project 2 Tutorial

Wet on Dry—painting study

COLOR REFERENCES
Yellow-orange [Yo]
Yellow-green [Yg]
Red-orange [Ro]
Red-purple [Rp]
Blue-purple [Bp]
Blue-green [Bg]

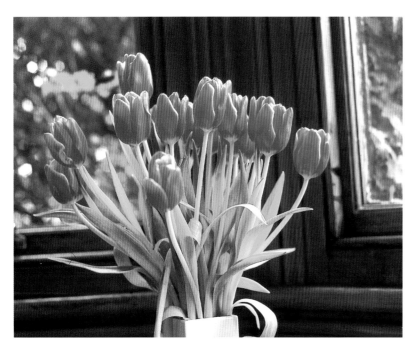

When choosing a mercurial still-life such as these robust, but equally delicate, blooms, it is essential to set aside the time required to complete the work. Tulips have a relatively short shelf life and their characteristics change almost hourly. While the flowers intended for display around the house may last for a week, their suitability as a subject may only last for a day or if you are lucky, two.

You need to decide whether to paint them with their heads closed or open. In this instance the heads were tightly closed and it would have been difficult to predict just when they would start to open and for how long they would stay fresh for painting. Tulips also have a tendency to move quite considerably in the vase. Would the stems stay upright, or would they droop, and for that matter which ones would do what? I applied a little horticultural trick for getting blooms to open on the cut stem, by putting the tulips into a vase of warm water. Within 20 minutes the heads started to open and by the time my equipment had been set up, materials gathered, and sketchbook at the ready they were fully open.

COMPOSITION

The curve of a drooping tulip stem always breaks up any possible symmetry and I was delighted that several stems obligingly flopped over. Perfect symmetry in a painting tends to make it appear static, so any leanings toward an asymmetrical composition should be grasped and in some cases exaggerated. In this painting you will notice the vase is not in the exact center of the page and its faces are arranged so that they are not equal in area. Two distinct arcs can be traced through the positions of the flower heads—one in the top right, the other in the bottom left. The negative spaces between these heads then provide all the irregularities that are needed to engage the eye. Finally, the window spaces are sized differently and carefully observed to note differences in the shape of the light areas, describing their perimeters.

SETTING UP

My wish to exploit the possibilities of deep pools of Wet on Dry watercolors by necessity demanded that I worked flat on this occasion. It took some time to position, as I wanted the backdrop of the window seat, yet didn't want to paint the still-life from above. This meant getting down on the floor— not the most comfortable of positions, but on this occasion "needs must"—in order for my eye to be level with the vase. It was also necessary to be on top of the paper, to avoid visual distortions in the proportions, which might have occurred had I worked from one end. These reference photographs were my back up if the flowers gave up the ghost.

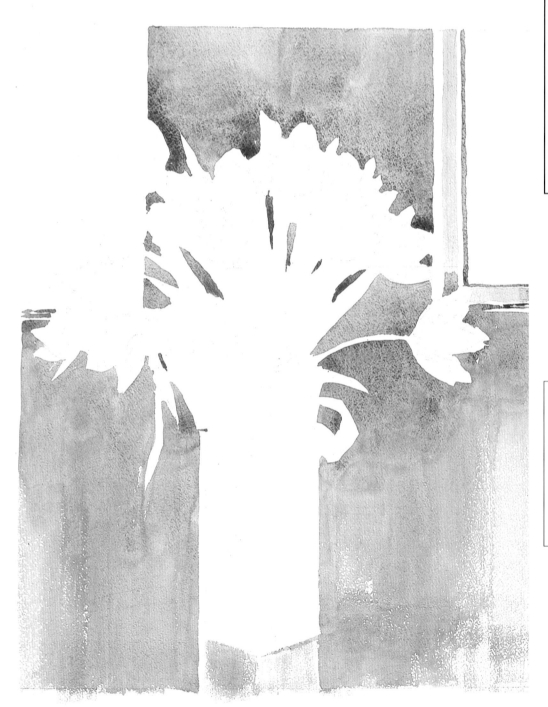

COLOR MIXING
Where the prefix letter is shown
in capitals it denotes a larger
quantity of that particular color.
Conversely, where the prefix letter
is shown in a lower case, this
denotes a smaller quantity of that
particular color.
e.g.
Bp= large amount of blue-purple.
bp = small amount of blue-purple.

STAGE I

Wet-on-dry watercolor creates sharp, focused edges. Your approach to the work must, therefore, be fresh and fast to exploit these qualities.

• Lightly sketch-in composition.
• Begin painting with a No. 12 round brush, identifying the flower heads that catch sunlight—yellow in the sun [Yo+Yg], cool in shadow [Bp].
• Mix a good quantity of the background color [Ro+Yo+bp]. It is crucial you don't run out half way through its application. This color is mixed thinly and applied in really deep pools, particularly around the flower heads, using a No. 12 brush whose point comes in useful to work into tight corners.

Here the paint separated into its constituent colors (granulation) due to the deep layer taking time to dry. The color from these pools is then "pulled" away, using a 50 mm Hake, loaded with the same color, to achieve the thinner, even layer, of color. As the Hake is pulled further toward the edges of the painting, it is allowed to run out of color, effectively scuffing the surface to yield the scumbles (bottom left and right). Note the downward stroke of the scumbles, here descending vertically into the reflective surface beneath the vase. This technique is used more powerfully on the reflection beneath the vase. Also note the background color above the flower heads. This contains just a little more blue, creating a more impressive contrast for the flower heads catching light along their top edge.

STAGE 2

Having started on only two flower heads, daylight ran out and the painting had to be left. Imagine my frustration the next morning when I returned to find the tulips had indeed been "dancing" during the night and were now standing bolt upright, with their heads closed! My own advice not taken the day before, I now quickly snapped a reference photograph and found that no amount of warm water would coax them back to their previous "pose." Far from being a disaster, this proved providential for it prevented me from slavishly copying the still-life in front of me and I was forced then to analyse and adapt its individual components to the composition defined thus far. I had already embarked on a stylized rendering of the flowers in which simplification was essential to enable the colors to remain intense and this further allowed me to concentrate on the inspiring qualities of brush marks and paint.

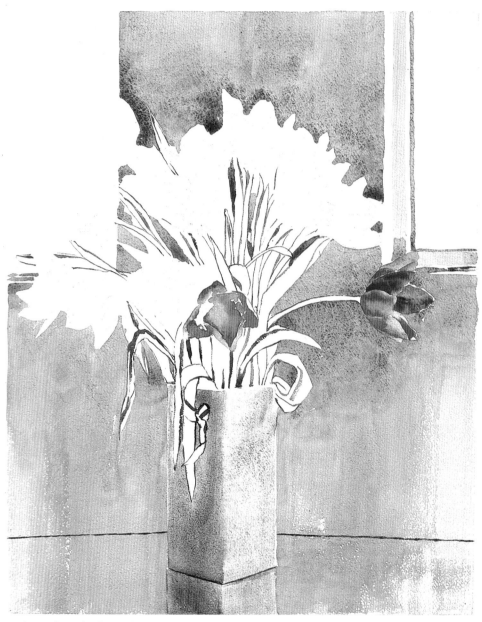

- *Now turn to the stems, leaves, and vase. The greenery needs more drawing, to take subsequent broad bold washes of color. Rather than strengthening the pencil in situations such as this, where the lead would dirty the purity of the white surface, it is best to draw in paint. With the point of the No. 10 brush, using medium green [Bg+Yg+rp] apply linework— differing pressures on the brush point give a marvelously descriptive line, from fine lines to accents, or small shapes between leaf and stem. The incredible morass of detail must be simplified to rhythmic and flowing marks that express the explosive movement from the vase up to the tulip heads.*

- *The vase, too, needs simplification so that it does not detract from the flowers. Its gray-purple [Bp+Rp+Yo] is tonally closer to the background than the actual subject. In this way, even though a different color, it does not have the contrast that would otherwise draw the eye. Painted restricted wet-on-wet—pre-wet its center with a Hake, leaving the outer edges dry so the brushstrokes at the edges are still sharp (wet-on-dry)—with the central brushstrokes being soft and gentle. Add yellow-orange [Yo] to the color to create soft shadow (top right) and then more Ultramarine [Bp] to the left hand side. Again the washes here are deep to encourage granulation, which adds body to an otherwise featureless area. Orange [Yo+Ro] is added to the mix to render the reflection. This dulls the color to match the surrounding orange, giving a soft balance between two otherwise complementary colors.*

- *For the line which defines the back of the window seat from the uprights of the background—and that which defines the base of the vase from its reflection—prepare a slightly stiffer mix [Ro+Yo+bp] with the No. 12 brush and pull brush across the palette surface to flatten the brush head into an "edge" and "dab" lines in place.*

THUS THE BACKGROUND AND THE VASE ARE REDUCED (ABSTRACTED) TO THEIR SIMPLEST.

> **TIP**
>
> Deep pools of watercolor, left flat to dry, possess an interesting quality once dried. If you were to magnify the dry perimeter edge, you would find that pigment has collected here, creating a wall or line of stronger color. Thus each pool becomes outlined with its own color. This increases the sharpness of the edge and a jewel-like quality is evoked in the final dried color pool.

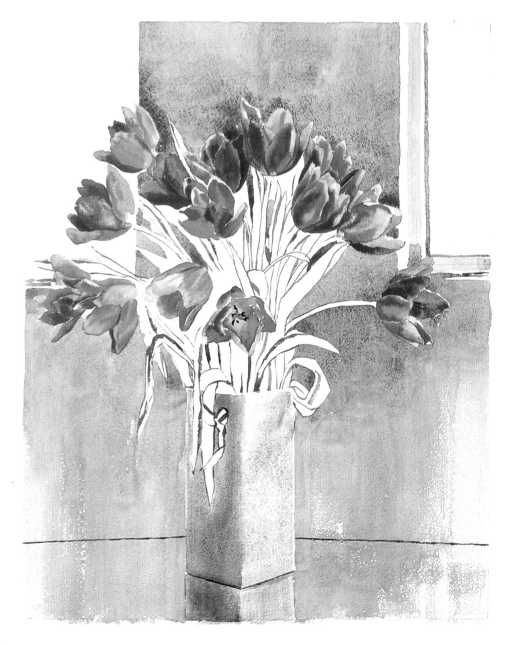

STAGE 3

Much to my frustration, the tulips were still standing erect at this point where I needed to get to work on their heads!

- *The deep pools of color to be laid on each petal take some time to dry. You must either move from flower head to flower head painting the petals separately or leave a fine dry line between them. Such a line need not be a problem as often it suggests a fine highlight and provides "sparkle" to the finished painting. If you are using a color on one petal, it can be used on a second if appropriate, but patience and perseverance is the byword. I hold several brushes at any one go, with different colors on each. My palette held several premixed washes into which I could dip or mix. These included a thick mix of crimson red [Rp], thin orange [Ro+Yo], thick red [Ro], and thick to thin yellow [Yo+Yg]. A typical petal might start with an overall coverage of thin orange. While still wet, crimson or red could be applied in one or two simple strokes, perhaps along a dry edge, creating a shadow. Into this, while still wet, could be dropped*

thick or thin yellows. The final yellow, at a highlight edge, often does not possess enough contrast and so this might be dabbed off with a tissue. Don't literally paint the flower, instead paint shapes and colors, and the flowers will look after themselves. Use different parts of your brush head, from the point to the side, to apply the strokes and make sure these vary in their direction to describe the form of each petal.

- *With the color mixes do note that there are no complementary colors used to darken colors. This is quite a change, because complementaries are nearly always used to dull or darken colors. Here, however, the effect of the reduction of intensity would be inappropriate. If you look into the dark depths of a flower you will see that intensity never wavers—the richness is stunning. To render fully the beauty of a petal you must retain the color saturation. Our aim is to render the lights and darks simply by varying the amount of water or pigment in the mix. Sometimes, minute amounts of blue are acceptable in shadows, but even here the amount must be carefully restrained.*

STAGE 4

- *It had been my original intention to capture something of the color and texture seen through the windows. However, at this point in the painting I decided to leave them in their simplified form. Texture in the window would have detracted from the flower and at the very least, made the top half of the painting over heavy. The white of the paper was beginning to work here as a color. Blank out with your fingers the two white areas in the painting and you will see how it loses its punch—the tonal values are in danger of becoming too close.*

- *In any technique which involves only one layer of paint, you must take into consideration the resistance of the paper to take the color. This is caused by surface (external) size and is responsible for the exciting scumbling, visible at the bottom right of the painting. This is often referred to as "pig skinning" when this effect is not such a happy accident—it is especially unacceptable in the smooth colors required on flower, leaf, and stem. Papers differ, according to the content of size in them. All that is required to correct this is to apply extra pressure when laying down the first or a single layer of color—something that will become second nature as you get accustomed to the way differing papers react.*

- *Nearly all of the greens of the leaves require some red as part of their mix. Generally the greens toward the top right are yellow-green, as they are struck by the same yellow light that hits the flower heads in this region. As the greens move into the shadow, bottom left, they move toward blue green, with the addition of more red to dull them down.*

Again, my palette was spread with premixed washes, into which I could dip or mix. The deep color washes, will force you to move back and forth across the mass of foliage to avoid colors running between distinct areas.

Beginning with the stems, draw two greens (warm and cool) along their length, mixing together to give a sense of volume. For added highlights, either dab off, or produce by drawing a line of thin wash along the very top edge (resist highlight). The highlight along the top of the vase is achieved simply by not painting on it—leaving white paper between greenery and the blue gray of the vase.

The bottom left hand area of greenery holds the darkest accents of green where they contrast well against the generally light-edged petals. In the top right area, the greens are light, especially against the dark underbellies of the flower heads.

This naturally indicates the amount of light in each area, but also ranks as counterchange, where the maximum contrast in color values at edges is sought.

Observe carefully the top right area of green and how in the final stage more of the background color is introduced to open up the solidity of the green. This earthy mix is carefully modulated from light to dark, depending on whether it runs next to a light or dark green. Once again counterchange achieves "light" through contrast.

Finally, the right hand face of the vase is treated to some lift-off by rewetting and dabbing away the pigment with an absorbent tissue. This tweaking just brings the central edge of the vase a mite closer and suggests extra depth and light.

GO WITH THE FLOW

This is not a botanical illustration where every nuance of detail needs to be recorded. This is just as much about the flow and brilliance of paint, where most areas are completed in one layer. Finishing in one go like this requires a bold approach, where the spontaneous qualities of the drying paint have to be accepted. You must therefore "go with the flow."

CAUTION

When working with an unpredictable still-life such as this, it is always wise to take precautionary measures. Always produce a quick, scribbly sketch for reference. Take a reference photograph to show the structure of the composition and any particular characteristics that may disappear rather more rapidly than you would wish. One of the most unpredictable works I have ever produced was a commission for a grand oil painting of a bunch of Mimosas. I had been warned the flowers could well fall off within a day of opening on the branch. As I had had the flowers flown in from Italy and Holland, I was not about to lose the impact of these ephemeral blooms. Sketches, Polaroid shots, and hastily produced watercolor sketches formed my "rearguard action" safety pack.

Tricks of the Trade

Lift-off and counterchange

LIFT-OFF

One of the greatest misconceptions in watercolor is that once painted, the surface cannot be altered. While this does depend on the absorbency of the paper, in most cases the color can be removed from the surface, either partially or successfully enough to function as highlights [A]. Large areas of lift develop a texture, unique to the technique [B], which brings out the texture of the paper. Taken to its full potential, lift-off can be used as a technique in its own right, for while it does take time to create; it has the **advantage of a great degree of control [C]—** excellent for illustration work.

TECHNIQUE

GENTLE LIFT

Wet the brush and apply it to the painted area to be removed. In the first instance, gently apply the water in simple, bold strokes. Do not rework the surface, but simply press a piece of absorbent tissue against the paint. Lifting off small amounts of paint will result in the lightening of the color value [D].

HEAVY LIFT

Wet the brush and apply to the surface. On this occasion work the brush into the paint until it dissolves. Press on a piece of absorbent tissue and a much greater amount of paint will be removed [E].

WHICH BRUSHES?

The stiffer the brush head, the more friction occurs as it is drawn across the surface of the paint. Thus the speed and degree of lift-off is increased.

Round watercolor brush *Flat nylon brush with short head* *Round bristle brush*

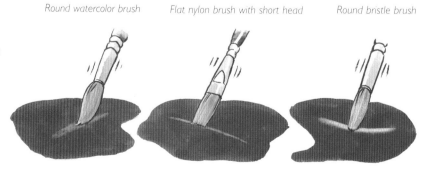

VALUE
Is the degree of lightness or
darkness of a color.

TONE
Is the degree of lightness or
darkness of a neutral gray.

COUNTERCHANGE

There is a much greater range of values in light than there is in pigment. The artist must always strive to manipulate contrasts wherever possible, so that effects of light can be interpreted as powerfully as possible.

The effects of counterchange exist in nature where an object seen as light against one background, will appear dark against another. So strong is this effect that it can even be seen against the silhouettes of a single subject, such as the tree shown here. Exploit this trick of the light whenever you can and look for it in the work of others. You will be surprised how it will enliven your subjects and your enjoyment of them.

Common Problems

Lift-off and losing edges

PAPER FOR THE JOB

Saving money by buying cheaper, less well-sized papers in the first instance usually turns out to be a false economy. Actions required to make up for deficient materials, usually involve the unnecessary purchase of corrective products.

Buy the right paper for the job in the first place and you will not only save money in the long run, but more importantly save yourself from becoming frustrated and disillusioned with your abilities.

PROBLEM

"The edges of my paint strokes are always drying before I can lose them."

SOLUTION

Set aside a separate brush for use in losing edges. Keep it wet and ready for use as you apply the color. Don't cover too large an area with color, before you start the losing process.

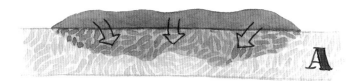

If however, you are following these simple precautions and are still experiencing problems, it may due to the paper on which you are working. Should the paper contain little size, it will be very absorbent and the color will sink into the paper fibers very rapidly [A].

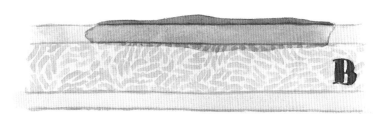

A well-sized paper often has a layer of size on its surface. When an area is softened gently with a clean wet brush this size turns temporarily into a gel. This stays wet longer and it is in this where the color lies [B]—enabling you to get on with losing the edges you require.

TIP—If your paper is very absorbent, the solution could be to brush over a thin layer of size before you start. It is also possible to slow the drying of your paint through the use of blending medium. This is added either to your water supply, or directly to the color mix. Keep a small quantity in one of the wells on your palette to make life easier.

PROBLEM

"I find that the color will simply not lift-off as it should, no matter how hard I scrub."

ANSWER

This is because the paper you are painting on is too absorbent. The color must have been absorbed into the paper fibers and once there, the only way it can be eradicated is to remove the fibers in which it is trapped.

SOLUTION

Several options are available.

Either scratch out the dry color or sand (with fine sand paper). This technique is not only a corrective one, it is a technique in its own right for creating sharp highlights [C]. It does, however, damage the paper and should only be considered right at the end of a painting.

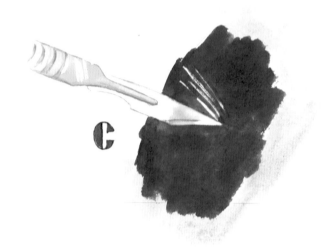

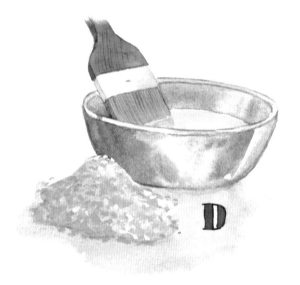

A layer of size can be added to make the paper less absorbent. Take a size used for preparing oil painting surfaces, generally available in granular form. Thin it down into a much more fluid consistency and apply evenly across the entire surface, using a large soft flat brush.

Alternatively, lifting preparation is available in liquid form. Brush on and leave to dry to give you a removable paint surface, making lift-off easier.

Project 3

Wet on Dry—painting structure and detail

While running a brush laden with paint across the surface of dry watercolor paper is the basis of the Wet on Dry technique, many other possibilities are available to the artist through the control of both paint and brush.

The transparent nature of watercolor paint can be fully exploited. By overlaying fluid wet-on-dry paint layers, colors are mixed on the surface of the paper. These strokes are filled with an internal energy as the colors glow through one another.

To achieve volume and form, however, the painter needs to manipulate the edges of these strokes, making them sharp or soft in focus as necessary. To "lose" an edge means to soften the focus of a brush stroke, and to do so either gently or vigorously. The process can be very mechanical or very loose, controlled or adventurous. Even when faults occur, such as color moving in the wrong direction, it is not necessarily a disaster. These could be incorporated into the painting and turned into a positive technique.

It is important to explore the possibilities with this process, to make the most of what the Wet on Dry technique has to offer. It is only by allowing yourself to make mistakes that you can analyze what happened so that you learn from the process and devise new techniques.

A newly learned technique is nothing more than an accident that can be repeated for future positive use. Keep your mind open for it is in this way that you develop skills that build up to form a repertoire of techniques that are unique to yourself.

In this project we start with a workshop that takes one of the most commonly seen elements in any landscape—rocks. With their color, texture, volume, and form, they make ideal subjects for practising the art of losing edges.

The step-by-step tutorial of painting an artichoke deals with losing edges and, in addition, offers the opportunity to experience color mixing through layering colors on the surface of the painting.

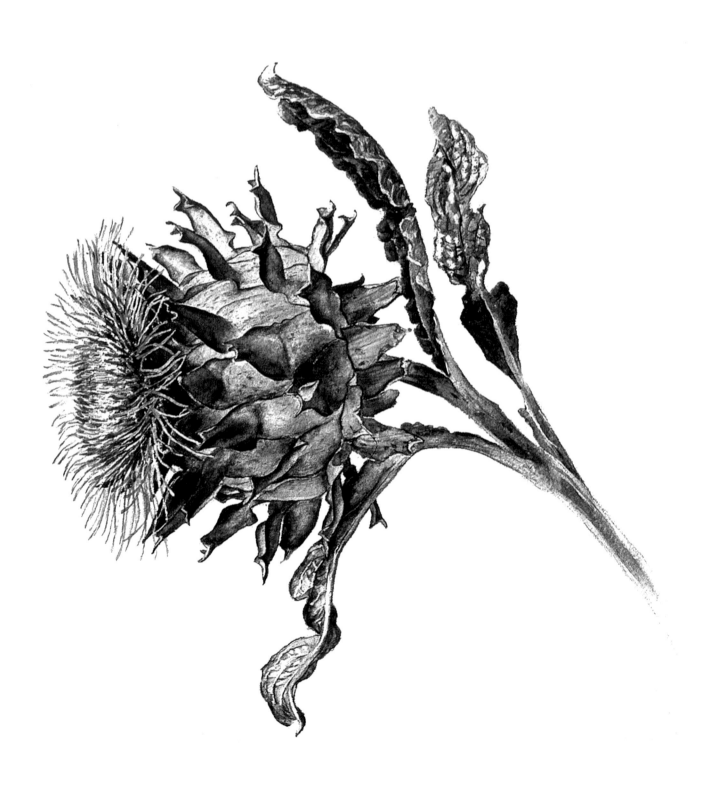

Project 3 Workshop
Wet on Dry—Painting structure

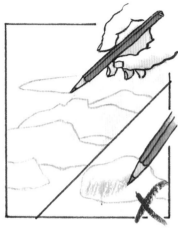

STEP 1 Draw in rock silhouettes gently. Avoid shading, which can look dirty under watercolor.

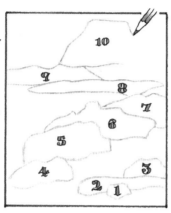

Start drawing from the front and work back—so that shapes overlap naturally.

STEP 2 Mix dull Blue-purple [Bp+ro] with plenty of water to create fluid mix.

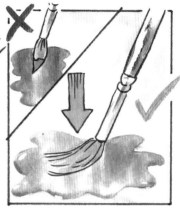

Don't just use top of brush to mix . . .

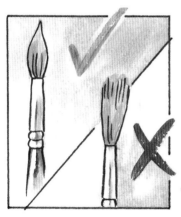

. . . so that body of brush soaks up sufficient fluid to shape and point. This prevents splaying of hairs.

Apply fluid mix along bottom of rocks.

Allow scuffing (scumbling) to occur as the brush begins to run dry.

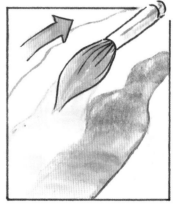

Wet area above wet color, using another, clean, damp brush.

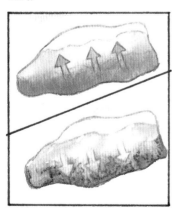

Depending on depth of wet layers, the paint will either spread into the water or vice versa, creating volume and/or texture.

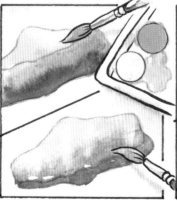

When dry, repeat technique with thin yellow (sunlight) across top of rock. NB Yellow over purple = colored gray (complementary mixing).

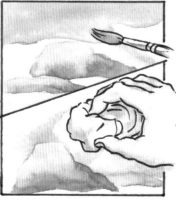

STEP 3 Lay wash of blue across sky and partially wipe off with absorbent tissue.

Lay wash of intense orange for sand, followed by another with added blue (shadow).

MATERIALS
Rough Watercolor Paper
2B Pencil
Watercolor Paints
plus Phthalocyanine blue
2 Round Watercolor Brushes
Flat Nylon Watercolor Brush
Kneadable Putty Rubber

STEP 1

Lightly draw the shapes of rocks onto a piece of student's quality watercolor paper. Many of these cheaper papers are excellent for studies when you are exploring the possibilities of watercolor. The size in watercolor paper makes it stronger and better suited than cartridge paper, enabling it to take the color washes and stay wet longer. Many newcomers to watercolor blame themselves for poor results that are, in fact, due to the use of unsuitable paper. These relatively inexpensive papers are made from cellulose (wood) and will give you a feel for the more expensive cotton papers you will inevitably want to explore if you continue with watercolors.

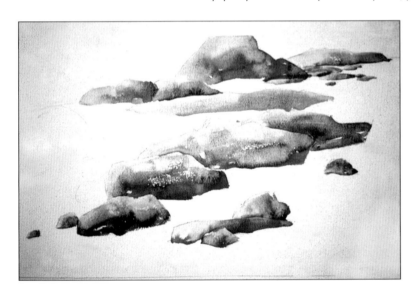

STEP 2

To suggest aerial perspective, lighten the shadow color for the rocks in the distance. Note how this color, mixed from a warm and cool color, tends to separate on drying. This most often occurs in very fluid deep washes, where the colors have the opportunity and the time to split and then dry. This occurrence is known as "granulation" and can be seen as a fault. Many artists, however, including myself, enjoy the effect. Another "mistake" or "technique" depending on your standpoint is occurring at this stage. Water or very fluid washes laid next to drying paints often overrun them, pushing pigment into backruns. Look for the very organic shapes these create (sometimes known as "cauliflowers").

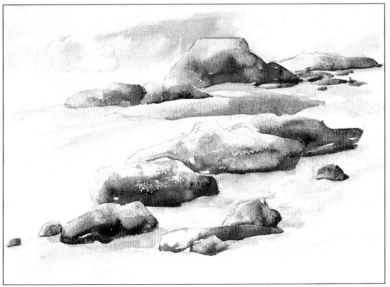

STEP 3

For summer skies I always rely on a special blue called Phthalocyanine Blue. Here it is mixed with a little Ultramarine so that even as a thin transparent wash it suggests some of the intensity to be found in a summer sky. Note how on the sky and also on the sand the color is allowed to dissipate as it reaches the outside edges of the composition. The resultant vignette focuses attention on the subject of the study—the rocks. The sand being relatively flat in relation to the rocks reflects more light and is lighter than they are. Its shadow/texture color is lightened in the distance to further the effect of aerial perspective.

Project 3 Workshop

Wet on Dry—Painting structure

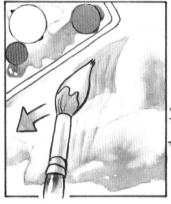

STEP 4 Pulling brush from a sharp edge of rock creates contrast. The rock appears lighter against darker ground.

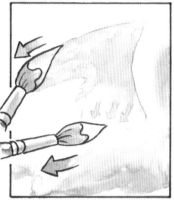

As brush runs out of paint it scumbles, creating textures. Hard edges are lost with a damp brush.

The horizon (top left) is darkened [Bp]—then lost with a damp brush.

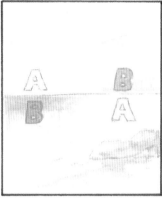

Regularly seen along the ocean's horizon—counterchange, dark [B] against light [A] and vice versa.

STEP 5 Directional brushstrokes help to create form.

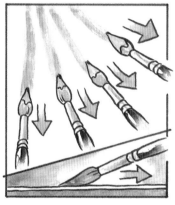

Pull brush along the stroke (top). Use side of brush head for fast coverage (bottom).

These flowing brush strokes, carried through the composition, lead the eye through a z-shaped format

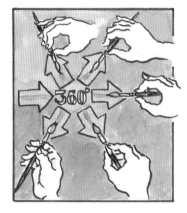

Try holding brush overhand to bring brush side close to surface for greater flexibility in stroke direction.

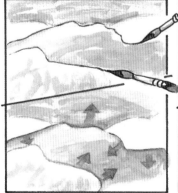

STEP 6 Linework, while wet, can be blended into rock or background, depending which is darkest.

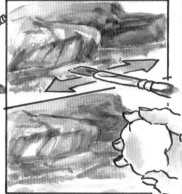

LIFT-OFF Rewet and gently soften paint with flat nylon brush. Dab off pigment with absorbent tissue.

SPLATTER TEXTURES with fluid color. Control application with a paper masks held by hand or masking tape.

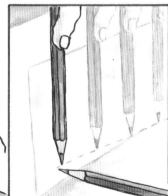

Finally measure level of sea against edge of painting and correct if necessary.

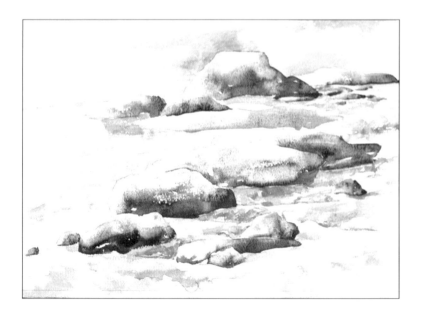

STEP 4

Lay dull yellow-green structure and texture over the sand. Then lighten and add blue into the distance to suggest aerial perspective (depth). Lighten foreground wash toward the edges and then wash further water into the area to create back runs. This results in the front edge of the ground appearing almost cloudy. Add warm blue accents to the sea, especially against the lighter rock edges. Develop the clouds in the sky further, by adding extremely light, blue washes, their edges softened along the bases or left hard along their tops.

COLOR MIXING

Where the prefix letter is shown in capitals this denotes a larger quantity of that particular color. Conversely, where the prefix letter is shown in a lower case, this denotes a smaller quantity of that particular color.
e.g.
Bp = large amount of blue-purple.
bp = small amount of blue-purple.

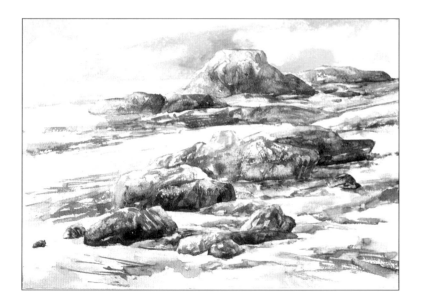

STEP 5

As the Wet on Dry technique develops, the quality tends toward detail through sharp edges of focus. From this stage on it is important to stay loose and fluid with brush marks. The blue-green texture over the stones partially neutralizes the strength of the purple (cool over warm). This same green is lightened and made cooler (adding blue) into the distance. Gentle, dull blue-green accents add a little kick to the waves.

HANDY HINT

If you feel there is anything wrong within the composition, such as the horizon level not appearing to be level, this can be easily checked out. Hold your work in front of a mirror and look at its reflection. Any imperfections will stand out quite noticeably.

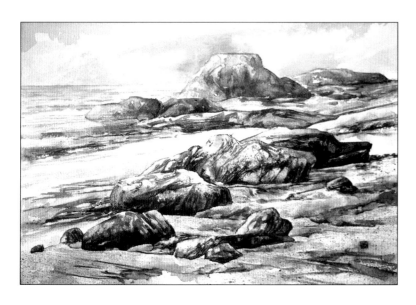

STEP 6

Linework and accents in a warm brown, to counterbalance the green (warm over cool), are added to create the final focus of the painting. As they are worked around the rock edges, they can be blended either into the rock or the background, depending on which is the darkest. The start and finish of a line can also be dissolved with a damp brush. Strong accents only go two thirds of the way into the painting and thus accentuate depth. Here the sand just beneath the central foreground rocks required lift-off, as it had become too dark and the base of the rocks had lost definition. The accent color was watered down and first scumbled and then splattered across the foreground to develop a gritty texture. The sea was found not to be level and was corrected.

Project 3 Tutorial

Painting detail

COLOR REFERENCES
Yellow-orange [Yo]
Yellow-green [Yg]
Red-orange [Ro]
Red-purple [Rp]
Blue-purple [Bp]
Blue-green [Bg]

Whether you own a garden, tend a balcony full of tubs and pots, or enjoy the simple pleasures of a single pot plant in the kitchen window—you could enjoy the results of your gardening labors throughout the year by capturing them with your brush or pencil.

The subtle colors and sharp contours inherent in this artichoke had me reaching for my watercolors. The question was which technique in watercolor to employ? Several smaller heads were captured in a freer style and were executed in line and wash. However, this giant head with all its variety of detail deserved special attention and so I opted for a botanical illustration approach. Who among us has not been impressed by botanical illustrations, those intricate studies of plants and flowers, where every stigma and petal can be seen, frozen in time? One flower head painted with such painstaking clarity can fascinate and please, especially those studies in which the richness of the colors has not been overworked and lost.

I am not a botanical illustrator. However, that does not prevent me from working in that style, nor should it prevent you.

Very seldom do I make a study with this degree of focus. Usually I opt for suggestion rather than definition. Here, however, is a perfect subject with which to display the benefits of the Wet on Dry technique, the sculptural nature of the globe, with its spikes and glossy colors. There are wonderful contrasts in texture and color between the flower and the seed head. It is almost a still life in its own right and using wet-on-dry will result in an overall sharpness of detail. By using the Wet on Dry technique, edges can be soft or hard and the degree of control can be loose or as tight as the subject demands.

Beware though; there is always the danger that such a rendition can result in a static, frozen image, so keep your mind and eyes open to the rhythms within the object.

STEP 1 Masking fluid applied at the drawing stage protects fine detail against a dark background applied later.

STEP 2 Losing hard edges of freshly applied color using a damp brush begins to suggest volume even at an early stage.

STEPS 3 & 4 Complementary overlaying of color (warm over cool—top; cool over warm—bottom) is effective. Keep mixes bright as layers dull one another upon drying.

MATERIALS

Rough 140 lbs. Watercolor Paper
Automatic Pencil 0.5 mm, 2B
Clutch Pencil 2 mm, 2B
Watercolor Brushes
2 × large round
Rigger brush
Watercolor Paints
Kneadable Putty Rubber

SIMPLIFYING FORM MAKES STARTING OFF MUCH EASIER

Try the following simple exercise. On a small scrap of paper and using a yellow pencil, draw the outline of a cup, with no handle, resting on a saucer. Now turn the paper once, to your left, so that the image is reading from top to bottom and there you have the beginnings of a drawing of a daffodil head, the trumpet. Using a green pencil draw a straight line from the middle of the saucer to your right and then down to form the stem. You can now start to make the subtle changes to this outline, such as a scalloped edge to the cup, which turn this basic shape into a passable drawing of a daffodil.

STEP 1—STARTING OFF

Stretch the paper on a board and wait until fully dry before starting. With the 2B 0.5 mm automatic pencil, draw out the flower head. You can see that this drawing is quite detailed and complex, so it was important during the early stages to interpret the simple underlying form of the subject. Look closely and you can see that the petals are contained within two ellipses and the body in a circle. Once you have recognised the simple outline structure in this way, you can then begin to break down the large simple forms into smaller ones. It is better to see the leaves that make up the "bowl" of the flower as a series of triangular shapes. If you can fit these together like pieces of a jigsaw, any irregularities can be added later. As you look at each leaf it is different and interesting in its own right. It is very frustrating if, after drawing several of these, you find that they are in the wrong place and simply don't fit together. However, if you have an underlying structure or skeleton of simple lines on which they can be placed, all the detail you will capture will be worth the effort, as it will be correct. Use the kneadable putty rubber to erase or refine the structure as you work up the drawing. Note how the line thickness varies and is kept much lighter under the delicate petals. Be aware at all times of the negative space of the white paper. Between petals and leaves it will help you get the shapes right. Overall, the balance between the whole object and the rectangle that contains it will depend on the negative space between them.

STEP 2—MASKING OFF AND FIRST LAYER

Apply masking fluid to areas where fine highlights (on petals) or light texture (on leaves) are required. The first layer of gentle washes are laid to give solidity to the form and fix the pencil line. There is a temptation to become involved in the detail of texture and form and finish off each leaf as you go along. Resist this and keep the washes simple. In this way the color will remain pure. Fiddling about in one spot leads to dirty color and will be especially unpleasant when dealing with mixes of complementary colors, such as the greens and reds in this painting. To avoid smudging pencil line as work progresses, keep a paper sheet under the brush hand to protect the work underneath from rubbing. To ensure a smooth wash, avoid lifting the brush off the surface. Keep it in constant contact with the surface, loading your brush with enough fluid paint in the first

place. Avoid applying color in a dabbing motion as this causes pooling which dries unevenly. Use a second damp brush to lose edges where necessary. At this point you must decide whether you are going to put color into the background. This is not always a matter of style, but may depend on the subject. Here we have a subject and a viewing angle that provide us with an interesting silhouette. The power of this silhouette could be compromised by adding anything to the background. Should this be an approach that appeals to you, you may wish to think about different types and/or colors of paper to use in future paintings. There are many fascinating papers on the market that could provide a variety of backdrops to your work.

Now the groundwork has been completed, subsequent work concentrates on the detail.

STEP 3—SECOND LAYER

Purple-reds were laid over the cool greens on the globe. Note how the complementary contrasts now enhance one another, as opposed to simply adding another layer of the first color on the leaves and stem. Colors mixed in layers on the surface are quite different to those mixed on the palette beforehand. Here, as the reds move over the greens, the quantities of each constantly vary. This is much more natural as it echoes the way in which nature mixes her colors. The spikes behind the fine petalled flower head could be confidently painted since the petals themselves had been previously protected with masking fluid. Darker greens added to the leaves behind the globe begin to suggest extra volume and texture.

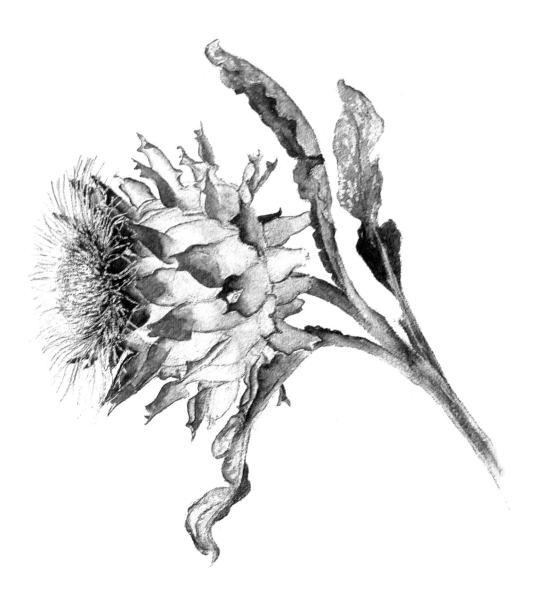

STEP 4—BUILDING CONTRAST AND DEPTH

Once again, complementary overlays (green over red) on the spiky globe played their part in providing both color and tonal contrast. As complementary overlays inevitably turn toward gray as they dry, they should always be applied as bright colors to avoid potential dullness. Interestingly the darker of the leaves, now added, are warmer (yellow-green) than the highlights (blue-green). While this is true of a specimen painted in the studio, it would not be so of a plant in full sunlight. Here I was using the subject to hone my color mixing, by copying the colors I could see as closely as possible. For future paintings, however, you may wish to pursue the thought that sunlight is very yellow and in a garden or natural setting, the greens of the plants will be affected strongly by this. Should you wish to echo this quality in your paintings, then it is advisable that you spend as much time as possible studying plants in their natural environment.

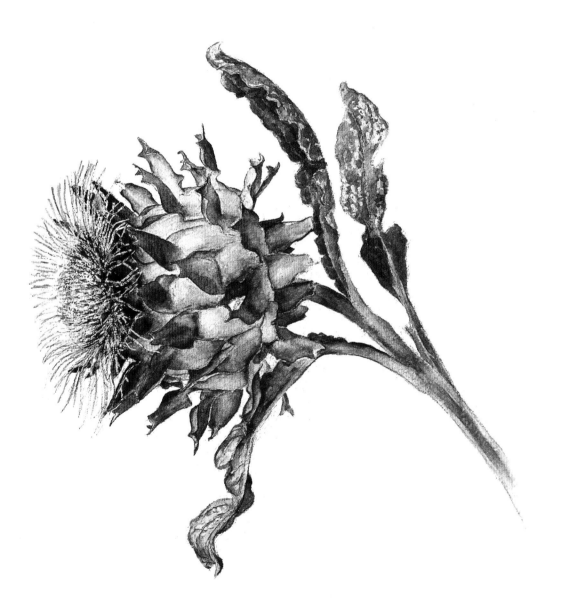

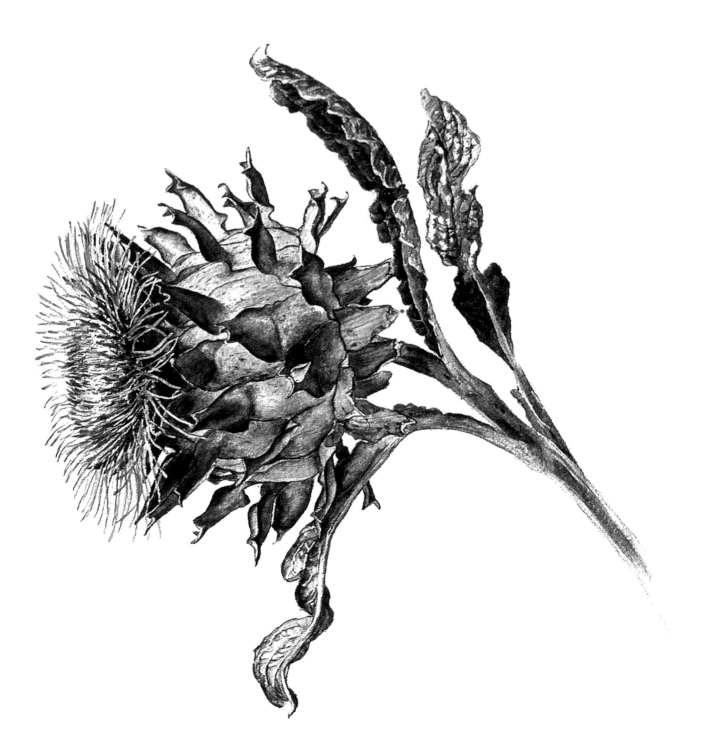

STEP 5—FINISHING OFF

Remove the masking fluid with a putty rubber at this stage. Complete final accents and generally tighten up. In this painting, dark red accents and brown scumbles were worked into the spikes. Final linework using the tip of the brush head created a crisp finish. Beware; at this stage the painting can easily become overworked and begin to look dirty. In fact, the paper surface can become so fragile with overworking that it could begin to disintegrate. If in doubt, stop, step back and look at the overall effect.

Tricks of the Trade

Losing edges

THE THEORY

Wet-on-dry brush marks, no matter how pale, dry with very sharp focus edges. If, while still wet [A], you were to lay a thin layer of water alongside [B], when the two meet, the color would naturally flow into the wetted area [C].

IN PRACTICE

In fact, the color flow is affected by two elements. First, the depth of the pool of color. Should this be very shallow, the flow, both in degree and speed, will be gentle [D]. If deep, the flow will be more aggressive [E].

Brush loading also affects flow. With the right amount of water, the flow is regular [F]. Too much water and the flow of color can be halted, or even reversed, with the water flowing into the color [G].

GRADUATED COLOR FLOW

If the first wetting allows the color, however slight, to reach the far edge of the wet area [H], this may become visible and sharp when dry. Clean the brush and lay a second water pool to lose this fine edge of color [J].

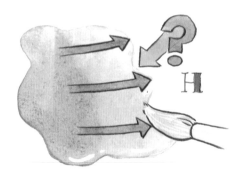

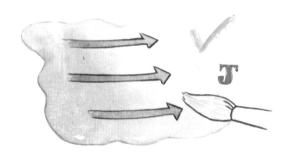

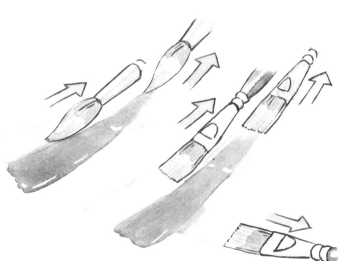

BRUSHES

Round or flat brushes are suitable for losing edges, but experiment to find out how they differ in use.

RESULTS

Lost edges can be used to
• Create volume [K]
• Develop texture [L]
• Suggest movement [M]
• Suggest depth [N]

Common Problems

Lost edges

QUERY

"I don't seem to be very successful at losing edges. Am I using the wrong brush or doing something wrong?"

ANSWER I

You could be using your brush in the wrong way. Many of those new to painting overuse the tip or point of the brush and try to make it fulfill functions of which it is incapable [A].

SOLUTION

Practice pushing the brush to the surface so that the side of the brush head deposits water [B]. Keep the brush on the surface as you make the stroke. If you dab on the water, it will form a more irregular layer, which can look messy as the color begins to run.

ANSWER 2

You may not be wetting the surface sufficiently and therefore may be causing irregular or inadequate paint flow [C].

SOLUTION

Increase the water load until you get the desired effect.

ANSWER 3

You may be overwetting the paper, which will cause the paint to back up into itself [D], drying into the all too familiar "back run."

SOLUTION

If you see this happening, reduce the amount of water, or even squeeze the brush on a tissue and lift a little of the water from the surface.

QUERY

"When losing a succession of edges to graduate a color, I find that upon drying, there are definite borders between the values [E]. How can I make the gradation more continuous?"

SOLUTION

As each edge is softened, allow the brush to migrate into the color, picking up a small amount of pigment to encourage its flow into the wetted area [F]. Alternatively, mix a little color with the water used to lose the edge. Both will help to eliminate the hard transition from dark to light, along each edge.

SOLUTION

If you have completed the gradation and then notice the fault, take a clean, squeezed brush. Flatten the head gently between the fingers and feather the pigment in the still-wet paint to even it out [G].

SOLUTION

If the paint is too dry to feather, allow it to dry completely and then re-wet and partially lift off the offending edges with an absorbent tissue [H].

Project 4

Wet on Wet—Painting movement and form

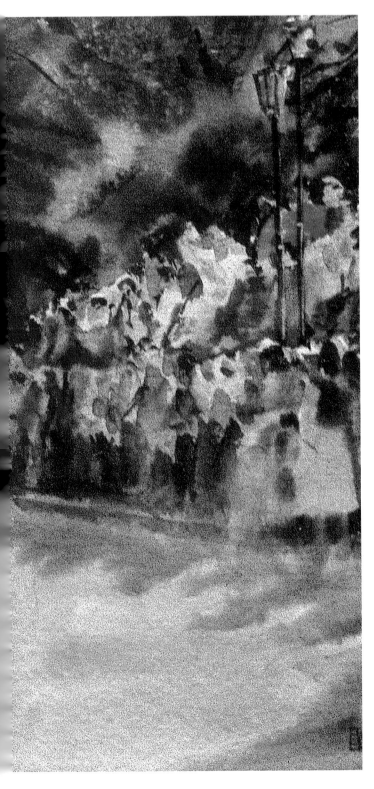

Wet on Wet is, without doubt, the ultimate technique in watercolor. The soft depth and rich dark values of this technique fit so naturally into the qualities we expect from the watercolor medium.

Yet it is one of the techniques that can lead to the most misunderstanding. The term wet-on-wet implies that the paint flow will be uncontrolled and therefore completely experimental. If this is how you choose to use it, then of course it can be very exciting. There is, however, much more control available, leading to even greater possibilities.

It is best that you scan the entirety of this project, to get a better feel for the technique, before you embark on an actual painting.

Be patient with yourself, for you must also get to grips with the feel of the paint flow. All your efforts will be amply rewarded when you finally master this extraordinary technique.

Wet on Wet is seldom used as a technique on its own. By its very nature it will not provide areas of focus, which are often created through the use of wet-on-dry strokes.

In this project, all painting is carried out wet-on-wet, to allow you the chance to practice the technique in its own right. Hard edges are created through the sharpness produced in the use of masking fluid.

Painting waves is by no means an easy task in watercolor, yet it is a popular subject that sets our imagination racing. The workshop will give you ample experience for creating hard and soft highlights, using masking fluid and lift-off respectively.

The tutorial is of water again, featuring the movement of a cascading fall. By painting purely in wet-on-wet you will find the technique can be layered to build density of color and value.

Undoubtedly, it is unusual to use the technique on its own in this fashion. However, if you persevere and have a go at these particular subjects, you will become well versed in the subtleties of the technique and the materials needed to achieve them.

Your future watercolors will benefit from the addition of one of the most stunning techniques available to the watercolorist.

Project 4

Wet on Wet—Painting movement

Masking fluid is either white or a very pale color—add a few drops of Indian Ink and shake well to turn it gray . . .

. . . so it can be easily seen against white paper or even over light colors . . .

. . . thus avoiding over-heavy application (top). Gentle scumbles are often more effective.

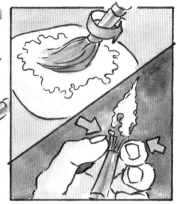

Protect the brush from drying fluid when in use. Create lather on bar of soap. Work gently into base with fingernails.

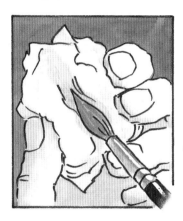

Remove excess soap on clean tissue. Soap left inside brush head will slow drying of fluid.

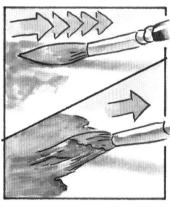

If drying begins, brush starts to drag on surface (top). Color change occurs in fluid and brush eventually sticks. Stop before this happens!

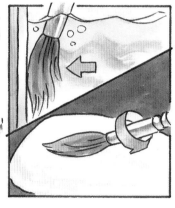

Clean thoroughly in water pushing brush against side of jar to remove mask (top). More soap helps removal (bottom).

If mask has dried in brush don't pull brush hairs (top). Wash it in thinner (turpentine), soap, and water (bottom).

TIPS To help visualize linear nature of foam, imagine a net lying on the water surface.

This would take on shape of the surface and if pulled could break, causing irregular holes.

Foam acts exactly in this manner—following contours of the surface.

Think of rocks as stacked boxes (top). How might water run off them? Apply foam to rocks in same way (bottom).

EXERCISES
EXERCISE 1

Before starting this workshop, it is a good idea to practice the "directional strokes" that will produce the "white" of the foam, this being the natural color of the paper, not white paint. Do this on a spare piece of rough watercolor paper before committing yourself to the application of masking fluid. Use a strong color so that you can observe the subtleties that can be achieved by using this technique. Note the balance of lightly covered areas against heavily covered areas creating contrasts that interest the eye. You will soon get used to the fact that the dark brush marks you are making will eventually be the highlights in your painting.

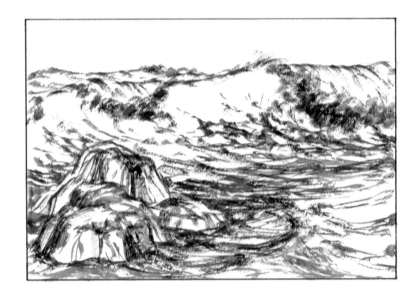

EXERCISE 2 (FIRST STAGE)
APPLYING MASKING FLUID AND
LAYING WASHES

Lightly sketch out the composition with the 0.5 mm 2B pencil. With the masking fluid, paint out the areas that you need to protect, mirroring what you did in exercise 1. Leave to dry. Once dry, rewet the whole surface with the Hake brush, then apply color washes as simply and swiftly as possible. There is a lot of masking work in this subject, so you may need to wash your brush out several times during its prolonged use with masking fluid. Put out only a small quantity of masking fluid at a time, so that if it begins to dry you can discard it and start with a fresh supply.

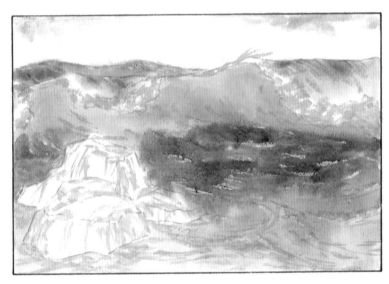

EXERCISE 2 (SECOND STAGE)
REMOVING MASKING FLUID AND
SOFTENING COLOR

Remove masking with a kneadable putty rubber, only when the paper is completely dry. Try softening some of the foam edges with lift-off and experiment putting gentle color over the foam using small areas of wet-on-wet. Make this blue in the shadows and yellow where sunlight might fall.

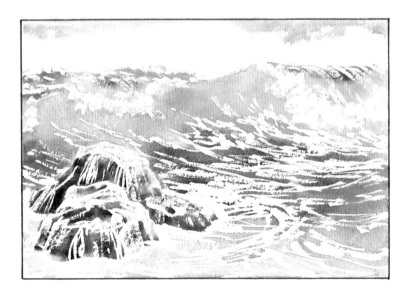

MATERIALS
Rough Watercolor Paper
Automatic Pencil 0.5 mm, 2B
Watercolor Paints
Round Watercolor Brush
Hake Brush
Flat Nylon Watercolor Brush
(with short brush head)
Palette
with large flat area for mixing washes and wells for
holding paint
Masking Fluid
Kneadable Putty Rubber

Project 4 Workshop

Wet on Wet—Painting movement

COLOR REFERENCES
Yellow-orange [Yo]
Yellow-green [Yg]
Red-orange [Ro]
Red-purple [Rp]
Blue-purple [Bp]
Blue-green [Bg]

TIP 1 As the wave breaks a section of translucent water is revealed.

This appears as a dark soft "stain" along the top of the wave (wet-on-wet).

TIP 2 Overly heavy areas of mask can be "opened up" by gently rubbing with a finger.

TIP 3 Take water's surface textures right up to sides of rocks, or halo effect will result.

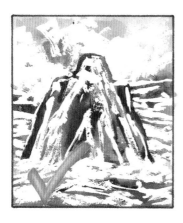

Also important for "movement" behind to appear continuous.

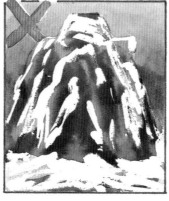

TIP 4 Foam rivulets across the rocks should not suddenly stop—it looks unnatural.

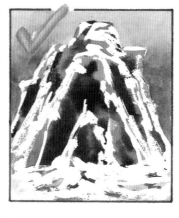

Carry them right down into the water surface instead.

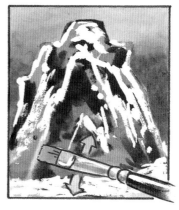

If you do forget, the mistake can be rectified with lift-off.

TIP 5 Lift-off helps to soften foam edges (top) or extend a hard line softly (bottom).

The "flat" of the brush can lift off wider areas.

TIP 6 As a final highlight scratch (hard) or sand (soft) the surface.

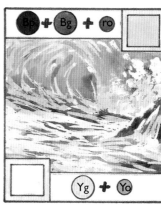

TIP 7 The color of foam in shadow (top) and light (bottom), gives final form to the wave.

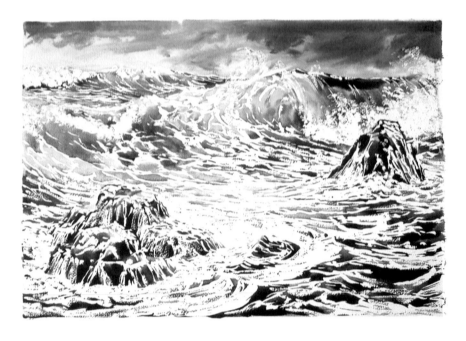

THE PAINTING

Apply the masking fluid. Once it is dry, wet the surface with your Hake. Paint wet-on-wet as before. Once the paint is dry, remove the masking fluid. Take note that strong emphasis is made in creating a variety of greens. If you lose concentration "sameness" will creep into your color. I added reds and blues, as well as yellows, into my greens to keep the color alive.

Lift off color with the flat nylon brush. The softening of the brush strokes gives a greater sense of movement and also suggests bubbles beneath the water surface. Only wet a small area at a time so that removal with an absorbent tissue is effective. Wetting too large an area can lead to the paint drying again before it can be lifted.

Reapply masking fluid to areas of foam which are to receive direct sunlight. The shadow color to the foam can then be applied freely, knowing highlights are protected. A wash of orange-brown [Ro+Yo+bp] enriches the sky and adds a complementary contrast to the blue-green of the sea. Remove the masking fluid and scumble a light wash of yellow over the exposed white areas to suggest sunlight.

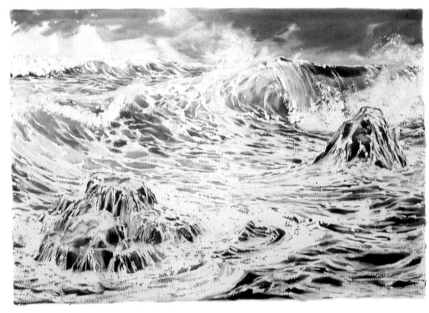

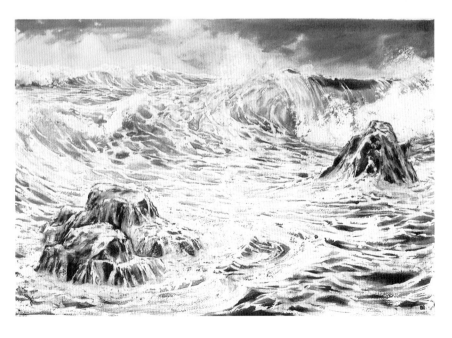

Project 4 Tutorial

Wet on Wet—Painting form

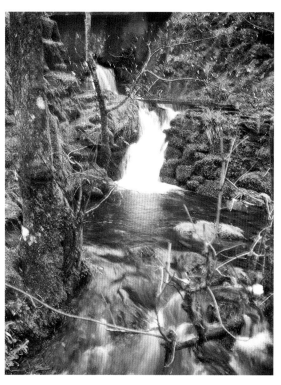

The rain had been falling steadily during our walk. When we finally came to the fall it was a raging torrent of churning, writhing spume. The force was such that the sound resonated against our chests as the water plunged into the depths in a display of nature's frightening ability to change in such a short period of time.

However, to one side of the fall a more tranquil scene contrasted vividly. Here, in this manmade cul-de-sac a bridge traversed a small culvert, and diverted water gently fell over strewn boulders. Nature's subsequent work in depositing saplings and ferns, surrounded by moss-encrusted stone, softened the composition. The greens were vibrant in their damp surroundings. The palette of this scene was made more intense by its contrast with the golden leaves, leftovers from autumn.

REFERENCE GATHERING

For the painter, this was not the weather for drawing or painting in situ—photographs captured the scene. This day out had not been intended as a reference-gathering one, but as always, a camera was part of my kit. Missing the moment of that perfect subject is something with which all artists are familiar. It isn't always feasible to have a camera with you, but wherever possible you should.

It is important that you do not limit yourself to just one shot, as you will miss too much information and a painting back in the studio will simply not be possible. Take as many as you need and of the overall view, as well as of details or aspects that are fleeting and of the moment.

Whenever possible, make a few thumbnail scribbles on a piece of paper. Any paper will do if you don't have a small sketchbook—the back of a box of matches, or an old envelope. The purpose of this being to compose your painting on site. Doing this will guide you in the selection of shots that you need as reference.

One of the most dramatic paintings I have ever produced was based on a few snatched photographs taken of a swollen river that ran parallel to, and was flooding, the road on which we were driving. Having been in the middle of the fast-changing weather the drama required in the subsequent painting came quite naturally, as I recalled the urgent need to get away from the danger.

THE TECHNIQUE OF WET ON WET

This tutorial solely employs the technique of Wet on Wet, which involves wetting a surface before applying color. As with any other skill it does require practice. However, once you become familiar with its nature, you soon lose your fear and there are many tips that will make your approach more liable to succeed.

As its name implies, the technique involves painting into an already wet surface and thus the paint moves, merges, and blends naturally with the fluid previously applied. You can well imagine what can happen if this is not controlled. In fact you may even see this suggested as a way of beginning—simply to let go and see what happens [A]. While you may sometimes feel this is just what you need at the beginning of a painting, inevitably you will yearn to control those runs of paint.

There are two conditions that cause paint to run and they are usually related to the surface, rather than the condition of the paint in the brush.

First, the layer of water can be very deep, as in the cross-section [B]. In this event the color will tend to flow or "explode" vigorously. The color mixes can even begin to separate (granulation), although you may grow to like this effect [circle below B].

Second, the layer of water can be uneven. This may be caused by uneven application with too small a brush, or by the paper cockling with the water. When this occurs, the water can run into and collect in the valleys. Should your paintbrush hit a valley, then the deep water will cause the paint to run, often in the direction of the valley [C].

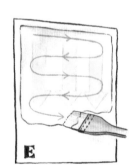

PREPARING TO PAINT

- Paint with your board in an upright position. Excess water applied during wetting will simply run off. It won't be long before you get used to working upright and to prefer working so.

- Always stretch your paper.

- Apply the water with a really large brush, such as a Hake, and keep it constantly in contact with the surface as you apply the water. Every time a brush is lifted off the surface it has the tendency to leave a little pool behind, which causes unevenness in the water layer [D].

- Never remove excess water with a tissue, unless you want to dry out a particular section. To lift water from a valley, for instance, use a squeezed (thirsty) brush. This leaves the surface still damp enough to take wet-on-wet brush strokes.

- Wet the paper from the top and work down, so the water flows with the brush [E]. Rewet several times until the paper really takes up the water. Working upright means the paper dries from the top first. You should therefore not only wet from the top, but also work your paint into the top first. This usually works well, as the top of most paintings is the background, which is naturally overlaid by following foreground layers as the painting progresses.

Trying wet-on-wet for the first time? Don't despair if you feel that you aren't getting the hang of this. It takes a while to get to grips with the correct balance of fluid required.

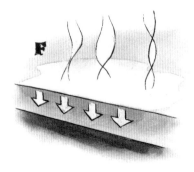

<table>
<tr><td>

COLOR MIXING

Where the prefix letter is shown in capitals this denotes a larger quantity of that particular color.
Conversely, where the prefix letter is shown in a lower case, this denotes a smaller quantity of that particular color.
e.g.
Bp = large amount of blue-purple.
bp = small amount of blue-purple.

</td><td>

COLOR REFERENCES

Yellow-orange [Yo]
Yellow-green [Yg]
Red-orange [Ro]
Red-purple [Rp]
Blue-purple [Bp]
Blue-green [Bg]

</td></tr>
</table>

MATERIALS
Watercolor Paper Rough 140 lbs.
Automatic Pencil 0.5 mm, 2B
Brushes
50mm superior Hake
round petit gris nos. 10, 12, and 14
pure sable Rigger No. 4
flat nylon for lift-off
Watercolor Paints Tubes
basic set of 6 primaries
Palette
plastic with large flat area for mixing large washes plus wells for storing colors
Masking Fluid
Kneadable Putty Rubber

DRAWING OUT

Back in the studio, I sketched out the most dramatic elements on a piece of cartridge paper to act as a guide. When these had been assembled into a suitable composition, the main masses were transferred to my previously stretched watercolor paper, using a 2B, 0.5 mm automatic pencil.

TIP

NATURAL RHYTHM FOR WETTING AND PAINTING
* Thoroughly wet the entire surface.
* Mix the first color you will be working with. By the time you are satisfied with the consistency of your first mix, the water will have permeated the paper fibers, but the surface will be beginning to dry through evaporation.
* Wet the entire surface for the second time. The water lies on the surface and the surface should remain wet just that little longer, so that you have a better chance to get a large area of paint completed before drying halts your progress.

STEP 1—STARTING OFF

Masking fluid will provide the only sharp edges in this exercise, so use it quite generously for this first stage. When applying you must imagine you are painting white or very light colors onto the surface. The variety of direction and strength of each stroke will thus be as descriptive as possible, for the qualities of mark—highlight, texture, or focus—they provide. Often several applications of mask are required for an area where an interlacing of textures would provide the density of resist required. If these are overdone, they can easily be rubbed off or rolled away from the surface once they are dry. Evidence of this can be seen down the left-hand edge of the center waterfall, which was initially "painted" too wide.

STEP 2—FIRST LAYER

Apply the first washes as brightly as possible. Use the yellow-green for the "moss yellows." The red-orange is used for complementary mixing, where duller intensities are required. As is normal in watercolor, the color will dry lighter and duller generally, so make the effort to paint brightly and densely to compensate. In this painting, several areas were treated to light washes applied wet-on-wet. These were then reworked with darker washes while still wet (particularly the mossy bank and foreground fall). In this instance the surface began to dry before I was able to complete the first layer throughout. If this should happen to you, leave the surface to dry so that these areas can be rewetted safely, using the Hake, without paint lifting-off or creating back runs (blooming).

TIP
HAKE
Made from soft goat's hair, this brush holds a great deal of water and will deposit a fast, even layer of water or fluid paint across the paper's surface.

STEP 3—SECOND LAYER

Working upright allows you to exploit the fact, in this and the previous step, that the extensive masking holds the washes in place. See this effect at the pool edge just under the green wall and above the boulder (bottom right). Where the colors found a gap in the mask and ran through, they were swiftly lifted-off with an absorbent tissue. Previously unpainted areas are now rewet using the Hake and then painted using the largest of the petit gris brushes. While the the latter do not have the "bounce" of sable brushes, they are, nevertheless, able to hold a large amount of color and applying their shoulder to the surface deposits it swiftly. You must fill them well with fluid to ensure they keep their shape without splaying. Rewetting already painted areas with the Hake allows further color definition without mixing with, or lifting off, underlying layers. The suitability of the paper for lift-off is well demonstrated in the rock reestablished above the large boulder (bottom right). Here the orange water was lifted off and a more suitable color inserted while still wet.

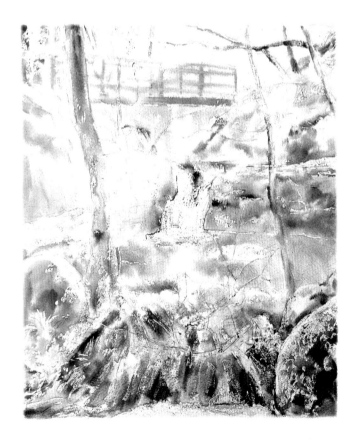

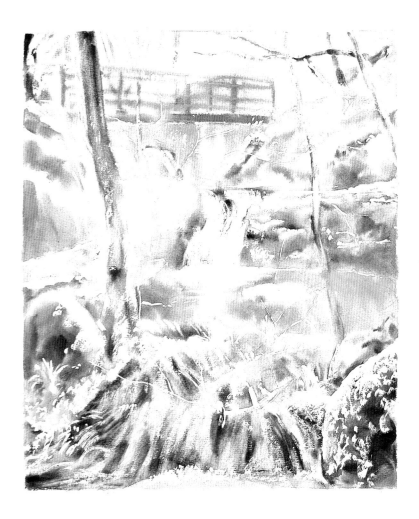

STEP 4—REMOVING MASKING FLUID AND MODIFICATIONS

The white surface—almost totally covered at the end of step 3—returns as highlights on removal of the masking fluid with a putty rubber. The starkness of the white areas bears witness to the need to remove the mask before the painting becomes too complete. Areas that are incorrect can easily be overpainted, while having their edges gently lifted off can soften others that are too sharp. Note, for example, how much softer the whites in the foreground waterfall seem, against those of the surrounding rocks.

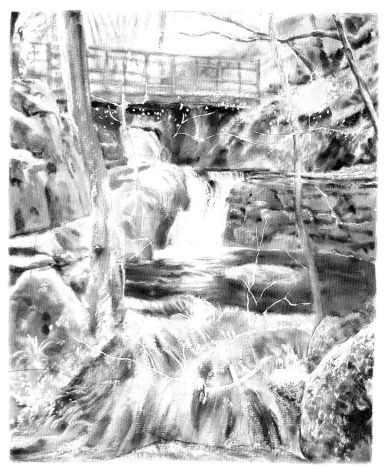

STEP 5—HIGHLIGHTS, ACCENTS, AND FOCUS

Repaint the finer branches with masking fluid to ensure they remain in focus and dominant in spite of their light value in the final picture. Unusually, the painting should now be worked from the center outward, rather than from the top down. The reason for this is that the strength of the central pool should control the values of the rest of the picture. As you work toward the extremities of the painting, you can then decide whether to add paint to a particular area or leave it soft and diffuse, whichever suits your taste. Even on this dull day, the top surfaces of the mossy rocks remained a bright yellow-green, while upright surfaces not receiving full light were much cooler (blue-green), as well as darker. Within these areas, as I painted with the smaller round brushes, their slightly "floppy" nature gave some erratic brushmarks which were extremely suitable for the irregular surfaces they had to portray. As the areas are worked toward their darker accents they begin to dry. This ensures slightly denser marks, but care should be taken not to allow fully dry, sharp edges to occur. Do be bold when applying really dark accents, as these will easily lose half their strength as they dry. Once this is finished, remove the masking fluid with great care.

STEP 6—FINISHING OFF

Again, rather unusually, I began painting from the foreground and worked back. This ensured, if anything, that the background would remain less worked than the foreground, creating depth of field. For finishing detail I used a pure sable Rigger No. 4. This is a superb brush for pointing, and carries sufficient paint to prevent constant reloading of color. Paint should be mixed on the palette with the larger round brushes, which are faster to use, less liable to damage, and being cheaper, more expendable. The accents, still worked wet-on-wet, are either soft, when painted into previously soft-edged areas (e.g., the island in middle of pool), or hard, when worked up to hard-edged, previously masked areas (such as the twig in the waterfall). In the case of the green walls and banks, the surfaces were not wet with the Hake but with the large round brush containing a green wash. While this rewetted and repainted area was still wet, use of the fine sable Rigger added the necessary accents (restricted wet-on-wet).

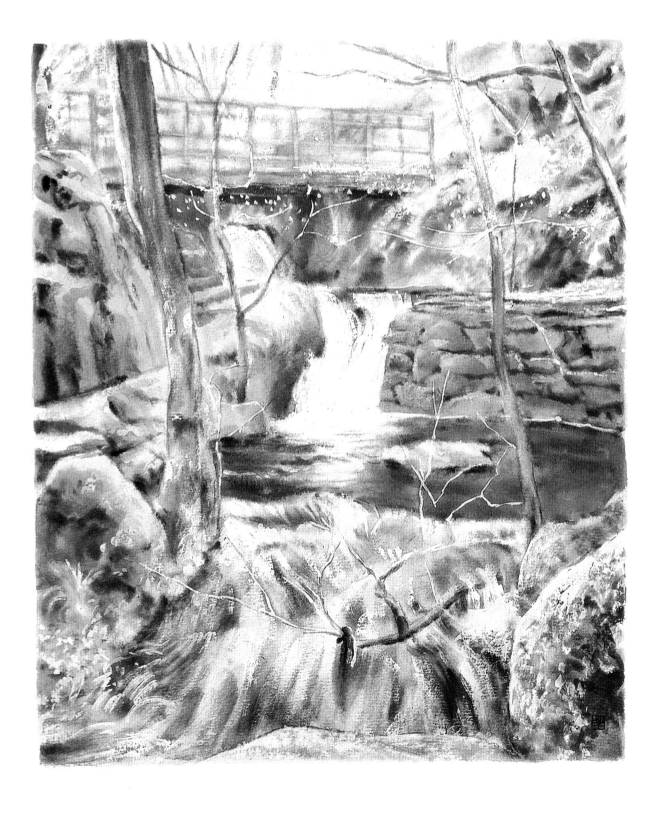

Tricks of the Trade

Stretching paper for watercolors

When any sheet of paper is dampened, its fibers absorb the water. They expand and thus the sheet becomes slightly larger [a]. As the water evaporates, the fibers—and so the whole sheet—shrink back to their former size [b]. If the edges of the sheet can be fixed in place when the sheet has fully expanded, then on shrinking the paper will become taut and "stretched" like the skin of a drum.

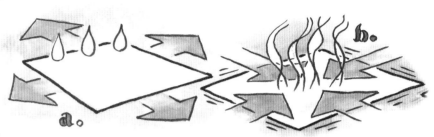

This stretched paper is less likely to wrinkle if rewet, especially if you only wet a portion of the paper, something that is normal in the painting process. If it does wrinkle, then at least it will flatten out again on drying, leaving you with a perfectly level piece of finished artwork. Once the paper edges are released the paper will return to its normal size, as it is no longer stretched.

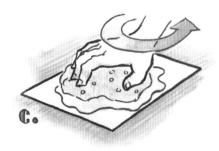

The thicker the paper the more water and soaking time are required to stretch it. With 90–140 lbs. (200–300 gsm) paper you can simply wet both sides with a soft (natural) sponge [c]. Do make sure you wet the wrong side first, as this may pick up dirt or stains from your drawing board when you turn it over to wet the other side.

With 140–200 lbs. (300 gsm–425 gsm) you can run both sides under a tap [d]. Leave 200–300 lbs. (425–600 gsm) papers in a bath of cold water for approximately five minutes [e].

TIP
Stretch a few pieces of paper on separate boards to make it worth your while to draw a bath of water.

Really wet papers need to be lifted gently by one corner avoiding folding or bending. Allow sufficient time for excess water to run off [f]. Now turn paper to hold it by its opposite corner so that the water on the sheet will not be concentrated in one corner but evenly distributed.

Transfer the sheet to a drawing board, which should be unvarnished plain wood of a sufficient thickness not to bend under the strain of the stretching paper (hardboard will not do). Bubbles of air can be gently squeezed out with the side of your hand [g].

The paper is now to be fixed along its edges with 2 in. (50 mm) wide gum strip—a gummed paper parcel tape. Each length of gum strip should be immersed in water and then run between two fingers to remove excess moisture [h].

TIP
Rolls of gum strip must never come into contact with water or the whole roll will stick together. To avoid this, precut lengths at least 2 in. (50 mm) longer than the length of the paper, four pieces in all, before you begin working with the wet paper.

Lay the gum strip along the edge of the paper, half on the paper and half on the board [j]. Holding down one corner of the gum strip, press down firmly with a tissue. Run the tissue firmly along the length of gum strip overlapping its paper edge. Excess "gummy" water will be squeezed out onto the paper and this needs to be picked up on the tissue before it can spread [k].

As a final seal, run your fingernail along the ridge formed at the paper's edge beneath the gum strip [m].

The paper should now be left flat to dry naturally. If you stand it up or dry it from one side, the paper will dry unevenly and distort, pulling away from the gum strip. Cats love to sit on flat paper sheets, so take the necessary precautions to keep them away from drying paper! Allow at least half a day for drying. Drawing on damp paper damages the surface, creating areas that stain when paint is applied.

Common Problems

Stretching paper for watercolors

QUERY

"I have followed all the rules to stretch my watercolor paper, but when dry the gum strip doesn't hold in place and the sheet dries unevenly and becomes wrinkled. Why?"

ANSWER

The gum strip isn't doing the job. As the manufacturers will tell you, gum strip is not designed for stretching paper but for wrapping parcels. Hence, the amount of gum on its surface can vary considerably and you may simply have bought a roll that won't stick very well. The only answer is to go to a different store which may have a different batch with more glue.

TIP

If most of the gummed paper has stuck, but has come away just along one edge for instance, you may be able to remedy this situation as shown in stages below.

First check all edges and tear away any loose or damaged paper [A].

In your bath, pour some water inside the "envelope" created between paper and board [B].

Pour out across paper [C].

Wet the front of the paper evenly and restretch [D].

After a few minutes reseal the edge with gum strip and leave flat to dry. This, however, works only with a small area of difficulty.

If too much of your paper has become unstuck, you must remove it completely from the board, resoak it in your bath until the gum strip can be easily peeled off, and restretch.

QUERY

"When I tried to remove the finished painting from my board it began to tear. What should I have done?"

ANSWER

The normal way to remove the paper is to cut the gum strip along the ridge formed by the edge of the paper sheet [E]. Usually the paper will "snap" away from the cut edge.

Sometimes, however, some of the wet gum might travel from the gum strip under the paper, which then becomes stuck to the board. If you feel this has happened, first gently slip a blunt kitchen knife into the cut and try to ease the paper away, as if you were opening an envelope [F].

If it is still stuck fast, cut again inside the gum strip and lift out the paper [G]. The excess can be torn away from your board later.

TIP

The migration of gum can cause a real problem if it gets into the center of your drawing board. For this reason, never stretch two pieces of paper on the same side. If you later stretch a large piece on the same board the gum strip in the center can stick to the back of the paper. Instead, stretch one large piece and paint on both ends. Protect the end you are not using by a sheet of cartridge paper held in place by drawing pins or masking tape. You can, of course, stretch on both sides of your drawing board, as long as you always protect the unused side with paper.

Project 5

Combination—painting basic reflections and buildings

Reflections and buildings are wonderful things to paint, yet so many painters avoid them because both subjects involve linear perspective. The specter of technical drawing immediately rears its ugly head, which suggests reaching for the nearest rule and setsquare. Not wishing to be involved in what is perceived as a technical process, many people consequently turn their backs on the whole idea.

What a pity that such beautiful sources of inspiration should be so easily shelved!

While there is great pleasure to be derived from dealing with vanishing points, eye levels, and so on, there is a simpler level at which any painter can start on the subject of painting buildings—a level at which the color, design, and textures can be enjoyed without all the worry of getting to grips with perspective.

An ornate building in Amsterdam is the basis for the tutorial in this project, in which it is tackled literally head on, as a piece of almost flat design. There are many buildings that can be approached in this way, leading to no less exciting possibilities than a wall full of paintings executed in perfect perspective.

Reflections can also seem complex at first and the workshop section in this project may well seem to confirm this. Go through it carefully, however, and you will find that this is not the case. The structure of reflections is actually based on very simple principles, which are within everyone's grasp. Every reflection is composed of these principles in a unique combination. Understanding the basics enables you to interpret the subject, breaking it down into simple components.

Once you have mastered this, it will become second nature and you will see reflections occur in wet streets or shiny surfaces, such as tables in still lifes. Knowing how to include reflective qualities will ensure an added dimension of richness your work should not be without.

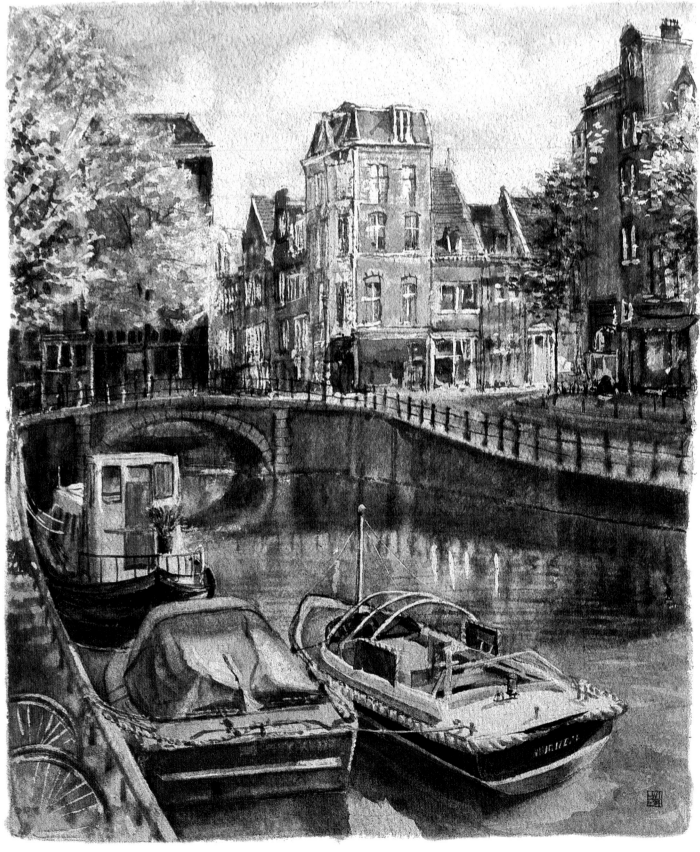

Project 5 Workshop

Combination—reflections in water

COLOR REFERENCES
Yellow-orange [Yo]
Yellow-green [Yg]
Red-orange [Ro]
Red-purple [Rp]
Blue-purple [Bp]
Blue-green [Bg]

Pencil in masses lightly. Lay two graded washes [Bp + water] with large brush. Lighten toward horizon.

When dry, block in silhouette shapes of subject. Use muted green of differing values [Yg+Bg+ro].

The reflection—actual colors of the water—brown [Ro+Yo+bg] grading lighter toward bank as depth decreases.

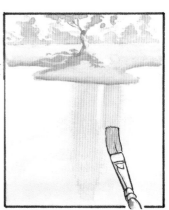

Preliminary wash must avoid tree and its reflection otherwise will interfere with "sunlight" yellow.

Paint highlights of tree first. Add a little purple into color for reflection.

Brown of the water predominates in reflection in water.

Paint as [A], but for the reflection, wet the surface with a Hake or equally large brush.

Use flat brush or "flattened" round brush to pull color straight down from water's edge.

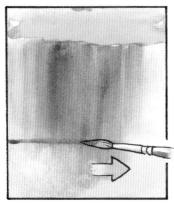

Suggest water surface with some horizontal strokes. Apply extra pressure for wider strokes toward bottom.

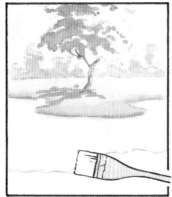

Paint top as [C] but leave water till last. Then wet thoroughly with Hake brush.

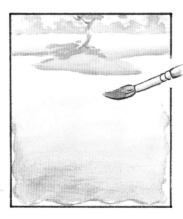

Create your graded "reflected sky" wash wet-in-wet.

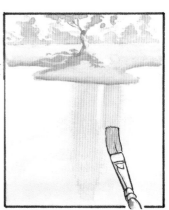

While still wet work as lower [D] but with colors of lower [C].

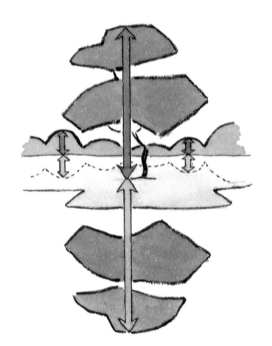

EXAMPLE A

The diagram shows the basic workings of the reflection. The water's edge plays no part in the construction of the reflection, save that it separates a reflective from a non-reflective surface. The reflection actually begins at the base of the object. When the water is smooth, the reflection is "perfect" and the depth of the reflection is the same as the height of the object. You can see that the background bushes are therefore, too far away from the water's edge to be reflected.

COLOR MIXING

Where the prefix letter is shown in capitals this denotes a larger quantity of that particular color. Conversely, where the prefix letter is shown in a lower case, this denotes a smaller quantity of that particular color.

e.g.

Bp = large amount of blue-purple.

bp = small amount of blue-purple.

EXAMPLE B—DULL DAY/CALM WATER

Here the color of the reflection bears no resemblance to the object (tree) reflected. The tree is simply blocking the light from the sky being reflected from the water's surface. Its silhouette is sharp-edged and focused as the water is undisturbed. The reflection, therefore, is a hole in the sky's reflection, allowing us to see through the surface to the water depths below. If there are fish or rocks in the water it will be in this area only that we are able to see them.

EXAMPLE C—BRIGHT DAY/CALM WATER

With the sun out, the tree is lit and becomes much lighter and brighter [Yg+bg]. Such is the strength of these colors that they are reflected down into the water. Even the shadow side of the tree has changed enough to influence the color of its reflection. Both are affected by the color of the water beneath and the fact that not all of the light falling on the water is reflected. That which is absorbed tends to make the reflection a little duller than the tree itself.

EXAMPLE D—DULL DAY/DISTURBED WATER

Disturbance now elongates the reflection and softens the form. This downward pull of the colors is the main element of a reflection. Depth of reflection is extremely difficult to achieve without incorporating it into your technique. However it is often "hidden" by surface detail. Always look below the surface detail for the downward movement of color. Somewhere on the water you will always find it if you look hard enough.

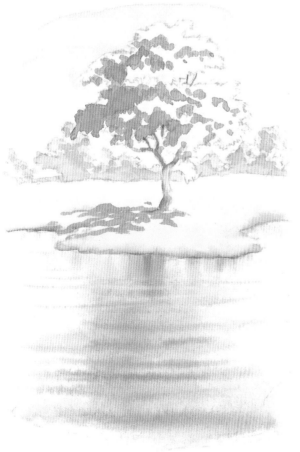

EXAMPLE E—BRIGHT DAY/DISTURBED WATER

The color of sunlight on the foliage is pulled downward into the water. Always make sure that the reflection goes straight down. It is shadow that falls across a surface, whereas a reflection penetrates it. Note how the yellow reflection pulled into the wet sky reflection can "push" the latter to one side to remain bright.

Project 5 Workshop

Combination—reflections in water

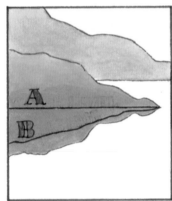

Distant hills are simply reflected along their water level.

Water level [A] and water's edge [B] are not the same in foreground. Reflection of headland works from water level directly beneath.

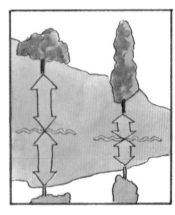

Base of bush is almost at water level, so start construction of its reflection there.

With trees on the bank you must judge how far they are from waterlevel so you can construct their reflection accurately.

So, too, with tree behind headland.

If there were no reflections of trees or land, the water would simply reflect the sky.

If the sky were not reflected, color of water would become lighter into the distance (aerial perspective).

When these two elements are combined, reflection begins to work.

Distant edges—reflection or solid—are softer than those in foreground (aerial perspective).

Positions of reflections are plotted.

Reeds are masked before beginning to paint.

Depth of bank is reduced in the reflection.

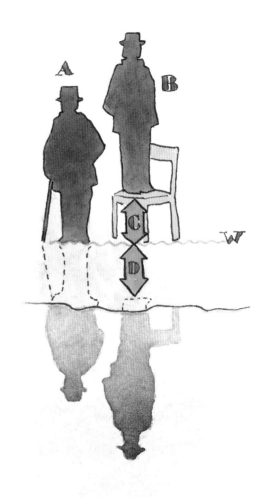

EXAMPLE

On plotting the reflection of the two figures you must imagine that the water does not stop at the water's edge but is extended beneath their feet. If you do this, you'll see that the left-hand figure [A] is standing almost on the water, so its reflection starts here. The right-hand figure [B], however, is some distance from the imagined water surface [W], so we must take account of the height of the chair [C]. This measurement must be "reflected" [D] before we can determine the position of the figure's reflection.

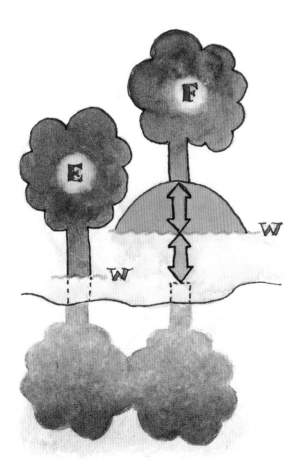

EXAMPLE

Now we have two trees at different distances from the water's edge, one on a small hillock. Once again, the reflection of the left-hand tree [E] begins almost at its base. In [F], however, the "extended" water surface is some distance below and must be taken into account when plotting the reflection. Oddly, the reflections now both seem at the same level, while the trees certainly are not. This explains such a lot about the fact that reflections often look at odds with the objects they are reflecting.

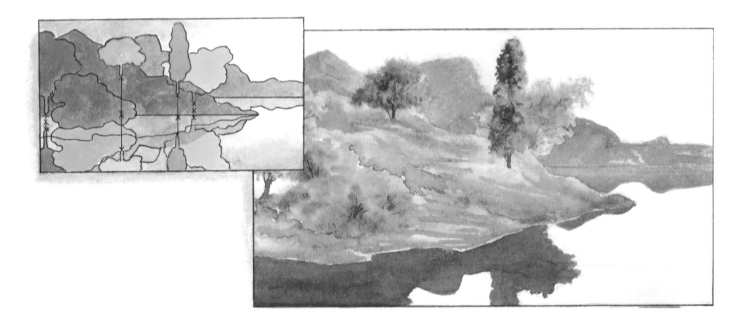

EXAMPLE

In this more complicated composition, all the reflections follow the simple rule detailed. Each tree must be separately plotted to understand its subsequent reflection. In nature one would normally simply observe the shapes of light on the surface of the water, but now that you understand the theory it will be easier to interpret and capture.

Note how the water's edge plays no part in the construction of the reflections.

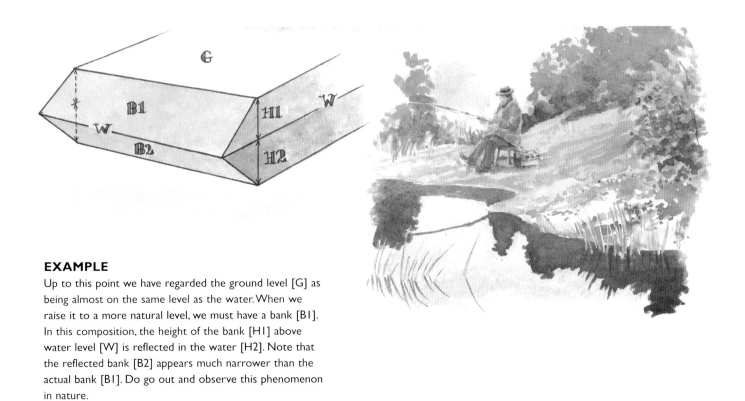

EXAMPLE

Up to this point we have regarded the ground level [G] as being almost on the same level as the water. When we raise it to a more natural level, we must have a bank [B1]. In this composition, the height of the bank [H1] above water level [W] is reflected in the water [H2]. Note that the reflected bank [B2] appears much narrower than the actual bank [B1]. Do go out and observe this phenomenon in nature.

Project 5 Tutorial

Combination—painting buildings

COLOR REFERENCES
Yellow-orange [Yo]
Yellow-green [Yg]
Red-orange [Ro]
Red-purple [Rp]
Blue-purple [Bp]
Blue-green [Bg]

It is little wonder that artists all over the world are drawn to architectural subjects, for these are the signatures of any village, town, city, region, or country. Suffolk barns, Middle Eastern minarets, long houses of Borneo, stilted homes of Asia, pagodas of the Far East, onion domes of Russia, castles, villas, palaces—there's so much to choose from, each providing an instant clue to the location.

Sadly, painting such subjects is often avoided both by those who paint for pleasure and those who paint for a living because they fear the problems of architectural perspective and rigorous drawing which can drain the excitement from the keenest artist's brush.

Yet these are subjects begging to be exploited. They offer both colors and textures, which can be every bit as exciting to capture as the most exquisite sunset. Being a part of history, they also tell a story about the people who lived there and the changes they witnessed.

This tutorial aims to break down the fear of painting buildings and will, should you accept the challenge, provide you with a lifetime of subject matter to consider.

COMPOSITION

When I chose a vantage point to paint from, I opted for a "flat-on" view. By employing this tactic the matter of perspective is reduced to a minimum, as the vertical and horizontal lines are parallel to the sides and bottom of the painting. The thumbnail yielded a very thin rectangle, which eliminated much of the surrounding street. Contained within the composition, trees soften the hard architectural lines. I also introduced some diagonals of sunlight in the foreground that, along with the sunlight on the leaves, provides a frame for the building in shadow.

STEP 1—STARTING OFF

Stretch the paper and commence work when it is fully dry. Lightly draw in the main outlines, ensuring that the verticals are kept parallel to the sides of the picture rectangle. As the building is very symmetrical, a line down through the center helps keep both halves identical. Horizontal lines drawn across this at right angles keep windows and doors level. The placing of the chimney (top right) and trees help ensure that this symmetry does not become overwhelming and creates an interesting negative shape for the sky. Once completed, apply masking fluid with the No. 12 chisel edge to those areas on which the sunlight and highlights will be introduced.

MATERIALS
Rough Watercolor Paper
Automatic Pencil, 2B 0.5 mm
Watercolor Brushes
chisel edge No. 12
no. 8 round plus smaller round brushes for accents and linework
44 mm Hake
Tubes of 6 Primary Watercolor Paints
Cadmium Yellow [yellow-orange]
Primary Yellow [yellow-green]
Cadmium Red [red-orange]
Crimson Red [red-purple]
Ultramarine [blue-purple]
Prussian Blue [blue-green]
Kneadable Putty Rubber
Masking Fluid

ACCENTS

All paintings require dark accents against which the lighter colors can contrast. As such they are as important as highlights. Often the problem is that these accents can be too dull or lack color. To avoid this, I created three large mixes of dull secondary colors on the palette:

[A] Dark orange [ro + yo + Bp]
[B] Dark purple [Bp + ro]
[C] Dark green [Bp + yo].

These were used where appropriate. (Note bias toward blue = cool shadow.) Brushes down to No. 3 and a rigger were used to apply accent detail and linework. "Spot Color," or areas of bright color, were also exploited within the woodwork of the ground and first-floor windows.

STEP 2—FIRST LAYER

The first layer of paint is applied using only the one brush, the No. 12 chisel edge, to prevent overworking and fussing with detail. Apply these highlight colors swiftly, into a surface wetted with the Hake brush.

- SKY—Bp working down gradually to Yo.

- LEAVES—Yg + bg, painted now, so that the building can be painted between leaf masses.

- BUILDING GABLE/APEX—Bp + Ro.

- BRICKS—Ro + Yo + bp.

- WINDOWS—a series of colored grays painted with one stroke of the chisel edge after pulling "flat" on the palettes surface. Top windows—Bp + ro; Middle windows—Bg + ro; Bottom windows—Ro + Yo + bp.

- PAVEMENT—Bp + Ro. Colored grays again to the buildings on either side.

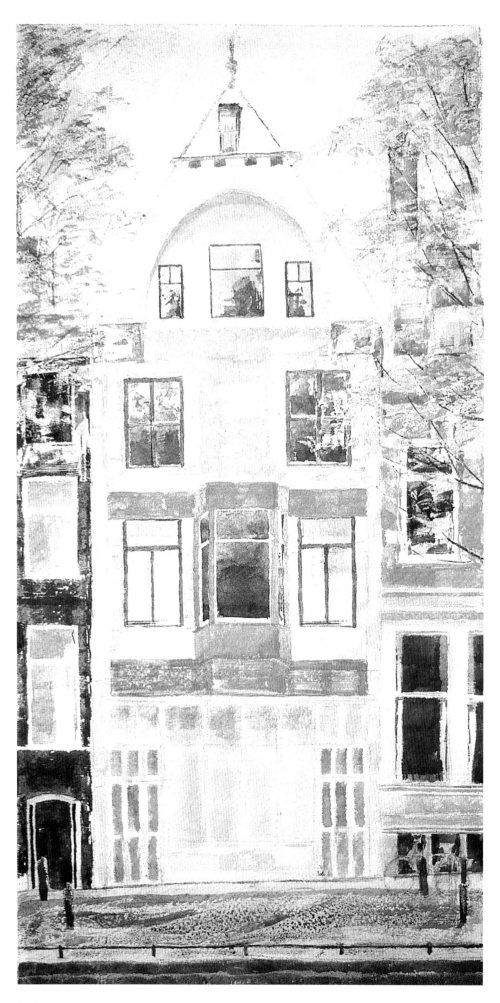

STEP 3—SECOND LAYER

Even at this relatively late stage you can decide to add another focal point, here a small one in the form of a bicycle placed to the bottom right of the building. This helps to offset the symmetry in the bottom half of the composition. An area of paint is lifted off where this addition is to be placed. Again the No. 12 chisel edge brush is employed to good effect in creating washes and scumbles on brickwork, and in defining the squared window shapes with its flat end. In this layer the differing values across the face of the structure are rendered. This patterning of light and dark excites the eye moving across the painting, as the building takes shape. All achieved with nothing more than the No. 12 chisel edge brush.

STEP 4—REMOVING MASKING FLUID

The masking fluid should now be removed gently using a putty rubber.

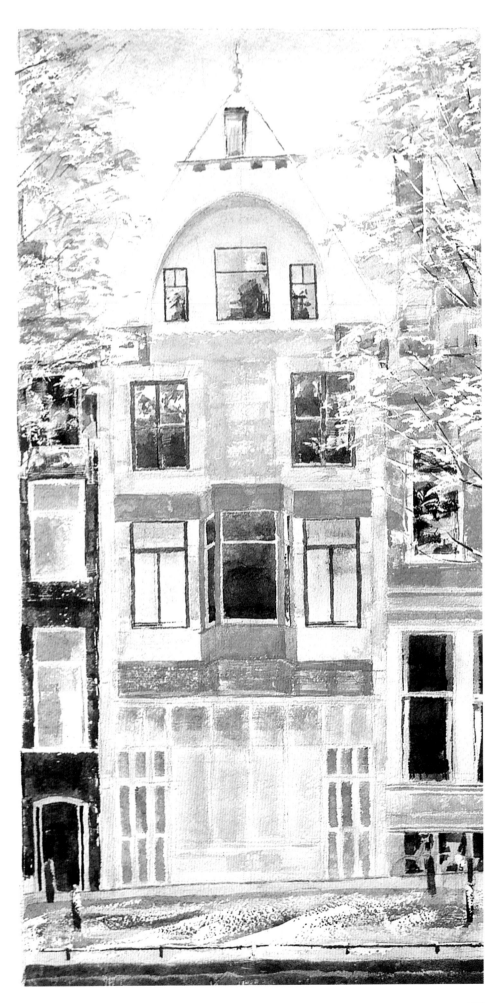

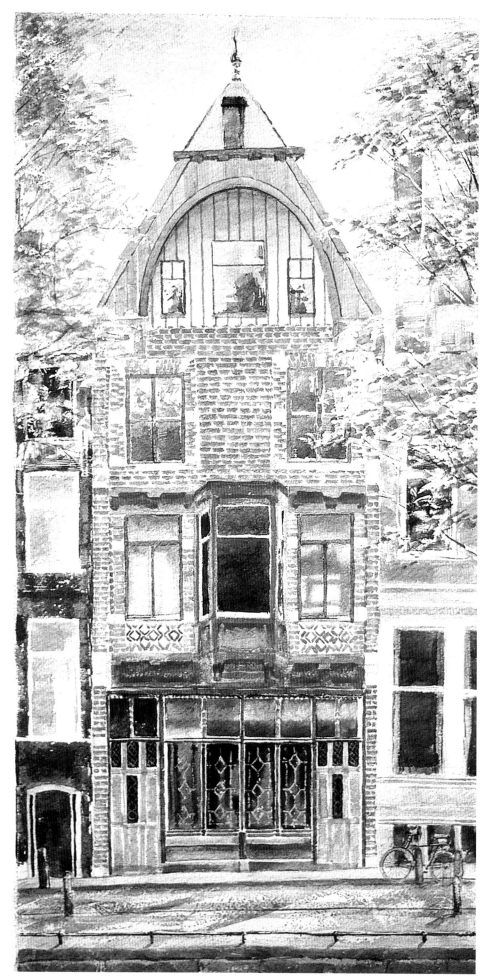

STEP 5—ADDING DETAIL

- *Model the trees by introducing sunlight to the previously masked areas [Yg + bg] and shadows along the base of the leaf platforms [Yg + Bg + ro].*

- *Yellow-orange on branches suggests sunlight with contrasting brown accents [Yo + Ro + bp].*

- *An orange wash [Ro + yo] over the blue-gray apex/gable produces an interesting layered gray color.*

- *The light-colored stripes below this are light against dark at the top, then dark against light below. To create this effect, paint around the top stripes with a darker purple, before applying the color to them.*

- *Use the No. 8 round brush to block and scumble-in the brickwork.*

- *Masking fluid is now applied over the painted fretwork of the lower windows and the wood highlights above them. Wait until the mask is dry, and then paint the first-floor windowpanes into a wetted surface. (This technique is called restricted wet-in-wet—with a round or chisel edge brush wet only the area you are about to paint to achieve internal soft edges.) Now turn to the ground-floor windowpanes and paint them first in a light color, then immediately, working into the wet paint, add a darker and bluer color. Note the base color of each of these colored gray accents—blue, green, yellow etc. In this step-by-step the middle window, which had become too dull, was given a strong wash of pure Ultramarine. Apply accents to the window frames using browns [Ro + Yo + bp] or purple [Ro + bp]— these contrast with the colors of the windowpanes within. Lay a dull purple [Ro + Bp] into prewetted rectangles under the groundfloor windows. Unpainted areas become highlights by contrast.*

- *Lay Yo over the foreground to suggest sunlight and apply gentle detail to the bicycle using the No. 8 round. By adding linework to the bollards, the railing, the wood, and the stoneware, the suggested detail brings the foreground into some focus.*

STEP 6—FINISHING OFF

Gently remove the masking fluid, using the kneadable putty rubber, to reveal the previously protected highlight accents on windows, doors, and woodwork.

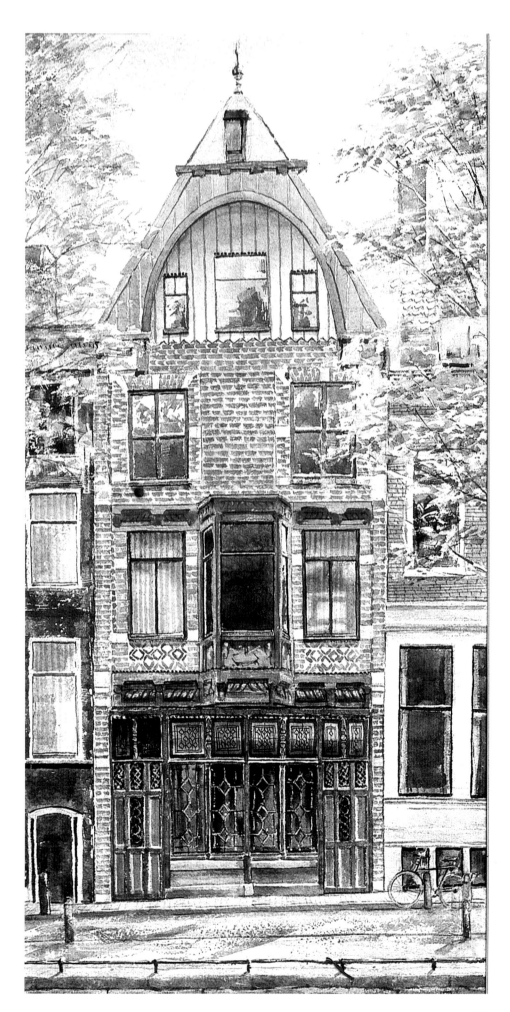

Tricks of the Trade

Steady as you go

Working on areas of fine detail can present problems, often nothing to do with the ability of the artist, but everything to do with the incorrect handling of the brush.

If the hand holding the brush is too close to the surface, this results in inflexibility of the wrist. This, in turn, leads to the brush being presented at the wrong angle to the surface.

It is a simple matter to pull the hand back from the surface, support it on the other hand, and the problem is solved.

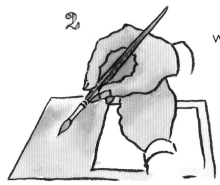

When working flat it is advisable to protect the work with a piece of paper. This prevents soiling with grease from the hand.

If you don't have a surface on which to rest your hands, support your hand below the wrist. This still allows flexibility when painting, while providing stability. When working for some time, rest the supporting arm on your knee.

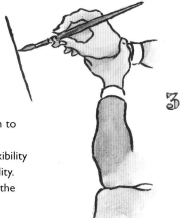

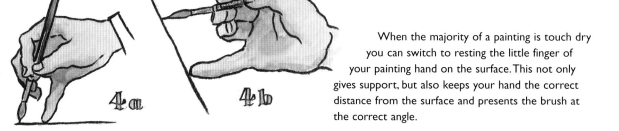

When the majority of a painting is touch dry you can switch to resting the little finger of your painting hand on the surface. This not only gives support, but also keeps your hand the correct distance from the surface and presents the brush at the correct angle.

Another option is to rest a ruler across two rolls of tape placed on either side of the work. This is ideal for detail work requiring a steady hand.

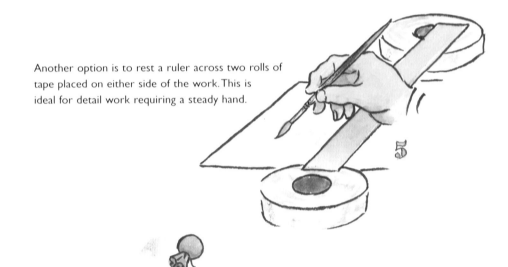

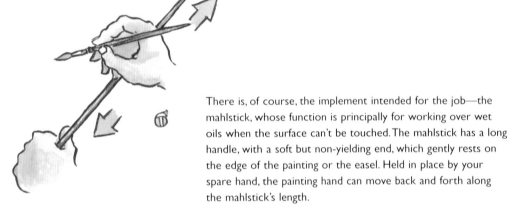

There is, of course, the implement intended for the job—the mahlstick, whose function is principally for working over wet oils when the surface can't be touched. The mahlstick has a long handle, with a soft but non-yielding end, which gently rests on the edge of the painting or the easel. Held in place by your spare hand, the painting hand can move back and forth along the mahlstick's length.

TIP
Some artists use the mahlstick in place of a ruler to draw lines. If the stick is moved as the line is drawn, a curved line results.

MAKE YOUR OWN—tie a sponge onto a length of dowel. Make sure the dowel is strong enough to take the weight without bending or snapping, and is long enough to reach across, around three feet (a meter) in length.

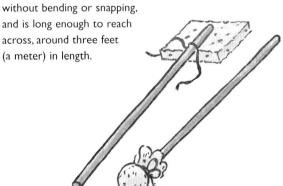

Common Problems

Wet-on-wet watercolor: brush loading

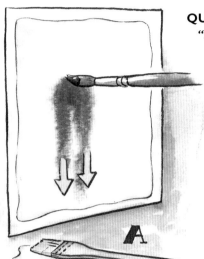

QUERY

"How do I apply the paint to get the best results in wet-on-wet painting?"

ANSWER

Working upright, first wet the paper with a large brush, preferably a Hake. With a fully loaded round brush, apply a few strokes of paint to the surface [A]. Runs will occur immediately, running down a board in the upright position, and in all directions on one that is laid flat [B].

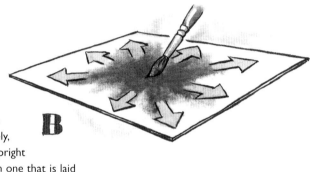

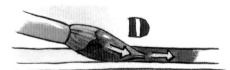

Should this be the required result, then all is well, but what if you wish to preserve the integrity of the brush stroke? There are two ways in which this can be achieved and these can be linked directly to the stage at which you are in your painting.

Usually, when at the start of a watercolor painting, a swift blocking in of colors is required to establish the main masses and highlights. These colors are kept light so that once applied and assessed, changes can still be made to the overall composition. So, the paint mix is kept very fluid with lots of water and it is precisely this "fluid" mix that flows or "explodes" when applied to the wet surface. When a heavy pool of fluid is deposited on the wet surface, the water already present on the surface allows the pool to expand to level out. This outward flow causes the "explosion" [C].

The aim is to load the brush with just the right amount of fluid so that it can slip the pigment into the wet surface without unsettling the water on the surface [D]. To do this, excess fluid must be eliminated from the brush and this can be achieved in several ways.

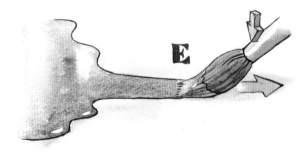

PRACTICE MAKES PERFECT

If you are trying wet-on-wet for the first time, don't despair if you feel that you aren't getting the hang of it. It takes a while to get the feel for the correct levels of water required for the two techniques.

Mix your color on a palette with a large flat surface. With your brush, pull the color away from the main mix, along the palette. This action will both squeeze out and deposit the contents of the brush head [E].

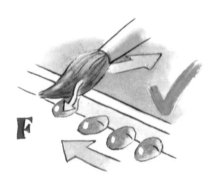

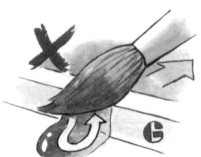

HAKE BRUSH

Made from soft goat's hair, this brush holds a great deal of water and will deposit a fast, even layer of water or fluid paint across the paper's surface.

Scraping the brush head across the rim of the palette also squeezes out water [F]— but do make sure you move along the edge with each stroke. Keeping the brush head in the same position will both squeeze out and re-absorb deposited fluid, defeating the purpose [G].

Dabbing on a tissue [H] also does the job, but be careful not to remove too much fluid as the brush will become "thirsty" and lift off fluid from the paper's surface, rather than deposit color.

QUERY

"Can I ever use really stiff paint straight from the tube? When and where would this be most appropriate?"

ANSWER

The second layer of a wet-on-wet painting can be used to create dark soft accents. For this a stiff mix is required, using paint almost directly from the tube.

This is thinly spread across the palette surface [J] and will dry swiftly. Add water when necessary by dipping the very tip of your brush into your water supply and transferring to the mix on the palette. The resultant stiff mix has the effect of shaping the round brush, so that when applying the color to the wet paper you can create a variety of marks [K].

Project 6

Combination—painting reflections from photographs and nature

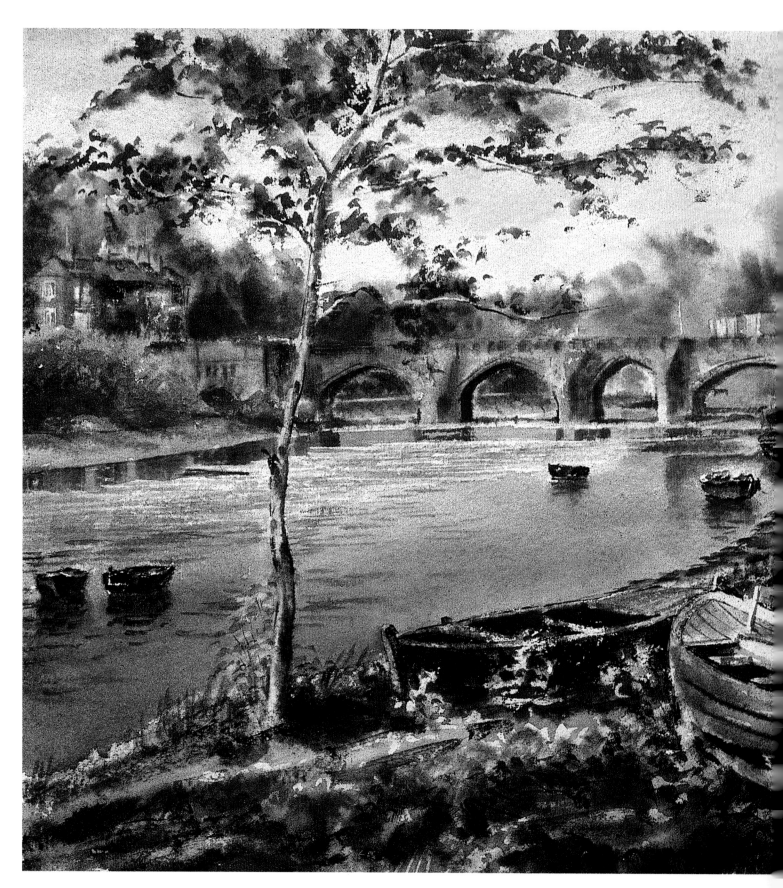

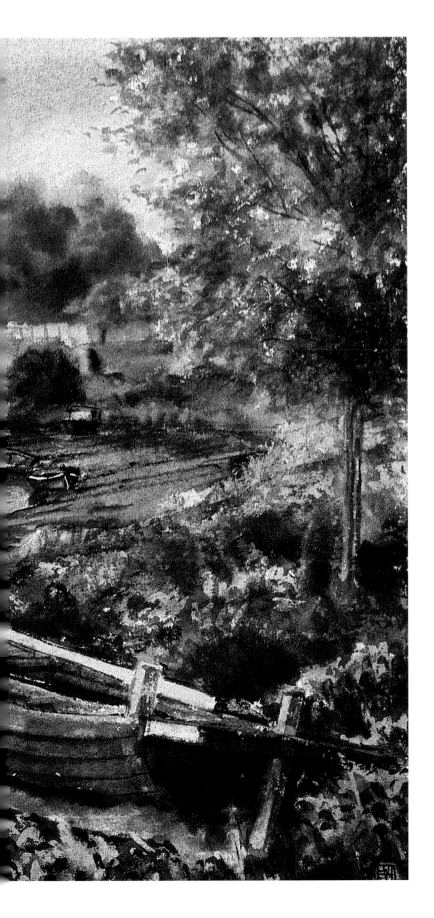

Painting landscapes is an all-time favorite, but can photographs be used legitimately for reference material? Yes, of course they can! For beginners they are ideal, providing something to aim for. For enthusiasts they are ideal when the artist is not in a position to produce a painting on the spot. It is certainly preferable if the references were photographed by the artist personally, for in taking them much can be observed and absorbed about the subject—information that will reinforce the memories when it comes to working from the photographs.

What if the only reference you can access is not your own, or you choose to work from someone else's material? There is nothing wrong with this approach, but be cautious not to be a slave to the original reference. It is better to use the material as inspiration and for information on detail that is critical to recognition of the subject.

Used astutely, the camera is unsurpassed as one of the artist's most useful tools, along with a sketchbook for making visual and color notes. As soon as the camera came on the scene, many painters used it widely, recognizing its value as a recording device. To get the best from using a photograph, it is important to develop a method of working, which involves being able to analyse each shot to determine its strengths, but more importantly its weaknesses.

The art of the photographer is that of capturing a moment in time—being in the right place and at the right time, with the camera primed and ready. The resulting photograph is of that fixed moment and all the elements that exist within the framework of that shot. Painters, on the other hand, can contemplate the subject. They can move or shrink a component, dispose of another, and obliterate something that offends. This is as true for working from a photograph, as it is for working on the spot.

The principle of using thumbnails and sketches is also as pertinent when working from reference material as it is when painting in situ. This process allows the painter to evolve the composition into something unique, before making a start on the painting. Going through these initial steps will help you achieve something that can be an improvement on the photograph.

Working out of doors, on the other hand, may seem at first intimidating. Do try it out, however, for more will be learned in a day spent out of doors, than many days working indoors.

Start in the privacy of a secluded private place, and you will gain experience unique to working in situ. You will learn quickly about color mixing through having to work with the ever-changing light, that brings with it changes to the colors in the subject being painted. Watch how shapes seem to shift as shadows deepen and lighten, come and go. Experience the behavioral differences in your materials—how paints perform when the air is still or moving, warm or cold. But, most importantly, there is nothing to surpass the feeling of achievement, when you pack up your materials and head for home with a painting under your arm.

Project 6 Workshop

Combination—painting reflections from photographs

COLOR REFERENCES
Yellow-orange (Yo)
Yellow-green (Yg)
Red-orange (Ro)
Red-purple (Rp)
Blue-purple (Bp)
Blue-green (Bg)

Plot out positions of reflections—straight down into the water.

TIP: Having drawn a tree on tracing paper, fold along the tree root.

Rub down vigorosly with the back of a spoon . . .

. . . to transfer its reflection to the "water."

The further back a tree, the higher the fold required to pass through "roots"—see diagram.

Trace outlines onto back of tracing paper (top). Reverse and rub image onto stretched paper.

MASKING WATER LILIES
Sharp edges will establish water's surface. Use horizontal strokes of varied length and pressure.

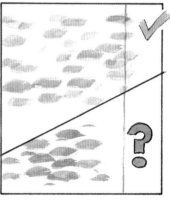

Don't worry if mask goes beyond edge of drawing. Preferable to not going far enough.

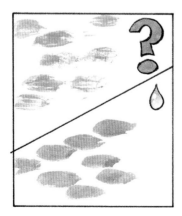

Brush marks beginning to scumble when they should be solid. Add a drop of water to fluid.

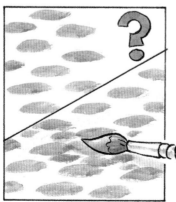

Don't fall into unnatural, regular patterns. Return and fill in some spaces to "naturalize" the balance of shapes.

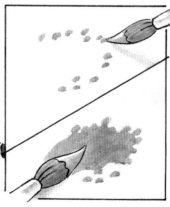

FLOWERS—Dot in irregular edges before filling in body of flower mass.

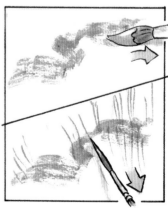

GRASSES—Drag scumbled texture before adding individual grass blades with Rigger brush.

STEP 3 Overlapping shapes (planes) suggest depth and recession.

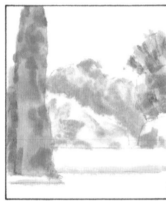

Overlapping painted shapes give the same effect.

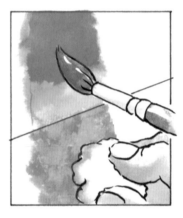

Trees painted with middle values (TOP) are then dabbed while wet, with clean absorbent tissue. This is TONKING.

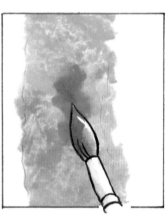

While still wet, further texture is stippled on with side of brush.

STEP 4 Wet water in sections and pull color down. Darken lower section to suggest depth and receding surface.

Allow to dry—then rewet and apply darker values.

Tonk (TOP) to create soft textures (BOTTOM).

Damp brush drawn horizontally through still-wet wash creates "line resist" suggesting ripples.

STEP 5 Gently redraw lilies (TOP) then remask with masking fluid.

Apply lily pad color wet-on-dry. Lift mask. Flatten brush point to suggest leading-edge shadow.

FOREGROUND—Scumble dry color onto grasses.

Apply more fluidly for broad leaves of bush so they appear more solid.

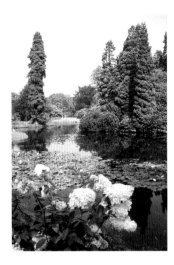
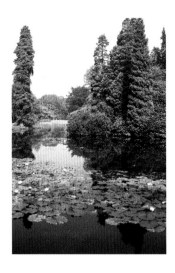

A wonderfully calm day yields an almost perfect reflection. The grounds surrounding the lake are quite level, reaching no great height over the water level itself. In this case the reflections can be assumed to start at the bottom of each tree. Your drawing on the watercolor paper should be kept as simple and as gentle as possible. The majority of the colors and shapes in the reflection will ultimately be soft-edged and transparent. Over-enthusiastic quantities of pencil work will almost certainly show through and diminish the quality of the final result. Reflections of both trees and sky must be kept transparent and soft, even though they become involved with water lilies and foreground foliage. The only answer is masking fluid. With this in place you can concentrate on the reflection, returning to the complexities of the foreground foliage in your own time.

DIAGRAM

F1, F2, F3, F4 indicate position of folds in paper required to construct reflections by transferral of pencil through rubbing as demonstrated in Artstrip.

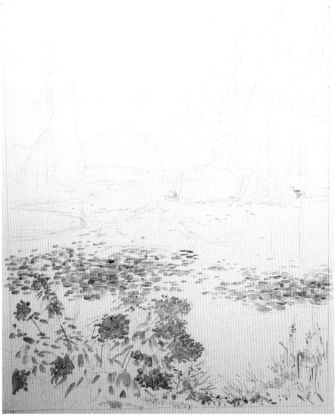

STEP 1

Once the drawing has been gently transferred to the previously stretched paper, considerable masking fluid should be applied to the foreground. The intention here is that the focal point of the painting will be the foreground and the water, with the trees as a soft backdrop to the scene. Masking fluid creates sharp-edged brush strokes, which will create the focus needed to keep the eye fixed on the important elements of the composition. The mask always looks powerful against the pure white paper and it is so easy to think you have overdone it. Look at how the area covered seems to shrink once the color is applied and you will know that you must be bold with the mask.

STEP 2

The first layer of color is applied wet-on-wet. This technique will supply the soft brush strokes needed for the distant trees and the fluid water surface. Use as large a brush as possible, starting from the top with the yellow-greens of sunshine highlights on foliage. Keep the graded wash on the water brushy, to suggest reflections of clouds. The foreground foliage needs to be dark dull-green. Here, unlike the distant trees, the highlight colors are masked and we are painting the soft, dark shadows.

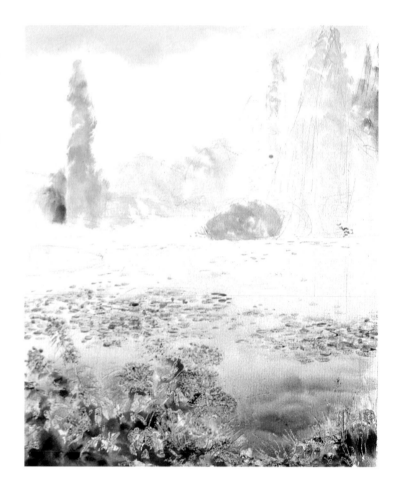

MATERIALS
Cartridge Paper
Absorbent Tissue
Rough Watercolor Paper
Automatic Pencil, 2B 0.5mm
Brushes
round watercolor
Rigger
44mm Hake
Tubes of 6 primary Watercolor Paints
Kneadable Putty Rubber
Masking Fluid

STEP 3

A dull red-purple graded wash (Ro+BP) is applied wet-on-wet, across the water surface, to add extra contrast against the foreground white flowers. Any remaining pencil work is to be removed by working gently with a putty rubber, especially against the sky, which is to remain light. Note how the trees, right, exploit counterchange by being dark against the sky, but lower down, are light with sunlight. Tonking (see Artstrip) must be swift, while paint is still wet. If necessary, paint small sections and tonk individually.

Project 6 Workshop

Painting reflections from photographs

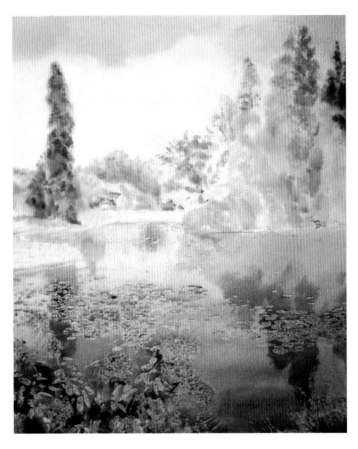

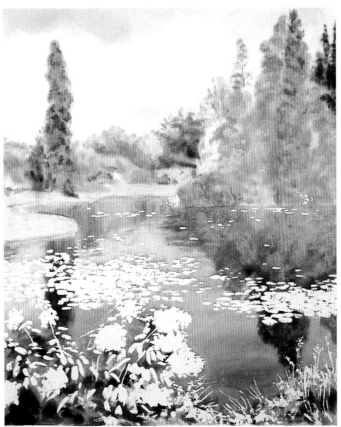

STEP 4

The application of darker values to the trees continues with tonks supplying the soft textures that suggest leaf masses. Their reflection in the water becomes darker as it moves lower. This not only echoes the counterchange of the values in the actual trees, but creates a recession over the water surface. I always encourage a downward stroke of the brush to suggest reflective surfaces and the tree reflections on the left are entirely created this way. Any texture here is sublimated to this vertical movement and works as a perfect foil to the hard horizontal element introduced in the lily pads, which effectively position the level of the water surface. The masking fluid is now removed.

MAKING NOTES

From the color variances of the photographs of the steps in this painting, taken on the spot, you can see quite clearly how the sun moved across the sky. With shorter days such as this (early November), the changes in sunlight—and, therefore, the shadows—are quite marked and can be very frustrating to a painter. Being well aware that the dramatic shadows across the lake would rapidly disappear as the sun moved, I had to make a note of their general position on the swiftly completed thumbnail.

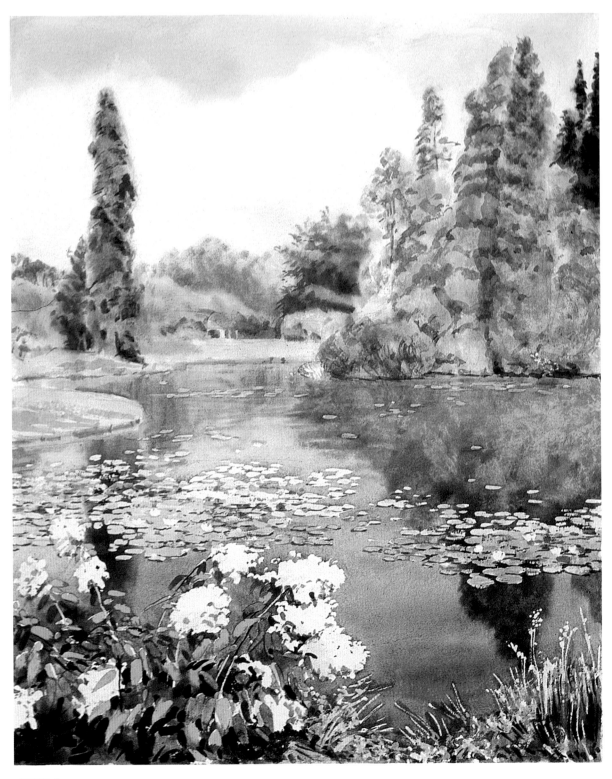

STEP 5

Apply middle value wet-on-dry brush strokes to create gentle focus on the distant trees. Variety in your directional strokes is essential now. They must not be overworked or they might lift previously laid color and begin to look dirty. Be bold, yet gentle; avoid blending, to keep color strokes clean and simple. Warm orange-reds give some complementary contrast, making greens seem more intense. The flower heads are simplified in order not to lose the purity of their "whiteness." First wash them with yellow (Yo+Yg); then, while still wet, wash them with a shadow of dull orange (Yo+ro+bp). When dry, apply a few accents of light brown (Yo+ro+Bp) to break up the otherwise solid "white" silhouette. Note the orange touches to stems and their stark contrasting value in shadow, producing a linear structure, which balances with the blades of grass on the right.

Project 6 Tutorial

Painting reflections from nature

<div style="float: left; border: 1px solid black; padding: 8px;">

MATERIALS

Rough Watercolor Paper
Automatic Pencil, 2B 0.5mm
Brushes
large chisel edge sable
large round sable
Rigger
flat nylon with short head
44mm Hake
6 Primary Watercolor Paints
plus Phthalocyanine Blue for sky
Kneadable Putty Rubber
Masking Fluid

</div>

It was one of those days that greet you with a sun-filled sky grazed by will-o'-the-wisps of clouds. One just knew it was going to stay that way: a crisp autumn day, where a step into shadow meant a considerable drop in temperature—a day when all that was needed to keep warm was to don a favorite jumper and move from one sunny spot to another.

So it was that the planned schedule for the day was cancelled, in favor of throwing some materials into the car and driving off in search of a "stunning view," something that would capture the essence of autumn, but more importantly, something that could be completed in a day and on the spot.

The view was stunning as I set up my easel. Low autumnal sunlight was slicing through dark evergreens and falling across the lake. Here it picked up the bright greens of copious amounts of pondweed, so thick in places it resembled a grassy lawn. Behind the lake the trees were just beginning to come into their full autumn glory, while still retaining a hint of green to offset their new warmth of color.

TECHNIQUE

This painting was completed predominantly with the chisel edge sign writer's brush and a Hake. It was a swift rendition through which the brush strokes would create the structure of the individual components. The combination—two layers of wet-on-wet and a third wet-on-dry.

CHISEL EDGE SIGN WRITER'S BRUSH

Round in cross section, flat ended when dry [A], it shapes into a natural chisel edge when wet [B].

The tip can be used to create line, or pulled from the line creates an edge of color. Excellent for washes when worked with slowly, and yields scumbles when worked with quickly.
TRY THIS — Move from brush point to side of brush in one stroke.

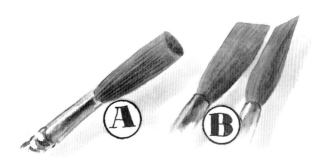

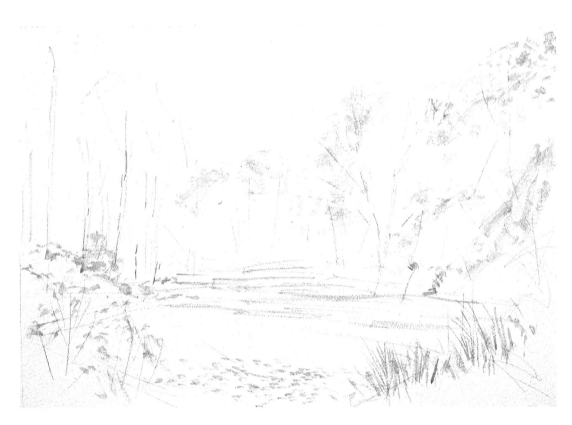

STEP 1 — STARTING OFF

Transfer chosen thumbnail proportions onto previously stretched watercolor paper, lightly sketching in the basic masses. To protect the bright, sharp highlights, such as the sunlight on the autumn golds, use masking fluid applied with a large round brush. The grasses and foliage of the foreground against the soft texture of the lake cannot be captured successfully, unless you protect them with masking fluid at this stage.

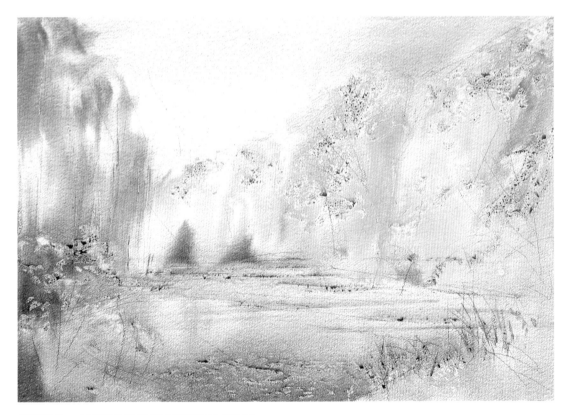

STEP 2 — WET-ON-WET FIRST LAYER

Wet the whole surface with the Hake, liberally brushing on a first layer of water. Prepare first washes on the palette and then give the paper a second wetting, before applying the first color wash. Use the Hake to begin painting the sky wet-on-wet, with the Phthalocyanine Blue, adding more Ultramarine on the right. Painting this with the Hake adds more drama and spontaneity, not to mention getting the large surface covered before it has a chance to dry (the painting measures 18 in x 26½in (458 mm x 673 mm). One of the advantages of working on this autumn day was that the surface took a long time to dry out, giving me plenty of time to complete the first layer. Working from light to dark, as one does in watercolor, the first layer of light colors should, nevertheless, be applied powerfully, as watercolor invariably fades as it dries and this composition demands powerful colors. Even at this stage one can see the strong opposition of the colors of the trees catching the full sunlight against the coolness of the evergreens (left) in shadow.

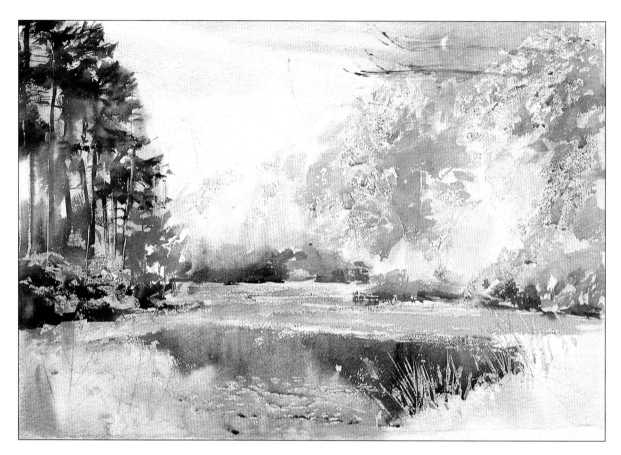

STEP 3 — WET-ON-WET SECOND LAYER

The moon is introduced by lifting off the background color with a flat nylon brush. This is then strengthened by repainting the surrounding sky. Rewetting only the sky for this not only offers the opportunity to add soft shapes, indicating wispy cloud; it also allows the top right edge to dry sharp, giving a crisp edge to the treetops. The conifers on the left are a great joy to paint with the chisel edge brush. First, wet the surface unevenly, so that the added brush strokes erratically blend into the underlying colors, creating interesting depth. Mix a variety of blue-greens with the addition of reds to achieve the necessary cool, dull shadow color. As the surface begins to dry, add darker accents to the still-wet pools of color. The bright autumnal trees should be approached in a similar fashion, again exploiting the wonderful scumbled brush strokes that can be achieved with the chisel edge brush. A maroon-colored reflection should be dragged down from the edge of the weed mass and softened along its lower edge with a Hake. While still wet, boldly draw downward the bright colors required for the reflections of the trees above.

DAYTIME MOON

Only after I had started the painting did the half moon [top right] come to my notice. Luckily I was able to incorporate it in the picture, and I feel it adds a certain quality to the whole, one that would have been missed had I worked from photographs. As the day wore on it moved out of sight, and eventually a passer-by couldn't help but ask, "Do you always paint an artificial moon into your picture, even though it isn't there?" Many passing walkers stopped and chatted awhile on that day, remarking on the painting and comparing it to the actual view; all were pleasantly surprised when informed that the moon was a genuine observation.

STEP 4—REMOVING MASKING FLUID

Apply some broad strokes of color to the foreground grass banks and leave the painting to dry. When completely dry, remove the masking fluid with a putty rubber. Many surprises were revealed on this painting—some I liked, others I did not, as is always the case with a mask.

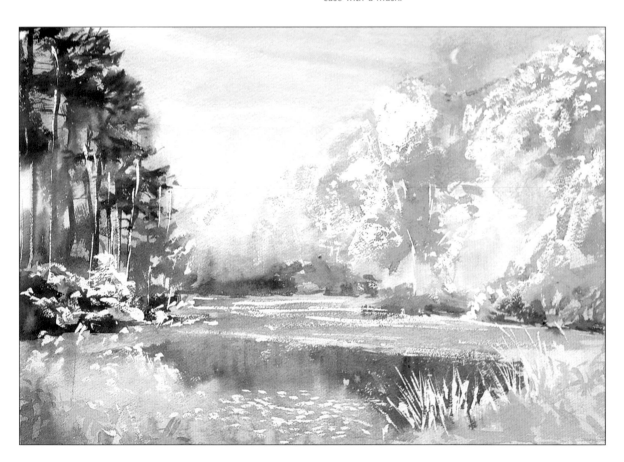

REFLECTION Flatten chisel round by pulling across palette from paint mix.

"Pull" color down from weed edge. Note flat angle of brush to paper.

Wet Hake thoroughly, then tap gently against flat tissue to shape and remove excess water.

Pull through bottom third of still-wet paint strokes and blend away hard edge as you continue down.

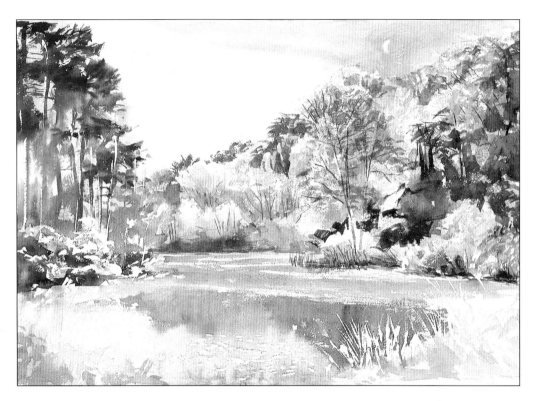

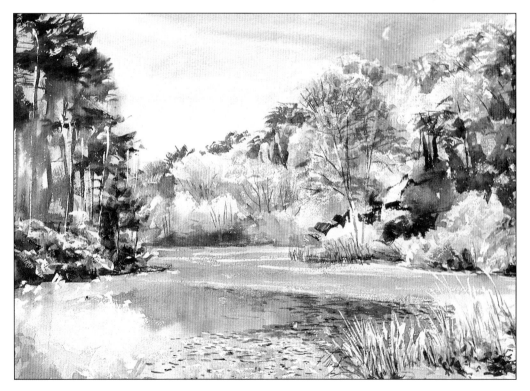

STEP 5 — MIXED TECHNIQUES STRENGTHENING LAYER

Using the chisel edge brush, work on the golden trees using wet-on-dry, to add focus and structure. A very light tree mass is often "created" by painting a strong dark area behind and around it. This is called negative painting. Once the silhouette has been achieved, turn to the texture inside the mass of trees. The dark areas must be applied really strongly so that they do not lose impact upon drying. Cooler, darker accents should be introduced into them while they are still wet, the technique called restricted wet-on-wet. The rigger brush is perfect for capturing some of the fine trunks and branches. Some yellow sunlight added to the surface weed is progressively watered down as it moves into the distance to suggest the change wrought to the color by aerial perspective.

Middle blue-greens, added to the small trees and undergrowth beneath the firs, will enrich their density. Use the rigger, to scatter a suggestion of grey-green weed over the surface of the water. Move to the grasses to the foreground right; paint them yellow first, moving through to orange-red. This moves through to dark green at the base so that the finished effect is one of counterchange — light against dark at their tips, dark against light at their base.

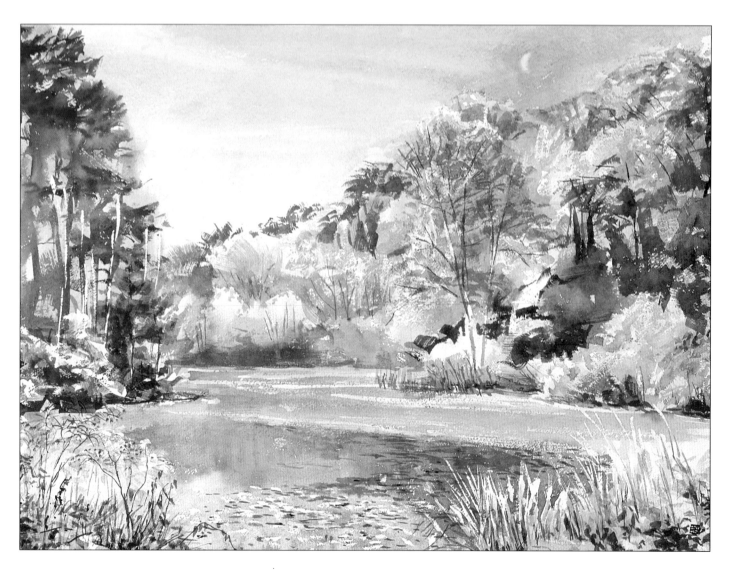

STEP 6 — FINISHING OFF

For the final touches, move to the weedy growth in the right foreground. Scumble soft pink into the masked areas. Paint over linework and detail with the flattened edge of the chisel brush. The detail here is sharp and dark against a light area of water, a counterchange to the grasses on the right which are light against dark water. This balance not only creates interest for the eye, but also prevents the foreground being a visual barrier to the rest of the composition. The temptation to overwork foreground detail is always present so I stopped myself short, allowing brush strokes to remain suggestive—the choice is yours.

Tricks of the Trade

Getting the point: watercolor brushes

Taking a few simple precautions in the care of brushes can save an enormous amount of money on their seemingly and totally unnecessary short-lived existences. This is especially crucial when sable brushes form part of your painting kit.

Furthermore, and all too often, artists feel they are responsible for bad workmanship, when it is their tools that are letting them down. Brushes will only respond to the best of their abilities and if they have not been cared for properly, they are guaranteed to let you down.

MOTH ATTACK A more common problem than might be imagined, the moth larvae are often not noticed until they have chewed away at the very base of the hair, causing irreparable damage. The simplest solution is to place the dry brush in a closed drawer, accompanied by mothballs. I line my drawer with corrugated cardboard. Sitting the brushes in the slots prevents them rolling together and also helps to easily identify which brush I need [A].

PLASTIC SLEEVE These often protect new brush heads. Keep them to use again, they are invaluable when carrying brushes around. To make your own, roll some paper round the head and fix with sticky tape. I prefer blotting paper, but any stiff paper will do [B]. For small thin brushes a split drinking straw is ideal [C].

NEW BRUSHES Sometimes they seem hard and stiff, because of the coating applied to preserve their shape and protect against moth damage. This dissolves in water, but you are left with the problem of protecting the now soft, malleable and easily damaged head. There are several simple steps you should follow to make your brushes last longer.

Try not to let paint dry in your brush. Even watercolor can cause damage over a period of time. At the end of a painting session clean with soap and cold water. Never use hot as this can weaken the glue holding the hairs in place and could cause the metal ferule to expand, loosening the hairs. Gently work the soap into the center and base of the brush head with a fingernail [D].

BRUSH CLEANER I prefer a brush cleaner rather than soap for the job, it is amazing how much more paint this releases, and it also helps to keep the brush head in good condition. A second application of the cleaner can be left on the brush head to dry. This allows you to "point" the brush and dries to a stiff protective coating for storage and transport. When the brush is required for use, all you need do is wash out the coating or "flick" it out of the brush head [E]. Do not use household soap for this purpose as it dries too hard and the brush hairs can actually snap or suffer damage.

STORAGE Brushes should be stored upright to dry [F], never left standing on their heads, even in water [G]. They should not be allowed to dry misshapen, even when carried about — they can only too easily retain this incorrect shape. Should this ever happen try the following simple trick, the result will depend on how long the brush has been in this condition. Apply a heavy dose of brush cleaner, reshape the brush head, and leave to dry with the cleaner still in brush head. After a couple of days gently rinse off.

It is far better to avoid such damage. A brush carrier is useful and there are several types you could purchase.

MAKE YOUR OWN

Brush Roll Interweave elastic at two points, into rush place mat and tack at each end. Roll up, fixing with a shoelace [H].

Brush Tube Outer tube is plastic piping, each end closed with reusable plastic lid. Don't have brushes loose inside. Fix them to stiff card with elastic sewn into loops [J]. Excellent cardboard tubes with ends are to be found around gift-packaged liquor bottles!

Common Problems

Watercolor brushes

Here we tackle some of the most common problems that arise due to brushes being incorrectly cleaned or handled during a painting session.

PROBLEM

"I just can't seem to get some colors out of my brush when I'm mixing my watercolors and I end up with dirty mixes."

ANSWER

Some colors are more powerful than others. Prussian Blue for example has a very strong "tinting strength" and you need only a tiny amount to change a color mix. This sort of color can be difficult to rinse out from your brush, especially those made of nylon and it can frequently accumulate around the base of each hair.

SOLUTION

To get the water to this area, push the brush head against the side of your water jar and rotate. When you feel all the color has gone, place the brush in a clean tissue. Gently squeeze and roll between finger and thumb. Inspecting the tissue will tell you if you have been successful in removing all of the color.

CAUTION
Never pull brush hairs along their length. This can weaken, snap, and even pull the hairs free of the ferrule.

QUERY

"My watercolor brush is always transferring color to the fresh colors in my palette. Do I have to clean my brush every time I need more color?"

ANSWER

Cleaning your brush each time you need more pigment is wasteful of time and paint.

SOLUTION

If you can reduce the amount of fluid in the brush head it is much less likely to spread into your freshly squeezed color. Gently press out the color into the flat of your palette with a finger applied to the brush head. Don't use too much pressure or you could pull out the hairs of the brush. A gentle squeeze will relieve the brush of the excess fluid and as a "thirsty" brush will now suck up color rather than deposit it.

LOADING BRUSHES

**Do your brushes tend to splay and open during use, resulting in lack of control? You are not using enough paint!
Brushes can hold a great deal of liquid, which temporarily binds each hair to its neighbors.
You must choose either to fill the brush you are using, or to use a smaller one that will fill more easily.
Don't compromise if you need the bigger brush to do a proper job on the painting in hand!**

PROBLEM

"When I begin to use my brush at the beginning of a painting session it seems reluctant to take up enough paint."

SOLUTION

You can always add a few drops of Ox Gall to your water pot. This breaks the water tension, not unlike soap, and allows the water and paint to adhere to the brush more readily.

However, more often than not, you can simply tap your brush against the bottom of the water pot, ensuring that all the hairs open up. You will often see a bubble rise to the top which was air trapped in the hairs. When applying paint to the brush, carry out the same action against the palette surface to open up the hairs.

So many people just mix with the tip of the brush, and this is only exploiting a fraction of its volume, equlvalent to using a much smaller brush!

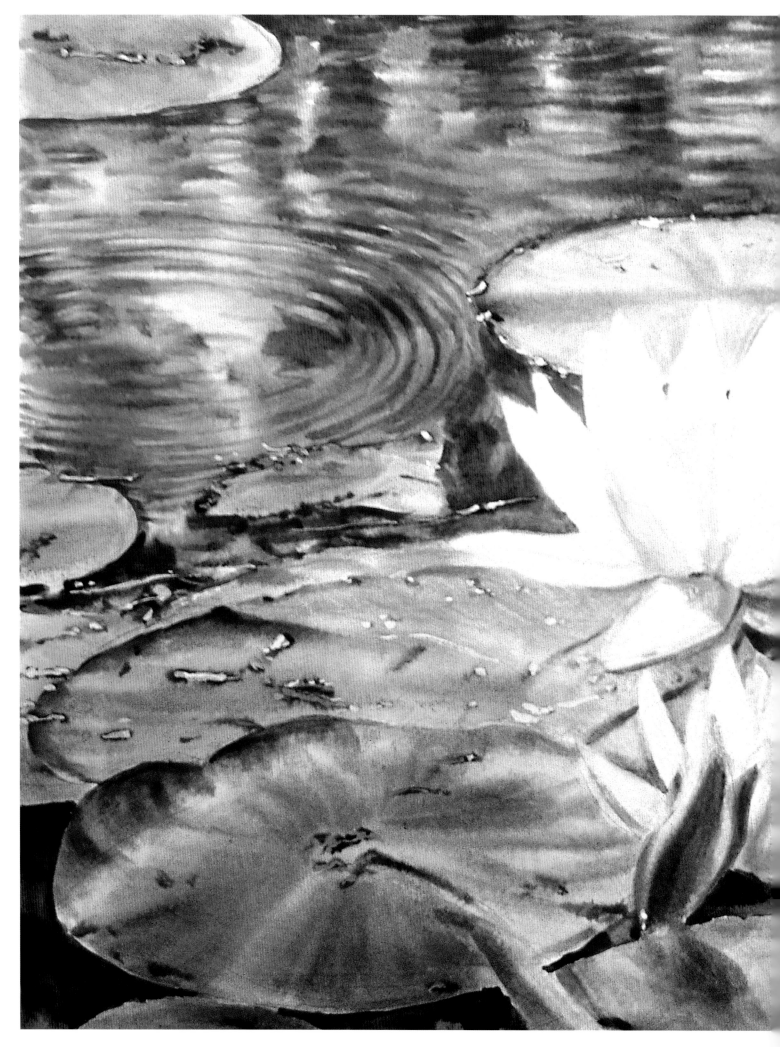

The Essential
Acrylic Painting Guide

Introduction

While acrylic paint is still relatively new compared to the more traditional counterparts, the speed at which it has gained in popularity is not surprising. As with watercolors, acrylics can be diluted in water, yet they can also be built up thickly to resemble many of the characteristics possessed by oil paints. They are fast drying and incredibly permanent and flexible once applied.

Common with all media, acrylic paint features unique strengths and foibles which make its use not simply an echo of the others, but distinctive in its own right.

There are several types of acrylics on the market, along with a plethora of mediums that imbue the paint with new identities. Some of the colors are fluid, designed with the express intention of exploiting watercolor techniques; others are stiffer and more solid, favoring the impasto techniques (laying paint thickly) of oil paint.

In spite of these common bonds, the medium should be thought of neither as watercolor, nor oil. Since it can be used opaquely, there is no reason why highlights should not be rendered with white, even when using acrylics in the manner of watercolors. Since each layer is permanent on drying, the overpainting of thin washes of color is carried out with ease. There is no danger of paint lift or gum release, no matter how many layers of paint are used, as can be the case in the multiple layering of watercolor.

With colors drying swiftly, even in deep layers, the waiting time involved, as in the drying of thick oil paint layers, is not there. Work can move on a pace, which may prove useful with some subjects or when having to paint under conditions that demand speed.

There are special mediums in the form of pastes which can be added to the paint to inject extra body for impasto work. The composition of these consist acrylic medium mixed with a variety of possible materials such as marble dust, silica, sand, and pumice, all of which produce different weights and finishes. One variety contains tiny glass beads for use in specialized decorative work. Making one's own texture paste is an option, using material such as sand and seeds.

Because of the fast-drying nature of acrylic paint, a wide range of tools is available to overcome any possible problems. The stay-wet palette keeps raw paint and mixes wet throughout a painting session, also providing longer storage time for colors squeezed from tubes. Speciality nylon brushes, with both flexible and stiff filaments, perform different tasks by applying paint in ways unique to the heads. Being prepared for these fast-drying paint is essential before any painter begins using them. An unplanned and uninformed approach could lead to disaster.

Once a painter begins to experience the versatility of acrylic painting, it should be borne in mind that other media can be brought into play. Acrylic is a natural adjunct to collages, being a strong glue as well as pure color. Once painted, textured materials can be adhered to the surface.

As an underpainting to oils, the use of acrylic paints could be a great boon on several levels. Acrylic paint will size, underpaint, or create impasto layers, over which the oil paint is applied. In thick layers it is far more flexible when dry than similar layers of oil paint. If the work is completed on a surface that could move, such as canvas, the likelihood of cracking is reduced.

On occasions, painted canvasses are rolled for storage, the ultimate test for paint stability. With acrylic underpainting the layers of paint stand a better chance of survival and returning to normal when unrolled.

Watercolors, too, can benefit from a close association with acrylic paint. On a simple level, there may be instances when a highlight has been lost in a finished painting. Difficult to reinstate with watercolors, a touch of white acrylic paint will do the job adequately and furthermore, could be allowed to protrude from the surface so that it physically catches the ambient light.

When overpainting opaque watercolors, such as gouache, there is a tendency for color to bleed through. Overpainting with acrylic halts this, enabling the painter to continue.

Adding acrylic medium to a watercolor imbues it with acrylic strength and stability. Underpainting watercolor with acrylic reduces its grip on the surface and the watercolor can be partially wiped away with a damp cloth, revealing unique textures.

Acrylics and pastels perform equally well together. Pastels need a textured surface on which to fix, and an underpainting of acrylic provides both this and color for contrast. One wonderful side effect of the underpainting beneath pastel strokes is that texture is picked up by the overlaid pastel. So, the finished painting, while possessing all the attributes of the pure pigment color, is also imbued with painterly brush-like strokes that would be impossible to emulate through any other means.

Working with acrylics offers the artist a wealth of possible avenues for creative expression, not only as a medium in its own right, but as a partner that enhances any medium with which it is coupled. It can be used on almost any surface, from walls to textiles, be they raw or fully prepared. The paint can be brushed, squeezed, toweled, splattered, and dropped onto the painting surface and will dry hard and fast, no matter how insubstantially or casually applied.

And finally, mistakes are easily overpainted.

Equipment Focus
Acrylic painting brushes

In theory, any brushes used for oil or watercolor painting can also be used in acrylic painting. The deciding factor is whether the color is to be applied in a smooth watercolor fashion—in which case you will need a soft brush such as sable or nylon [A]—or as stiff impasto textured strokes—in which case you will need a stiff brush such as bristle [B]. Ensure that any brushes used for oil painting have been thoroughly washed in soap and cold water before swapping to acrylics.

BRISTLE OR NYLON?

One slight problem can occur with traditional bristle brushes normally used for oils. If they are left to soak in water for too long, the hairs absorb the water and expand. As they are gripped tightly at their base by the ferrule, they have a tendency to splay [C]. To overcome this problem, there are now many types of nylon brushes available. In the past these have been created to mimic the soft watercolor brushes [D]. Now, however, stiffer varieties are available; created for acrylics or water-based oils, they successfully mimic the stiffer oil painting bristle brushes [E]. The nylon resists water and will not splay.

SHAPES

Brushes fall into four main shapes. The round brush [F] is round in cross-section with a long flexible head. The flat [G] is square-ended and flat in cross-section. A shorter head is found on the bright [H] and this is similarly flat in cross-section. A filbert is flat and rounded off at its edges [J].

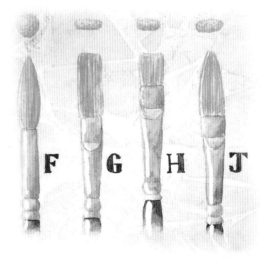

LENGTH OF HANDLE

The length of the handle denotes the way in which the brush is to be employed. Short handles are usually found on watercolor brushes, where the smaller scale encourages close work. Here a long handle could prove dangerous to the eyes. For upright work and more distant viewing, the long handle of the oil painting brush comes into its own. For acrylics, take your pick, depending on the way you like to work.

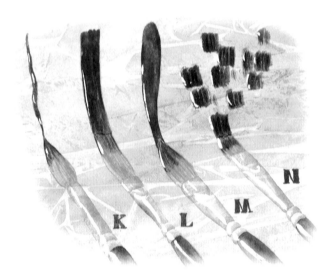

STROKES

Each brush shape yields a naturally individual stroke. For linework and detail, the round [K] comes to an excellent point, although one can use the side of the head for larger areas or scumbling. Differences in pressure create different widths of stroke. Faster coverage is provided by the flat [L]. Its long flexible hairs or bristles deposit color swiftly. It is also excellent for scuffing dry textured surfaces. The filbert [M] has a naturally tapered stroke and generally gives softer edged brush marks. Finally, the bright brush or short flat [N] holds only a small amount of paint and is thus best employed for sharp staccato strokes, producing a mosaic of color or with less color load, employed for stippling.

BRUSH CARE

Never stand a brush in water as this will distort the shape of the head [O]. Instead, use a brush washer that suspends the brush in the water [P and Q]. Only immerse brush up to ferrule.

Brushes carried carelessly can become misshapen [R]. To correct, wet and impregnate with soap or brush cleaner [S]. Repoint [T] and leave to dry. Gently dissolve soap when ready to use [U]. Brushes can be transported or stored stiffened and protected with brush cleaner [V].

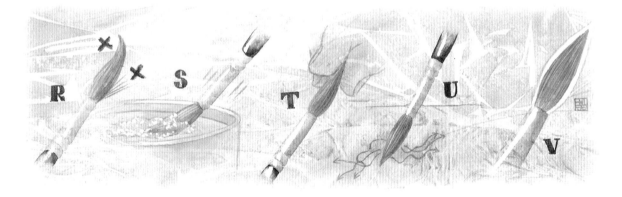

Should acrylic dry on the brush head, soften overnight in methylated spirit [W]. Wash out well the next day with soap and cold water [X].

Equipment Focus

Understanding acrylic paints

It is important to understand the characteristics of acrylic paint to get the best out of it. Through appreciating how it performs, the strength and fast-drying properties of acrylic paint can be exploited as assets, rather than being seen as obstacles that have to be overcome.

COMPOSITION

Acrylic paint is composed of pigment (color) and medium (glue) that fixes the color to a surface. The medium can best be imagined as particles of plastic suspended in water, to give us an acrylic emulsion [A].

DRYING PRINCIPLE

More water and/or pigment can be added to a mix of paint, either making it more fluid, and/or strengthening its color. When the water evaporates off and the paint dries, the plastic particles have bound together, trapping the colored pigment within [B]. This layer of acrylic color, once dry, cannot be dissolved again and is one of the toughest, most permanent and flexible paints available.

NOTE While the dry acrylic film will not dissolve, it can become separated from a surface to which it does not adhere properly. For example, by soaking a ceramic palette on which acrylic has been mixed, the film of paint will eventually lift off.

DRYING CHARACTERISTICS

When in use, the most significant aspect of the medium in the paint is the way in which it changes color and transparency as it dries. A jar of medium looks milky and slightly opaque. Once allowed to dry it becomes completely transparent [C].

This has a direct effect on the paint as it dries, so that any acrylic color becomes a little darker, the pigment becoming more noticeable. It also becomes more transparent [D].

NOTE: Once the color has dried it cannot be removed; this change in intensity and value has therefore to be taken into account when painting. If the color dries inappropriately it can however be altered, once dried, through overpainting, with no danger of bleed through from underneath.

ADVANTAGES

A great advantage in working with acrylic paints is the variety of surfaces on which they can be used. Most other media constantly require consideration of the absorbency of the painting surface. Usually the surfaces have to be sized and/or primed to prevent the paint from soaking in and disappearing, or losing its consistency. Even on the most absorbent of surfaces, acrylic paint acts as its own primer.

The first layer may be absorbed by the surface, but once dry it becomes solid and far less absorbing of subsequently applied layers [E].

NOTE: The more layers that are applied, the less likely they are to be absorbed by the surface.

Each layer of color, however, will be bound strongly to the layer below and as with an iceberg, much of the paints strength will actually lie below the surface [F].

Equipment Focus

Acrylic palettes and texture paste

PALETTES

A good stay-wet palette is essential for anyone working with acrylic paints. This ensures the raw color and color mixes are kept workable throughout the painting session.

PRINCIPLE

The basis of this palette is a reservoir of water, usually a layer of wet sponge, which constantly feeds the mixing surface [A]. The surface consists of a semipermeable membrane that allows the water to filter through, while being stable enough to take the stresses and strains of mixing.

USING THE PALETTE

Good quality stay-wet palettes include a series of reservoirs—spaces, pots, or wells—into which the color is squeezed. This is important in controlling the fluidity of the mix, for color transported directly to the mixing surface will soon absorb too much water and begin to flow. The deeper these reservoirs the better, for they should produce their own contained damp atmosphere that keeps the colors wet [B]. Adding a few drops of water occasionally will keep their fluidity under precise control. Pots with lids are even better, for once sealed, the paint will remain wet and useable for some time.

NOTE: An airtight lid that fits over the whole palette is imperative, especially for those occasions when the work has to be suddenly left for a short time or overnight. This will prevent both raw color and colors mixed on the surface from drying out too quickly.

MAKING YOUR OWN PALETTE

While there are many excellent stay-wet palettes on the market, it is easy to make your own [C].

1. Take two shallow flat plastic trays with rims (e.g. plant or food trays), one as the base, the other as the lid (held on with heavy duty elastic/rubber bands).
2. Cut two or three sheets of thick blotting paper, or thin sheet of sponge, to fit and line the base of one of the trays.
3. Cut two sheets of greaseproof paper to size. These will cover the blotting paper/sponge as the semipermeable membrane.
4. Soak the blotting paper/sponge in the sink and line the tray.
5. Soak the greaseproof paper and drain off excess water from it. Lay on the blotting paper/sponge and wipe the top surface with an absorbent tissue to remove excess water.

When mixing a small quantity or very fluid washes of acrylic paint, the alternative is to use a standard palette. This must never be plastic as the paint will dry permanently and ruin it. Glass or ceramic palettes are the only options which can be soaked so that dry paint lifts off [D].

PAINT RESERVOIRS

Any small receptacles with lids make good reservoirs, one for each of the six primary colors, plus extras for any additional colors and/or whites. Especially useful are miniature glass jam jars with screw top lids.

TEXTURE PASTE

IN USE

Imaginative use of texture paste will yield a host of possibilities. In addition to being used to add texture in paint, its adhesive strength enables it to be used for embedding objects, especially in collages. Seeds, pasta, sand, grasses, pieces of metal or wood, beads, and string, all would add character when embedded into a collage painting and painted over.

BE INSPIRED: Application or modeling of texture paste does not need to be restricted to a brush or painting knife. Other tools could be exploited to yield a variety of results, e.g. blunt kitchen knives, cut pieces of smooth or corrugated card, the beveled handles of cutlery, combs etc. Not to mention some of the modelling tools used in crafting with clay. There are no limits to the use and exploitation of texture paste.

Starting Off

Perspective

PERSPECTIVE

The very word can make an artist's jaw set tight, even that of a professional. Why should this be when perspective is such a useful tool in helping to create a sense of depth in a painting?

To many people, perspective is perceived as being associated with technical drawing. Useful perhaps for the architect, but a real burden to those who would like their work to have a little more freedom.

The difficulty is when you place a building in your painting. Were its perspective to be incorrectly rendered it will stand out like a sore thumb. Or will it?

Take the work of L.S. Lowry. His early drawings show that he was a master of perspective. His later paintings however, often have irregular vanishing points; nevertheless they do not look wrong. Just what is going on?

The secret is out! Perspective is there to use when you need it. Once you know how it can help, you can then break the rules if it doesn't. The guiding principal being— if it looks right, it is right. Perspective, after all, is only a distortion that produces the perception of depth.

There are times however, when you know it looks wrong; so let us look at some of the tips that can help you exploit the potential of perspective.

EYE LEVEL

This is the first building block in learning about perspective. Just why should the level of your eyes be so important?

Take the landscape without a building in sight. The eye level in [A] is close to the bottom of the rectangle indicated by <—. The result, a lot of sky at the top, suggesting that you are looking upward. In [B], the eye level is more central, giving an equal balance to land and sky. With [C] the eye level is very high. The sky has almost disappeared and has now been dominated by the ground, giving the impression that we are looking downward.

The actual subject matter of the painting can thus be changed by simply moving the eye level. Try this out for yourself and it will prevent you from producing a picture full of sky, when you actually want to look at the landscape and vice versa.

SCALE

Something strange seems to happen when the eye level is moved behind a box. While the box in [D], [E], and [F] covers approximately the same area, its dimensions appear to change in each case. In [D] we appear to be looking up at it; while in [F], we appear to be looking down on it.

By changing the eye level, we assume that a figure standing next to the box has the same eye level as ourselves. The figure must therefore either get larger to accommodate the higher eye level [G], [H], and [J]—or it must gain height by other means to eventually look down on the box [K], [L], and [M].

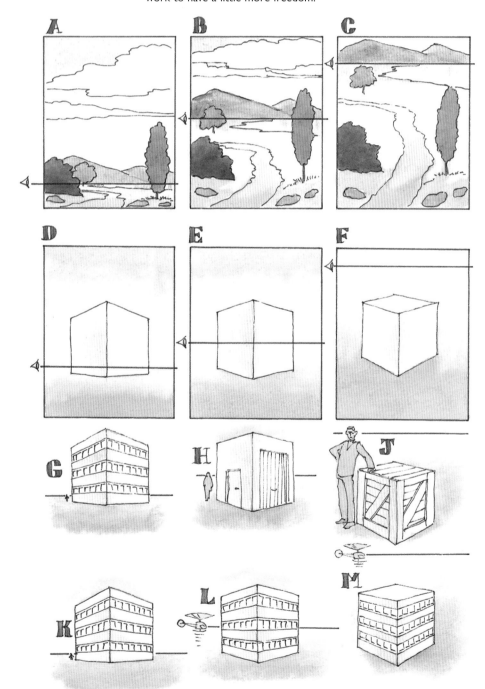

Something that can be seen when we take off in an airplane and look down on the scenery below, or in any situation when we rise above ground level, such as in a multilevel parking structure.

FINDING & USING THE EYE LEVEL

Buildings provide a wealth of subject matter, possessing volume, texture, light, and color; everything an artist could wish for. Why then aren't they painted more often? Usually it is the perspective that dissuades an artist from exploring the glorious potential of these structures. Instead of thinking of them as we would other subject matter, we get caught up in a multitude of vanishing points.

What a pity to ignore this wealth of material! It is all a matter of looking carefully to begin with. The aspect of perspective can be addressed at a later point, if things look terribly wrong.

Commence by drawing freehand what you see to familiarize yourself with the shapes and volumes. Later on you will know just where and when to bring in vanishing points. You are far more likely to be restricted by the rigidity of the vanishing points, were you to start off with them. When there is need for perspective, some simple, standard practices, will help conquer any fears you may have.

FINDING THE EYE LEVEL

Just how do we determine the position of the eye level, especially when working from a photograph? It is easy to see the eye level when standing by the sea, as it is the horizon where sky meets the sea. You can imagine a line leaving your eye and traveling level to the sea until it meets the horizon at a point in the far distance. Turn your head and the point will move along the horizon. Replace the sea with a flat, grassy plain. Around you are people of the same height as yourself. As their eyes are on the same level as your own, you all share the same eye level [1]. A child stands below your eye level, so you naturally look down on him/her.

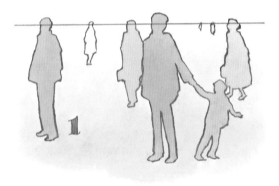

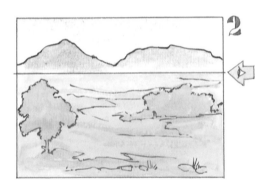

Pick a photograph. If it is of the sea, then once again, determining the horizon and eye level presents no problem. What happens if your subject is a landscape without buildings or people [2], with some hills in the distance that hide the horizon? In your mind's eye, replace the flat land with the sea. If the sea flowed under the distant hills, where would it touch the sky? This is the horizon/eye level; only on this occasion you have made an informed judgement as to its position.

Pick a photograph with some buildings [3]. You will notice the tops and bottoms of windows, doors, roof, and gutter are all at an angle. Starting at the front edge of each building, they are all angled toward the eye level. Above the eye level however, they angle downward from the front corner of the building, while below the eye level they angle upward [4]. It stands to reason therefore, that the position of the eye level is where they are flat (horizontally level).

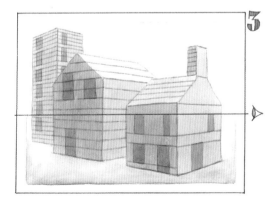

USING THE EYE LEVEL—SIMPLE EXERCISES

Draw in your eye level and a figure positioned to share that eye level. Beside the figure, draw an upright pole, approximately twice the height of the figure [A]. The pole represents the front corner of a building. From this pole, draw lines outward, angled to the right [B]. Note how these level off toward the horizon. Repeat, working to the left [C]. Complete the drawing as a brick box [D]. Repeat the entire exercise, with the front corner edge (pole) either apparently much larger [E] or much smaller [F], by raising it above or keeping below the horizon. In repeating these exercises several times the process will fall naturally into place.

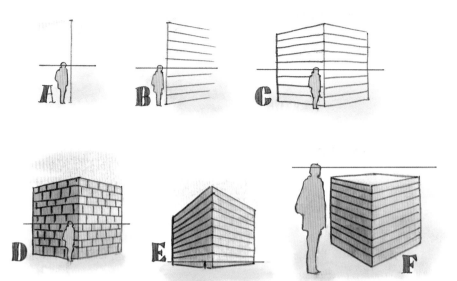

VANISHING POINTS

Vanishing points are such a strong measuring tool that they can overwhelm and intimidate those new to the subject. Rather than start a drawing with these, it is far better to look at buildings either in situ or in photographs, and judge their angles. Familiarize yourself with how a mass works before you begin to worry about the absolutes of perspective. In most cases there will be no need to establish actual vanishing points, but it is necessary to understand how they function and affect the composition as a whole. Try out the following exercises on a rough piece of paper to help you understand the principles of vanishing points. Once you have gone through these exercises a number of times, turn your hand to sketching a building as loosely as possible. Bear in mind, that perspective is a distortion that suggests depth. It is a tool for the painter, not a master that should be slavishly followed.

USING ONE VANISHING POINT—SIMPLE EXERCISES

EXERCISE I

STEP I Draw a series of lines radiating from one point [A]. This is the vanishing point (VP).

STEP 2 Draw the eye level through the VP: <— [B]. Vanishing points are not always on the eye level, but they are for surfaces or objects that are level—i.e. floors, windows, and gutters.

STEP 3 Draw a series of smaller lines between converging lines, as shown. Keep these lines parallel to each other and to the horizon, while at the same time progressively narrowing the gap between each parallel line, as they recede into the distance. [C].

 The lower half of the drawing now resembles a series of tracks converging into the distance, while the upper half resembles beams on a ceiling that are receding. Both achieve a sense of depth and recession. This is the basis of the illusion that linear perspective creates.

EXERCISE 2

STEP 1 Repeat steps 1 & 2 from exercise 1. Divide into four equal segments by highlighting two of the crossed lines, as shown [D].

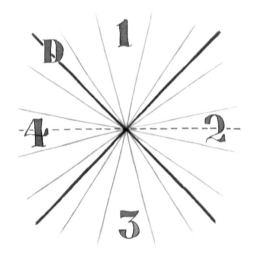

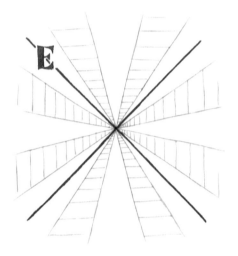

STEP 2 In segments 1 & 3 draw the narrowing parallel lines parallel to the eye level. In segments 2 & 4 draw the narrowing parallel lines parallel to the right & left hand upright edges of your paper [E].

Now you have created not only a set of tracks converging into the distance and receding beams on a ceiling, but also a right hand and left hand wall.

EXERCISE 3

Repeat exercise 2, but use a very light line, to create the skeleton on which you are going to proceed with a drawing. Drawing with a slightly stronger hand, selectively extend and join some of these to suggest a far wall, a door, windows, paintings, and floor tiles [F]. Firm up by adding different tones with washes of gray paint.

EXERCISE 4

Go through the process of exercise 3, using the room in which you are sitting as the subject. Superimpose the various elements on walls, ceiling, and floor.

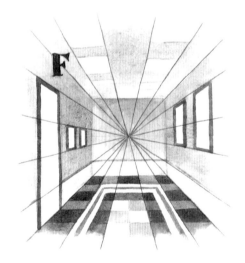

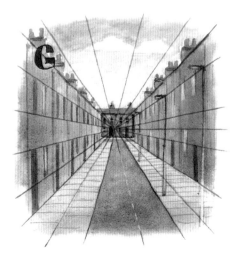

EXERCISE 5

Having tried out these various exercises, step outside. Again, draw out the basic skeleton in light lines and superimpose the elements of a street scene [G].

These exercises may seem very basic. They will however help you to understand the basics of perspective, which in turn will enable you to cope much better when confronted with more complex compositions.

Project 1

Wet on Dry

The most direct way to apply paint to a surface is to do so wet-on-dry, in other words paint wet paint onto a dry surface. Apart from a wide range of surface options, the paint itself can vary in consistency and the use of acrylics offers a versatile repertoire.

Acrylic paint can be watered down. Thinning down most paints invariably weakens them, as it also thins down the very glue/medium that fixes the pigment to the surface. When it comes to acrylic paint however, the medium is so powerful that even very weak washes of color become permanent, once dry. While wet, acrylic paint behaves in the manner of thin watercolor, flowing into textures and being totally or partly resisted by any greasy or slippery surface.

As the paint is thickened with more tube color, the richness increases; so, too, does its grip on the surface. More medium can be added to create transparent color of incredible strength. Not only do these colors contain wonderful depth, they also fix everything they cover with a tough, yet flexible, shield.

The technique of slowly building layers, each more powerful than the last, affords the painter tremendous freedom. The work develops at the artist's pace. Some areas could be left quite primitive in nature, with little color, something that can be especially effective over unusual painting surfaces. Elsewhere, the image could be more fully developed, carefully controlled by the painter.

Since the paint layers add to the strength of the surface over which they are applied, possibilities abound to work on the unusual. Even very absorbent surfaces are possible, since the acrylic paint, once absorbed, dries hard and fast. No matter how fragile the surface, the subsequently applied acrylic paint will preserve its integrity.

Imagine the opportunities this presents. The workshop within this project explores one possibility where a piece of papyrus is brought into play for a relatively simple study.

The tutorial features a traditional surface—watercolor paper—coupled with the traditional watercolor painting wet-on-dry technique that has been exploited for use with acrylics.

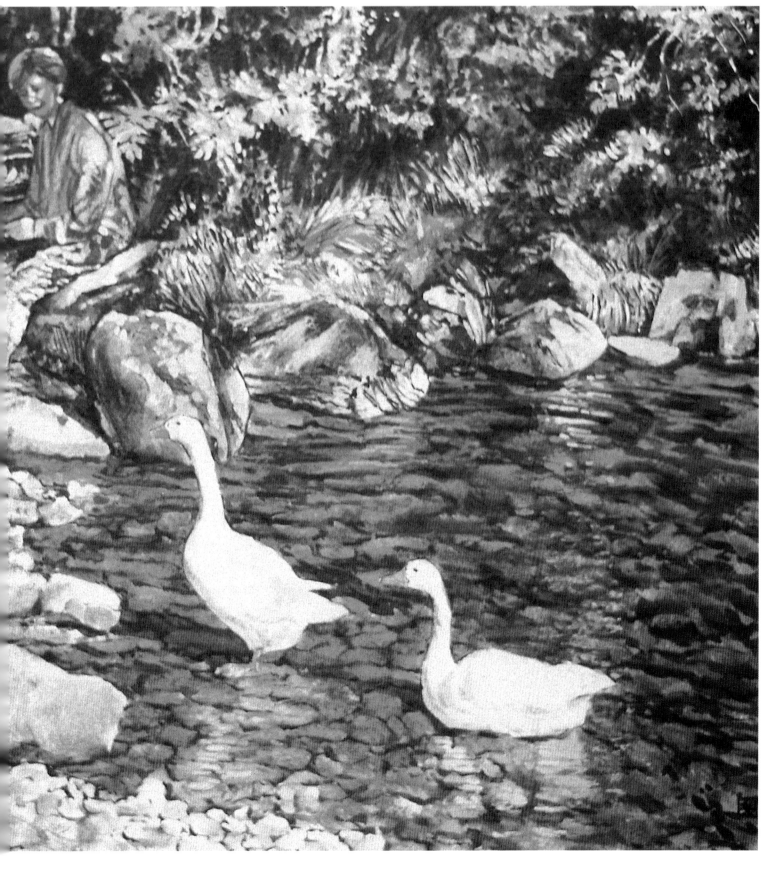

Project 1 Workshop

Wet on Dry non-paper surface

DRAWING Use almost anything under acrylic—[A] pencil, [B] brush pen [C], dip pen [D], Rigger. . .

. . . because fine linework can be protected with transparent acrylic layer, heavy line overpainted with opaque/semi-opaque color.

Apply brush line vigorously. Where overheavy, partially dab off with finger (finger tonking).

FIRST WASHES Adding water to create washes thins glue (medium). Dries weak and dull.

Add medium to create washes that dry strong and glossy.

Glossy surface gives depth to dark accents. Dull surface looks much flatter.

LAYERING COLORS Working wet-on-dry creates paint areas with hard edges.

Rewet surface before adding color to achieve soft edges.

A very soft brush (Hake) can rewet still-wet top color and soften edges without disturbing or streaking.

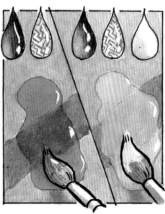

Color + medium = GLAZE. Color + medium + white = TINT.

Repetitive patterns with regular strokes and equal spaces between are unnatural.

Irregularity is more natural (top). Achieve rhythm, flow, and motion by good positioning of patterns.

STEP 1

Stick the papyrus onto a piece of stretched watercolor paper using matte acrylic medium. Once dried, apply the medium over the papyrus to create a stable surface on which to paint. Scribble in the composition with a No. 3 nylon Rigger and a dull, purple mix. Add sufficient water and gloss medium to make the application fluid and shiny when dry. Block-in thin washes of color using a soft round nylon brush. Washes spread thin with water tend to dry dull, so cover the whole piece at this stage with a thin layer of gloss medium to bring out contrast and depth. Now that the main masses are established, you will be able to execute further drawing more confidently in dark line using the Rigger. Allow the brush to skit across the rough surface when you do this to generate some descriptive scumbling and dragging. Varying the color of the line will also increase its versatility for describing detail. Tonking the line with a finger yields subtlety as you expose underlying textures.

MATERIALS
Paper
watercolor papyrus or other textured surface
Brushes
round nylon
nylon Rigger
Hake
Paints
6 acrylic primary colors plus Titanium White (TW)
Acrylic Matte Medium
Acrylic gloss Medium

STEP 2

Apply another layer of gloss medium and, while still wet, brush thin purple and blue washes around the pineapple to bolster its form. Also work in stronger accents of this color while still wet, as well as the middle values of blue-green into the foliage. A tint of dull purple laid into the structure of the pineapple gives solidity and form. To echo these patterns, lighten the negative diamond shapes in the trellis. Cool dark colors will solidify both branches and trellis. Solidify the trellis at the bottom with a light wash. Ivy growing is highlighted around leaf edges with a pink tint. These positive Ivy leaf shapes echo the negative shapes of the trellis above right. Links such as these help to knit the composition—note how the rhythm of the foliage around the pineapple is picked up by the limbs of the wisteria and by the ivy along the bottom. Use the Rigger to apply highlights to the dry leaves along the base. Be careful ithat the pattern of the leaves remains irregular. The paving slabs are scumbled-in with dry light green color, and rubbed over with a finger to exploit the surface of the papyrus. Paint the flowerpot in a range of burnt orange values, through to white. Apply a blue highlight to run along the leaves of the daffodil converging on the focal point of the pot in the corner. For the daffodil head, apply a splash of yellow, add white while still wet, and tonk off the whole with a finger to allow undercolor to show through.

STEP 3

Continue with highlights and glazing to finish off. Apply a damp brush to still wet highlights to soften them into underlying colors and prevent them from becoming hard. Stone of the pineapple has a soft look—place pink-white highlights with a gentle brush stroke onto a pre-wet surface. Red berries around the feature add attractive complementary contrast—paint from purple-red through orange-red to a white highlight. Lighter colors on foliage, both warm (yellow) and cool (blue), soften the silhouette of the pineapple. Blue lights solidify the wisteria stem and provide a complementary contrast to the warm browns beneath. Follow with orange-yellow highlight (complementary to the blue). Augment negative spaces with highlights, intensifying the effect of light shining through the structure. Some ivy leaves are given blue central highlights. Work a transparent glaze of warm orange into the dead leaves and plant pot, to contrast against blue of the daffodil and leaves. Run a green glaze behind the ivy to suggest the mossy damp surface of the trellis near the ground. Pure Ultramarine glaze beneath the ivy and behind the pot improves recession. Washes of yellow tint solidify the ivy leaves and pink highlights further define their edge. Scuffs of yellow through to white bring further texture to the stone floor. Finish off with yellow-green highlights to the daffodil leaves and light yellow to the daffodil head.

Project 1 Tutorial

Wet on Dry

COLOR REFERENCES
Yellow-orange [Yo]
Yellow-green [Yg]
Red-orange [Ro]
Red-purple [Rp]
Blue-purple [Bp]
Blue-green [Bg]

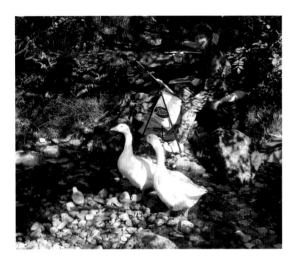

A group of happy painters were about to start a day's work along the river-bank, when along came this feathered couple accompanied by just one solitary youngster. Something so endearing could not be resisted by one and all, not least as possible subject matter for the future. Despite attempts to woo the family to stay, with sandwiches being unwrapped and shared, they did not succumb and were soon on their way.

SUBJECT

This is an inspiring subject which includes the opportunity for detail in the human figure, the birds, the water, and reflections, and the dappled sunlight. A happy accident, one which could not have been set up and would have been missed had it not been for the ever-ready camera. These two reference photographs are only two of a large collection taken continuously in the short amount of time the ducks were in our company. The rest could provide more possible subjects for studies and full compositions in the future.

COMPOSITION AND DRAWING OUT

The balance of this composition is unusual. With the rhythm and lines all converging toward the painter at her easel, she is placed oddly in the top left-hand corner. Furthermore, a figure is usually a strong focal point in any painting, but here, while our eye is drawn to the artist, she is camouflaged by the dappled sunlight that falls across her form. This leaves the ducks as the strong focus, creating strong silhouettes against the powerful color of the transparent water. Looking more carefully, you are rewarded by discovering the duckling, a little surprise against the small, white, sunlit stones. With a wealth of detail such as this, working wet-on-dry will provide all the necessary control, combined with a looseness and fluidity of brush stroke to avoid becoming too tight. It is essential to stretch the watercolor paper to avoid cockling from the weight of acrylic layers to follow. Loosely sketch in the main outlines of the elements.

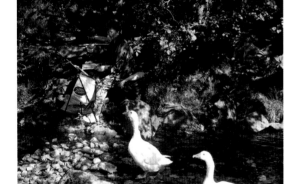

COLOR MIXING
Where the prefix letter is shown in capitals this denotes a larger quantity of that particular color. Conversely, where the prefix letter is shown in a lower case, this denotes a smaller quantity of that particular color.
e.g.
Bp = large amount of blue-purple.
bp = small amount of blue-purple.

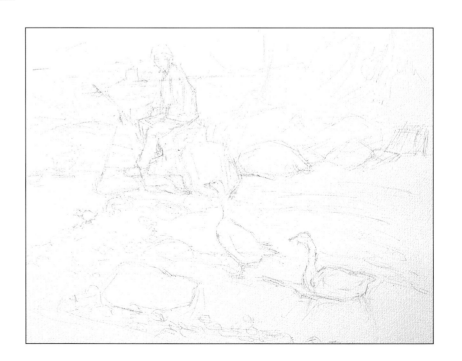

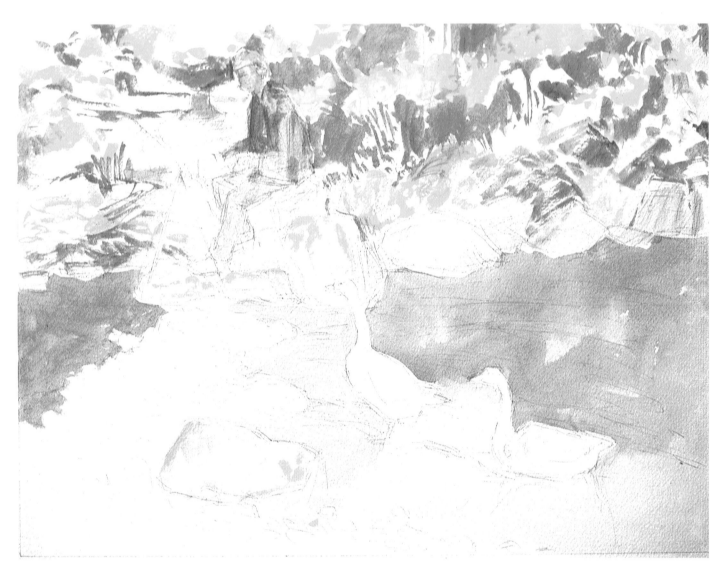

STEP 1

Start with as big a brush as possible, with a good point for detail and a big fat body for bold coverage (a No. 20 round nylon was used here). Dab and scuff on the highlight color for the leaves [Yg+yo+bg+ro], using the point. Between green leaf highlights, add light warm orange washes [Yo+ro+bg] or strokes. Directional strokes will suggest rhythms in leaf masses. Using the side of the brush body, apply a graded wash for the river water, working downward, adding progressively more water to the color as you go. Apply light warm colors across the figure, working these swiftly next to each other so that the colors can flow, producing naturally soft edges. Drier scuffs (less brush-loading) of orange and green start off the rocks, but again, apply swiftly to achieve color blending. Wash a loose, scrubby and irregular gentle yellow [Yg] over the foreground stones and ducks. Previously dried acrylic color is permanent, allowing a loose approach such as this, which can cause no damage, no matter how aggressively applied. The larger rocks on the riverbank are given a more mixed bag of colors. Not all of the white needs to be covered by these first layers, just enough for you to see that the balance of the composition will work.

MATERIALS
Rough Watercolor Paper
Brushes
small, medium, and large
round nylon
nylon Rigger
round squirrel
Paints
6 primary colors
Phthalocyanine Blue
Titanium White
Acrylic Gel Medium

STEP 2

Move to a slightly smaller brush, such as a No. 12. Load well with color [Yo+Yg+bg+lots of water], and flatten out the brush head (removing excess color as you do this) to achieve the varied strokes required for the leaf patterns of the trees. Use the rigger to draw a red-brown line [Ro+Yo+bp] around each stone, slightly bolder along the bottom edge, and swiftly lose the latter up into the stone. Be constantly aware of the speed at which acrylics dry. This will allow you to complete only a handful of stones at a time, if you are to successfully lose edges. Also note that the small stones do not all lie horizontally, but as a whole they create a wide arc, a strong movement that carries the eye through the picture. The stone linework goes right up to the edge of the ducks and then seems to disappear behind them. Take the same linework onto dry land, where edges are not lost, but are broken and made irregular by the texture of the paper. A slightly more orange linework brings more definition to the larger rocks along the river's edge. Orange and green washes define these rocks and the left-hand edge of the figure more precisely. Give the duckling a slab of this orange. Some purple scuffs [Yg+yo] + [rp+bp] add solidity to the foreground stones.

SCUFFS
Individual strokes dragged over rough textures = gentle coverage

SCUMBLES
More solid areas dragged over rough textures = heavy coverage

STEP 3

Paint into the dark accents or shadow areas behind the trees (negative painting) with a dark purple [Bp+Rp] + [Ro+Yo]. Switch to the squirrel brush to produce soft, irregular, subtle strokes for the middle green leaf color, and lose where required. This mix [Yo+Yg] + [Bg+Rp] provides the link between the mid-yellow-green and the purple accent just applied. As such it overlaps both. Apply a graded orange wash across the water [Ro+Yo+bp] progressively adding Yg plus water, and tonk off with your thumb to create additional texture.

> ### FAMILY MIXES
> Make a large wash on your palette and bring small amounts of other colors to its edge and mix. The central mix helps keep the smaller mixes all within the same family, both in terms of color and of value.

STEP 4

Move to the figure and apply a loose orange wash [Ro+Yo+bp] across the face and hands, adding a touch more Bp for accents. Shade the hair [Yg+bp]. Apply warm and cool purples (less or more blue) to shadows and folds of the blouse. Those on legs are grayed with a little Yg added to the purple mix. Work orange-brown descriptive linework on the rocks along the river and around the figure, keeping it fluid and dynamic to retain excitement. Careful redrawing with a brush to the line detail of the face and the silhouette of the ducks brings focus where it is needed. The transparent water is now fractured with strokes of dark mid-brown to suggest the ripples that break up the uniformity of the stones beneath, and shadows such as those cast by the ducks on the river bed. At the far end these are applied and lost with a medium round brush, while in the foreground they are applied with the Rigger. Gently apply a dull purple shadow to the ducks and add blue for the shadow over the dry rocks.

Intensification of colors and texture

Adding gel medium to the colors gives them more body and increases their transparency. This mix will provide a rich, glaze-like finish to the colors, while, being more solid, can easily create texture. On your palette, add the medium to the edge of a mix in order to control the degree of pigmentation. The orange-textured glaze of the water is achieved in this way and, with a little added blue, is used over the foliage as scuffing. Stroke a very gently pigmented Yo gel mix over the ducks to create light and texture, and to subtly gray down their purple shadows.

LOSING EDGES

A paint stroke dries naturally with a hard edge all around it. If, however, before the color dries, another wet area (water) is laid alongside it and is allowed to touch the wet color, then the color will flow into this and be lost. This softening, or losing, of an edge is used to suggest volume and/or movement.

STEP 5

Apply a yellow-green [Yg+bg] gel mix over the foliage, and while wet, break up by scratching through with the end of your brush handle (sgrafitto). Dull purple gel mix accents [Rp+Bg+yg] throughout the background provide complementary glazes and contrasts. Yellow-green gel scuffs applied to the water, especially to the foreground edge and to the large foreground rock base, are complementary to the oranges beneath, and bring extra richness to the colors. Gentle purple linework on the foreground stones, lost in parts, provides extra definition to this very light area. Switch to a small brush for fine detail such as the brown accents and linework on the face. Colors can now begin to benefit from the addition of white to create opacity, either for coverage or highlights. Shadow accents applied across the figure help merge its form into the backdrop of the foliage. Accents to underwater rocks [Ro+rp+Yo+Bp] follow the arc previously noted. The surface of the paint here is now quite deeply layered with acrylic, and will feel quite slippery. This indicates that it will absorb more slowly and wet brush marks will stay fluid longer, allowing for easier blending (losing). Paint can now be applied quite stiffly (little water) with plenty of time for adjustment. A natural part of wet-on-dry work

is the sharp focus, and now you can take delight in drawing in line detail through the foreground stones, both in and out of the water, around the figure and the large stones in the background. This linework holds the composition together, while providing contrast as dark accents. Note sharp detail created by negatively painting the figure and, especially, the leaves behind it. Gel glaze textures [Ro+Yo+bp], squashed on with the side of the brush head, scuffed and dabbed out the water, with a little more blue and gel added to the foreground stones. Add no water here, but exploit the gel textures to their maximum. Even the deeper orange to the beaks and duckling, or the dull purple strokes to the plumage, benefit from the gel texture. In the final touches, white can be added for highlighting. Remember, however, that these mixes always darken a little as they dry. Water reflections are the colors of the objects being reflected, so they are either yellow (rocks), white (ducks), or blue (sky). Note how these are seen mainly over lighter areas of the water, retaining the dark accents between the stones. Yellow highlights should be applied to the figure, on the hair, face, and clothing, also on leaves, on the ducks' backs, and on the rocks wherever the sunlight touches.

Tricks of the Trade

Stretching paper

All paper cockles when wet. It is very difficult to produce even brush strokes on a surface that buckles. Cockling is due to uneven absorption of water into the paper fibers, which swell as they take up the fluid. If you take a thin piece of paper and wet only one side, you will find it immediately curls away from the wet surface. The fibers on the dampened side have swollen, while those on the dry side haven't; this causes the distortion. Imagine how the problem is compounded when a dry piece of paper is first fixed to a board. As soon as the paper is wetted, it begins to swell, but being fixed on all edges, it has nowhere to go and pushes itself up and out. By wetting the paper before fixing, it shrinks upon drying and goes taut like the skin on a drum. When wet paint is applied, if any cockling does occur, it will level out immediately upon drying.

Establish whether your paper has a right and wrong side. Many watercolor papers, when bought in sheets, will display a watermark, visible when the sheet is held up to the light. Ensure you mark the "right" side with a pencil if cutting the sheet to size. Paper in a pad is bound so that each sheet presents the right face up; so, again, mark this before removing. Wet the paper as evenly as possible on both sides to keep distortion to a minimum. The thickness of the paper will determine which of the following methods of wetting you use.

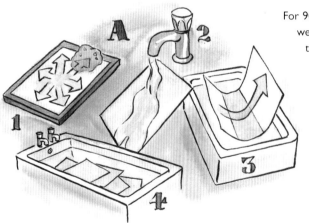

For 90 lbs. (200 gsm) thin paper, a natural sponge can be used for wetting [A1]. Always wet the wrong side first, so that when you turn to wet the right face it will not matter if the back becomes soiled with dirt or paint from your board.

For slightly thicker papers—140-200 lbs. (300-425 gsm)— run both sides under a tap [A2] or dip into a water filled kitchen sink, etc. [A3].

Heavier weights—200-300 lbs. (425-600 gsm)—can be left to soak in cold water for 10 minutes to allow the depth of fibers some chance to take up the water [A4]. Fill up your bathtub to soak several sheets at a time to have a stock of stretched paper at hand.

The board on which you stretch your paper should be of unvarnished natural wood—not surface-laminated in any way. Alternatively cut ¹/₂ in. (12 mm) plywood to size, and sand the edges well to avoid splinters. If you regularly use one size of paper, the board could be customized to that size—allow a 1 in. (25 mm) margin all around (2 in./50 mm bigger, therefore, on either length) to accommodate the overlap of gum strip [B].

The paper should be fixed to the board with a 2 in. (50 mm) wide gum strip—buff paper parcel tape with gum on one side (not the self adhesive thin plastic tape or masking tape). Precut it into lengths 2 in. (50 mm) longer than the length of the paper, keeping well away from any water while you do so. A roll of gum strip can be instantly ruined should it be splashed or were you to pick it up with wet fingers.

If you are dealing with really well soaked paper, hold it by one corner over the sink/tub to run off excess water, and then switch to the opposite corner to ensure that the water is evenly distributed [C].

Place the damp paper on the board. Should the wet paper have trapped air bubbles beneath, squeeze out from center, using the heel of a clean hand [D1] or, lifting half a sheet at a time, pull taut, and relay [D2].

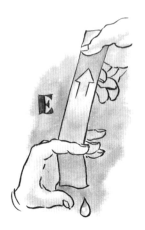

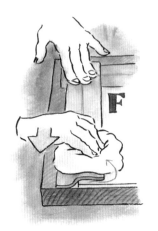

Wet the gum strip piece by piece by laying the gummed face into water. Run the strip through your fingers to remove excess water [E] and fix across paper edges, half on paper, half on board. Hold the strip firmly at one end and push down with an absorbent tissue [F]. Overlap the tissue onto the paper so that any gum squeezing out from underneath is picked up immediately.

Ensure the paper is firmly stuck by running your nail along the edge of the paper, pressing home the tape [G]. Leave the board flat to dry evenly. Once dry, the paper will remain stretched as long as it remains fixed to the board.

Common Problems
Stretching paper

PROBLEM

"One side of my stretched paper always comes loose."

ANSWER

If the gum strip lifts, this can be caused by uneven drying. If the board is left upright to dry, the water will run under the tape along an edge, causing it to loosen. If left against a heat source, one side may dry faster and, on contracting, can pull the opposite side free. Of course, it could just be that the roll of gum strip was poorly gummed.

SOLUTION

Remove all loose gum strip, tearing away from the paper [A]. Take the board to the bath, pour water between paper and board [B]. Hold the board horizontal, paper side down, so that the water flows and wets the back of the paper sheet. When sufficiently wetted, pour excess water out into the bath. Wet the face side of paper [C] and leave for a few minutes to allow the paper to expand. Reseal the loose edge with gum strip and wipe down securely with tissue as when stretching [D]. Leave flat to dry for 24 hours.

If the paper tears, it can be caused by uneven drying or from soaking too long during stretching. Thin paper especially, can overexpand in ratio to its thickness and on contracting may well tear along an edge. If this occurs it is best to remove the paper and start again.

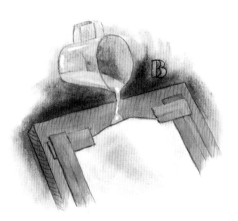
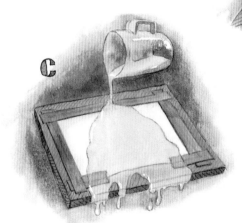

PROBLEM

"When I stretch paper, the tape doesn't remain stuck to the board."

SOLUTION

There are many possible causes here. Check the following:

- Are you using gum strip, the parcel tape, gummed on one side only which requires wetting?
 Masking Tape, Clear Adhesive Tape, and Brown Plastic Tape are of no use, as they will not stick successfully to a wet surface.
- Does your drawing board have a shiny, non-absorbent surface?
 If it has a melamine, plastic, or varnished surface, it is too smooth for the tape to adhere.
- Was the gum strip sufficiently wet?
 The gum on the paper needs to absorb a lot of water to become sticky.

PROBLEM

"When I had finished my painting and tried to remove it from the board, it stuck and was damaged as I tried to remove it."

ANSWER

It is not unusual for small amounts of gum to migrate from the tape under the paper. Be vigilant when removing the paper. Having cut it free with a sharp knife [E], the sheet should snap away cleanly. If it doesn't, never pull the sheet away or it may tear. Instead, insert a blunt kitchen knife or letter opener and gently ease the paper free [F]. Matters can be made worse if you have been tempted to stretch two small pieces of paper on the same board. On removal, this leaves gum strip down the center and if you stretch a full sheet, then it is likely that gum migrating from the gum strip [G] will stick the middle of the new paper sheet to the board. Stretch one large sheet and complete one painting at either end. Protect one by pinning a cover over it, while you are working at the opposite end [H].

REMOVING GUM STRIP FROM FINISHED PAINTING

You don't need to remove the gum strip from the finished painting. The gum strip will be hidden by the mount if it is close to the edge of the painting. If it is some distance away, you can cut it off, along with the paper beneath it. But remember to leave enough of a border around your work so that it can be easily fixed to the back of a mount.

Project 2

Working with color

Most subjects will dictate the manner in which the use of color is approached. The effects of light are quite different across a sunny meadow, to those in the twilight of a room's interior. This is the meat of a painter's imagination. It provides the inspiration to capture the fleeting effects of light on canvas or paper.

The more that painters work from nature, the more is understood of the beautiful simplicity of light and color. This, in turn, leads to a better understanding of how to control paint and color in translating nature to the painting surface. To look at the work of past masters is to appreciate that they, too, went through this process, before developing their own view of the world.

This project is based on two different approaches to translating the essence of nature. Both are recorded accurately, yet each is viewed and worked in a different manner.

The workshop subject is based on an Impressionistic approach to the use of color. The works of the Impressionist painters were filled with bright sparkling light. A black and white photograph of one of their paintings will look flat, for they rejected a large range of values in favor of exploiting color. Shadow areas are full of color, which vibrate against the highlights. For a painting full of color, the possibilities offered by painting in a "high key" need to be exploited.

Throughout the ages, artists have sought to create light in their paintings. Pigment does not, however, provide light; in fact, it absorbs it. The range of values that can be seen through human eyes is vast compared to those that can be recorded on canvas. A photograph taken of a landscape at sunset will show a fraction of what was actually seen at the time by the viewer. Colors within the clouds may be visible, but any element that is silhouetted against the sunset will show as a dark mass. In fact—as anyone on the spot would have seen—it is full of color. How can the painter best represent this?

The answer lies in balance and contrast, taking what is there to the limits. This section's tutorial demostrates just how far the value range of colors can slowly be pushed into providing the sunlight that dapples over a pond full of water lilies.

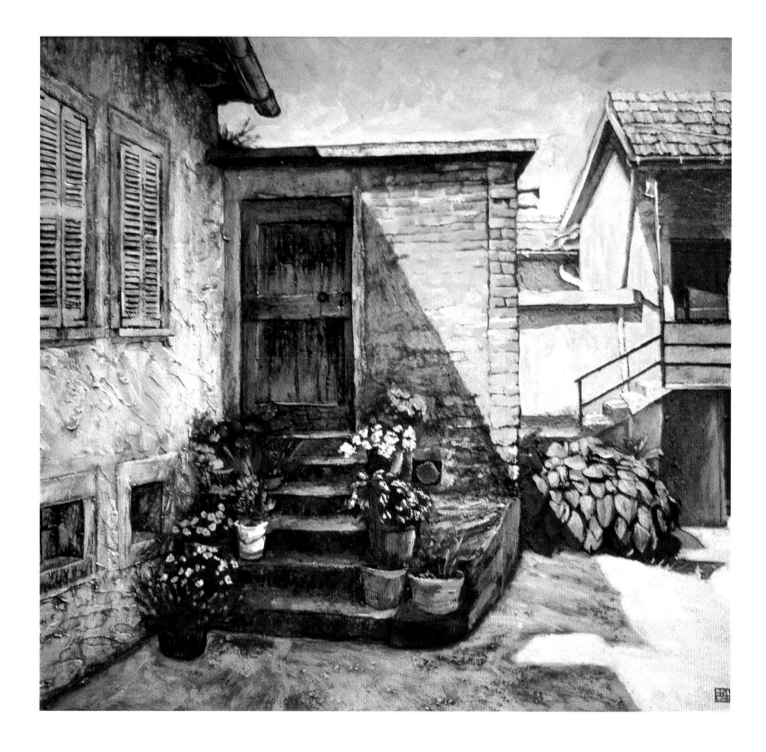

Project 2 Workshop

Working with color—high key and complementaries

STEP 1 Use flat brush as trowel to scoop good supply of paint onto brush head . . .

. . . and develop generous strokes of textured paint.

Lay large areas wet-on-dry.

While still wet, rework with other colors for fluid texture.

Keep to larger brushes to avoid temptation to over-detail.

HIGH KEY Pale, brightly colored painting (top).
No strong darks as can be seen when color removed (bottom).

LOW KEY Dark, murky colored painting (top). Middle to dark tones when color removed (bottom).

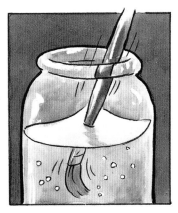

STEP 3 Textures: Flat Brush. Always wet brush before loading with acrylic paint to prevent premature drying.

Squeeze most of the water out before dipping into color so mix remains thick (don't pull hairs).

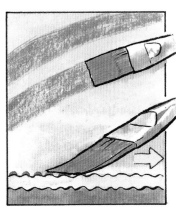

Use tube consistency paint and keep brush angle low to pick up surface texture.

As brush runs out of color it scuffs more easily.

Eventually, when very dry, increase the angle to scrub color on.

This is to be a high key painting with the values being kept as near white as possible and the colors light and bright.

MATERIALS
Rough Watercolor Paper
Brushes
small, medium, and large round nylon
flat nylon medium size (12 mm)
nylon Rigger
Paints
6 primary acrylic colors
Titanium White
Acrylic Matte Medium

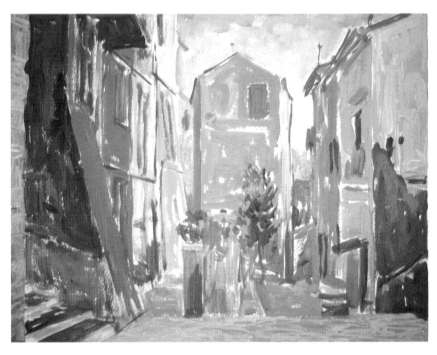

STEP 1—DRAWING OUT AND BLOCKING IN FIRST LAYER

It is essential the paper is strong and stretched to take the acrylic paint. Sketch out the main elements of the composition. Swiftly block in color masses with the flat brush. The inherent bounce in this brush will encourage texture. Underpainting must be kept reasonably light, by adding Titanium White, but feature developed texture to compensate. The paper remains absorbent during this first layer, so speed is of the essence here. Don't worry about individual color mixes; just get the majority of the white paper covered.

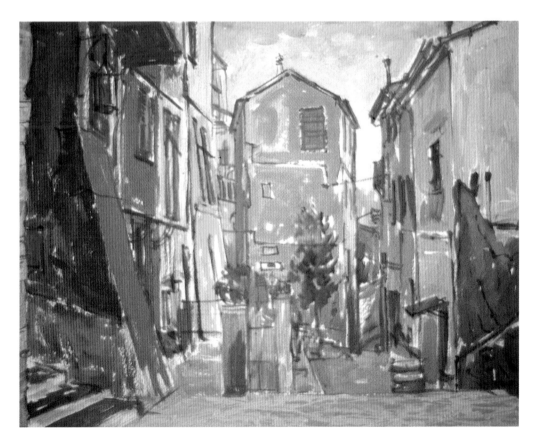

STEP 2—LINEWORK

Create a fluid mix of medium value blue-gray [Bp+Ro+matte medium— the medium added to increase fluidity]. Keep application of linework speedy to avoid over-detailing. Concentrate on suggesting detail and keeping the work lively. Inaccuracy can be forgiven if the painting has life. You can see how light the first layer is by contrast, once the colored-gray linework is applied. It is a good ploy to work with a blue line, as it not only defines areas, but also acts as a complementary contrast to the warm oranges of the underpainting, helping to retain their intensity despite the white in their mix.

Project 2 Workshop

Working with color—high key and complementaries

COLOR REFERENCES
Yellow-orange [Yo]
Yellow-green [Yg]
Red-orange [Ro]
Red-purple [Rp]
Blue-purple [Bp]
Blue-green [Bg]
Titanium White [TW]

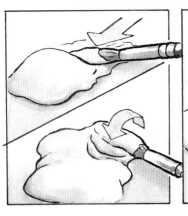

STEP 3 Deep paint, round brush—scoop mound of paint on palette (top). Rotate head to deposit color from mixing brush.

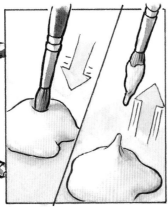

Slowly push tip into mound of paint (top). Pull out swiftly (bottom) . . .

. . . and drip onto surface as a deep stroke.

Rotating round brush during stroke creates a tiny wall of paint down one edge, for extra definition (sky and building edges).

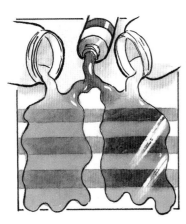

STEP 4 Glazing gloss medium (right) revives depth of dark values (none in this painting) a matte medium (left) does not, so . . .

. . . use matte medium for glazes to develop texture and color only.

Just before applying glaze use flat brush to wet the area.

Use round brush to apply the glaze.

Glazes of opposite color temperature to undercolor create subtle grays.

Glazes of same color temperature intensify undercolor.

Mixing warm and cool colors into a glaze create a subtle colored-gray.

Finish off with Rigger to apply selective final linework.

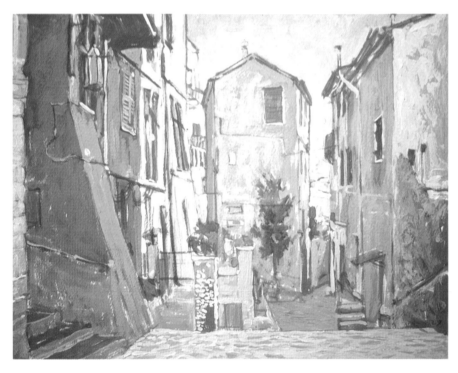

STEP 3—OVERPAINTING

Continue using the flat nylon brush for as long as possible, but ensure brush strokes are gentle daubs. Too heavy pressure will flatten the soft, tube consistency paint. Work into still-wet areas of color with even lighter mixes, adding generous amounts of Titanium White. Wherever possible alternate color temperatures of subsequent paint layers, to compensate for the lack of tonal range—e.g. pink cracks around foreground of cool pavement. Small mistakes can be removed swiftly with the end of your brush or with a fingernail. The brush marks are now structural strokes and scumbles, sometimes looking a little chalky with the addition of so much white. Intensity can be added with the next stage.

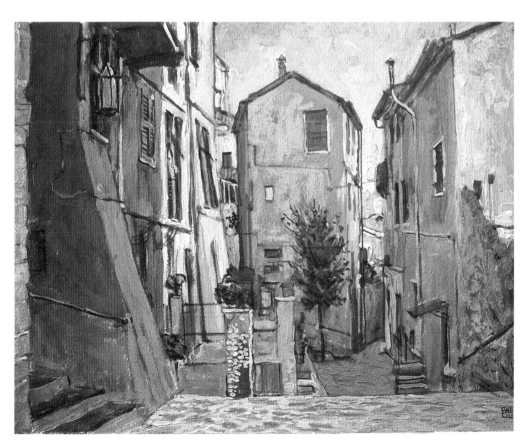

STEP 4—WARM AND COOL GLAZES

Wetting the surface before glazing ensures a soft-edged gentle layer of color, allowing sufficient time for alterations before drying occurs, through either adding or removing color. Apply blue glazes [Bp +matte medium] to the buildings (middle right) and the ground on both sides of the central small wall (which is thrust forward by contrast), also to the inner parts of the large red entrance on the left and under the overhang above. Switch to a red glaze [Ro+rp +matte medium] for the same red entrance and the red face of the building, and the central small walls to bring them forward from the surrounding blue. Mix the blue and red for contrast on the gutters, windows, and any areas than need to become a touch darker and more textured—e.g. left and right foreground walls.

Project 2 Tutorial

Wet on Wet—light to dark

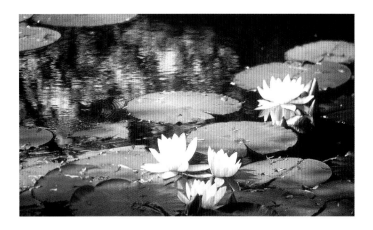

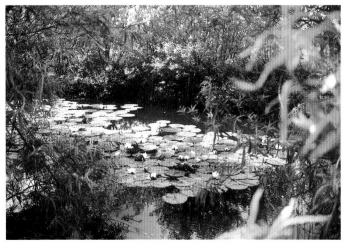

We came upon the small pond with its sun-dappled water lilies quite unexpectedly on a summer afternoon stroll. Armed as always with my camera, I swiftly popped off several shots of the whole view, and switched to a telephoto lens for some detailed close-ups, before the sun moved and the light changed.

TECHNIQUE

This painting borrows several watercolor techniques. Painting in layers, working from light to dark, and most importantly of all, the ultimate in watercolor techniques, wet-on-wet. By working wet-on-wet you will learn to appreciate that not all acrylic paintings need to be hard-edged. On the other hand, when you do need texture or sharpness, a few scuffs or wet-on-dry brush marks will produce all the focus and contrast required. Wet-on-wet is about painting into a pre-wet surface, either as a whole or in sections (restricted wet-on-wet).

THUMBNAILS

These thumbnails produced in my sketchbook show how I played around with the idea of painting the whole pond. I still think there is a future painting here, as I am particularly fond of the way the view is framed by fragile foliage. For this study, however, I decided to focus on the flowers and therefore referred to the detail photograph, playing around with the elements until a better balance was achieved.

THUMBNAILS

These are a series of loose, scribbly sketches to determine the composition. Produced no larger than a matchbox, the key is to keep the detail out of them. It is the outer frame and key elements within the composition that matter, not the detail of each element. Keep them spaced apart and well away from the edge of the paper to avoid confusion or an imbalanced composition. I find it useful to frame the view with my fingers so I can visualize the best proportions for the outer edges. It should take you no longer than 10 minutes to produce six thumbnails—any longer and you are overworking them. Change the position and proportions of the elements within compositional frame. You can also change the shape of the outer frame of the composition. When working from a photograph, the proportions often dominate the first thumbnail, even though they may be inappropriate. Work exactly as you would if you were working in situ, moving things until you get a more balanced composition and one that you would be pleased to work up as a painting. This is the benefit of being an artist as opposed to being a photographer; you are in control of the composition, not it of you.

DRAWING

Transfer the composition to the stretched watercolor paper. Use a 0.5 mm 2B pencil for this, to ensure drawing is kept very light and doesn't show through subsequently applied transparent washes.

STEP 1—HIGHLIGHT COLORS

The painting is a balance between the positive shapes of the plants and the negative shapes of the water between. Your first task is to fill these areas with highlight colors, so that you can assess early on whether this balance is likely to be achieved. Make a large central mix of yellow-green [Yg+Yo+bg] on your palette to use as a base color. Add either red [Ro] or blue [Bp+Bg] to different sections, to allow for adjustments to different areas of the lily pads. Wet the entire surface with a 2 in. (50 mm) Hake brush before applying colors with a large (No. 12) nylon round brush. Acrylic colors dry and stain faster than watercolors so wet thoroughly and constantly rewet with the Hake as you work, to ensure brush strokes remain soft. The water is first painted a light orange [Ro+Yo] and the flowers very light yellow [Yo]. Also add some orange to the edges of the lily pads.

COLOR REFERENCES
Yellow-orange [Yo]
Yellow-green [Yg]
Red-orange [Ro]
Red-purple [Rp]
Blue-purple [Bp]
Blue-green [Bg]
Titanium White [TW]

COLOR MIXING
Where the prefix letter is shown in capitals this denotes a larger quantity of that particular color. Conversely, where the prefix letter is shown in a lower case, this denotes a smaller quantity of that particular color.
e.g.
Bp = large amount of blue-purple.
bp = small amount of blue-purple.

MATERIALS
Rough Watercolor Paper
Stay-wet Palette
0.5 mm 2B Automatic Pencil
Brushes
2 in. (50 mm) Hake
medium and large round nylon
Paints
water-mixable acrylics—
6 primary colors
Phthalocyanine Blue
Titanium White
Water-mixable Linseed Oil
Water-mixable Painting Medium

CHOICE OF MEDIUM
There are many who would have chosen the transparency of watercolors to render this subject. Acrylics were selected as I intended to use a layering technique to slowly build the colors. Layering with acrylic is far easier than with watercolors, as dry layers cannot be disturbed by subsequently applied washes. With white flowers there is also the advantage of being able to justifiably the use of white paint, a practice the purist in watercolor would not endorse.

STEP 2—SECTIONAL WETTING AND DIRECTIONAL STROKES

The previous layer takes little time to dry. Once it is, rewet each leaf sequentially, taking the water about 1 in. (25 mm) beyond in all directions. Apply yellow-green strokes from the center of each pad, pulling them out toward the perimeter. These strokes will visually flatten the surface of each and achieve structure in the pads. Go cooler toward the foreground shadow [by adding Bp+Rp]. Jump around the composition so as not to overlap the wetting of any area with its neighbor, while the latter is still wet.

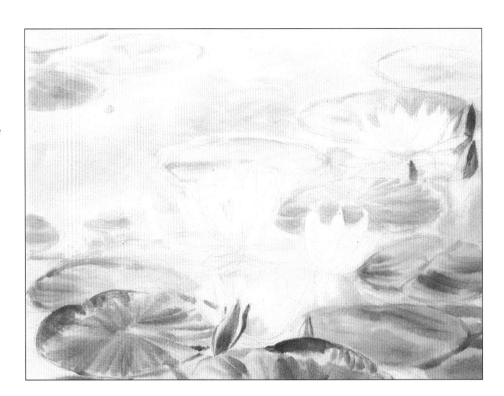

STEP 3A—RESTRICTED WET-ON-WET; POND WATER

While the ripples and reflections are to be kept soft, the edges of the lily pads are to become sharp. This calls for restricted wet-on-wet, in which the area of pond water is wet right up to, but not over, the leaf edges. When the color [Bg+Yo] + [Bp+Rp] is then applied to the same area, the pond water will feature soft edges until it reaches the dry-leaf edges. These leaf edges become hard and will have then been painted negatively and sharply through the application of the color for the pond water. You will find it impossible to achieve the speed necessary to paint this all in one go, so wet and paint the whole area of pond water in sections. You will be lucky to complete all of the top section of the pond water before the surface dries, so keep a look out for hard edges developing where they should not. The second stage of this step shows just how involved this negative shape becomes as it winds around the lily pads.

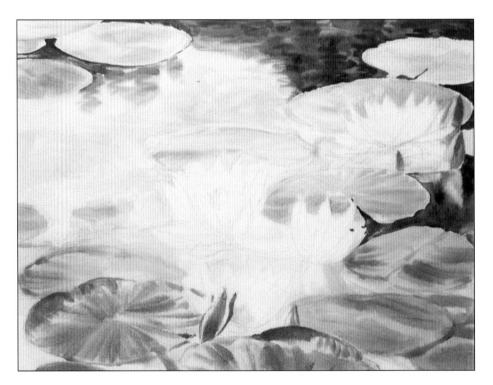

TIP

More open areas can be wet with the Hake, but as you move into the narrow channels, move to the smaller No. 12 round.

NATURAL RHYTHM FOR WETTING AND PAINTING

Thoroughly wet the entire surface. Mix your colors on the palette. By the time you have done this, the water will have permeated the paper fibers, but the surface will be beginning to dry through evaporation. Wet the entire surface again. The applied water will now largely lie on the surface, so that it remains wet just that little longer. Now you have a better chance to get a large area of paint completed before drying halts your progress.

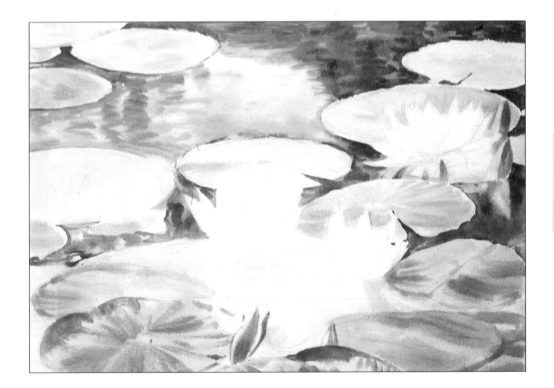

TIP
Mix your colors before painting so that you prevent wetted areas from drying, which will happen if you mix as you paint.

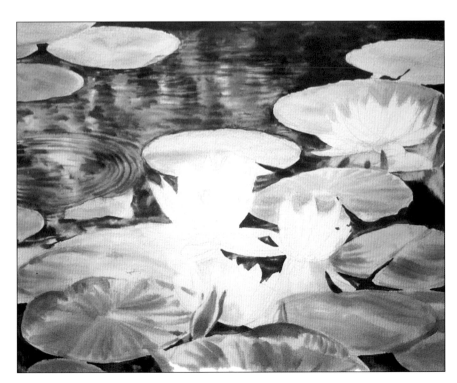

STEP 3B—RIPPLES AND REFLECTIONS

The circular rippled area and the central reflection are both treated in a similar fashion. After wetting, create large pillars of downward reflections, blocked on with the No. 12 round. For the ripples, use a No. 6 round to work fine linework around or across them. Finally, add cool green [Yg+Yo+bg] to the mix and apply wet-on-wet over the warm dry washes, providing more varied color in the darks, working selectively throughout the water area.

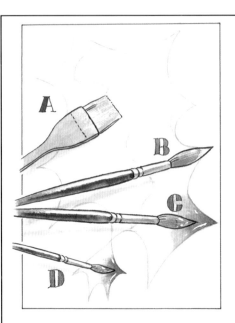

RESTRICTED WET-ON-WET PRINCIPLES AND PRACTICE

Practice on a spare piece of paper to give you the confidence before working on the painting. Draw an irregular shape in pencil on a scrap piece of watercolor paper. Wet larger areas with a Hake [A], but use a round brush to work the water up to edges and into corners [B].
Use the large round brush to apply color inside the wetted area and work right up to dry edges [C]. Use a smaller round brush within tighter wetted areas [D]. Try not to dab color, but keep the head on the surface. This creates smoother strokes and gradations of color.

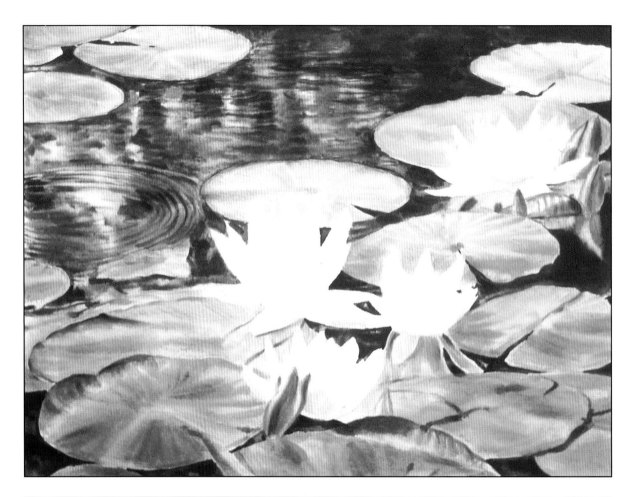

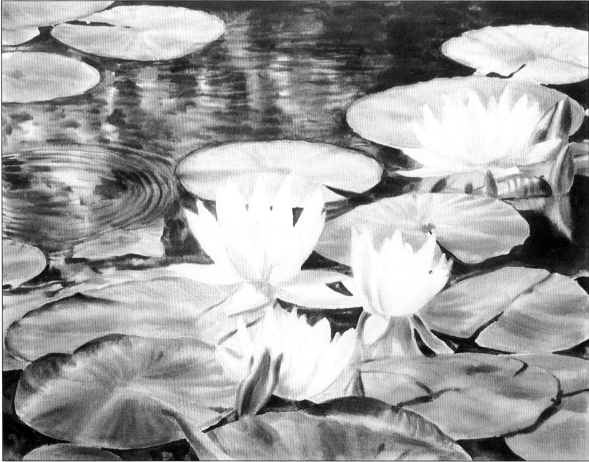

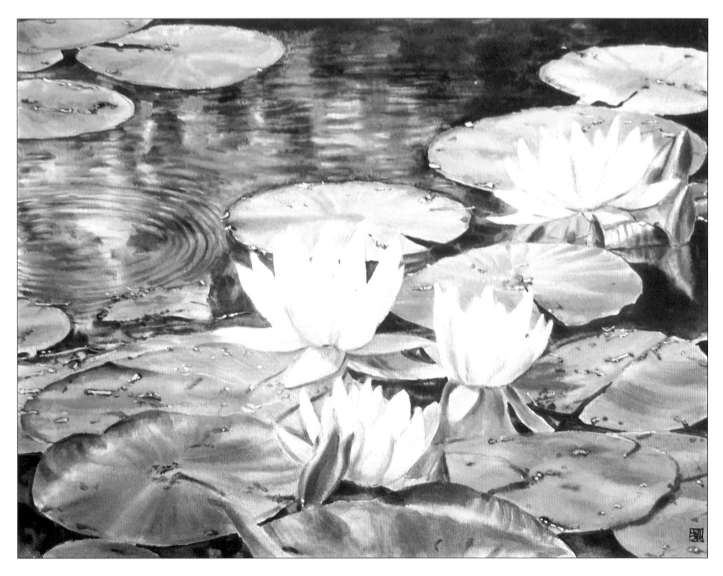

STEP 4—LILY PADS (Above Left)

With the dark backdrop provided by the pond water, the lily pads can now take further work. Again, wet each pad in sequence and apply warm orange [Yo+Ro+rp+tw], stroked toward their centers, like the spokes of a wheel. A touch of red [Rp] encircles the pads, providing wonderful complementary contrasts to the greens, making the colors sing out. The warmth continues, even into the foreground shadows. Follow the oranges with mid-green spokes and leaf edges (cool over warm). Buds and curled leaves (top right) are rewet and accented with warm brown strokes [Ro+Yo+bp].

STEP 5—FLOWERS (Left)

At this stage working with acrylics provides two advantages. The first is that we can use white wet-on-wet to reshape the flowers, or add it to other colors to make them opaque. The second is that the surface, now fully covered with a good layer of acrylic does not dry as swiftly (the acrylic coated paper can't absorb moisture). Color inadvertently or mistakenly applied can be lifted off immediately, without damage to underlying layers. You can now take chances with color, trying something out and removing it if it doesn't work. The flowers are thus worked lighter with a touch of yellow to suggest the sunlight touching their petals [Tw+Yo+yg+ro]. For duller whites (in shadow) add a little purple [Rp+ro] to the mix.

STEP 6—DETAILING (Above)

It is fascinating how tiny little details bring clarity and realism to the final painting. The detritus on the lily pads, gentle highlights on the water and final sparkles of white highlights to the flowers all play their part. Start wet-on-wet, particularly for tiny dark accents, but final highlight touches can be wet-on-dry. The contrast between the resultant tiny sharp edges and the soft mass of wet-on-wet beneath will be extremely eye-catching. Enjoy this detail but try to be fluid. Look at the tiny specks on the lily pads—they are almost calligraphic in character.

Tricks of the Trade

Using watercolor techniques

The further you dip into acrylics, the more you will discover that this medium is tremendously versatile. While possessing its own distinct attributes and characteristics, the repertoire of techniques available when working in acrylics can be enhanced considerably by borrowing techniques from both watercolor painting and oil painting. To do so you must first understand the practical differences between them and here we tackle those between watercolors and acrylics.

Both watercolor paints and acrylics can be let down and made more fluid with the addition of water, but acrylic paint seems to dry faster. This is due to the medium/glue in the paint, which is an acrylic polymer, a type of plastic. As soon as an acrylic surface is dry it sets hard and permanent. You cannot go back and dissolve paint in the process of drying, as easily as you can with watercolor. Acrylic paint is either wet or dry; there is no in-between stage.

What can be done (a) to give you that little extra thinking time and, more importantly, (b) to help you avoid those hard edges from developing where you don't want them?

Using the watercolor technique of wet-on-wet is one possibility—in other words, wetting the surface before you paint. When the surface is paper this can be easily achieved with water. On a less absorbent surface, the addition of a little medium and/or a drop of water tension breaker may be required, a handy substitute for these being a couple of drops of liquid soap. Subsequent brush strokes will then be soft-edged as long as the surface remains wet [A].

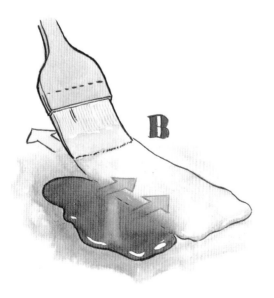

If a brush stroke or mark develops a hard edge where a soft one is required, you can, providing it is still wet, rely on the watercolor technique of losing an edge. Run a wet brush against and along the hard edge. The hard edge of color will flow into the wetted surface, thus the edge is softened or "lost" [B].

The Hake brush, traditionally used in watercolor painting, is made from very soft goat's hair. This softness means it can be used more extensively, for it is gentle enough to deposit water with the minimum disturbance to wet paint underneath. Thus a complete brush stroke or a larger area of the painting can be covered to soften many, still-wet edges simultaneously [C].

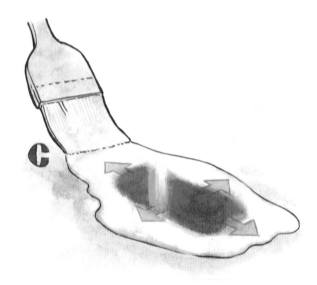

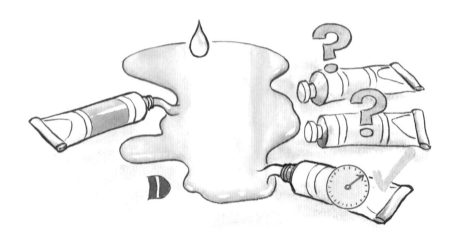

Buttery acrylic does need to be let down with water to achieve a fluid consistency, if you wish to emulate watercolor painting. The medium in the paint is very strong and usually, there is no need to add either matte or gloss medium into the fluid mix. These can be kept for stiffer, transparent films of paint, known as glazes—to be used over textured paint. Retarding medium can be useful, however, as it slows the drying time of the paint mix, which will give you more opportunity to keep edges soft where required [D].

All the soft flexible brushes used in watercolor painting can be utilized in acrylic painting. Do not, however, under any circumstances, lie a brush down with even the thinnest wash of acrylic paint in its hairs [E]. The power of the medium in acrylic paint is incredible, even in weak solution, and once the water has evaporated off, the acrylic is at full strength and will ruin your brush. While it may be possible to dissolve the dried paint in methylated spirit, it is unlikely to clean out fully. Care of your brushes when working with acrylic paint is particularly important and it is advisable to clean them out thoroughly whenever they are not in use, even if it is only for a few minutes.

Common Problems

General problems

PROBLEM

"The painted handles of my acrylic brushes split and the paint peels off [1]. Are the brushes poor quality, or is there something I should do to prevent this happening?"

ANSWER

The paint finish cracks like this because it is being immersed in water for too long. While the paint is obviously waterproof, the end of the brush, where it meets the ferrule, is the most vulnerable. Here the metal ferrule has been squeezed to grip the wooden shaft and this may well have caused tiny fractures in the paint, through which the water can enter [2]. The end of the wooden shaft inside the ferrule may also be open to absorption of water if not painted. As the wood absorbs water it swells and not only cracks the paint layer, but also loosens its grip on the wood. Most paint and varnish finishes will weaken if immersed in water for extended periods. This can happen to even the most expensive brush — so it is not the manufacturing process, which is to blame. Acrylic brushes are the most vulnerable, as they need to be immersed in water when not in use, during the painting process. It is far more damaging to have the paint drying on the brush head, than a little paint loss on the handles. I have to admit that some of my favorite brushes have lost a little paint in this way.

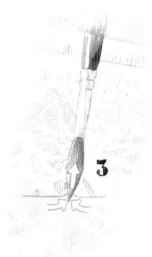

SOLUTION

To prevent or reduce damage, avoid immersing the brush beyond its ferrule. There are many types of brush cleaner available that suspend the brush head just below the water level. You only need to touch the water surface with the tip of the brush to ensure that capillary action carries water up to the rest of the brush head to keep it moist [3]. Always wipe excess paint from the handles, otherwise it will dry there and can be difficult to remove. Laying brushes across the moist surface of a large stay-wet palette keeps the whole brush damp and any paint soft, while not being wet enough to soak through the handle.

PROBLEM

"My tubes of acrylic paint often get a dry plug of paint in their neck, which is difficult and messy to remove. What can I do to prevent this?"

ANSWER

The neck of the tube is the most prone to drying, being closest to the air and containing such a small quantity of paint. Ensure the cap goes back securely. If you don't replace caps immediately, the paint in the screw will dry and the caps will screw on unevenly [4], allowing air access to the paint. If the cap or screw neck contains dried paint you must gently remove this with a penknife.

SOLUTION

If the paint in the cap and around the neck is wet, scrub it off with something like an old toothbrush [5], before replacing cap on the tube. A trick I employ before replacing the cap is to immerse the tube head in clean water and gently squeeze the sides of the tube [6]. This pulls the color back into the tube and a small amount of water with it, filling the neck. When the cap is replaced the water remains in the neck, keeping the color at the top of the tube fluid for a long time.

PROBLEM

"I would like to be able to squeeze out substantial amounts of acrylic paint to last a full painting session. However, I find this difficult to keep wet, and what can I do with the paint I don't use? It certainly won't go back in the tube!"

ANSWER

An essential item for your kit, if you paint regularly with acrylics is a "stay-wet" palette. Either make your own or get one of those on the market. Some have pots with lids, in which to keep quantities of squeezed paint. If not, get hold of some tiny lidded pots or collect small, one-serving jam jars [7].

TO STORE PAINT IN POTS/JARS

Squeeze out a good quantity of paint, building a central mound of it. Deposit a "moat" of water around this mound, using a dropper or paint brush to drip the water in place [8]. This moat, if kept full throughout the painting session, will reward you by keeping the paint soft. When collecting color on the brush from this mound, ensure you dip it into the mound and not the moat. Thus the paint will be thick and not overly fluid with excess water [9]. At the end of the session renew the moat if necessary and replace the lid. The paint will now keep for several weeks, if necessary, despite being free of the tube.

Project 3

Linear and aerial perspective

Technically, there are no limits to the number of layers an acrylic surface can take. Creatively, however, too many layers can lead to overworking. This can be sensed as the freshness and vitality within the composition begin to wane. When working with acrylic paints, this is easily overcome and can, in fact, be exploited as a contrasting foundation. An overworked, dark, and dismal base provides a glorious foil for brighter, more vigorous brushwork to follow.

Acrylic paint, used opaquely, will fully or partially cover already dried layers. If texture exists beneath, this can be either exploited as a feature or overwhelmed with even heavier textured paint.

The process for this technique is to work from light to dark in the underpainting, subsequently working back from dark to light. Inevitably, as white is added to increase opacity and light, the colors will lose their intensity and become a little chalky. Their vitality can be restored through the use of the oil painting technique of glazing with transparent color.

As in oil painting, glazing in acrylic painting is achieved through the addition of medium. A variety of acrylic mediums exist, including gloss medium, which not only restores the intensity of the colors, but also brings back the shine to dark accents retained form the dark underpainting. Conversely, a matte medium provides a dull glow for more subtle effects.

The build back to light does not have to be completed in acrylic paint. The surface will be receptive both to oil paint and pastel. The dark and textured underpainting can be exploited for use with these alternative mediums, whose opacity will work well against the weight of the acrylic paint.

Both the workshop and tutorial in this project feature compositions based on a subject that daunts many prospective painters—perspective. Although aerial perspective and linear perspective sound alike, they are quite distinct.

The workshop is based on aerial perspective, whereby recession is achieved through careful manipulation of the colors, in order to create a sense of depth and feeling of distance. Linear perspective abounds in the tutorial and depends on careful observation of angles and the accurate transferral of these to the painting. Although this sounds difficult, there are simple techniques that can be employed to achieve this more easily.

Project 3 Workshop

Aerial perspective

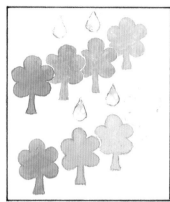

AERIAL PERSPECTIVE
Colors become blue as they move into the distance—add blue, usually Bp.

Colors become gray as they move into the distance.

To gray/dull a color, add its opposite (complementary) on the color circle.

Colors become lighter as they move into the distance. Add water (transparent) or white (opaque).

One or all of these alternatives can create a feeling of distance.

Aerial perspective means foreground accents (darkest bits) are warm and dark (cracks in wall).

Distant accents are cool and light (gaps in trees).

DARK TO LIGHT Colors are darkened by addition of complementaries: to red add green; to blue, orange; to yellow, purple.

Sunlight is warm and light, so add yellow and a touch of white to most colors.

Shadows are cool, dull, and dark, so add blue and/or a touch of complementary.

A warm color on top and a cool color beneath suggest the effect of sunlight.

This can be heightened when the value differences are added.

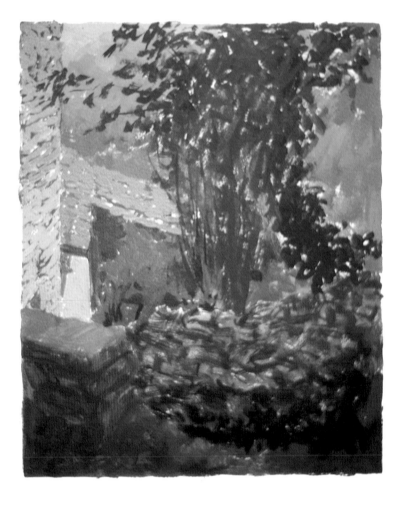

MATERIALS

Rough Watercolor Paper

Brushes

small, medium, large round
nylon
nylon Rigger
flat nylon

Paints

6 primary acrylic colors plus
Titanium White

Acrylic Matte Medium

Acrylic Gel Medium

Texture/Modeling Paste

STEP 1

The initial drawing can be scribbled in pencil before blocking as solidly as possible with dark dull color. To make the odd angles of this composition work, you need to keep two principles in the front of your mind. First, exploit the potential of aerial perspective to give the painting depth. Second, you should pursue all the possibilities that working dark to light has to offer, in order to create the contrast needed to suggest fully the bright sunlight. The greens are thus all dull at this stage, making them blue-gray in the distance and adding more red and blue into the greens for the foreground. Use a large round nylon brush with a good point for detail.

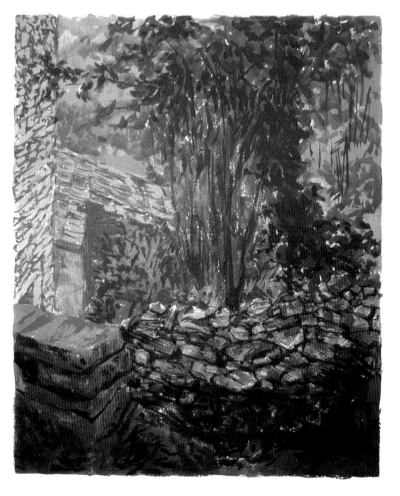

COLOR MIXING

Where the prefix letter is shown in capitals this denotes a larger quantity of that particular color. Conversely, where the prefix letter is shown in a lower case, this denotes a smaller quantity of that particular color.

e.g.

Bp = large amount of blue-purple.
bp = small amount of blue-purple.

STEP 2

Having removed all the white of the paper, the colors will not appear as dark against each other. Use a smaller round nylon, or a Rigger, to develop rhythmic lines and strokes. This acts like a colored line drawing over your color blocks, giving definition and that extra dark value against which later highlights can shine. Notice the blues in the distance, turning to purple in the middle distance, and eventually dull red in the foreground. This follows the principle of aerial perspective, even for the darkest accents. Now that the linework is complete, look at how light the first layer of colors seem against it. Push these darks as far as they will go, especially in the foreground. While you will not be consciously aware of these in the finished painting, the composition will contain no depth or light if they are missed out.

STEP 3

Working from the background to the foreground, apply middle value colors. Yellow-greens make their first appearance, as scuffs over distant trees [Bp+bg+Yg+TW] using a small round brush. As the greens move forward, they should be warmed up [add Bp+Ro] and made slightly transparent with the addition of matte medium. Look for directional brushstrokes that help to create the structure of the leaf platforms. Scrubbing and the addition of matte medium to the dull oranges [Ro+Yo+bp+TW] over the wall allows the undercolor to show through effectively. Use all the textural tricks in your repertoire, such as finger tonking, wiping, scuffing, and daubing to increase interest in the foreground walls and even over the ground beneath the foliage.

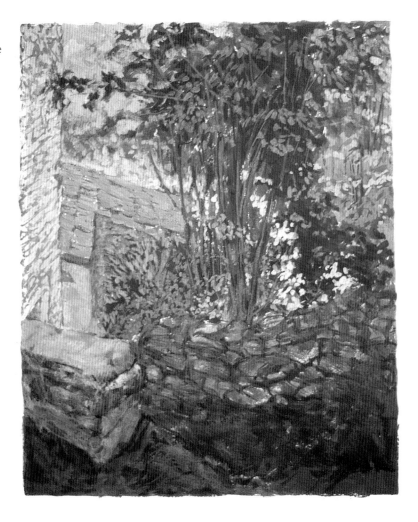

STEP 4

Work now from the foreground back into the painting. In this way, you can ensure that any lights applied to the foreground are immediately balanced against the sunlight beyond the tree. Texture paste is now added to wall colors to increase texture. These broad strokes can be scratched with a fingernail to distribute the color more irregularly. The greens of the foliage in the foreground shadow start dark on the right, with yellow [Yg+tw] gradually added to them as they move left and receive more light. Reflected orange midlights brings some warmth to the fine tree branches and a sweep of yellow-green leaf is carried through and behind them, leading our eye into the distance.

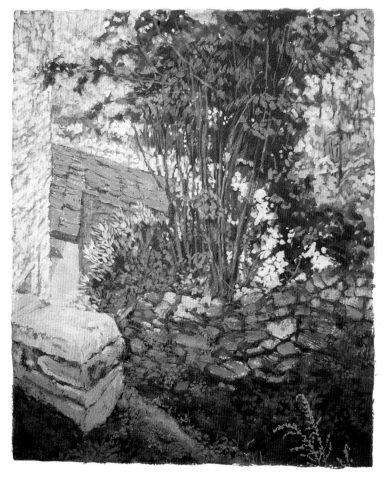

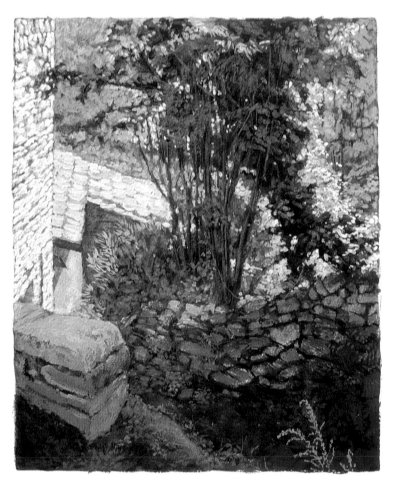

STEP 5

Further recession is achieved with tints over the distant trees. On the left-hand side they are blue, but on the slightly closer trees to the right, they are yellow. Apply these tints with a flat nylon brush, to achieve a flat even spread. Create a gel medium mix of transparent yellow-green to tonk the center tree. For the roof, apply a gel medium orange mix, followed by juicy strokes of more opaque, lighter color, while the former is still wet. Apply more light yellows to the walls below and to the left of the roof, followed by texture paste and white. Soon the sunlight begins to sparkle. This light is carried across to the right-hand side of the central tree, where a wedge of light strokes, moving right through to pure white, provides a startling highlight. As we move through to pure white highlights, the colors overall appear to become clean and crisp.

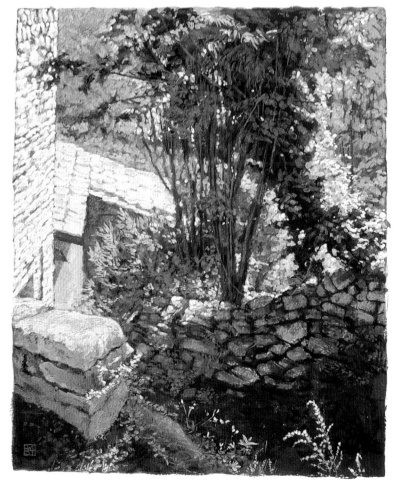

STEP 6

The final composition depends on sunlight at the top of the painting being contrasted against the large dark mass of the tree. Conversely, the bottom of the painting is about fine light detail caught by the sunlight against the dark backdrop of the wall. Yellow dapples of sunlight fall across the top of this wall and the small wall to the left. Use texture paste, tonking, and sgrafitto to develop these light textures and to avoid blocking out the underpainted layers. For the finer detail, a small round brush with a good point comes into play. Starting with the bush directly below the roof and moving through the foreground fine detail, begin with gray-greens. While these contain the sunlight yellow, they also have red in their mix, which slightly dulls them. More yellow-greens can thus be built on top, culminating once more in some carefully selected strokes of pure white.

Project 3 Tutorial

Linear perspective

Whenever you choose to mix different painting media within one piece of work, there should be some underlying reason for the decision. It is not good practice to change to another simply because you run out of ideas or enthusiasm for the medium you are already using. Assess the strengths and weaknesses of each and use them strategically to bolster each other's potential.

CHOICE OF MEDIA

The underpainting in this tutorial is used to provide a texture/tooth on which the pastel can cling more effectively. The effect is increased with the addition of texture/modeling paste, which increases the impasto (raised relief) effect across the surface. Should you have a limited range of pastels, the acrylic painting can also provide all the darks required, which remain as accents in the finished piece. On the other hand, the pastel can be more intense and softer in finish than the acrylic paint. Colors can be blended on the surface long after acrylic would have dried hard and fast. Dry pastel will also pick up and enhance the dry acrylic strokes beneath effectively and in an easily controlled manner. Thus the two media can be brought together to yield results that would be much more difficult to achieve were they to be used on their own.

COMPOSITION

While on a painting trip to Tuscany, I spotted this rise of sun-dappled steps, and swiftly photographed them for future use. With too much to paint at the time, this quick photograph was all that could be managed, but the allure of the subject could not be wasted. This composition contains a wealth of aspects that continually confront the artist, particularly that of linear perspective, strong contrasts, evocative lighting, and a variety of textures.

THUMBNAILS

Such an involved subject, with its several layers of depth, requires a systematic, relaxed approach. Use thumbnails to identify the main elements of the composition and those that are important to you. With disappointing photographs such as this one, thumbnails will clarify whether or not the painting is worth pursuing. The shading in each thumbnail is used purely to fill masses, not to suggest their final values, and is consistent in each, so that comparisons are made easy.

LINEAR PERSPECTIVE WITHOUT TEARS

You don't need to know anything about vanishing points, horizons, or other aspects of linear perspective to cope with the angles of this subject. All you need to do is record what you see. Take any angled edge within the original photograph, such as the fore edge of one of the steps. Lay a pencil along this edge. Hold down one end of the pencil and move its straight edge until it is parallel with the bottom (or top) of the picture. The angle between the pencil and step can be judged by eye and transferred to the drawing.

1. The first approach, with the steps playing a large part and the walls at either side straightened.
2. Makes more of the side walls, and while giving height, does not allow enough space for the distant windows.
3. Sees the side walls reduced and the windows given more attention.
4. The best, with the change to the angle of top-right gutter being more dynamic and allowing the wall at the right to work better. The left wall is reduced slightly, giving more space to the tree.

DRAWING

It is critical that the sheet of watercolor paper is stretched before you start, as the deep layer of acrylic to follow will inevitably cause the paper to buckle if it is not. As the drawing will be easily covered by the acrylic, you can draw and correct this stage until you feel happy with it.

MATERIALS

Rough Watercolor Paper
Brushes
round nylon bristle
round nylon soft
Paints
6 acrylic primary colors
Titanium White
Artists' Soft Pastels
Acrylic Texture Modeling Paste
Erasing Knife
Paper Wiper
Kneadable Putty Rubber
Stay-wet Palette

PAINT LAYERS

STEP 1

This first loose series of washes should be applied in a very relaxed fashion. Fill in the shapes so that the masses can be seen more effectively, enabling you to make the final decision with regard to their positioning. Warm colors are generally used throughout, but don't feel that they have to be accurate in hue or value. In this tutorial the washes are applied wet-on-dry, using a large round nylon brush. There is no white in the paint mixes, for the white of the paper is used, as in watercolor painting. Be bold with the color, as it always looks darker against the white paper than against other colors.

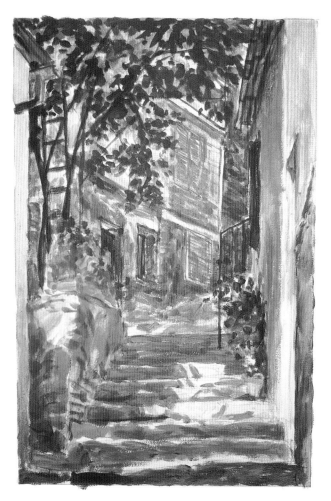

STEP 2

Middle to dark values are now applied, to achieve a sense of light and depth. Add texture paste to the paint mixes to give structure with each stroke of color. This overall tooth, even in relatively flat areas, will help with the adhesion of the pastel to come. The general texture of the watercolor paper is slowly overtaken by the impasto of the brushwork. The latter will become exposed when the pastel is drawn over, giving the pastel work a brushy fee that is impossible to achieve with pastel alone. Any redrawing, such as the repositioning of the window on the right hand wall, can take place at this stage.

STEP 3 (Below left)

Full impasto is now achieved by bulking the paint with generous amounts of texture paste. Use the round nylon bristle brush to whip up the texture, keeping the round soft nylon for detail. Create direction in each impasto stroke. Remember that even with the addition of modeling paste, some of the bulk evaporates off, so lay it on heavily. For the steps, work downward, with the soft brush at the top through to the bristle brush at the bottom, progressively adding more paste as you go along. Inevitably at this stage, colors being to flatten out into their middle values. The soft darks and harmony of the surface will be restored with the pastel. Sand gently overall and then sprinkle some dark brown pastel, scraped directly from the stick with a knife. Fix with a wash of acrylic matte medium, which washes the color into the grain of the texture.

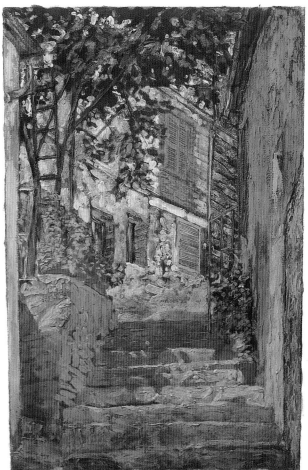

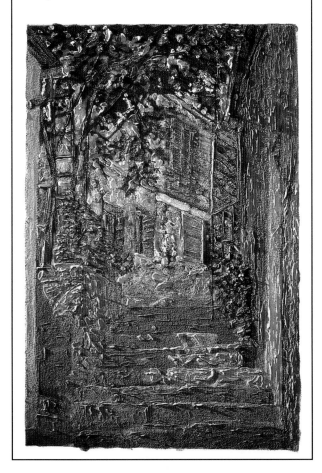

ACRYLIC TEXTURE STAGE
With side light the true structure of the surface becomes evident. The areas to catch sunlight are built up to the greatest extent, not only to hold more pastel layers, but also to catch light falling across the picture surface making these areas really shine.

PASTEL LAYERS

STEP 4

Apply middle greens to the leaves and wipe in with a paper wiper. Remove any excess color with the kneadable putty rubber. The main energy of these leaves is derived from negative painting with a light brown into the spaces between them. For the walls, drag mid-yellows and oranges across, wiped in or scraped partially away with the erasing knife. Note how much of the underpainting is allowed to show through, creating accents. Splashes of bright red on the flower and rail are dabbed on and pressed into the surface with the paper wiper. Overall, a warmth and intensity of color is established, which will glow through overlaid layers of pastel.

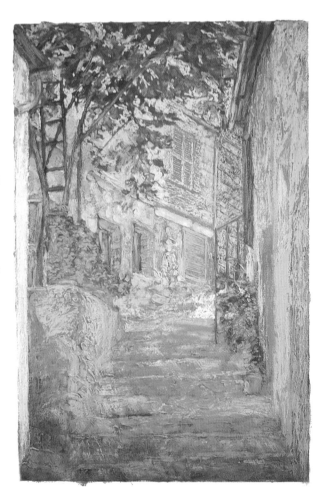

STEP 5 MID TO LIGHT VALUES (Below)

Lighten the back wall so that it recedes (aerial perspective). White is used here, gently scrubbing it into the existing pastel layer with no physical blending. The visual blending that results would be impossible without the acrylic texture beneath, which breaks the solidity of the pastel stroke as it is played across the surface. Applying different pressure when using the white pastel creates glowing light (soft) or sparks of light (hard). Middle greens on the leaves of the trees are left unblended, allowing the pastel strokes to be broken up by the paint texture, inviting the undercolors to play their role.

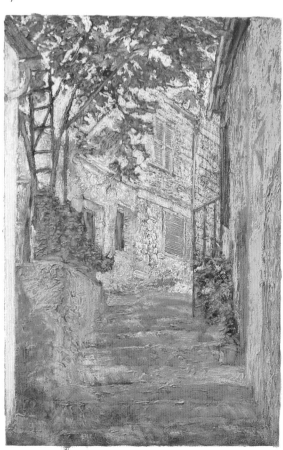

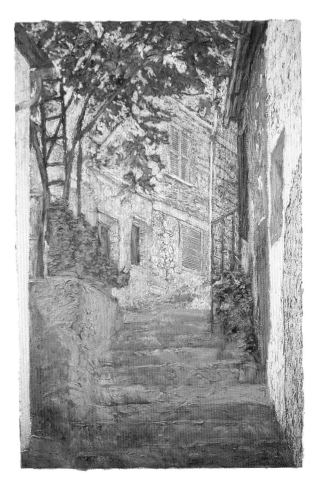

STEP 6 MID TO LIGHT VALUES (Right)

With a heavier white than that used to scuff the back wall, add focus lights on the drainpipe and to the windowsill. By comparison the white on the wall will now appear to become a color. Light greens on the tree are followed by selective dabs of pure yellow to suggest sunlight. Note how these yellow dabs, seen together, move diagonally down from right to left. They are not placed indiscriminately, but with a definite pattern that carries the eye. Both side walls are lit with a very light lemon yellow and really begin to work as a visual frame for the composition. A variety of pressure used when working the pastels yields different degrees of coverage of the color beneath.

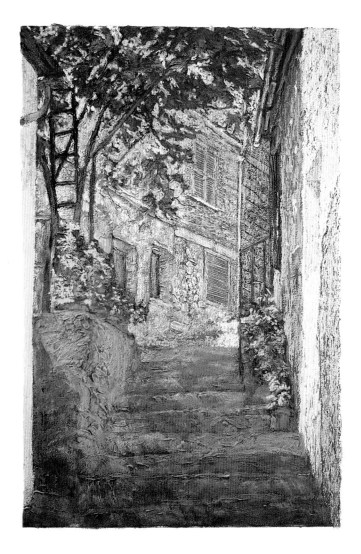

STEP 7 MID TO LIGHT VALUES (Left)

Place the lights across the back wall using very subtle scuffs, such as the lemon yellow to the yellow shutter, blue-gray to the blue door and window frame. On the right-hand wall, the gutter, shutter, and stonework are given cool strokes, including light blues to show the reflected cool lights that are found in shadows. Sunlight falling on the plant leaves becomes yellow-green and finally pure yellow, even stronger than that used in the tree above. Note how both these strokes and the bright red of the flowers are placed as irregularly as possible to give a natural effect. More subtle cool (blue) and warm (yellow) lights are applied on the patch of grass just above the steps, providing temperature contrasts against the wall behind.

STEP 8 MID TO LIGHT VALUES (Right)

Exploit the impasto paint beneath when applying the highlights to plant leaves and flowers, by just catching the topmost points of the raised texture. The diagonal yellow pattern established earlier in the tree is now extended through the plants to encircle the center of the composition. Highlights to plant pots and the wooden structure below the tree are achieved by adding a yellow and then a white overlay, to ensure bright shining highlights. Cool reflected lights are scuffed onto the shadows of the steps, with much bolder orange scumbles where bright sunlight will fall.

STEP 9 MID TO LIGHT VALUES (Far right)

Apply final highlights to the steps—in the shadows, warm light orange over the cool lights already established. Often you will see this effect in Mediterranean countries where the sunlight is strong and is being reflected from a white surface. The final reflected lights, which in more temperate climes would be blue, are applied here as orange. Treat pure sunlight areas first to a lemon yellow and then pure white, applied with some pressure. The thick acrylic beneath takes good qualities of pastel, producing the shimmering highlights essential for this raw sunlit scene.

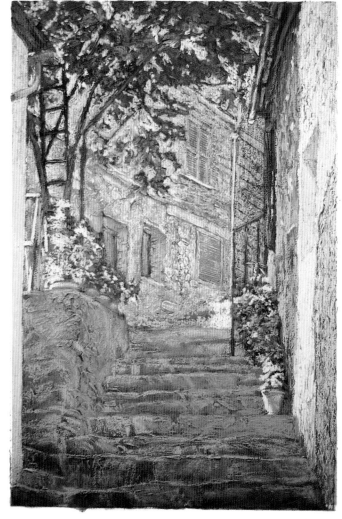

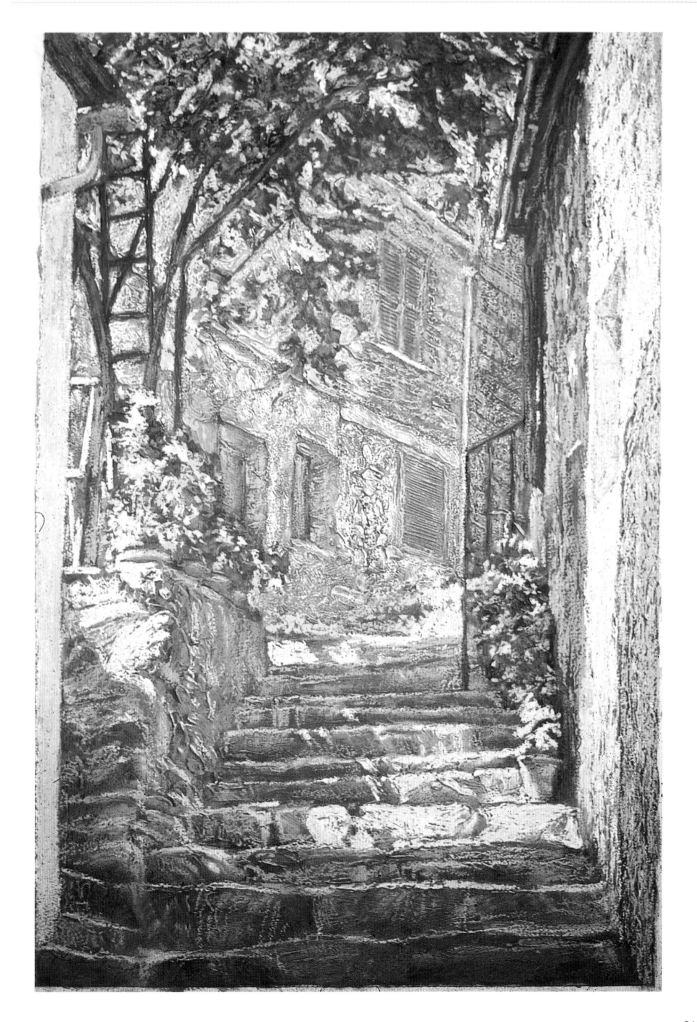

Tricks of the Trade

Using acrylics in mixed media

Being such a strong medium, acrylic is an excellent addition to your mixed media repertoire. By fully understanding its nature you will be able to best judge when and where it can be incorporated.

ACRYLIC MEDIUM AS GLUE

The medium at the heart of acrylic paint is so strong that it can be used as glue for fixing things to the surface, other than just the pigment. Anything— the lightest leaf, or paper and wood, even metal—can be stuck to the surface and incorporated into the painting. The transparency of the overpainting is affected by the thickness of the applied layer or the amount of white or medium [A] added to the mix. Thus the color of the object can be exploited, or its texture, or its shape. Adding material, such as sand, to the paint mix creates stiff heavy color, for applying with stiff brushes, palette knife, or other tools that could enhance the texture.

ACRYLIC WITH WATERCOLORS

While acrylic paint dries to a permanent surface, dry watercolors can be dissolved again. An interesting combination is to paint a layer of acrylics that is allowed to dry. This layer could be of tube consistency or heavier, with texture paste added. Alternatively, there is a lighter version of texture paste, composed of pumice, which makes the layer slightly more absorbent when dry. The acrylic layer is generously over painted with watercolor paints and allowed to dry. This takes a little longer than normal, since the water isn't absorbed, as it would normally be when painted on paper. Wiping the first layer with a damp cloth will lift the watercolor paint off the protruding points of the surface, leaving color in the valleys between, to create a unique texture [B]. This layer could be fixed with a gentle layer of acrylic medium, either painted on or sprayed over. On the other hand, you could continue to paint, adding more layers of watercolors or acrylics, or for that matter, introducing pastels.

TIP: Watercolors can effectively be changed into a form of acrylic paint through the addition of an acrylic medium into a color mix. Having done so, you must treat them as acrylics. For one thing, they will dry solid on palette and in brushes if you allow them, so it is important to take the necessary precautions.

ACRYLICS WITH PASTELS

Working with pastels involves two prerequisites. First, the painting surface must have a tooth, or texture, to which the pastels adhere. Often the nature or design of this texture becomes an important element in the finished work. Second, when building layers of pastel, it is beneficial to start with dark colors. By their very nature, pastels, especially the less expensive ranges, can be a light in value. An acrylic layer beneath pastels can provide all the necessary texture and dark color. This has the advantage of providing extra stability than pastel alone [C].

> ### TONE
> is the degree of lightness or darkness of a neutral gray
>
> ### VALUE
> is the degree of lightness or darkness of a color

ACRYLIC WITH OILS

Oil and water don't mix, or do they? For once a layer of water-based acrylic is dry, it presents a very acceptable surface on which to continue in oils. Acrylics could be used simply to achieve fast drying underpainting on a raw, non-primed and unsealed surface [D]. You can start oil painting immediately the acrylic layer is dry. On the other hand, they could be taken further, building up base textures, through the addition of texture paste, which can then be overpainted with oil, especially glazes [E]. Before texture paste came along, tempera paint was often used to build fast-drying texture, followed by glazing with oil paints. Acrylics are more flexible and long-lasting, however.

NOTE: While acrylics can be used under oils, they cannot be mixed with, or applied over, oil paint. The latter provides too slippery a surface for the acrylic paint to adhere.

> Acrylics prove indispensable in sealing any raw surface to accept subsequent layers of paint or pastel. Other than paper or canvas, they can be used on surfaces such as metal, wood, cloth, stone, or plastic. For once the acrylic has soaked into, or coated, the surface, it dries rock hard, stabilizing the surface and reducing absorbency.

Common Problems

Applying color

QUERY

"I have been working in watercolors for some time now and would like to turn my hand to acrylics. Can I use my sable brushes, or should I buy some just for working in acrylics?"

ANSWER

You could use all of your watercolor brushes with acrylic paints, providing you understand how acrylic paints behave and take certain precautions. Acrylic paints dry through water loss from their mass. It is important, therefore, always to wet a brush thoroughly before dipping it in the acrylic paint. Squeeze out excess water between two fingers and/or a tissue, so as not to make the paint more fluid than required. A little liquid soap worked into the base of the brush head would also make the individual hairs a little more slippery, which slows the speed of paint adhesion in the head.

BRUSH CARE

While the brush is being used, it is usually the paint movement in and out that keeps the whole head in a fluid state. However, watch out for the base of the brush head and the ferrule, where the paint is more static, for it is here that the paint tends to dry in. Keep your eyes on these and you will know when it is time to clean the brush [A].

BRUSH CLEANING

When cleaning, gently work your fingernail into the base of the brush to remove any clinging color [B].

CHOICE OF BRUSH

Consider the nature of the surface on which you will be painting. Heavily textured acrylic paint can present quite an aggressive surface. A soft brush used over this could easily be damaged. In this case it may be worthwhile considering nylon, rather than sable, brushes. Nylon brushes are stronger and cheaper. [C].

QUERY

"I find it really tiring to keep on cleaning a brush each time I need to dip in to one of my pots of paint for some new color. Apart from which, there is the waste of paint every time I do so. Is it strictly necessary to do this?"

ANSWER

A brush will only deposit color when it is really full of paint. You don't need to clean the brush every time, just remove this excess fluid. In point of fact, if the brush is really squeezed out, it will act like a sponge and suck paint in—known as a thirsty brush. To empty the brush, squeeze gently between two fingers. Do this slowly and take great care not to pull too much, because this will loosen the hairs in the ferrule.

The safer way is to use one finger, gently squeezing out the color against the palette [D]. In this way the brush is emptied and the paint collected. The same method can be used to gently shape the brush for linework [E].

PROBLEM

"When I start to use texture/modeling paste in my color mixes, the bulkier paint mix ends up covering too much or going where it shouldn't!"

SOLUTION

As soon as you notice the paint going where it shouldn't, such as over an edge, reverse your brush and scratch it away with the end—this is called "sgrafitto" [F]. For larger areas you could use a fingernail or invest in an erasing knife. These have a curved blade that is stiff (unlike the flexible palette knife used to deposit color) and will lift color without damaging the surface—a technique called "scraping" [G]. You may get to like the results enough to include them in your repertoire of techniques to achieve special effects.

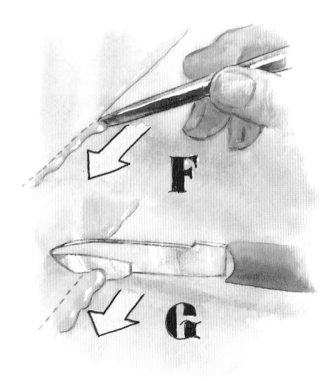

Project 4

Working with texture

Ever since the first paintings on the stone walls of caves, the effects of texture have fascinated humans. These textures take on three distinct forms.

First, there is the naturally occurring characteristic of any surface, which can be anything from a piece of driftwood found on a beach, to collected layers of spiders' webs, to the natural purity of a sheet of watercolor paper—painters have worked on all of these surfaces. I term them "arbitrary" textures, and they can be exploited through selection or application. Carefully choosing which texture or part of a texture should be painted over can create something unique.

Arbitrary textures can be exploited by vigorously brushing paint on, or through dripping, dribbling, splashing, squeezing—the possibilities are endless. In whatever manner they are achieved, every brush stroke applied over arbitrary textures will be interrupted, the painting invigorated by the effect.

Second, there are "structural" textures, those applied and controlled by the artist or craftsman. A structural texture can be the natural result of a brush moving across a surface, creating patterns or rhythms as it goes. More importantly, it can be a series of structured marks that follow the shape, or model the form, of elements within the composition. This structural texture catches the eye and carries it across the painted surface. Not unlike a storyteller, it leads the viewer through the painting, by introducing drama at significant points, before moving on.

Light falling on the surface is reflected from the heavier textures, suggesting highlights. The dark areas, through lack of texture, will conversely seem deeper and more mysterious by contrast.

Finally, there are "visual" textures, which, although physically flat, create the impression of physical texture through the juxtaposition of values and/or colors. This characteristic is the basis of camouflage in nature, prime examples of which are moths and butterflies. Even though the surfaces of these creatures' wings are relatively flat, the pigmentation within provides a welter of different patterns, designed to act as protective camouflage in each species' natural habitat. A settled butterfly or moth is exceedingly difficult to spot, seemingly disguised as a piece of bark, or a green leaf.

This project deals principally with achieving arbitrary and structural texture. Visual texture, however, emanates as a natural process of the interplay between them and the layers of overpainted acrylic. Again, the acrylic paint is built layer upon layer, but with the added dimension of texture the composition is imbued with structure and drama.

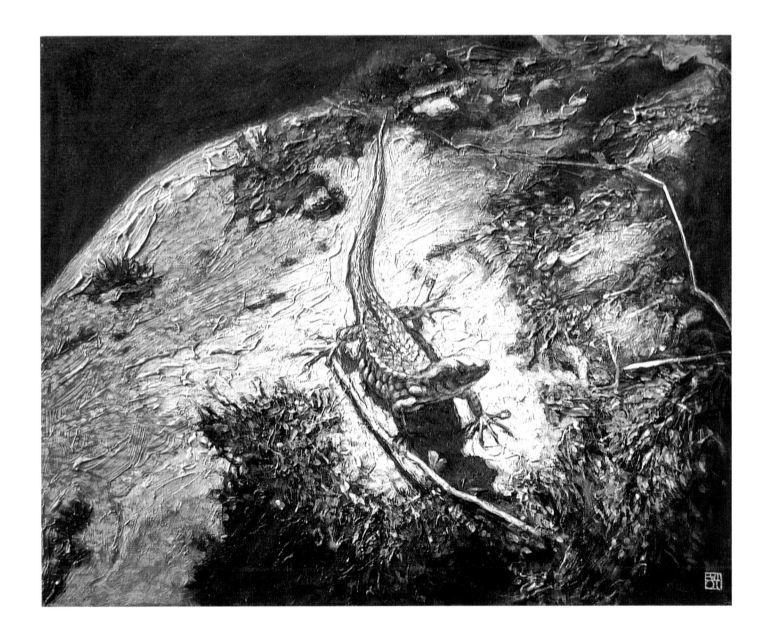

Project 4 Workshop

Working with texture

COLOR REFERENCES
Yellow-orange [Yo]
Yellow-green [Yg]
Red-orange [Ro]
Red-purple [Rp]
Blue-purple [Bp]
Blue-green [Bg]
Titanium White [TW]

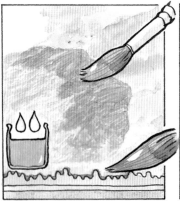

STEP 3 GLAZING Dried textures can be enhanced by applying dark fluid washes with added medium.

REDRAWING Use at any stage to suggest fine detail and accents. Apply with Rigger and fluid color.

WIPING Opaque fluid color (with medium) laid over textured area begins to dry . . .

. . . but is partially wiped away using clean absorbent tissue . . .

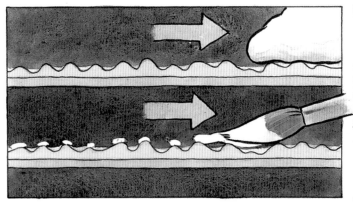

. . . to remove still-wet color from raised surfaces, leaving opaque color in grooves (opposite to glazing). This retains textures for subsequent exploitation with scuffs and scumbles.

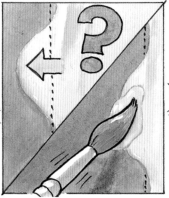

ACCIDENTAL COVERAGE If color goes too far, rewet (before drying) with wet brush.

Use fingernail wrapped in tissue to accurately lift off excess paint.

DAUBING Add extra medium and/or gel medium (no water) to paint to make it stiff and glutinous . . .

. . . to achieve unique textures with side of brush.

STEP 5 HIGHLIGHTS Apply lights to small rounded forms such as scales. Soften or lose using small wet brush.

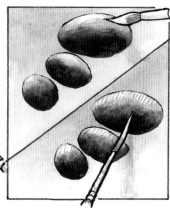

Revisit with stronger highlight, dabbed or hatched on.

MATERIALS
Watercolor Paper
Waterproof Drawing Ink
Brushes
small and medium round nylon
nylon Rigger
round bristle
Paints
6 primary acrylic colors
Titanium White
Acrylic Modeling/
Texture Paste
Acrylic Matte Medium
Acrylic Gel Medium

COLOR MIXING
Where the prefix letter is shown in
capitals this denotes a larger quantity
of that particular color.
Conversely, where the prefix letter is
shown in a lower case, this denotes a
smaller quantity of that particular
color.
e.g.
Bp = large amount of blue-purple.
bp = small amount of blue-purple.

STEP 1

Acrylics are, in effect, self-sealing, with the first layer of paint forming a non-absorbent surface. They can be used on absorbent surfaces, such as pastel paper, as used here. Using a colored surface can provide a foil for the opaque paint, particularly when using white or colors with white in their mix. Some painters also find the prospect of working on a colored ground less daunting than being faced with the stark white of non-colored paper. Pastel paper does need stretching, otherwise it will cockle quite violently, and the heavy acrylic textures that are to be applied will increase this probability. Start the drawing in pencil until you have scribbled in the main features. You can afford to be relaxed with your drawing, for all pencil lines will disappear under the acrylic paint, disguising any mistakes. Once satisfied, outline the correct lines in ink. I used a brush pen for speed, but a Rigger, dip pen, reed pen, or waterproof felt tip would do equally well.

STEP 2

The first step is to block in the color masses and at the same time build the textural structure of the painting by adding good quantities of acrylic modelling paste to the mixes. For this I used a variety that contains marble dust. There are other versions, however, including a lighter one, produced for use with paper, which contains pumice. The choice is yours. Apply the mix with a bristle brush to increase texture, ensuring as little water as possible is added to the mixes. The whiteness of the texture paste diminishes on drying, but while wet it ensures the textures are highly visible against the colored paper. Note the complementary pinks beneath the lizard. These will add extra spice to the dark undercolors to follow and provide a complementary foil against which the subsequently applied greens will sing.

STEP 3

Once the textured layer has dried thoroughly, apply a layer of dark transparent glazes (see Artstrip). From here, you will be working back toward light, making the most of the underlying dry textural structure. Be as adventurous as possible, utilizing a variety of techniques to achieve the texture, darks, lights, and contrasts. Exploit the fast-drying quality of acrylic, by applying colors and wiping them away (see Artstrip). The longer you leave the applied paint, the more remains on wiping. Add texture paste to the colors to enhance scumbling, as paint from the tube can often be too fluid. Tints can also be exploited effectively, to soften textures and create depth [Color+Medium+TW]. See these used over the darkness behind the rock, especially along its edge. These layers dry swiftly and successive layers of tint, glaze, and scumble are possible.

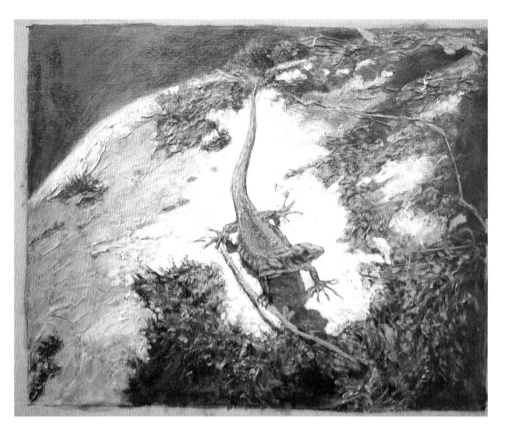

TIP

Halo Tint (something I have developed over the years)—a tint of dull orange [Ro+Yo+bp+TW] completely encircles the outer edges of the painting. Although subtle, its effect is one of focus.

STEP 4

Final highlights, applied on the green and orange of the moss, twigs, and leaves, encircle the lizard, adding to the light already built toward the center. It is sorely tempting to finish off the lizard, but the background must be completed so that the creature's highlight colors can be correctly judged against it. Note how the strokes of light follow the contours of the rock, and how each stroke is broken by the dry texture beneath. Great pleasure can be derived from adding all the detail at this stage. Its rendering is made more spontaneous, however, by the layers of texture and color you have painstakingly built up. Having prepared the way successfully, you can now enjoy working on all the sharp focus the image deserves.

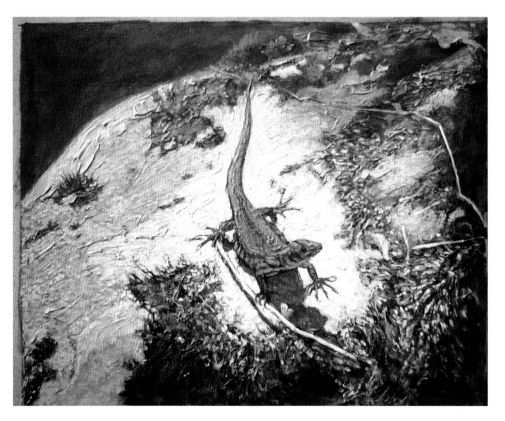

STEP 5

In the detail you can see how the greens are lightened both across the lizard's back and down into the shadow of its side. Highlights on nearby twigs now lead the eye into the depth of the painting, through the complexities of the moss and leaf detritus.

Final highlights to the lizard need to be almost pure white and will work only if they are placed on top of an already light color. Placed directly against a dark color they will appear too crude, so take your time and highlight carefully. After all, it is the highlights of a subject that invariably catch the eye. Work progressively from the first highlight, which is TW+[yo+ro]; through a second, adding more TW and Yg, until finally finishing off with even more white in the strokes. If contrasts become too aggressive at this stage, a localized tint into a shadow, or across a highlight, can soften the harshness—for example the lizard's head, feet, and shadow.

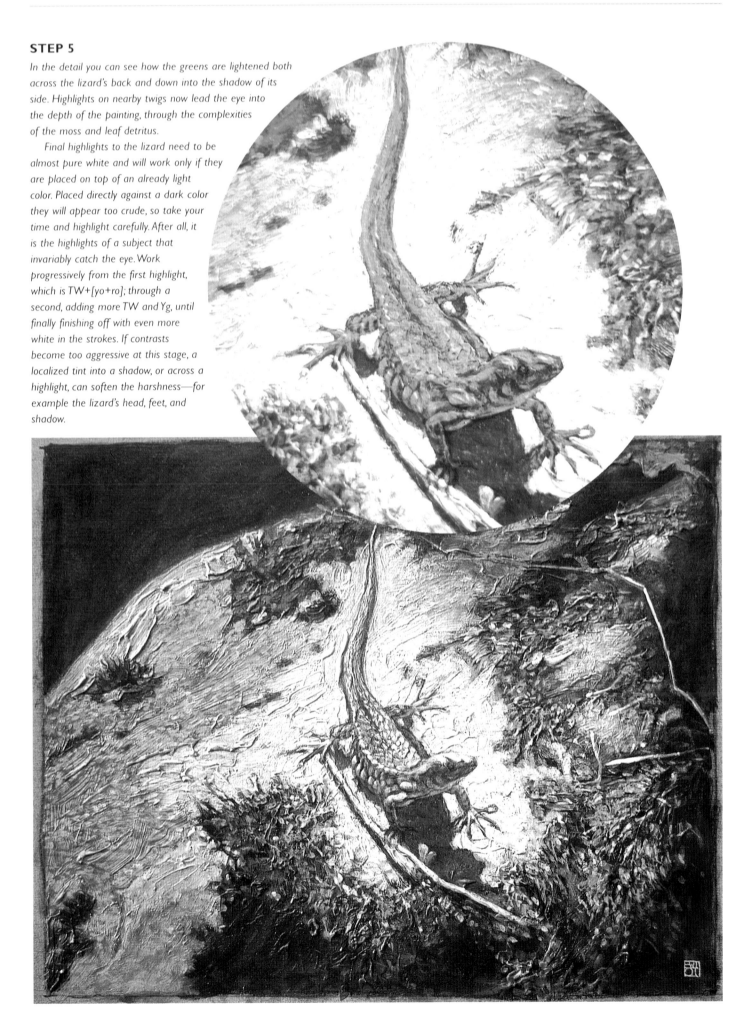

Project 4 Tutorial

Working with texture

Over a period of time the lake at the foot of this massive and majestic tree has nibbled away at the soil surrounding its roots. A dry summer led to the root system being exposed, with its writhing mass of interlacing tentacles creating a living sculpture. There is something about trees that attracts the majority of painters—perhaps it is the symbolic link of the tree of life that lies at the heart of this attraction.

CHOICE OF SUBJECT

This subject is based chiefly on structure. While there is light, it is not the aggressive yellow of the summer sun, but the damp glow of a typically English autumn. Colors are muted and textures dominate; yet it is the contrast between the two that provides the life that permeates the composition. The tree stands eerily, yet tranquil in its setting beside the gently lapping water of the lake.

CHOICE OF MEDIUM

To recreate these powerful textures the use of acrylics affords a painter the opportunity to give full rein to a variety of textural possibilities, including the use of modeling paste. However, in borrowing the oil painter's technique of working dark to light, structure is also achieved through the gradual build-up of color that imbues the painting with texture, depth, and contrast, and eventually exploiting the benefits that glazing and tinting bring.

THUMBNAILS

These three thumbnails were produced in my sketchbook while I was on the spot, and were used as a guide for the reference photographs that I took at the same time.

- 1 shows the influence of the dominant tree, but this would result in a painting of the tree and not its roots.
- 2 is more squat, eliminating or shortening the trunk, while retaining the branches, which are interesting against the sky.
- 3 allows more space for the roots. however, along with a view across the lake.

CROSSING FROM ONE MEDIUM TO ANOTHER

This painting can also be produced as mixed media, taking the best of both worlds. Begin the work in acrylics to build the textures and colors. Complete it in oil paint with scumbles and glazes. Acrylics create a perfect base for oils and here, with added texture, a fast drying solid base onto which the oil can easily adhere.

STAGE 1—ESTABLISHING COMPOSITION, STRUCTURE, AND UNDERPAINTING

STEP 1

Stretch a large sheet of watercolor paper to capitalize on the dramatic nature of the subject (this painting measures 20 in. x 26 in./51 cm x 66 cm). Once dry, sketch out the elements in pencil, firming up with an ink line once you are satisfied with the composition. For this I used a brush pen for speed, enabling me to pick up on the natural rhythms inherent in the subject. The principle of this painting is to initially create maximum textured structure through the use of texture/modeling paste, on which color can be subsequently built up. However, the white paste can be difficult to see against the white paper, affording less control in its exploitation. To render it more visible, the surface can be colored first. Instead of merely laying a flat overall color, tonal washes in dull brown, not only provide a preview of the composition, they also help you to assess where the texture paste would be more beneficially laid. A large flat 1 in. (25 mm) nylon brush can be used to lay this color on swiftly. The use of directional strokes will further reinforce the structural possibilities of the paste to come. Note that the ink drawing can still be seen through these powerful brown washes. Note also the high visibility of the first areas of white paste that have been laid against the underlying brown washes (sky and water).

Details—take a good quantity of texture paste and spread out a thin layer (¼ in./5 mm deep) onto the stay-wet palette, any deeper and the top layer will begin to dry. Use the flat brush to apply this to the painting. Note how strokes are pulled away from the edges of branches and stones. In a solid area, such as the water, cover heavily to get the paste to adhere, then smooth out or work up the texture before it dries.

MATERIALS
Rough Watercolor Paper
Waterproof Drawing Ink
Stay-wet Palette
Brushes
large flat 1 in. (25 mm) nylon
various sizes of round bristle
round nylon
nylon Rigger
Palette Knives
Paints
6 primary acrylic colors
Titanium White
acrylic texture/modeling paste
Acrylic Matte Medium
Acrylic Gloss Medium
Acrylic Gel Medium
Acrylic Retarding Medium
Small Natural Sponge

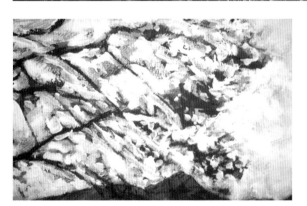

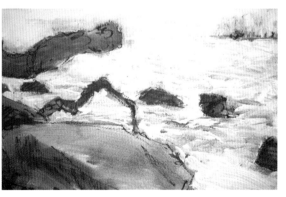

STEP 2

Here, the full painting and detail have been photographed in two ways. The first in each case shows the work flat on, enabling you to see below the paste to so that you know where it is being applied. The second features side lighting, which exaggerates the structure in order that you can see exactly how the texture is worked up. As you gradually apply texture across the surface, the tonal balance will disappear. Don't worry about this, keep on building the structure. Apply the paste using either bristle brushes or palette knives, exploiting the different quality of mark that can be achieved with each. You can work directly onto the dry paper, or paint the area with a layer of acrylic medium first. Wetting with medium actually improves the surface's acceptance of the paste and the resultant mark can be worked into the surface (softening) after application. This can be seen on the distant hills and the foreground grass. The surface can be attacked with various other techniques such as sgrafitto, using the end of the brush handle. Apart from scratching out, try scraping through or squashing the applied surface with a palette knife, or for that matter scraping away. The key to this underlying structure is to create something dynamic, which can be achieved through the inventive use of all manner of tools or techniques.

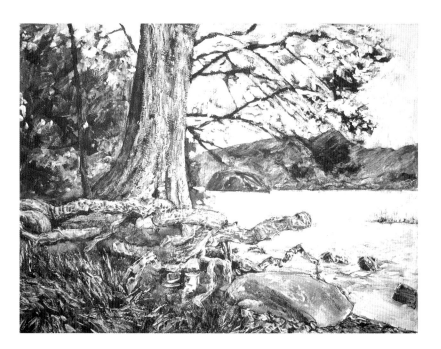

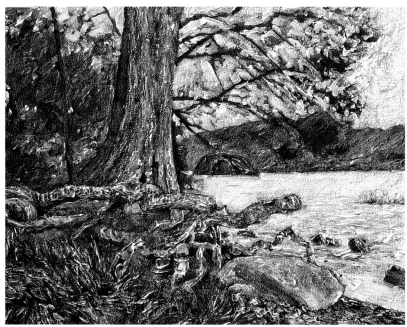

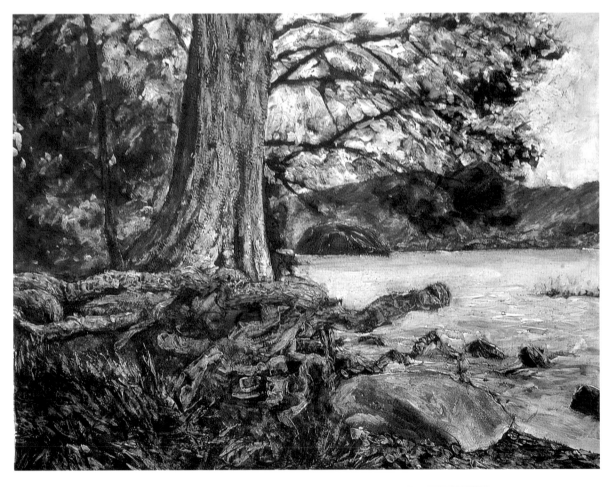

STEP 3

Once the structural layer is thoroughly dry, sand gently to remove any protruding sharp edges, which could rip your brushes to shreds. Texture paste is slightly absorbent, more so if you have used the pumice-based variety. It needs to be sealed, but you might as well add color at the same time to achieve the base painting layer. A wash of blue-gray [Bp+ro+yo], plus some acrylic medium and lots of water, provides a complementary contrast to the brown already used and will produce subtle grays or blue, depending on the thickness of the dry paste. Use the flat brush to swiftly block on the washes, and then work in slightly deeper blue [less water] into darker areas, to begin to recover the values.

> **Now the structure and dark underpainting is completed, work on the painting can be continued in either acrylics, oils, or pastels using the same layering technique of working dark to light. This painting is continued in acrylics.**

STAGE 2—PAINTING

STEP 1

Use the sponge to start off some bold dabbed textures of paint in the bushes behind the trunk and the leaves against the sky. If you are nervous about paint going where it shouldn't, lay a scrap piece of paper as a protective mask over the trunk and dab right up to its edge. The sponge should be dragged as well as dabbed, both here and across the foreground grass. Work on the base of the tree and its root, by applying a mix of dull orange to which is added a good quantity of retarding medium [YO+Rp+bp+TW]—the retarding medium will slow its drying time, to enable you to tonk-off gently, thus exciting the texture and allowing the underpainting to show through.

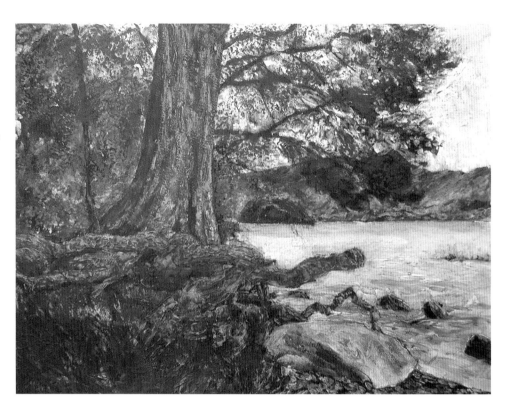

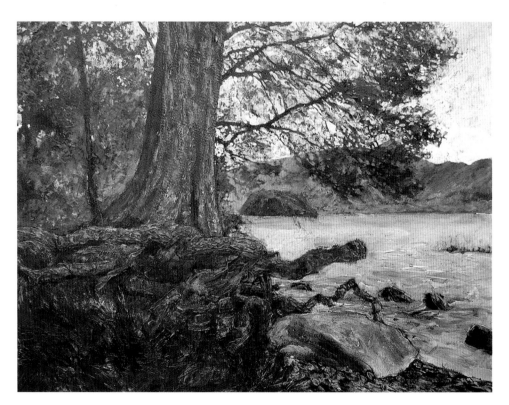

STEP 2

Just as an oil painting can be rejuvenated by bringing its surface shine back to life through oiling out, an acrylic an be made more glossy through the application of a thinned layer of gloss medium. This restores the depth in colors, especially in the darker accents. Once dried, move on to painting the composition, working from dark to light. With a smaller round nylon brush, use negative painting between branches and leaves to render the sky. The pink [Rp+Yo+bp+TW] provides a complementary contrast to the abundant greens within the painting. Once applied, wipe and/or tonk off with a finger and/or tissue, with the aim being to keep textures that favorably occur, while reworking those that don't. Blue-gray [Rp+Ro+TW] plus water and gel medium, is painted on to the distant hills and tonked off. Turn to the island and apply a thin wash of gray-green, followed immediately by a thicker yellow-green and tonk off.

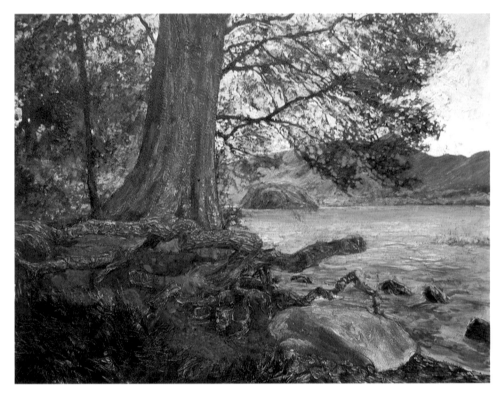

STEP 3

The pattern of applying color with a nylon brush and tonking off is continued.

- **Island**—*apply tonked washes followed by scumbles and dabs of more solid color, to create soft, yet textured highlights.*
- **Tree**—*apply tonked washes of brown to the trunk, lighter yellow-green highlights to the canopy behind.*
- **Earth**—*apply mid-values and continue more fluidly over the rocks, before tonking the whole.*
- **Fallen leaves** *(bottom right)—apply a tonked orange glaze.*
- **Water**—*wet the whole area and apply fluid purple washes, darker toward the foreground. This keeps the overall surface soft, while the change of values suggests distance across the water surface. Add yellow and white to the mix for the first hint of soft light across its surface.*

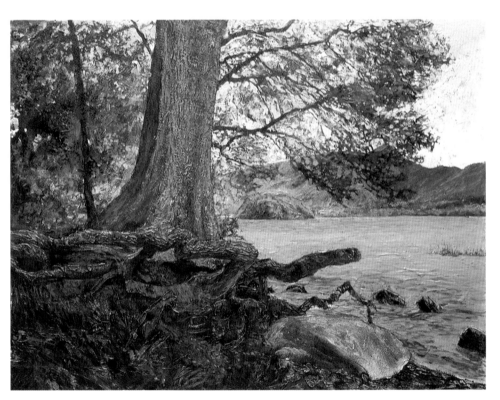

STEP 4

Now the color is stroked on using nylon brushes.

- **Water**—*wet the whole area with a layer of thinned gloss medium and work in horizontal strokes of blue-gray [Bp+TW+ro]. Add more white and move to a smaller brush into the distance. Negatively paint reeds and overlapping rocks and roots with care.*
- **Earth**—*scuff and rub the paint. Add generous amounts of modelling paste to a warm brown mix [Rp+ro+yo+bp]. Add TW and Yo as the layers build and finger tonk if light color develops too swiftly.*
- **Tree canopy** *(left)—apply strokes of thinned green [Bg+rp+yg+gloss medium] with varying amounts of TW, Yg, and Ro. Allow underlying textures to interrupt these loose strokes as they grow lighter.*
- **Tree canopy** *(right)—a tint applied to the center of the branches achieves recession and a glow of light.*
- **Trunk**—*carry the tint from the branches to the trunk, but instead of working it gently into the surface, use the side of the brush head to daub the color and create textured brush strokes.*
- **Grass** *(foreground)—wet the whole area and stroke on blue-green and orange, using a small round nylon brush.*

TONKING
This technique involves applying a fluid layer of paint (paint on the palette mixed to a fluid consistency by the addition of medium), over which a piece of absorbent paper is gently pressed down and lifted off, taking some of the paint with it. The degree to which the paint is lifted off is determined by the consistency of the paint applied. In this way an opaque (non see-through) layer can be rendered semitransparent and a transparent area can be made irregular or seemingly textured in a unique fashion.

STEP 5

Further textures are now introduced to the painting. Stiff, yet slower-drying mixes, can be created by the addition of both texture paste and retarding medium. One is used on the large and smaller rocks, allowing you time for tonking. Add the highlights, using an almost dry brush to apply scuffs of yellow-white [Yg+TW]. Drawing the brush across the grain of existing textures helps to define them. An orange wash, followed by thicker orange strokes, is applied to the fallen leaves. The inherent structure of the dull gray bark offers a dramatic opportunity for any lover of texture. Generous amounts of texture paste and retarding medium form a glutinous mix that scuffs well. Add more yellow and white as you work towards the lighter colors. This same mix works equally well, scuffed onto the roots, but these are tonked. Although the roots cry out for development, hold back. By gradually building up textures, you will know just how far they can be taken later.

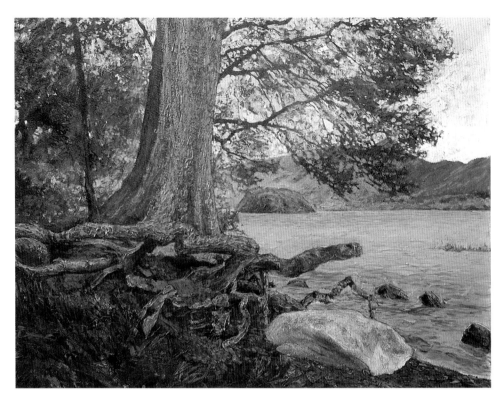

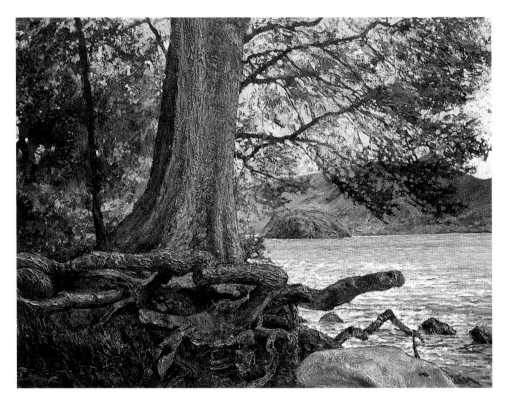

STEP 6

Turn to the water and create the following glutinous mix comprising one part gel medium, one part retarding medium, and five parts texture paste plus color [Yg+bp+ro+TW]. Apply with a small round nylon brush, finger tonk to achieve the shimmering light. Sharpen edges of roots and rocks through negative painting of the water. Work fine horizontally hatched strokes into the distant water, building these up, eventually adding some white centrally, into the mix. The reeds in the water are given some bright orange highlights, as are the fallen leaves along the water's edge. The rocks in the water are overlaid with warm and cool tonks and then given some almost-white touches.

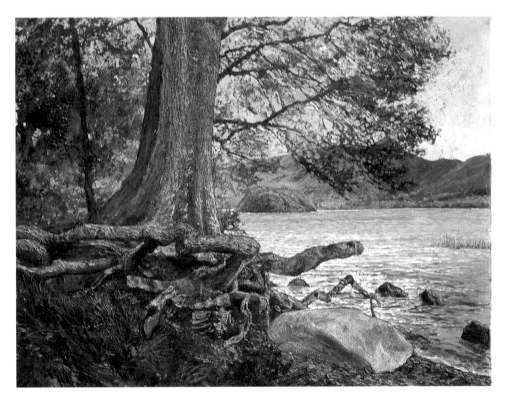

STEP 7

Work on the finishing touches. Create a fluid mix [Yo+ro+bp+TW] plus gloss medium and apply irregularly by floating over the fallen leaves, allowing it to pool and run into the textures. Carry splashes of this color through the grass and with a rigger brush apply linear strokes for the blades of dry grass. Finger tonk to settle the mix into the grass. Highlights on the trunk are light green [Bg+Yg+ro+TW], to stand against the dull warm of the existing color. Place them to catch the eye as it runs down the length of the trunk. With a fluid version of the highlight mix created for the trunk, apply and finger tonk on the roots, followed by slightly warmer highlights across the lower roots.

STEP 8

The final touches to the painting are nearly all to be found in the foreground. Be aware that the colors that will reduce on drying are those either without the addition of white, or those made very fluid through the addition of medium. Apply final highlights of color to the roots, with generous amounts of white included. The same color is also used on the left-hand top corner of the large rock. Note how the roots are light against the dark earth and yet dark against the water (counterchange). Develop the texture of the earth between the roots with fluid tonked strokes [Ro+bp+yo], adding yellow [Yo+TW] for middle lights. Catch

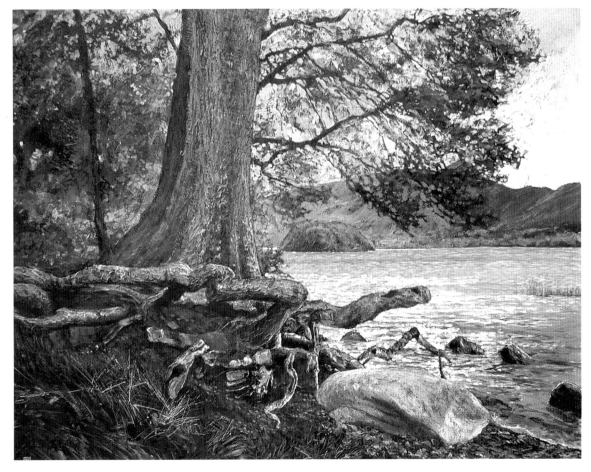

the raised textures of the foreground leaves with highlights, and use the rigger to add lights to the blades of dry grass. Concentrate on patterns and the spaces between them, when applying directional, irregular strokes of thin yellow-green on the grass. Keep your wrist loose and the pressure of application constantly variable. Cool blue highlights [Bp+TW] open up the shadow. Once these details are dry, try a fluid purple tint, with plenty of water, over most of the grass and rocks, to hold them together and soften colors. One final modification was carried out at this stage. I noticed that the top of the large white rock finished in a rough dark edge that didn't please the eye. This was scuffed to light and became much softer against the water, allowing the roots to dominate more.

233

Tricks of the Trade

Heavily textured acrylic paint

You will often hear it suggested that acrylic paint could be used in the manner of oil, in that it can be built into thick textured layers. You may wonder why your own paint refuses to do this. The main problem here is due to the differences in the mediums used for oils and those used for acrylics.

The "medium" is the glue that sticks the pigment, or color, to the surface. Since this, in oil paint, is stiff oil, and in acrylic, much more fluid acrylic emulsion, each must be applied in a different fashion.

NATURAL CHARACTERISTICS

Oil paint straight from the tube immediately creates impasto (deep texture effect).
Acrylic straight from the tube tends to go on much more thinly, often requiring several layers to achieve solid coverage.

DRYING CHARACTERISTICS

Oil paint dries by chemical reaction—none of its texture is, therefore, lost during the process.
Acrylic dries as the water in it evaporates from the surface downward and therefore shrinks down during the process.

HOW TO INTRODUCE AN IMPASTO QUALITY WITH ACRYLIC PAINT

One must bulk up the consistency of the paint or underpaint with a textured layer. There are heavy-bodied mediums, which thicken the paint, but if you require really deep texture, there is texture/modeling paste.

Acrylic texture modeling paste is produced from mixing acrylic medium or emulsion with a bulking agent, which must have minimum impact on the pigment when added to the paint. The bulking agents vary from marble dust, through pumice, to glass, silica, and sand. Each of these produces its own individual finish and holds applied texture differently. They vary in absorbency when used as an underpainted layer. Pumice, for example, is more absorbent than marble. Pumice is also much lighter than marble or glass and is thus more suitable for use on flexible or yielding surface such as paper.

The most commonly available is the modeling paste made from marble dust, which has the

consistency of household filler. It can therefore be easily applied with brush or painting knife, the surface retaining the signature stroke of each tool [A].
Modeling paste dries very swiftly, and when you have removed a quantity from its

pot the lid must be replaced immediately. Always ensure that you scrape the sides of the pot to replace drips into the main bulk [B]. If you don't they will dry and fall back into the main batch, causing unwanted lumps.

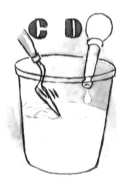

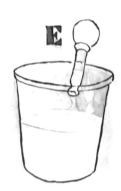

Flatten out the surface with a palette knife [C] and add a few drops of water [D] before replacing the lid to keep the air inside moist.

If you are not using the paste for some time, drop in an extra quantity of water to prevent drying out [E].

Spread the texture paste in use over a stay-wet palette, with a palette knife to keep moist [F] and make sure you immerse the knife in water immediately.

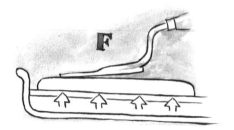

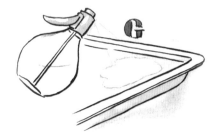

If it seems to be drying out during your painting session, spray it gently with a plant mister [G].

To fully appreciate the difference between the effects of modeling paste and white paint, try this simple exercise. Create two separate mixes to a similar quantity—one of texture paste plus a color, the second of white acrylic plus a color.

Paint onto a piece of paper [H].
You will see immediately that while the texture paste increases the texture, it has minimum impact on the pigmentation of the color.

On the other hand, the white, being itself a pigment, will not only lighten the color, it actually does nothing to stiffen the mixture.

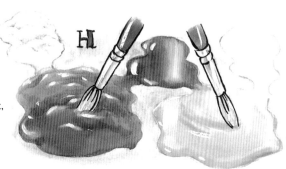

TIP
Check you are using a heavy-bodied range of paints, as opposed to the more fluid variety. Even if you are, you may still feel that you are not getting a surface quality that resembles oil paint.

Common Problems

Texture paste and white paint

PROBLEM

"I want the heavy textures that modeling paste can provide, but the brush strokes always seem so crude when the paint is this solid."

ANSWER

It often seems that in order to get the thickness of layer required, you have to be a little crude in its application. To some extent this is true, especially when the surface is dry. Pressure is needed to force the paste on, something that does not always go hand-in-hand with fine control. There are several ways of overcoming this problem.

SOLUTION

The surface can be made more receptive to the stiff paint, by painting on a layer of fluid medium (medium + water). The wet, slightly sticky surface will now take the texture more smoothly [A].

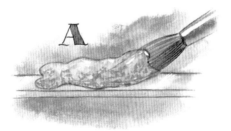

A thin layer of paste-filled paint can be scrubbed over the surface with a stiff brush or palette knife, to make it more receptive of gentle, textured brush marks [B].

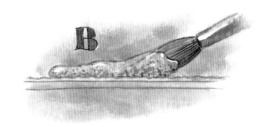

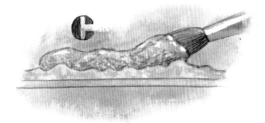

Improving the tooth or texture of the surface can also help. If you force a first layer of textured paint on and allow it to dry, its very roughness will grip the second layer more readily [C].

> **GLAZE**
>
> A mixture of color and one of the acrylic mediums. It must never have a white added or the color will become opaque and the intensity of the color will suffer once again. As the acrylic paint is so strong, it can be let down with water, rather than the medium. This will make a color wash, which is thinner, but still effective. The finish is dull however and if you require a shine in your finished color to bring out its depth use gloss acrylic medium.

ANSWER

The problem can also lie in the way in which you are using the brush. When mixing paste into color, ensure you use a large stiff brush for mixing and a smaller, softer brush for painting. The large brush provides fast mixing and will enable you to scoop the paint into nice deep mounds. The smaller brush can now dip into this mound, picking up a controlled amount to transfer to the painting. If you are loading a soft nylon brush with paste-filled paint, you will soon find that its head becomes over filled with material. This bulking up distorts the brush shape upon which you depend to deposit a controlled brush stroke [D]. It is essential, therefore, that you wipe this excess away on a tissue and squeeze the brush head back into shape [E]. Now you can reload with the stiff paint on the outside of the head, where it will easily transfer to the painting [F].

PROBLEM

"Recently I was painting a figure, who was wearing bright red socks. To get them light enough I had to add white, but this made them pink. How do I get light, bright colors, that don't look chalky?"

TINT
A glaze with the addition of white, whose transparency or opacity will depend entirely upon the amount of white that is added.

ANSWER

You did the right thing by first concentrating on making the socks light enough. It is better at that stage to make them just a little lighter than they should be. Once they are dry you can apply a transparent color or glaze [G], which will make them as intense as you need, or can change the color. Glazing does darken the color slightly, hence the need to keep them lighter in the first place.

Project 5

Collage

A collage has always been a natural adjunct to acrylic painting. PVA glue (poly vinyl acetate) is very close in nature to the medium that is a constituent part of acrylic paint. Thus either acrylic medium or acrylic paint can be used as a glue to fix materials or objects to the surface of the painting. Painting over these elements with medium or paint simply reinforces the strength of the bond.

Since acrylic paint is so powerful, it can adhere to almost anything—so the local (natural) color of the fixed material can be exploited or it can be overpainted with acrylics to change its color.

While the tendency is to stick things to the surface, there is a more unusual approach. Removing the surface, a technique that I have developed over the years, can be exploited to a dramatic and yet subtle effect. An underlying surface is created through building up several layers of paper. Sections are selectively removed or torn away, exposing the inner fibers of the paper, making it more absorbent for the overpainted colors. The greater the amount of color absorbed, the darker the values become. This technique allows the artist to achieve a variety of inherent textures and effects that can emulate the varied structure within a composition.

The variegated colors and irregular textures provide a dramatic base on which to paint the composition. There are as many possibilities for attacking the surface to create the texture as there are different ways to exploit a variety of tools to apply paint. Acrylic paint is the perfect medium for this approach, for it does not only glue the layers of paper together. Once the underlying paper structure has been carved, subsequent application of acrylic paint will bond areas that may have become fragile through vigorous knife work. The exposed fibers, which at first readily absorb the acrylic paint, are then naturally primed by it, protecting future layers that could dull down as the color is absorbed into unsealed fibers.

The whole of this project is dedicated to a single tutorial that demonstrates this technique, with detailed instructions of how to prepare the surface.

Project 5 Tutorial

Collage

As acrylic is a strong bonding material, with which almost anything can be fixed to any surface, it is a perfect medium for a collage. While the obvious collage technique is to affix things to create a surface relief, I have over the years, developed another, which involves removing material to create depth. In this tutorial I take you through the process from beginning to end, so that you too can be encouraged to explore various possibilities and develop a technique which is very much your own.

THE VIEW

This work was produced as a commission for clients who are devotees of Italy, particularly Tuscany where they spend most of their vacation time. They had a particular request, that I should produce something that would evoke vivid memories of their travels and portray an unmistakably Italian scene. This is where gathering reference material for future work comes into its own and proves invaluable. Using a collection of photographs to produce one single composition, such as with these five, can only really work if one is familiar with the view and has a personal memory of it. I had produced a succession of works such as oils, watercolors, and drawings of the village in which this aspect features. Two had been produced on the spot and thus I was very familiar with the individual components and the two ladies in the view.

TIP

The best way to tackle this tutorial, is to experiment with a simple subject in the first place, familiarizing yourself with the technique, before proceeding to a more complex composition.

PREPARING THE SURFACE

Stretch a sheet of 140 lbs. watercolor paper on a strong (non-flexible) board. Mix a solution of equal quantities of acrylic matte medium and water. Have ready the six sheets of good quality colored paper or thin card.

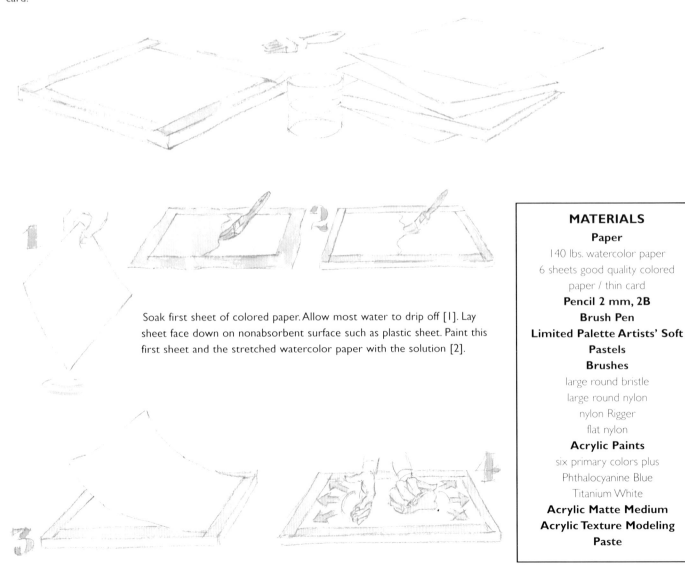

Soak first sheet of colored paper. Allow most water to drip off [1]. Lay sheet face down on nonabsorbent surface such as plastic sheet. Paint this first sheet and the stretched watercolor paper with the solution [2].

MATERIALS
Paper
140 lbs. watercolor paper
6 sheets good quality colored
paper / thin card
Pencil 2 mm, 2B
Brush Pen
Limited Palette Artists' Soft
Pastels
Brushes
large round bristle
large round nylon
nylon Rigger
flat nylon
Acrylic Paints
six primary colors plus
Phthalocyanine Blue
Titanium White
Acrylic Matte Medium
Acrylic Texture Modeling
Paste

Lay painted surfaces together [3]. Smooth out wrinkles from the center with the hand and/or press down gently with soft cloth to remove large bubbles or layers may not stick down effectively [4].

If too much pressure is applied, the solution may squeeze out. Allow to partially dry and repeat process [5]. If paper surface absorbs solution too quickly, spray on water with plant mister before applying solution [6].

TIP

If you are using really thick paper or cardboard, you may need to reinforce by fixing down the paper edges with pins or staples to prevent the gum strip tearing under extreme contraction as paper dries.

THUMBNAILS AND TONAL DRAWING

Reference photographs hold a wealth of information that has to be coalesced into a composition. This is where the process of producing thumbnails comes into its own. These scribbled sketches cut through any jumble of thoughts, allowing you to incorporate elements from different photographs. In a situation such as this you need to ask yourself what it is you want to capture in the final painting.

Thumbnail 1

The figures are important as a focal point and give the buildings scale—but I felt they were too dominant. I also ran out of space, on the right-hand side, when trying to encompass the required panorama.

Thumbnail 2

I extended the width of the rectangle a little, and consequently, the figures became smaller. However, I was still losing a lot of one of the most interesting buildings behind the silhouettes of the figures and I still wanted more of the view.

Thumbnail 3

I probably went too far here. The figures had become much smaller and now the distant hills had lots of space. Unfortunately, the interesting negative space of the sky—present in the first two thumbnails—was lost between the chimney, rooftops, and the top of the rectangle.

Thumbnail 4

This composition is developed to exploit the best of all options. I really didn't think this could be bettered, but there are still some nagging doubts. Much of my reference material was in shadow. I decide to complete a loose, but larger tonal drawing, to better grasp the whole composition, before committing to the final piece. If I had been really confident of the thumbnail I might have simply laid some shading across this to give me the tonal balance. In this case the large drawing is essential and the little extra time involved, paid dividends later.

When filling in a tonal drawing your eyes should move from photograph to photograph, just as it would from detail to detail when working on the spot. As you work the focal points will become clear—where there should be sharp detail and where to soften.

What did become clear from this drawing was that I would definitely need more sunlight. I decided to incorporate two elements that I had noticed while working on the spot on my last visit there. One was the way in which slabs of sunlight could move between buildings, creating stark contrasts. I decided that one of these slabs could be laid across the garden—indeed, if this were laid diagonally within the composition it would lead the eye between the buildings. Once before, during another painting session there, I had noticed that when the sun reached a certain point its rays traveled almost parallel to the wall of a building. Objects on or near the wall then cast exaggerated and exciting shadows down the smooth surface. I decided to use this tack on the wall behind the balcony, to add both interest and that all-important slab of golden light.

> **OUT AND ABOUT**
>
> When you are gathering reference material, going through this process of producing thumbnails and tonal drawings in situ will give you tremendous insight as to what you should photograph. It is too late, when back at your easel, to discover that you need the rest of a detail that is missing, cut in half by your photograph or missing altogether!

DRAWING OUT
Pencil

A detailed drawing is required at this stage because you will need accurate visual information when you begin to cut the surface. Start with pencil, certainly until the proportions have been accurately transferred from the thumbnail. Redrawing and erasure can be aggressive, as surface damage is of no consequence in this technique. The surface is to be cut and the acrylic paint is strong and need not be transparent. Heavy drawing and paper damage become part of the surface interest.

Once happy with the pencil drawing, you can define linework more strongly with an ink line. Thus the myriad of pencil drawn lines are harnessed and simplified into strong descriptive ink work. Here a brush pen comes in useful,

giving freedom and speed of movement without the need for constant reloading.

Note, this is not just a filling-in exercise. You should observe the subject carefully and use the under drawing as a guide only. Look carefully at the pencil lines of the building that have not been filled in.

Pen

As the pen line work continues, a certain similarity or sameness seems to creep into the rendering. No softness here, for example, with so much line. Don't be put off by this, for this is the structural stage of the painting, when you are discovering the patterns that ripple across the surface of the painting. Simply make the most of the chance to enjoy the expressive line a brush can make.

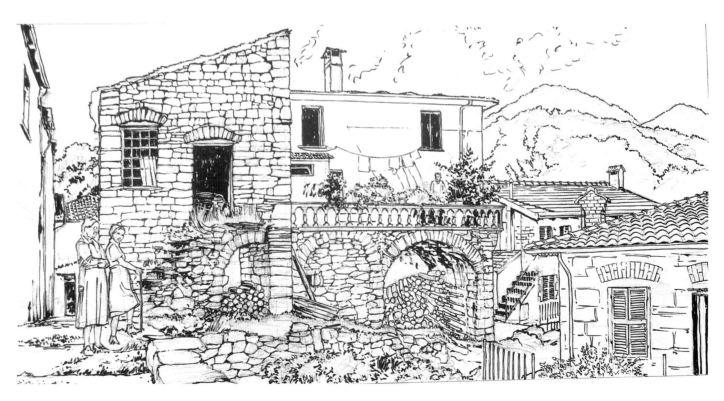

CUTTING

TECHNIQUES

I like to think of this stage as drawing with a scalpel. Most of the work is done with a sharp knife, although in this case I also used some strong, sharp tweezers, a small flat file (for filing metal—sandpaper is an alternative) and a lino-cutting tool. Gather everything you can find that will score the surface of the paper.

The process is very physical and you will at some point be gradually cutting your way through six layers of paper/cardboard. The watercolor paper at the bottom is your safety net. You know that when you get down to white you must go no further. The majority of the cutting, however, will probably only take you down about three to four layers. Some of the marks and cuts that I employed are shown below. Making discoveries of your own is far more rewarding, however. And once you get into the rhythm of cutting and scoring the surface you will soon happen on those you "invent" for yourself. What can seem rather heavily cut at this stage will seem less so when painted, so don't hold back, really work up those textures.

CUTTING

This was mainly executed with a sharp scalpel. You can either cut straight down, making a sharp edge (roof edges against sky), or at an angle. If two parallel cuts are angled towards each other, a V-shaped piece of paper comes away (large tree on balcony) [A]. Multiple cuts can be overlapped until the surface begins to break up. This was used for grasses under the feet of the two ladies and up the steps behind them [B]. As the paper strips begin to hang from the surface they can be shaved off, using the blade flat against the paper [C].

TIP

When this process is complete your work, surrounding areas and you, will be covered in tiny pieces of paper. Lightly brush off the entire surface of the work and using a nozzle attachment, vacuum the rest out of the nooks and crannies of the work. You must take care to remove all loose pieces from the work itself.

TEARING

Once a line has been cut, an edge can be lifted and the paper torn from this point. Tweezers are useful to get hold of the paper firmly [D]. The tear can be controlled in several ways. First, you can cut several notches along the cut line and tear away sections at a time [E]. Second, you can cut right around a shape and then tear within its boundaries [F]. Deep layers of paper can be reached using this method (log store). By putting your finger in the path of a tear, the tear can be controlled, either stopping it altogether or changing its direction [G].

NIPPING

Tweezers were used to nip the surface (grass) [H] and around a cut shape, making the edge more irregular (distant tree edges).

SCRATCHING, GOUGING, SANDING, AND FILING

Applied to cut or uncut areas, using the file or a lino tool. By making the marks directional, it helps not only the texture but to describe the lie of a surface (large dark wall—left).

NOTE: Areas that are not cut are important too. Both the figures and foreground foliage are left untouched. The paintwork on these can consequently be soft and blended in order that they do not dominate the painting. Stone faces on the wall behind the figures are also left smooth, so that paint effects, such as tonking can be employed to create the distinctive texture of this exciting surface.

CUTTING
RESULT

On trying this technique for the first time, you will have to practice much patience. It is a time-consuming technique and the results are largely unknown until you start painting. Once the cutting has been completed, however, you will have the structure of your painting in relief. This represents a strong "drawing" which won't be lost, no matter how you splash color across its surface. What has been labor intensive to this point suddenly presents you with a tremendous amount of freedom in the application of paint. Now you can take chances and explore fully the capabilities of the acrylic medium.

It is always difficult to photograph such a richly textured, yet sparsely colored surface. For these stage-shots I waited until late afternoon when I knew the sun's rays would catch the surface relief. The resultant image is a little false, but does give some idea of the work involved and the varieties of textures possible using the techniques described. It is interesting to note at this point that much of the heavy ink linework has been removed with the paper. This fact should encourage you to be bolder in your application of ink throughout the preceding stage. The surface at this stage is fragile and absorbent, but don't worry, for the acrylic will restore all its strength once it has been applied.

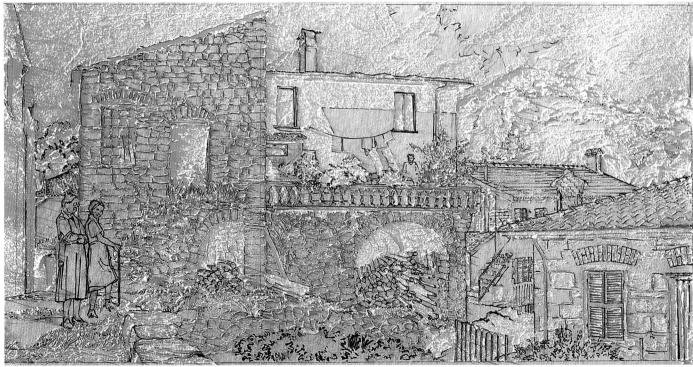

UNDERPAINTING
RUBBING IN PASTEL

Rather than carry out my underpainting in paints, I prefer to start with the much softer artists' pastels so that it gets into all the nooks and crannies, bringing all the cutting and texture into relief. Use a sharp knife to scrape pigment directly from the pastel onto the surface of the painting, which is laid flat. Here I used Ultramarine over the sky area and a dark umber over the buildings. Use a bristle brush to work the powder over the surface; you will find that it pushes into every cut and groove. I am always fond of the result at this stage and have often been tempted to consider leaving the work like this. However, it must be onward and upward on this occasion!

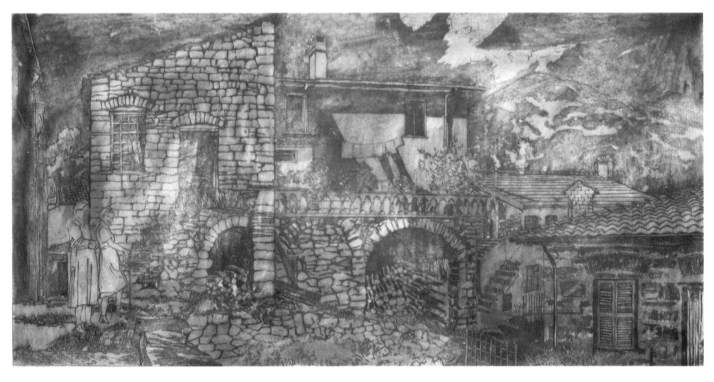

WORKING IN MATTE MEDIUM

The pastel pigment now requires fixing. This should be done with a thin solution of acrylic matte medium let down with water—a ratio of one part medium to three parts water. While the softness disappears, the pigment becomes richer around the torn and cut areas. This sharpening-up of the features encourages me to build up the paint layers. Note how the pastel pigments vary in some of the linework—some are lighter, bluer, and chalkier. This natural variation is exciting and more subtle than a flat, overall color tone.

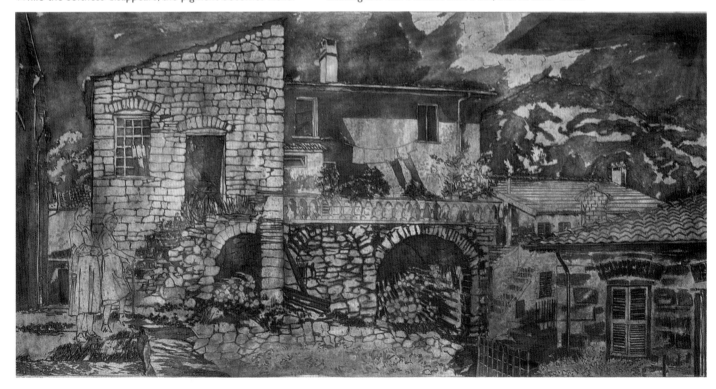

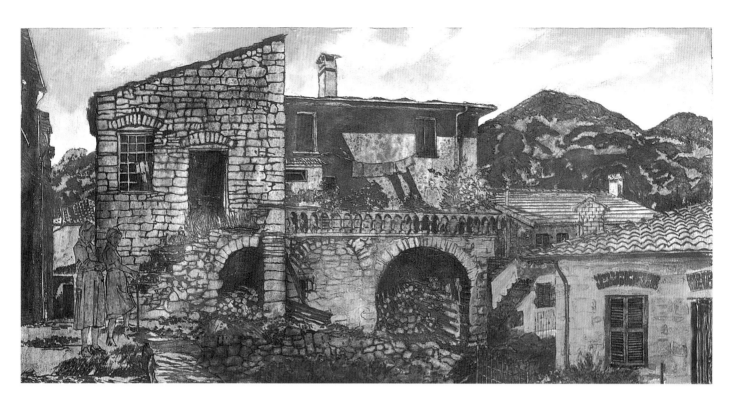

PAINTING
WORKING DARK TO LIGHT

STEP 1—SKY AND THIN WASHES

Round nylon brushes are excellent for this stage. They will not splay with the large amounts of water needed. Even large brushes have a good point to work into small areas and they can be used side-on for fast coverage. Much of this early work consists of very fluid (add water) washes of color, into which more dense mixes are worked while still wet. The surface is still absorbent and once soaked, stays wet and workable for some time. Fluid washes such as this dry to a very matte finish. Don't be afraid to put color on at this stage. It is absorbed by the surface and dulls down, no matter how bright.

SKY—Start with a fluid wash of color [Phthalocyanine Blue + Titanium White] becoming stiffer toward the horizon with the addition of more white and Yg. While still wet, apply the heavier color of the clouds [Titanium White + Yo] and work into the surface with a finger.

DISTANT HILLS—Washes are left thin; purple in the distance with a little Yg added as they move closer.

WINDOWS—Bp washes, again fluid, give extra depth. Over the paned window (left of the composition) apply color and immediately wipe from the framework with a finger.

DISTANT BUILDINGS—Give these a touch of the same Bp wash to push them back.

TALL WALL ON LEFT—When painted with a strong purple wash it absorbs the color, which visually mixes with the brown underpainting, to produce a dense-colored gray.

STONE WALL—The wall behind the figures is given a blue wash top left, slowly thinned with water as it moves toward bottom right.

FIGURES, WALL BENEATH BALCONY, BUILDING BOTTOM RIGHT—Give these blue-gray washes with the addition of white. This lightens the accent color in the linework.

In each case the painting outlined has the effect of solidifying these areas, reforming the patterns of lines into solid masses once more.

COLOR MIXING

Where the prefix letter is shown in capitals this denotes a larger quantity of that particular color. Conversely, where the prefix letter is shown in a lower case, this denotes a smaller quantity of that particular color.

e.g.

Bp = large amount of blue-purple.
bp = small amount of blue-purple.

COLOR REFERENCES

Yellow-orange [Yo]
Yellow-green [Yg]
Red-orange [Ro]
Red-purple [Rp]
Blue-purple [Bp]
Blue-green [Bg]

STEP 2—TREES

Once again exploit the technique of applying dark, fluid washes which darken and wet the surface, followed by the application of the lighter but more solid colors. Blending between the layers is, therefore, possible for some time and is especially useful on more distant objects, which by necessity should be less focused than closer ones. Using the soft round nylon brush helps to keep the application of color brushy and loose. The cut textures help to keep brush strokes irregular and more naturalistic, so these must be exploited, catching them with swift, edge-on strokes of the brush. The colors of the trees are affected by aerial perspective, which dictates that the more distant the green, the more blue, gray, and light it must become. To achieve this, add Ultramarine, reds, and white respectively. Exaggerate the effect by accentuating the light yellows within the closer of the trees. Note also how the color does not always follow the edge of a cut or tear exactly. By dancing around the line the tree silhouettes become more broken and natural.

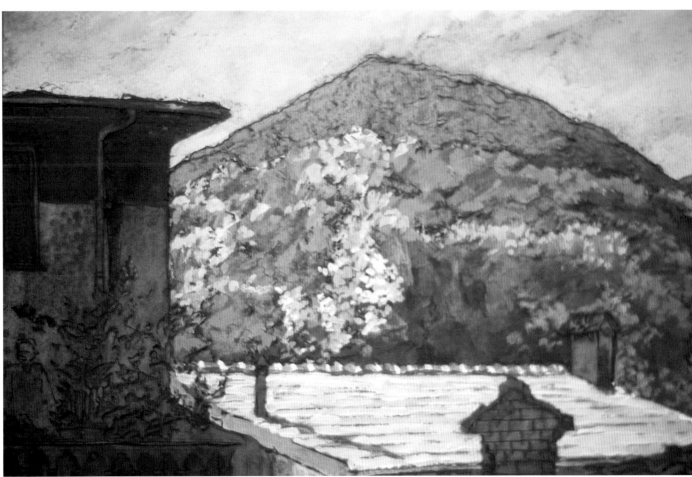

STEP 3—BUILDINGS

RIGHT-HAND SIDE—As you work with lighter washes of color, keep in mind that when fluid, they will run into the cut grooves, and when stiffer, will lie on the protrusions. As a general guide therefore, the roofs are first given watery washes to establish the overall color, then the highlight details are added, remembering also that these inevitably darken a little on drying. With the roof tiles, don't get hung up on individual tiles, go for strokes that suggest their texture. Similarly, the house (front bottom right) is first rendered with yellow washy brush strokes, then details such as windows are scuffed over with slightly stiffer color. This is effected more speedily with a flat nylon brush.

NOTE: *The roof here is taken right through to white to achieve the required contrast for a transparent glaze that could be added later.*

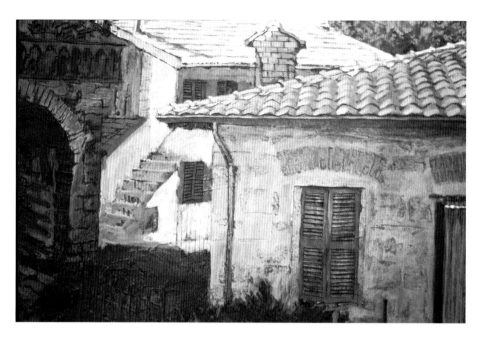

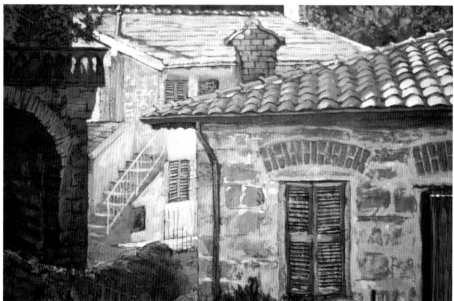

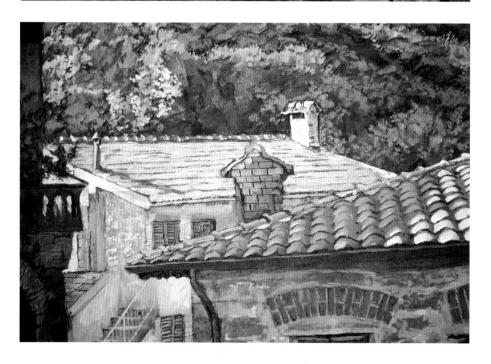

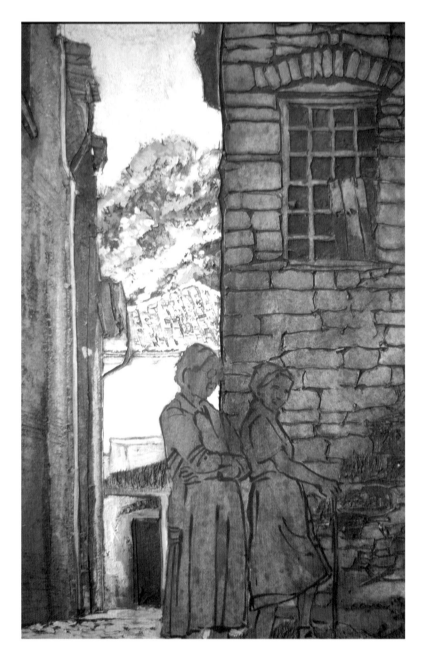

*LEFT-HAND SIDE—Distant buildings,
between passage: layer roofs through
pink and light yellow to pure white along
the ridge and gutter. The path in this
passage reflects the sky and is lighter
than the surrounding walls. Lay the first
dark washes into the cuts of the plants
along the balcony.*

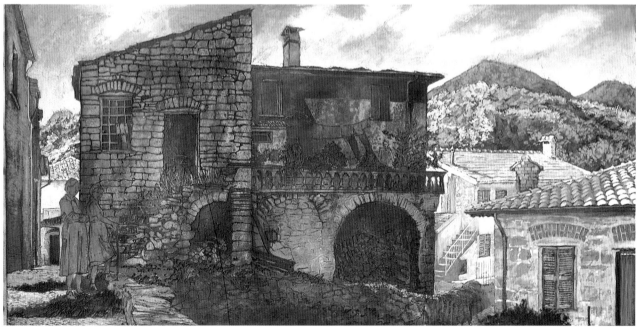

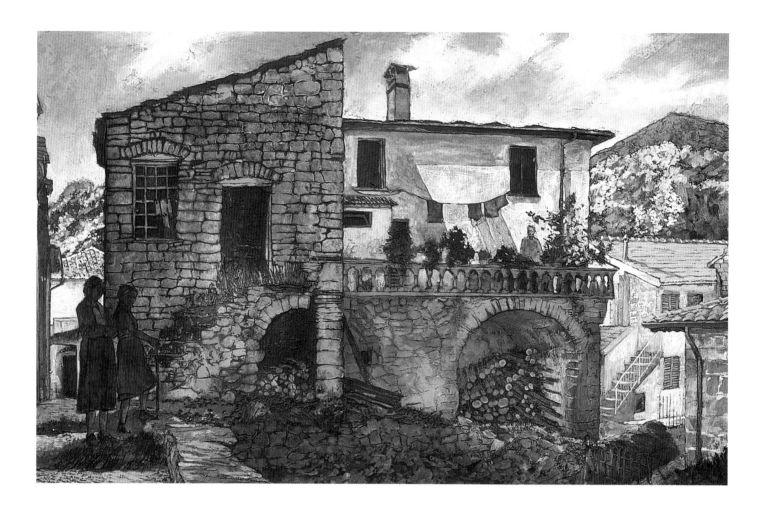

STEP 4—CENTRAL BUILDING, FIGURES, AND GARDEN (ABOVE)

Mix modeling paste with a dull orange to create a stiff mix for dabbing across the front of the central stone-faced building. Small amounts of texture paste make the mix stiffer without altering its color. Apply a fluid gray-green wash to the white wall above the balcony (see detail below). While still wet, add lighter and more yellow color and tonk off. Use thin dark colors to establish the general color of the balcony rail, the building on the balcony, the passage floor, foreground walls, garden, and the figures. Do not however, make any attempt at modeling just yet.

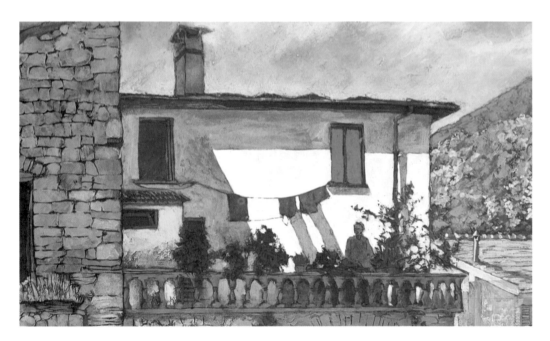

STEP 5—FINISHING OFF IMPASTO PAINTING

BALCONY—The three stages shown (left above, center, and below) describe the building of values on the figure and plants, not only from dark to light, but also from cool shadows (blue) into sunlight (yellow).

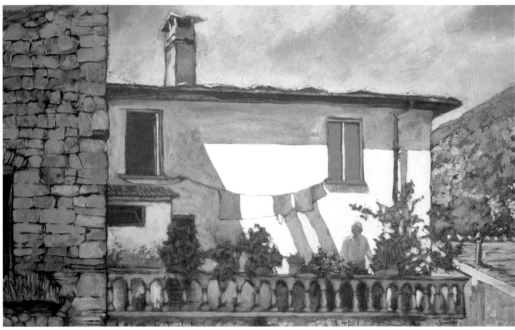

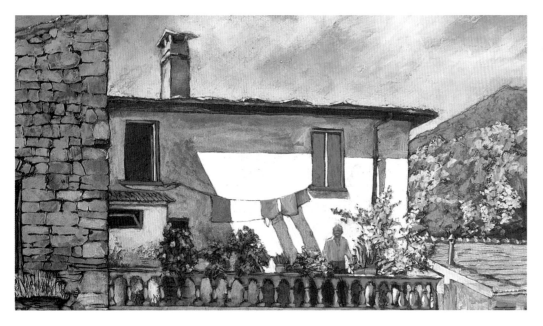

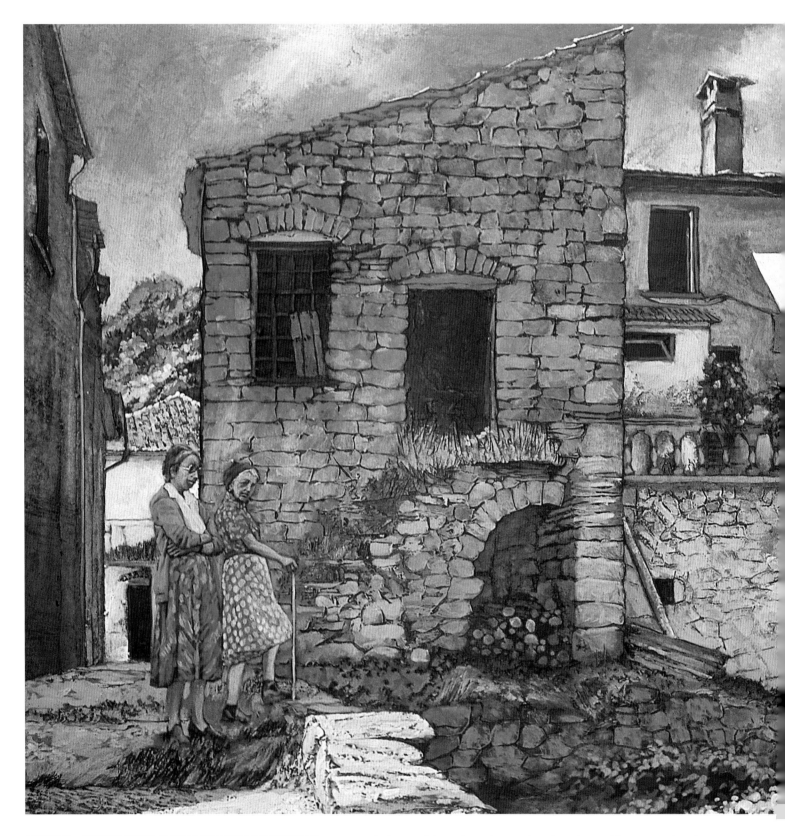

STEP 5—FINISHING OFF IMPASTO PAINTING (CONTINUED)

FLESH TONES—Use a small round nylon brush to build up the flesh tones in a series of interlacing small strokes (hatching) wet-on-dry. Build slowly from dark [Ro+yo] to light [Yo+ro+W]. Have a large pool of white on your palette with adjacent smaller pools of the red and yellow. The mix can then be changed easily, almost from one stroke to another. Finally, work a light pink wash over this modeling to add extra color and softness. Continue to complete the figures so that, as the background is

built around them, their edges can be softened into it. This ensures they do not appear stuck to the surface as an afterthought, but meld with the overall composition.

CLOTHES—Again, build gradually toward light. Carefully observe how the pattern changes direction around the form. The patterns can be simplified, but capture their essential structure and the figures will look solid. The figures are focal points and deserve this extra attention. Increase the light behind the figures to add contrast to their silhouettes.

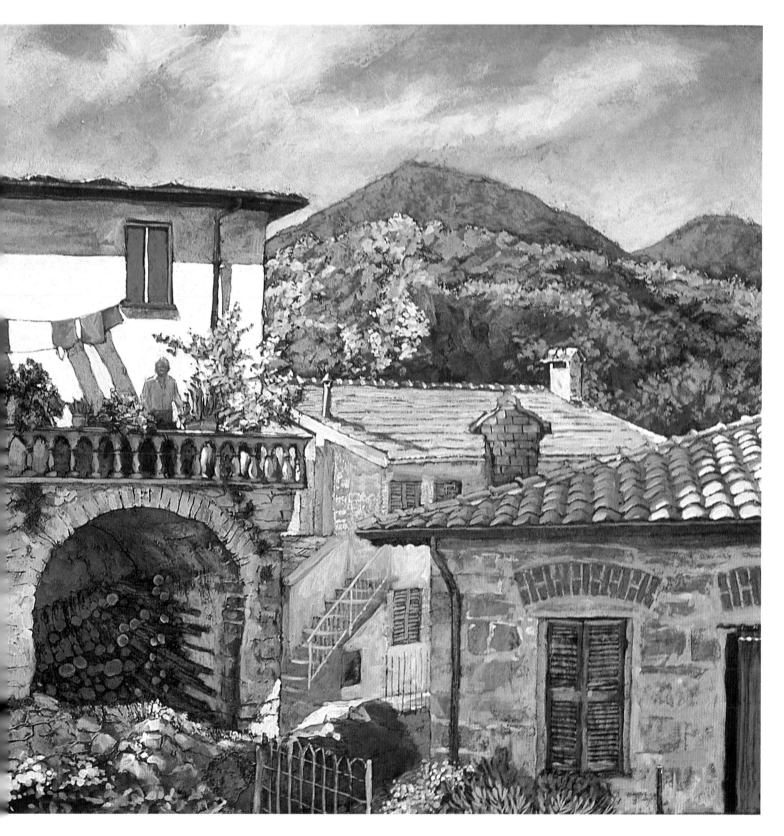

FACE OF CENTRAL STONE BUILDING—Now you can enjoy the fruits of the cutting and underpainting. The surface directly to the right of the figures is washed, scuffed, finger tonked, and wiped with both fluid and stiff color, to excite the inherent texture. Make sure, however, that in contrast with the sunlit areas, it remains dark and mysterious.

GARDEN—While building toward light, the main emphasis here is on keeping colors cool for details in shadow. Both the band of sunlight and the purple flowers, create two diagonal elements, which cut through the otherwise flat rectangle of the garden and carry our eye upward into the painting. Enjoy creating the texture here but also the occasional fine detail, such as the wire fence, which contrasts well against the powerful dark of the wall behind.

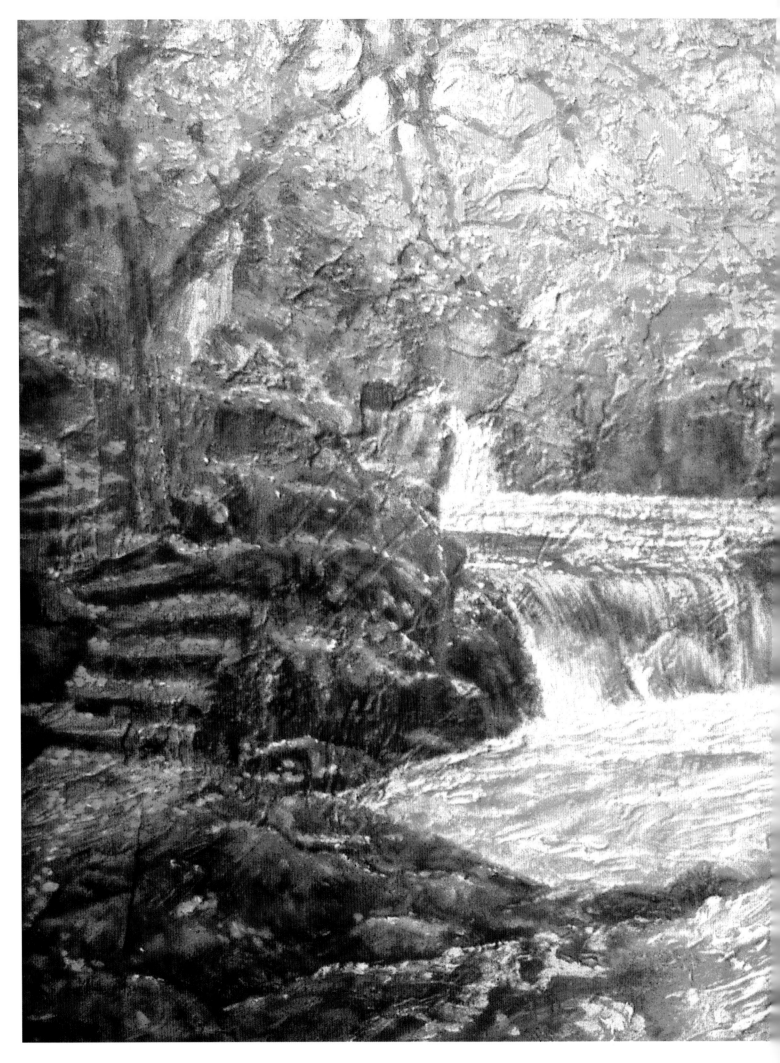

The Essential
Oil Painting Guide

Introduction

My fascination with painting started at an early age. However, it wasn't until I was given my first set of oil paints, brushes, and canvas in my teens that I felt like an artist. Precisely how I was going to use them didn't seem to matter at the time.

Looking back I can candidly admit to being intimidated by the medium. After all, the paint came out of the tubes like lumps of butter and the bristle brushes seemed unwieldy. Could this seriously be the same paint, these the same brushes used by Rembrandt and Monet to create their masterpieces?

Nevertheless, my enthusiasm to be a proper painter kept me going, as did my indulgent parents who encouraged those early pitiful efforts.

Eventually, however, through lack of good results I lost interest and returned to my watercolors and drawing, not returning to oil painting for some while, even avoiding it through my art college years.

Thankfully, I rediscovered the beauty of painting in oils, and through understanding and developing a wide range of techniques, it has now become the mainstay of my selling work. Sadly, the same cannot be said of all too many painters, for the abandonment of oil painting through failed early efforts is an oft-repeated tale, and one I hear from those who join my courses and workshops, or follow my published tutorials. Just how many oil painting sets lie dusty and forgotten in cupboards, lofts, or basements? What a waste, when this equipment could bring so much fulfilment to its owners, if only they knew how to use it.

Oil paint is a most versatile medium. There must be as many ways of using it as there are painters. The aspects that puzzled me as a teenager are the very qualities unique to it. First, those strange brushes made from bristle, that have been evolved by succeeding generations of artists to fulfill a very specialized function. Their job is to create texture. Then there are the buttery lumps of paint that are of a consistency that can be molded with the bristle brushes into a sculptural surface known as impasto. Finally, the painting surface itself—canvas, which is the perfect surface to accept the succulent, juicy paint.

To think that I simply had no idea all those years ago, just what was being consigned to the back of the dusty old store cupboard!

Anyone returning to oil painting or considering it for the first time can look forward to a number of possibilities. The paint can, for instance, be used very fluidly, with the addition of oil medium. Because of this added oil, the paint takes longer to dry, allowing the painter time to consider the brush marks being applied. Colors can flow into one another, not unlike the technique when using stiff watercolor paint. Dabbing the still-wet painted surface will create texture, which, if not liked, can be wiped off with a cloth.

Another approach is the more traditional, gradual build-up of layers, which engenders a considered, calm, unhurried state of mind in the artist. The beauty of this technique is that, as each layer is built; it is affected by those below. Textures and colors interact, and the painter is constantly surprised and excited by the results. The reaction between textured and smooth layers is enthralling.

The greatest advantage in oil painting is that the paint dries through the oil drying and fixing the color. This ensures that there are no hidden surprises, such as color or textural changes. What goes on, stays as it is, the finished piece unaltered in character or color. Thus the painter can feel reassured and confident.

For those who prefer spontaneity, there is palette-knife painting. Once the simple principles have been mastered, this technique becomes as joyous as working with a bristle brush. Palette-knife strokes feature a smooth surface, in which colors can striate as they are pulled along the canvas. The liquid surface is incredibly dynamic and results in one of the fastest techniques in the oil-painting repertoire.

This guide has been put together to help painters discover the delight of oil painting. There are no secrets, only my pleasure in being able to share with painters my own knowledge of a wonderful and rewarding method of painting.

While a broad range of subject matter has been included to try and suit as many tastes as possible, these are not of themselves important, nor is the style. These workshops and tutorials are designed to demonstrate a range of techniques and possibilities. Should a subject not appeal, the demonstration should not be ignored, for the process could be applied to most subjects.

It is only by going through the various approaches that painters can develop a technique unique to themselves, one that reflects their personality and style. To reach this is wonderful for it provides direction in a painters work.

I have no doubt that any painters trying out this rich medium for the first time, or coming back to it, will soon become hooked. For them this will become a lifelong pleasure.

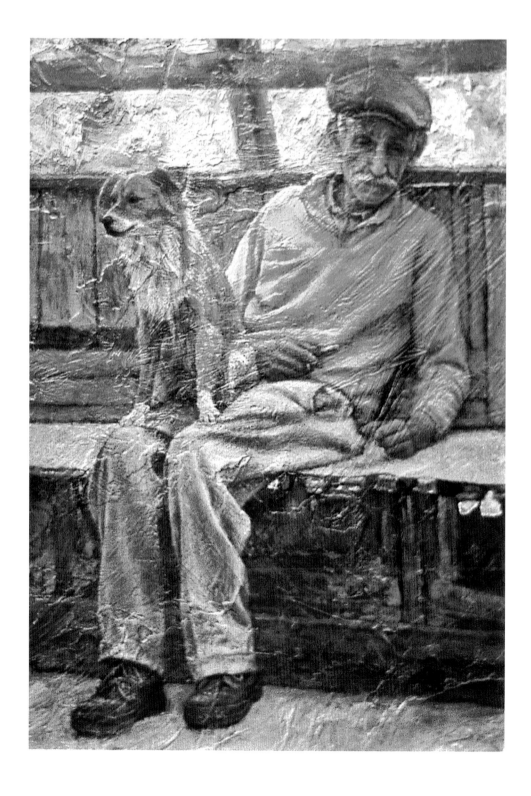

Equipment Focus

Oil-painting brushes

There is an enormous range of brushes available to the oil painter. This section identifies the basic few which would serve you well and with which the various workshops and tutorials in these projects have been produced.

STIFF: BRISTLE (HOG)

Stiff bristle brushes are the ideal companions to oil painting. They naturally create strong brush marks and textures in the stiff paint, thus exploiting its full potential.

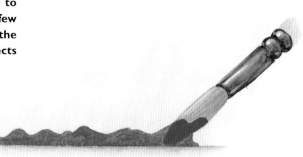

SOFT: NYLON/SABLE

Soft hair or nylon brushes create smooth brush marks. They are excellent for glazing, where it is essential they do not create their own texture [A]—but simply deposit paint in the texture already present. Drawing and detail can be provided using their fine points [B].

SHAPES

ROUND: BRISTLE

Round in cross-section, tapering to a point, this is the most traditional of all the shapes. For beginners especially, this is the shape with which to start as it fulfills most of the functions required.

During mixing, the bristle will resist damage and can produce streaky mixes that are much more exciting to the eye than fully mixed paint, which can appear flat.

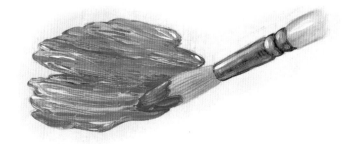

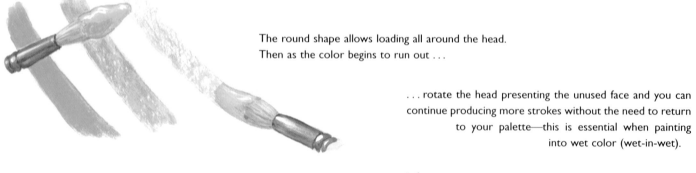

The round shape allows loading all around the head.
Then as the color begins to run out . . .

. . . rotate the head presenting the unused face and you can continue producing more strokes without the need to return to your palette—this is essential when painting into wet color (wet-in-wet).

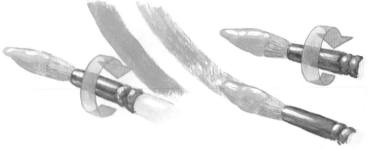

ROUND: NYLON/SABLE

The finer hair filaments of the round nylon/sable will point well for detail or linework. Rendering the paint more fluid, by the addition of a painting medium or a thinner, helps to achieve the necessary coverage for fine work. Fill the brush well to ensure good shaping of the head.

With stiffer paint, loading and dragging across the smooth palette surface can flatten the brush. The resultant soft flat shape proves perfect for scumbling over raised textures of a still wet color.

RIGGER: NYLON/NATURAL HAIR

As its name suggests, linework such as rigging can easily be accomplished with a fluid paint mixed with plenty of medium. Hatching and line texture are also achieved with this useful addition to your equipment.

Equipment Focus

Understanding oil paints

QUALITY

Colored pigments are derived from animal, vegetable, and mineral sources, garnered from all points of the globe. The rarity of some of these affects the price of the pigment and thus Artists' Quality oil paints vary considerably in price from color to color. The makers give the paints a series or group number, which denotes the price. Therefore price does not necessarily signify quality differences between the colors, but simply the cost of the principal pigment. Earth colors are relatively cheap, while at the other end of the scale genuine Ultramarine made from ground lapis lazuli (a semi-precious stone) can be costly.

Tubes sold as "oil paint for artists" are usually a cheaper student color and may be marketed under a different range name. In this case the color is often a chemical dye created to match the genuine pigment. This allows all the colors in the range to be kept at the same price. Student Quality colors may not be as well ground or have the same color saturation as the Artists' Quality equivalent, but will usually handle with sufficient distinction for a beginner to experience the full richness of oil painting.

PERMANENCY AND PRICE

Different pigments have different degrees of permanency, relating to their lightfast properties when exposed to daylight, and their durability when exposed to normal degrees of atmospheric pollution. Tubes are usually marked with a star rating, or letters, to indicate these. The group/series number that appears on the tube is not a degree rating of permanence; it merely indicates the price category in which the color falls. The price of a color is no guarantee of its permanency. In fact, the manufactured and cheaper student quality paints are likely to feature a more evenly distributed permanency rating across the range. On the other hand, Artists' Quality can vary considerably, depending on the source from which their color/pigment was obtained.

COMPOSITION

In its raw form the color or pigment is to be found as a colored powder. To apply and permanently fix this powdered pigment to the surface, it is mixed with glue, known as the medium. In oil painting this is oil that dries hard, creating a permanent colored layer. Traditionally, this is refined linseed oil, but other oils can be used. Refined safflower oil, for example, is often used in whites to ensure purity of color and resistance to yellowing.

In any tube of oil paint the main constituents fall into three categories.

1) Pigment
2) Extending agent or filler pigment
3) Medium

Some pigments are so powerful they need filler pigment in order not to overwhelm mixtures. However, the more filler present, the weaker the color. Cheap paints are bulked with filler, and while they may look good in the tube, they will be less effective once you begin to mix them with other colors. Paint with plenty of pigment is saturated with color, and although it will cost more, it will yield the best results.

QUESTIONS AND ANSWERS

Why do makers produce colors that fade?

Because there is a demand for traditional colors, even when they are fugitive (e.g. genuine madders) you must decide whether tradition is more important than the longevity of your work.

Why do makers produce some colors that contain hazardous materials?

Because these pigments produce the most brilliant colors (e.g. cadmiums).

Equipment Focus

Paint Layering

METHOD
Following this method the layers gradually increase in oil content (lean to fat), are built from "thin to thick," and are usually layered "dark to light."

UNDERPAINTING

The first layer is thinned with artists' distilled turpentine, white spirit, or an odorless thinner. This spreads both the pigment (color) and the oil (medium/glue) into a thin transparent layer. As the oil has been spread thin there is less strength in this layer, which can be disturbed by vigorous application of subsequent layers, even when dry. The thinner quickly evaporates off leaving a thin layer that dries quickly.

IMPASTO

The second layer is painted with oil straight from the tube, without additives of any kind. As the paint is stiff it is easily built up into textures, especially when applied with a stiff bristle brush. For beginners, this is the layer that requires the most confidence but once this is achieved, becomes the most exciting layer. Several colors can be laid onto each other, while still wet or once dry.

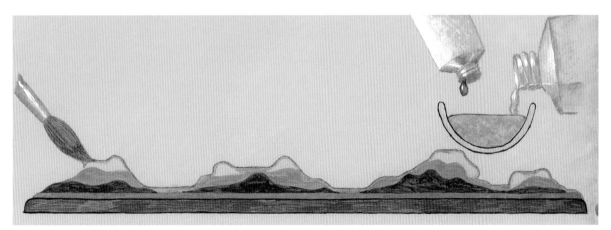

GLAZE

The third layer uses color mixed with a glazing medium. In effect, this means adding more oil to the color, creating a transparent fluid layer that discovers the nooks and crannies of the previously laid impasto layer. Colors thus become darker and richer, and their texture is enhanced.

Equipment Focus

Oil palettes and dippers

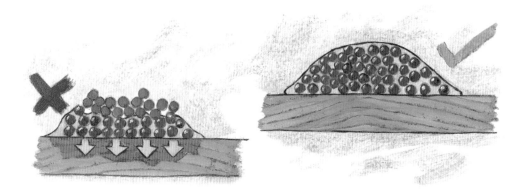

PALETTES

Oil palettes come in a variety of sizes and a host of different materials, such as mahogany veneer, birch plywood, melamine-faced, plastic, glass, and ceramic. For your main oil palette buy the largest you can handle comfortably.

SURFACES

Oil palette surfaces need to be non-metallic and non-porous. Metal reacts with the paint adversely. Porous surfaces will absorb the oil from the paint. The resultant paint is stiffer, duller, and having less binder (medium), will invariably be weaker

USING THE PALETTE

You should be able to hold the palette comfortably, supported by your arm, for some time. Brushes are held fixed between thumb and palette. Some of the larger palettes are balanced to take the strain out of holding them throughout the painting session. You can also hold a cotton rag beneath the palette, handy for corrections or paint spills. Lay out squeezed paints in the order of a straightened out color circle, with the primary "pairs" together. Put out plenty of white, as you will use more of this than any other color.

With such a limited palette of colors you will be not be shy to put out plenty of each. There is nothing that wastes time more, or frustrates as much, as constantly having to squeeze out more paint from tubes. Other colors can be added as required at the end of these laid out primary colors. Beware of false economy. Be generous with your mound of paint. Often when mixing you will dip a soiled brush into it to add to a mix. If you touch the hard surface of the palette the color will come off your brush and soil your paint mound. To keep your colors clean, try to only touch the soft paint—it is worth trying this out.

DIPPERS

Dippers are reservoirs for your painting medium and clip on to the side of the palette for easy access. They hold small amounts of medium for easy transport and help avoid your main supply from drying, which can occur when the cap is removed too frequently.

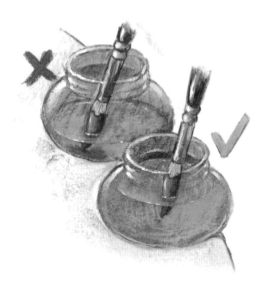

Fill your dippers well to avoid contamination with other colors— similar principle as with paint mounds.

Dippers with lids are available to keep out air, so that your medium does not dry out too soon. They also prevent spillage of medium.

Even if the contents start to thicken, don't add thinner to resin (Alkyd) mediums—this will only make them dry out faster. If the medium dries, gently cut around top surface with a blunt knife (palette) and remove the "lid" of dry medium. Fill to top immediately with fresh medium.

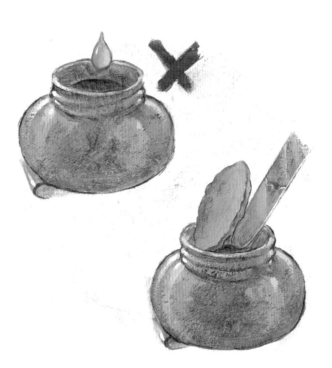

TIP
Always fill dippers at the end of a painting session and replace lids.

Starting Off

Thumbnails

STARTING WITH THUMBNAILS

"I just don't know where to start."

"I just can't decide what to put in my picture and what to leave out."

"How can I produce something that is unique to myself when this view has been painted a thousand times before?"

These questions crop up time and again, the problems being common to most painters. Even those who have been painting for some time can find starting off to be a frustrating experience. Yet the solution is so easy, when you use thumbnail sketches—small scribbles produced on the odd scrap of paper or the back of an old envelope, which concentrate your mind on a basic set of elements to make up the composition.

Thumbnails can fulfil different functions under a variety of circumstances, such as when working from photographs. Many tutors will advise students not to do so because they know how easy it is for the format of the photograph to dominate. However, if you start with thumbnails you can play around with the proportions of the subject and the shape of the rectangle framing it, until the balance is improved and a more personal view achieved. Using this method any number of artists could start from the same photograph and achieve a multitude of different compositions.

Many painters, when watching me complete thumbnails, assume that I have a preconceived idea of how the composition will work. This is far from the truth as it is only through putting down the shapes that I can decide what size they should be and whether to move them.

When producing thumbnails, think of them as scribbles rather than as drawings and keep them to a small size—no larger than two inches for the longest length. A small rectangle soon becomes overcrowded should you be tempted to overwork, while working within a large area only encourages you to fill up the space with drawing. If you do this, you will be faced with an overburdened composition to transfer to the painting surface or you will have to simplify things again.

The scribbles can be so basic that anyone looking over your shoulder may not recognize what the marks on your piece of paper signify. Essentially, once they become recognizable, detail has started to creep in and is more likely to confuse you.

Start by loosening up your wrist action, imagine you are scribbling a cloud of gentle lines and slowly increase the density in certain key areas. By working this way your fear of making the first mark will disappear, as each subsequent individual mark will be of little direct importance.

Train yourself to complete the thumbnails swiftly, for if you spend too long on them, they will begin to take on the characteristics of a drawing—with the accompanying urge to finish them off. It is also more time-consuming and difficult to transfer the contents of an over-detailed thumbnail to the actual painting surface.

You will need to complete several thumbnails, to give yourself a selection of possibilities to compare and from which to make your final choice. Don't let your thumbnails touch each other, or rest against the edge of the paper. Since you have made an effort to keep the elements within your rectangle rather abstract, confusion will arise if they are butted up, giving the illusion of one rather than two compositions—give each some breathing space.

SCALING UP

Having completed the thumbnails and decided on which appeals to you, you need an accurate method of scaling this up to the full size of the surface of your painting board. Many painters using thumbnails for the first time simply start their full drawing in the center of the surface. This is to ignore one of the main compositional elements that you have striven to exploit—the shape of the rectangle surrounding the composition. How big should your finished picture be? Does it have to fit a certain size/proportion of canvas? This method is based on a simple visual scaling up process.

Draw a diagonal line through the corners of your thumbnails [A] and extend two of its sides [B]. Along one mark out the length you require and from this point extend a line at right angles (use a set square if necessary) to join the diagonal [C]. Complete the rectangle by joining this point to the other length at right angles [D].

Any rectangle on the diagonal, larger or smaller, is the same proportion as the original [E]. You can now scale up your rectangle from your thumbnail to the desired size of the finished piece [F]. Conversely, use this technique to scale down from a fixed rectangle (canvas/canvas board) to accurately proportion your thumbnails [G].

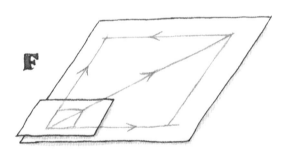

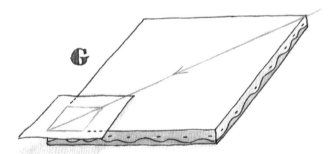

TRANSFERRING THE "OUTER RECTANGLE" OF YOUR COMPOSITION

While it is possible to enlarge your thumbnail and make a canvas to match, the reverse is often the manner in which this is tackled. For example you could start with the canvas and reduce this to produce a thumbnail rectangle that is fixed, thereby ensuring that you utilize the whole of the canvas.

In this instance you should set out a series of the resultant thumbnail rectangle in both horizontal and vertical format in your sketchbook/pad—before you begin to consider the balance of the composition This ensures that, before you begin, you are working out a composition which will transfer in proportion to the canvas—the thumbnail rectangle being identical in proportion.

FIXED THUMBNAIL PROPORTIONS

This method is equally valuable for watercolor paintings when you wish to work to a set size mount and frame around your painting.

This is often the most economical way to work as you could have several mounts and frames of the same size which can form the basis of an interchangeable set of frames—so useful if you wish to display paintings and subsequently replace the paintings within, without having to spend money on yet more frames!

Once you have decided on the final thumbnail there is one more aspect that has to be considered. How much of the outer area of the rectangle of the composition will be lost under the inner edge/slip of the frame? Frames around oils tend to have deep rebates and the smaller the painting, the larger in proportion to the whole that rebate becomes. Imagine how much would be lost on a 6 in. (150 mm) square canvas were you to lose a ½ in. (12 mm) border all round.

You could find yourself facing the loss of an important element of the composition—something that is easily prevented by simply allowing for this when mapping out the composition. See how in illustrations A and B objects that were meant to have lots of space, suddenly touch the edge of the frame, making the composition look cramped. Should you find yourself facing this situation there are two choices. Either repaint the area that could be lost or ask your framer to pack the frame.

The simple way to avoid facing this dilemma is to draw a ⅓ in. (15 mm) border around the edge of the canvas. Don't use a ruler to do this, work freehand as follows:

1. Bend three fingers at right angles to your palm.
2. With the flat side of these three fingers gently pressed against the side of the board, run your hand up and down (keeping contact with the board at all times). These are guiding fingers and can be lengthened or bent, depending on how far in you intended drawing the line.
3. Load a brush with thinned fluid color and place in between your thumb and forefinger, then draw the line, keeping your guiding fingers in place.

The scaled-down thumbnail can also be drawn within this inner rectangle. It is important that you ignore the canvas edge as you do so and concentrate on the drawn line as the edge of your picture. Once again, on small paintings you will often feel that the subject is floating in the middle of a lot of space. This will immediately be different when the frame is fitted [C]. Without this safety net, your image will look cramped and airless.

TRANSFERRING THE ELEMENTS OF YOUR COMPOSITION

You should never start to draw in the middle of your canvas/canvas board, blindly hoping everything will fit. The balanced composition of your thumbnail should be proportionately transferred to the surface of your painting to ensure a well-balanced end result.

Take the chosen thumbnail [A] and examine the various lines it contains—some will be parallel to the side or top of the rectangle. In your mind's eye, imagine these extended until they touch the edge of the rectangle—i.e. point [B]. Their positions can be transferred onto your painting surface [C] without measurement, as this is simply a division of the proportions of the line, which can be done by eye (see arrows). Moving down/across from this point on the edge draw a corresponding line parallel to the appropriate side as with [D]. Repeat with all other lines parallel to the edges [E].

For the diagonals in your thumbnail [G], again extend these to the edge as example [H]. Here you must transfer not only the point, but also the angle of the diagonal. Equating this to the hours on a clock face [J] is the

simplest way to translate this. Treat all diagonals in the same way [K]. Curves are more difficult [L]. Could they be temporarily translated as a series of lines [M]? Alternatively, you could look at the space between the curves and the lines that may surround them [N], which can help to position and plot them more accurately [O].

This process seems much more complicated than it is in practice. Once you have the grasped the idea, it is something which will become second nature and will literally be completed in a matter of minutes. As the proportions are being transferred by eye, it is a much more dynamic way to start a painting without the tedium of excessive measurement.

Project 1

Brush and rag

To paint in oils is often considered a lengthy process, since its application can consist of many layers of paint. As the medium/glue that binds the pigment is oil, the paint will only become dry once the oil has set hard. Should individual layers need to dry before application of the next, then of necessity the process takes quite a while.

While there is much to be said for this approach, one that allows a painter time to consider the work as it progresses, it may not always offer the chance to capture the moment of inspiration or that fleeting effect of light experienced when working outdoors. For this purpose, the approach must be modified to offer speedier results without losing the qualities that are so much a part of the oil-painting finish.

This project sets out to demonstrate that not only are these speedier techniques available, but they offer the painter a wider range of characteristics peculiar to the medium.

The paint can be used in a very fluid manner. Adding more medium at the very onset of the painting process creates a succulent and juicy surface onto which further brush strokes are floated.

Tonking becomes a joy and an extremely useful technique for creating unexpected visual texture. Many renowned artists of the past have employed just such an approach, often concocting unique recipes for the medium to add to their colors. Each variation would feature a slightly different viscosity or drying speed to suit the particular needs of the individual artist. This is something that could be emulated by anyone working in oils.

Alternatively, rather than using fluid paint, the opposite approach of working on a layer of stiff paint will make it more receptive to further layers of stiff tube color. Because the surface is wet, the brush strokes are fluid despite being stiff, and being stiff offers a further advantage. The brush strokes can be laid thickly until an impasto (heavily textured) surface is created.

Both methods will bring worthwhile results and should be explored as a means of loosening up one's approach to oil painting in general.

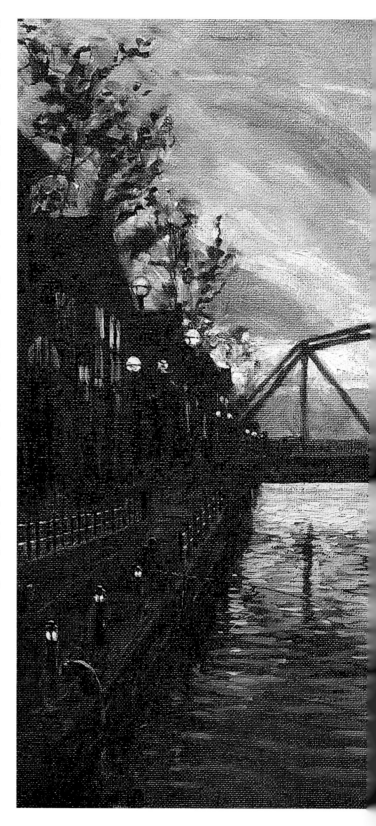

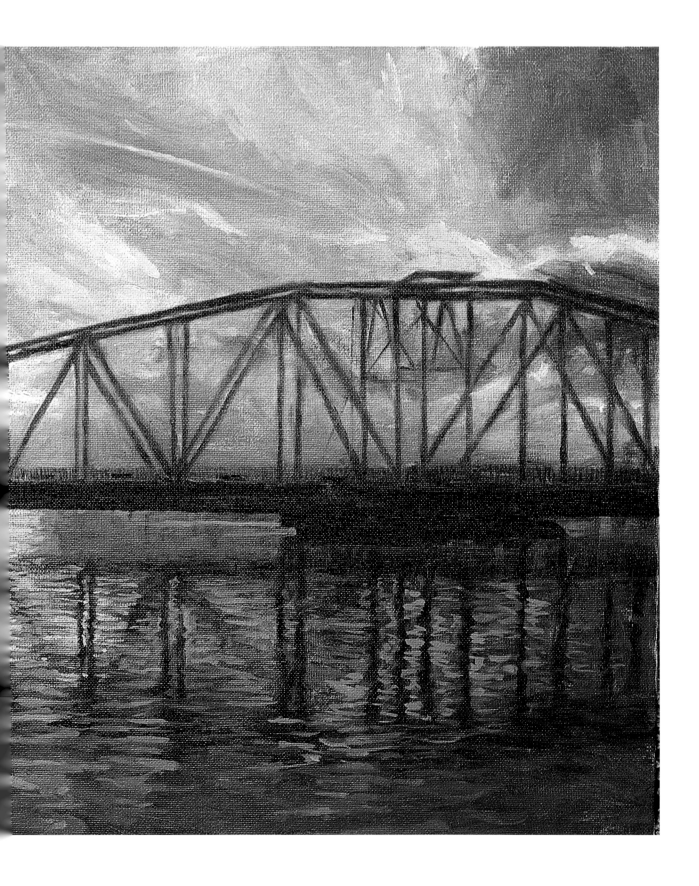

Project 1 Workshop

Fluid wash painting

Lightly draw in structure with nylon brush and turpsy color. Correct with bristle brush and turpentine.

MAKE OILY THINNER (Medium for slow drying)— mix equal parts linseed oil and turpentine.

Use bristle brush to mix medium fluid with color on palette. Paint with nylon brush.

Once first layer of fluid wash is complete, add more tube paint [Ro+Bp] to mix on palette and redraw structure.

As surface becomes too fluid and slippery to accept mix, use paint with little or no medium added.

Keep brush well loaded with paint (fluid or stiff) or the color already on canvas will lift up.

Be inventive with brush strokes to add vigor and vibrancy to surface quality.

Scumbling across wet surface is possible with soft brush—keep pressure gentle and use only shoulder of brush head.

Soften brush marks with clean bristle brush to suggest movement and/or depth.

Add ZW to lighten purple wash [Ro+Bp+yo] of building in distance to suggest aerial perspective.

Work stiff color straight from tube into the surface. Warm [Ro+bp] in light; cool [Bp+ro] in shadow.

Where color becomes too dark wipe off (lift-off) gently with bristle brush for soft transparent highlight.

Oil painting is normally associated with thick stiff impasto paint, used in the consistency that comes out of the tube. This project takes the basic approach of working with washes of fluid color throughout the painting. There are many artists who prefer this method, for it results in an immediacy and freshness to the medium of oil painting and relies on a spontaneous approach. Whether you use this as a sketching technique or for more finished pieces, it is an important aspect of oil painting to be included in your repertoire.

STEP 1

The subject of this painting is undoubtedly the sky and its reflection in the water, if only because of the amount of surface area that is devoted to it. This technique is ideal for capturing the complex interweaving of patterns of light in a fluid and immediate manner. These dramatic fields of color need to be contained in a simple way that makes sense, while still allowing their large areas to dominate the mood of the composition. The bridge and dark buildings fit the bill perfectly. With the first blocking-in of color, their positioning may at first appear odd. While the base of the bridge lies along the horizon, the buildings form a tight triangle to the left. As they are darkened later in the painting, they will merge into shadow, but will also provide the tonal contrast against which the light colors of the sky can shine. The fisherman was moved from his original place further up the dock to provide a focal point in the foreground and give scale to the other elements in the composition. Draw out the main components of the composition using a turpsy color (small amount of pigment diluted into very a fluid wash with turpentine). Block in masses by underpainting with fluid washes of color.

MATERIALS
Canvas Board
Brushes
round nylon
nylon Rigger
2 round bristle
Paints
6 primary colors
Zinc White [ZW]
Linseed Oil
Turpentine

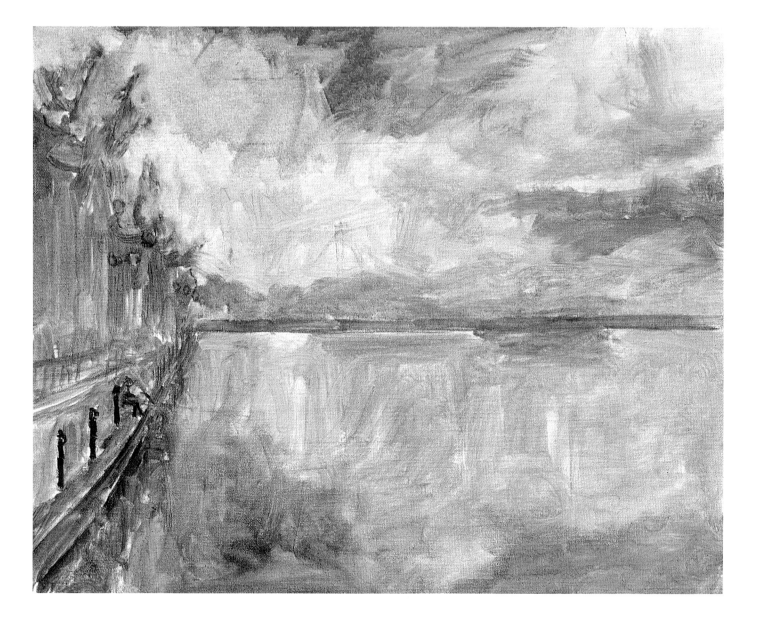

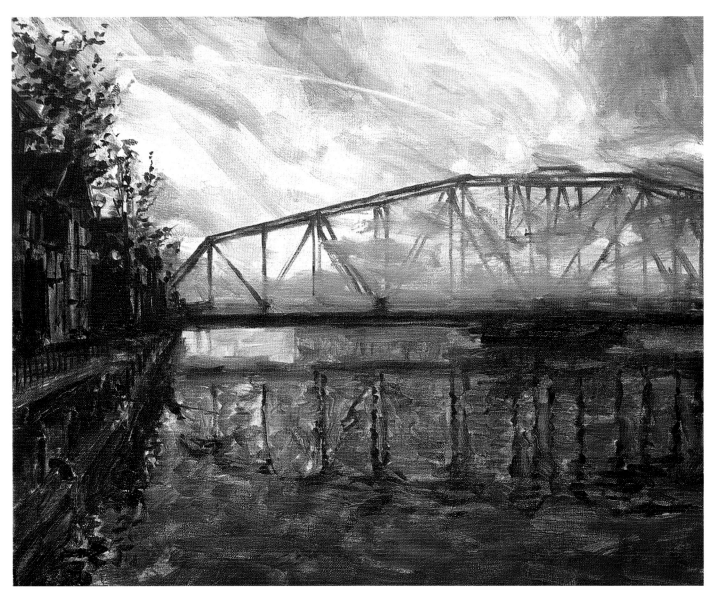

STEP 2

Working the middle to dark values across the surface starts to become really exciting as the lighter colors of the sky begin to glow in contrast. Note how the brush marks remain soft, even on the girders of the bridge, both solid and in reflection. During the day such a flat-on view of the bridge would be deadly boring, but here it actually breaks the sky into glowing geometric shapes. Colors can be applied transparently, to create intense glowing areas (orange in sky) or to produce rich dark areas (building). You will be surprised just how much dark pigment you can load into these dark shadows. These soft darks are as important as the sky highlights. It is tempting to work on the sun and its shimmering reflection, but spending time on these colored-gray darks is far more valuable to the overall drama. With the addition of white, opaque colored-grays offer a dramatic contrast to the richer, more intense colors. These pale, opaque colors need to be bold, brushy, solid, and dramatic. The wet surface demands a loose, fresh approach with lively brush strokes, so loosen up your wrist action and take some chances.

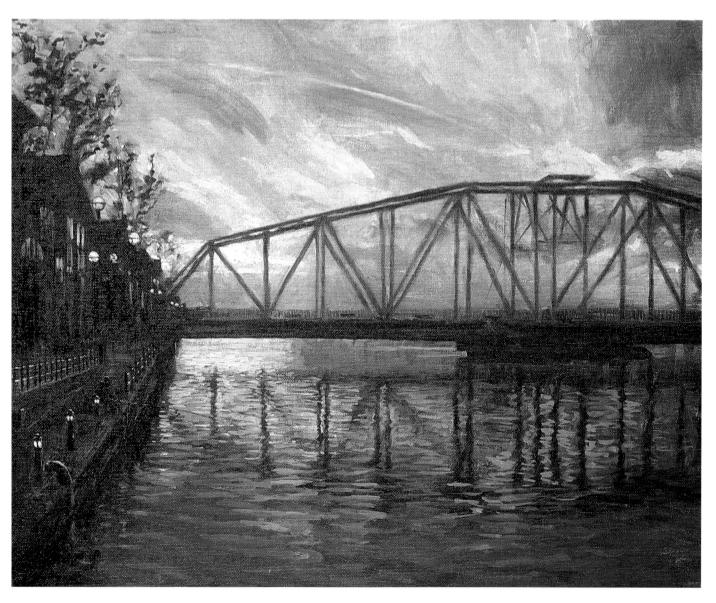

STEP 3

In this final layer, progressively reduce the amount of medium mixed with the color, until you reach tube consistency. Amazingly, the dark buildings and the bridge can take more darks, but now as fine detail. Note for example the detail in windows and lamps, how the road across the bridge is deepened, and the bridge's central support is drawn more tightly. The girders, both solid and in reflection are also tightened. These are obvious and enjoyable to paint, but it is within the subtle dark shadows where the structure of the building and the wharf can make or break the painting. Here the perspective of the windows, railings, and lamps converge sharply into the distance, giving this compressed triangle of darks the depth it needs. When used for dark areas (buildings), the paint must be worked into the wet surface, enriching the color, while not developing texture. Texture here would inevitably catch light and could appear as a highlight, which would destroy the richness and depth of the darks that you have striven to create. For highlight areas (water, sky, street lamps) the paint is built up so that the thick paint catches the ambient light and begins to "shine." Final linework and drawing (bridge detail, fisherman, etc.) can be completed with smaller brushes (nylon round and Rigger) adding just a touch of medium to the paint to aid fluidity, while retaining density of value (darkness).

HIDDEN GEM

In a daylight composition the fisherman would become a natural focal point. Here he is lost in the shadow and waiting to be discovered by the viewer. The joy of looking at a painting is to discover more and more each time it is viewed and including little gems can make a dramatic painting such as this all the more exciting.

Project 1 Workshop

Starting with a rag

COLOR REFERENCES
Yellow-orange [Yo]
Yellow-green [Yg]
Red-orange [Ro]
Red-purple [Rp]
Blue-purple [Bp]
Blue-green [Bg]

STEP 1 Cut a piece of cotton fabric approximately 6 in. (150 cm) square.

Roll into a soft pad and hold tight between fingers.

Use to mix color on palette so that weave becomes impregnated with paint.

Use fully loaded pad to apply color to surface.

STEP 2 Apply extra pressure for darker accents. Push finger inside the cloth or . . .

. . . roll wad as tightly as possible.

Mix generous amounts of paint. Take into account quantity that cloth absorbs.

STEP 3 Mix on palette with stiff round bristle brush.

Use a softer, round, nylon brush to paint. Pull color across palette shaping head into chisel shape.

Use bold, simple strokes to begin definition.

Linework around leaf and flower silhouettes concentrated on edge.

Blend brush strokes into background to create larger accent.

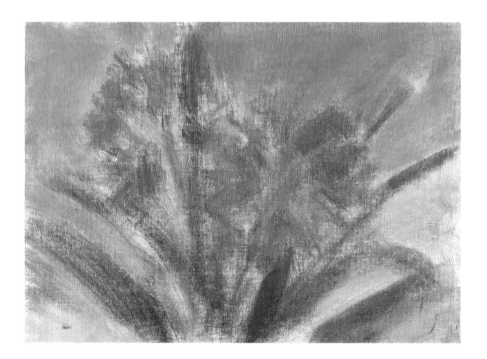

MATERIALS
Canvas Board
Cotton Rag
Brushes
fine, small, and medium size round nylon
medium size round bristle
Paints
6 primary colors
Titanium White

STEP 1—DRAWING AND BLOCKING IN

There is a way to start a painting with minimum drawing or none at all, one that provides a bold, yet soft start to a painting of any subject. It is essential that the surface for this technique is rigid to take the pressure required when applying the paint. It is useful to prepare a canvas board for this purpose. Apply a thin turpsy colored wash to block out the stark white of the board and allow this to dry before commencing with the painting. A complementary to the predominant color is best, such as the green used here, for the red-oranges to follow. The technique relies on using cloth pads/wads to apply the initial stages. The whole painting should be completed alla prima—in one go, with no drying time between the steps. Mix colors with the pad of cloth held tightly. Don't use any thinners, mix paint straight from the tube and create lighter versions of those to follow by adding Titanium white. Use the same pad for all color mixes and to apply, wipe, and rub the paint into the surface. The inevitable intermixing of color unifies this first layer. This technique forces one to analyze the essential composition, shapes, and rhythms within, with no danger of being sidetracked by unnecessary detail—a wonderfully free way to start any painting.

COLOR MIXING
Where the prefix letter is shown in capitals this denotes a larger quantity of that particular color. Conversely, where the prefix letter is shown in a lower case, this denotes a smaller quantity of that particular color.
e.g.
Bp = large amount of blue-purple.
bp = small amount of blue-purple.

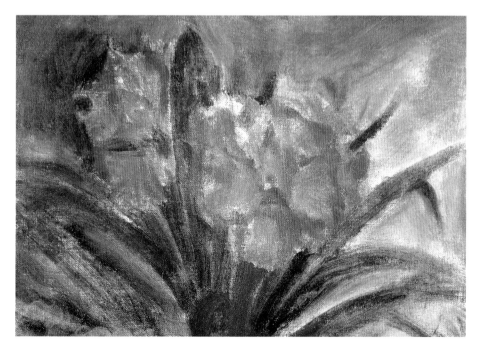

STEP 2—ESTABLISHING LIGHT AND SHADE

Continue using the pad/wad for this second layer. Use similar colors to the first, but darker versions mixed without the addition of white, to produce the darker values that are essential for the soft drawing. Creating a darker background is essential to provide contrast for the flowers to work against. Blue-purple is nearly a complementary to the orange, and as it is dark and dull, makes the flowers sing out. The spaces between the leaf blades and around the flower petals are painted as positively as the plant itself. These negative spaces should be treated as an essential element of the study, right at the outset. By the end of this stage the balance of light and shade will have been established, while the focus still remains soft, fluid, and malleable.

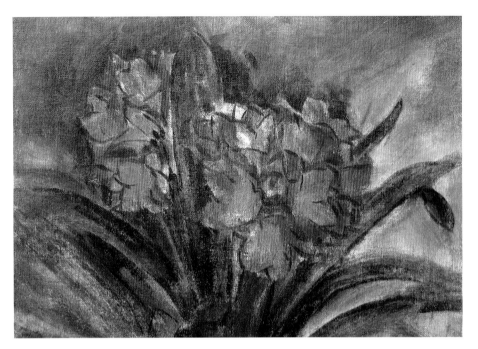

<div style="border:1px solid black;">

HIGHLIGHTS

During later stages of the painting, ensure that all of the turpentine is squeezed from brushes as they are being cleaned. If this turpentine becomes mixed with the paint that you are trying to apply, the paint will simply not adhere to the wet surface. The color must be kept at tube consistency. Although this may seem stiff, it will both shape your nylon brush and be sticky enough to remain where you place it on the canvas.

</div>

STEP 3—DEFINING FORM

The first hint of definite brush drawing comes with this stage. Load a medium-sized round nylon brush with stiff color. Push the side of the brush head firmly into the mix on the palette. You must fill the inside of the head with paint, so that it can be properly shaped and flattened to achieve sharp bold strokes. To create a vignette, or central focus, start with the flowers and move out, slowly reducing detail. Concentrate as you apply each stroke. Think not only of how each stroke will define any individual flower, but where it will fall on the flower head as a whole. You have the soft underpainting to guide you, so relax and enjoy the emerging shapes. Each stroke can be fine or with a little extra pressure, become a more solid accent.

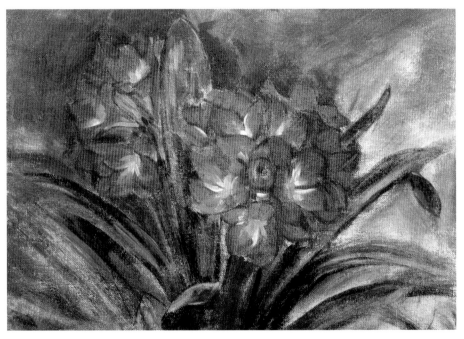

STEP 4—ESTABLISHING FORM

Concentrate on the flower heads. Apply a middle value orange to the petals, using a medium-sized round nylon brush, larger than you would expect, to avoid overdetailing. The strokes should be applied in the direction of the petals. Don't let this paint layer become too deep, as others are to follow. Once these colors have been boldly applied, take a medium-sized bristle brush and soften the majority of the lines around each petal by blending them into the orange. With a medium-sized nylon brush, which gives more control, apply a Yellow-orange [Yg+Ro]+[bg+bp] to the center of the flowers and then lighten with white to catch the light. Reflected light (blue-gray) is drawn along some of the leaf edges.

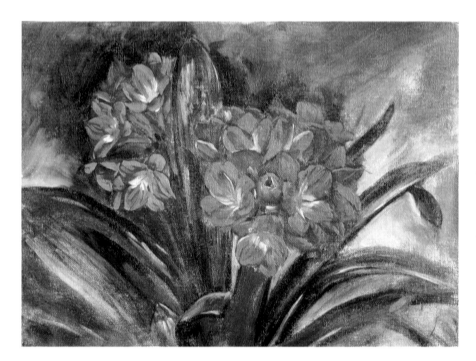

STEP 5—ESTABLISHING LIGHTS

Lighten the orange of the flower centers by adding Titanium White, using the same size nylon brush as before. Using a brush bigger than you would expect to use forces you to exploit its full range of strokes. Its flattened edge is used along the petal edges, carrying the brush along or away from them and pulling directional strokes from the flower centers. Lighten the overall orange of the petals. The soft strokes will blend with the wet underlying color relative to the paint load or pressure exerted on the nylon brush. This is natural or self-blending, requires no additional work, and is solely dependent on the immediacy of the action—painting at its most expressive. Some final blue-white reflected highlights are sparingly added to the leaves.

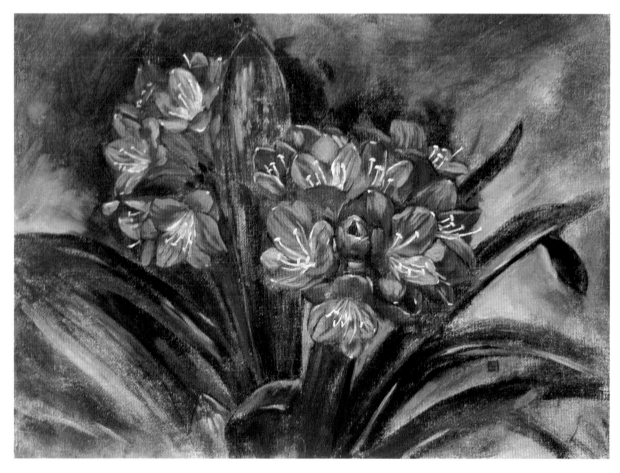

STEP 6—FINAL DETAIL

Now it is time to work with a smaller round nylon brush. Lighten orange petals further, adding yellow and then white. These final whites often benefit from a touch of complementary color to make them really stand out. The white on the orange petals for example, has just a hint of green added. Finally, build the fine stamens from dark to light, using a fine nylon brush. Start with a mix of [Yo+yg]+[ro+bp], adding white and finally a touch of purple. Support your hand when applying these lines and the curved ticks of the stamen heads [Yo]. With a dripping brush add a final highlight [Yo+TW] and these impasto touches will dance from the surface.

Tricks of the Trade

To dry or not to dry?

Most painters experimenting with the medium for the first time are often frustrated with oil paint either drying too quickly or too slowly. Once you understand the mechanics of drying in oil painting, the quality can be exploited to your own advantage.

THE PROCESS

Oil paint generally dries by chemical reaction and not by evaporation. The medium (glue) that is used to stick the pigment (color) to the ground is an oil. When the oil is exposed to the air, the two react, causing the oil to stiffen and eventually harden, thus trapping the pigment in a brittle surface. You will discover that some colors dry more slowly than others. Alizarin crimson, for example, used on its own may seem as if it will never dry. Certainly student quality colors often dry much faster than the better artists' quality. The latter are more saturated with pigment and good-quality oils which slow the process down.

THINNING DOWN

Adding thinner to your paint will speed up the drying process. The thinner itself evaporates swiftly leaving a thin layer of oil, which, being exposed to the air, dries more speedily. Unfortunately, adding thinner in this way reduces the abundance of oil, leaving the paint dull and vulnerable to damage. To stop at this stage of a painting is inadvisable. Even if you varnish the dry surface to protect and restore the shine, there is a secondary problem. The varnish itself can soak down into the "open" pigment and, having hardened, will be impossible to remove without removing the pigment itself. This will make revarnishing (restoration) difficult, should this be necessary at a later date.

REMOVING OIL

Oil can be removed from the tube paint. Squeeze the paint onto newsprint for a few minutes before transferring it to your palette. Alternatively, once on the painting, you can leave overnight with a layer of newsprint gently laid on its surface (tonking). Both methods soak out oil into the newsprint and the resultant dry paint is stiffer and dries out more rapidly.

SLOWING DOWN DRYING

Most artists are more interested in slowing down the drying of their paints, either so that they can rework the painting or simply to keep paint fresh on the palette. To facilitate slow drying you must restrict the passage of air across the surface of the paint. I have known artists who leave their palette and painting in the deep freeze—not for the cold but for the still air. I cannot recommend this, however, as lamb chops and Prussian Blue are poor bedfellows. It is better to leave your paint surface in a small room or closed cupboard where the passage of air is restricted.

WAYS OF PROTECTING WET PAINT

Cover the paint with transparent food wrapping. This is an ideal method for transporting wet palettes home.

Place the palette in a cardboard box covered with a lid to keep out air.

Canvas carriers are useful in restricting airflow and preventing surface contact. I use this method, as it is an excellent way to transport a wet palette, or two paintings of the same size, face to face.

In the studio, one of the simplest methods of restricting airflow is to lean the palette or the painting against a wall. Barring cats and children this can be quite effective for a few days.

Common Problems

Surfaces for oil painting

QUERY

"I am a beginner in oils. Is there a cheap method of preparing a surface for my first attempts by using materials I may already possess?"

ANSWER

When you are starting out it is quite acceptable to use cheaper surfaces, such as paper or hardboard, but they will still need priming and sizing. It is preferable that you get the feel of working on a non-absorbent surface (ground) from the outset, to experience the true nature of working in oils.

SOLUTION

Paper Surface—Applying a couple of layers of acrylic medium or acrylic paint of any color will suffice. If you don't have acrylics, then try a couple of layers of watered-down PVA glue, such as wood or craft glue.

Hardboard surface—Many painters prefer the more rigid surface of hardboard. While some choose to use the textured side, the finished result does tend to look as if it has been painted on hardboard. The smooth side, however, can be prepared to suit your personal taste. Whether you intend to prepare a smooth or textured ground, the shiny surface of the hardboard has to be sanded down first[A]. Wrap a piece of sandpaper around a small block of wood to even out the sanding. Then take a tin of ordinary household emulsion paint—this can be something left over from painting the house or a sample pot bought for the purpose. As today's emulsion is generally acrylic-based, this will prepare the surface to accept the oil paint. Thin the paint down with water and apply several layers, allowing each to dry and then gently sanding down each dried layer before applying the next [B].

Canvas boards—While there are many propriety brands on the market, you may like to try your hand at making your own. Cut a piece of hardboard or thin plywood to the size you want, making sure the sides are sanded smooth. Cut a piece of thin canvas to the same proportions, making sure it is two inches wider on each side. Using acrylic medium (or PVA wood/craft glue) paint one side of the board and then paint one side of the canvas [C]. Work the glue into the texture of the canvas. Protect the undersurface of the canvas by laying newspaper between it and the work surface. Bring the two wet surfaces together—with the canvas on top—and press down gently with the palm of your hand, displacing any irregularities by working out from the center. Turn over and paint glue around the perimeter (within two inches), then overlap the canvas and stick it down [D]. Carefully cut or flap corners [E]. Leave for at least 24 hours and then prime and size.

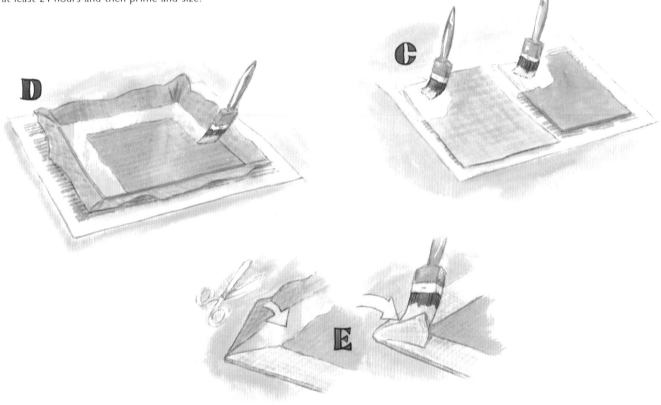

QUERY

"I like the idea of buying ready-to-use canvas boards. What is the difference between an oil board and a canvas board?"

ANSWER

Both canvas boards and oil boards are backed with thick cardboard. Canvas panels, on the other hand, are more expensive panels covered in primed canvas. Oil boards— [F] magnified—have a surface not unlike oil paper glued to the backing board. You can see the cardboard backing at the edges. Canvas boards have canvas fixed onto the backing board, which is folded over the edges and firmly glued onto the reverse—[G] magnified. The difference in finish is, as you would expect, reflected in the price. All these surfaces are available in a variety of textures and are generally primed and ready for use.

Project 2

Using a knife and water-mixable paints

There is nothing to beat the spontaneity of laying succulent strokes of oil paint with a painting knife. The technique demands a generous loading of paint and the result possesses the qualities and weight generally associated with oil painting.

With restricted possibilities for achieving fine detail, the painter is encouraged to suggest it within the flow and textures of the paint. There is a delicate balance between chance and control, which is exhilarating.

Yet so many painters stumble with their first strokes of a palette knife. Through mistakenly selecting the wrong knife, inadequate loading of paint, or incorrect application, first efforts are often doomed to failure. Once the initial confidence is dented, working with a knife becomes extremely difficult.

There are relatively few secrets to palette-knife painting and they are easy to master with a little practice. The most important thing is to establish exactly what you are aiming for. The workshop within this project concentrates on the simple, yet dynamic lines of a flower study to best demonstrate the textures and forms that are possible with knife painting.

While the knife is an alternative to working with brushes, what about an alternative to the paints themselves? Does anything exist as a substitute for oil paint, other than acrylics?

When acrylics were first introduced, painters marveled at this plastic-based emulsion for artists—at its ability to be used in fluid or thicker form and that it was water-soluble. In recent years a form of water-mixable oil paint has now joined the ranks and could provide a valuable alternative for those painters who prefer not to work with volatile solvents.

The tutorial was started outdoors and finished in the studio. It was carried out specifically to test the materials on several levels, for I wanted to see how they compared in character, performance, and ease of handling and transportation.

As with acrylics, the characteristics of water-mixable oils are unique and while not unlike oils, need to be exploited in their own right. The same holds true on the performance of these paints when working with them. Where they do stand out from oils is on the practical level, in that cleaning of the materials and tools can be done with water, thus eliminating the need to transport the additional cleaning agents required by oil painters.

Project 2 Workshop

Palette knife painting

Any tube paint applied directly to a dry surface will create a dry, scraped stroke.

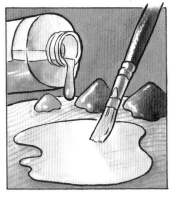

STEP 1 To prepare surface, produce color wash of oily thinner (half oil, half thinner) with dark-hued color mix.

Apply thin layer of this slow-drying mix across entire surface . . .

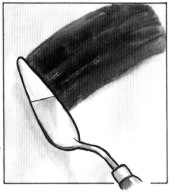

. . . to pick up color better and more fluidly from knife blade.

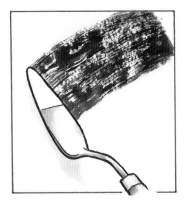

Receptiveness of this surface is increased when stiff tube color is worked in.

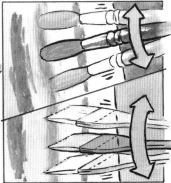

Soften marks by gently feathering with clean, dry, large round nylon/Hake—follow direction of surface strokes.

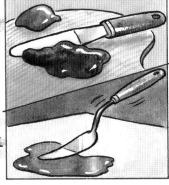

TOP—Stiff palette knife for mixing/scraping paint.
BOTTOM—Flexible painting knife for applying color.

STEP 2 After mixing, spread out an even layer on palette.

Wipe blade clean. Scoop up line of color along blade edge . . .

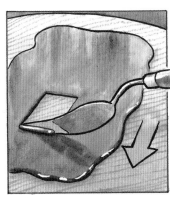

. . . or flex blade gently to pick up color on tip of blade edge only.

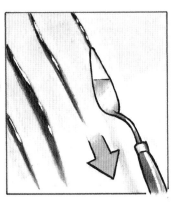

To apply line/thin stroke of color, run loaded blade edge along surface.

To apply thick stroke of color, draw loaded blade edge across surface.

While painting knives are available in a wide range of shapes and sizes, this exercise is produced using only the traditional medium-sized, trowel-shaped head. Having become accustomed to this, you can then expand your range and experiment with different blades, just as you would with brushes. A stiff surface, such as an oil board, is required. For paint, it is best to start with Students' Quality. The quantity of paint required demands a cheaper alternative in the early days. Rather than Titanium White, use Underpainting White that dries faster and is more stable in thick applications.

MATERIALS
Canvas Board
Trowel-shaped Painting Knife
Palette Knife
Brushes
large round bristle
large round nylon or
large Hake
Paints
6 primary colors
Underpainting White
Turpentine
Linseed Oil

STEP 1

Consider this stage as preparation of the surface to accept the knife strokes. Most of this underpainting will be covered by the knife work, but is essential in helping you to approach the work vigorously. Remove the dominant white of the surface and boldly divide the rectangular space. Note how the shapes diagonally cross the direction of the foliage to be subsequently applied. The color, while being of the same family as the flower heads, is complementary to the greens, providing the necessary contrast.

STEP 2

This stage requires confidence. It is advisable to sketch out on paper a compositional guide before you begin. Scrape away the color, using the blade of the painting knife, to establish the positioning of the flower heads and stalks that lie across the darker, deeper, purple layers. The leaves are fashioned with loose strokes of dark, dull green.

Project 2 Workshop

Palette knife painting

COLOR REFERENCES
Yellow-orange [Yo]
Yellow-green [Yg]
Red-orange [Ro]
Red-purple [Rp]
Blue-purple [Bp]
Blue-green [Bg]

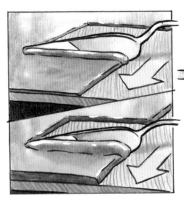

Depth of paint layer spread on palette affects speed and amount of paint loaded onto blade edge.

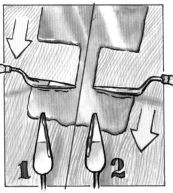

Determine which side of blade will collect the line of color . . .

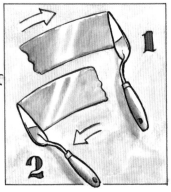

. . . which in turn affects direction in which a wide stroke can be made . . .

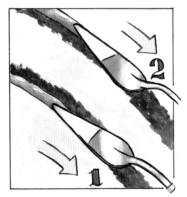

. . . or define an edge along which paint is drawn.

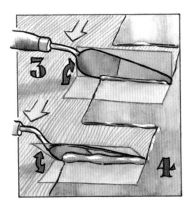

The flatter the blade angle, the more squashed and wider the paint build-up.

This affects width of drawn line.

Continually vary direction of drawn lines . . .

. . . and wide strokes to add variety, form, and rhythm to composition.

Be generous with paint quantities deposited on wet painting surface . . .

. . . which can then be smeared or spread with a clean knife . . .

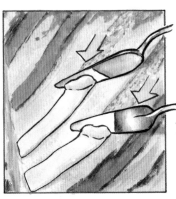

. . . or scraped off, or over, surface for thin textured paint.

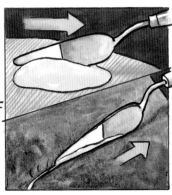

Drag blade edge through generous paint deposit on palette and use edge for "cutting" fine linework.

COLOR MIXING

Where the prefix letter is shown in
capitals this denotes a larger
quantity of that particular color.
Conversely, where the prefix letter
is shown in a lower case, this
denotes a smaller quantity of that
particular color.

e.g.

Bp = large amount of blue-purple.
bp = small amount of blue-purple.

STEP 3

The aim at this stage is to apply a layer of thin impasto paint across the whole surface. Middle tones of green are applied to the leaves, scraping back off or blending in with a finger where too heavy. Constantly change direction when applying this yellow-green mix to get into all the angles. Begin the flower with a color not much different to the undercolor, but laid more thickly in the direction of the petals. Then concentrate on their negative shapes by drawing in the dark background around them. Working on the rest of the background, note how (a) the color mixes are kept streaky and exciting, and (b) the underpainting left to show through is also effective in achieving interest. Note also the counterchange in light flowers against dark ground and dark leaf against light ground.

STEP 4

Paint will now be more easily laid into the thin, still-wet surface. Rhythmic patterns of leaves are reinforced, as you lay the mid to lighter green along one or another edge of each leaf. Using the edge of the blade, cut orange highlights into some leaf points. A distant wooden upright in the top left-hand corner can be exploited to provide an amorphous structure, so important to balance the composition by lifting the eye above the level of the flower heads. Streak color into the lower leaves, flower buds, flower heads, and the background (lower left), to begin to exploit the inherent qualities of paint applied with a painting knife. Whether the overlaid paint is lighter or darker, the eye becomes excited by paint mixed on the surface in this way.

Project 2 Workshop

Palette knife painting

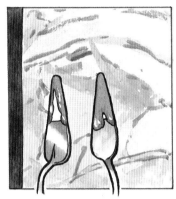

To check color before applying, hold wet mixing blade over area in question.

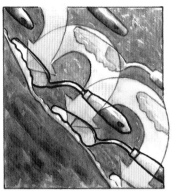

Generously scoop and dab on stems over already thick paint layers.

Flatter strokes tend to have edges disrupted by deep ridges of wet paint beneath.

Either smooth out area first with clean knife, or . . .

. . . partially scrape off or scoop out deep paint textures or ridges before overpainting, or . . .

. . . after overpainting, undercut irregular edge and straighten out or reshape (wipe blade clean regularly), or . . .

. . . push surrounding, still-wet paint, into edge and straighten out or reshape with clean knife.

Once level silhouette shape is created, lighter colors can easily be overlaid.

Highly raised textures (e.g. stems) will capture paint even from flat of knife blade.

Scoop paint into deep mound and . . .

. . . by dipping in knife tip, a finger of paint is produced.

This finger will drip or lay fine detail with all the capability of the finest brush.

STEP 5

Introduce the lily leaves over the already established palm leaf. Do so carefully and take note of the negative shapes created in the background and how overlapping effects the background leaves. Leaves that do not help the overall composition and balance should be left out to avoid confusing the eye. All flowers and their buds are to be stroked with lighter color, using generous amounts of paint. These areas are focal points, so make the most of the impasto and let it work for you. Once applied, the color needs to be smoothed or blended into the structure with a clean knife.

STEP 6

Now work on the final touches which bring flower heads, buds, and stems to the foreground, in this complex weave of patterns. Lily leaves are edged with strokes of yellow-green—to suggest light—picking them out from background foliage. The leaves and the stems are already raised from the surface to such a degree that they easily take highlight colors from even the flat of the knife blade. However, for the finishing touch, use the blade tip to drip on some fine edges. Take the buds through to yellow-green, adding a hint of the pink previously used for the open flowers. Streak red-purple and yellow-white onto the open flowers. Chances must be taken with these flower heads, to suggest bold structure and fluid coloration. Do not concentrate on minute detail. Colors should therefore be allowed to run on the surface and be applied in bold strokes, with much trial and error until the correct feel is achieved. Final details of stamens and stem highlights are very selectively dripped on from the knife tip.

Project 2 Tutorial

Water-mixable oils

COLOR REFERENCES
Yellow-orange [Yo]
Yellow-green [Yg]
Red-orange [Ro]
Red-purple [Rp]
Blue-purple [Bp]
Blue-green [Bg]

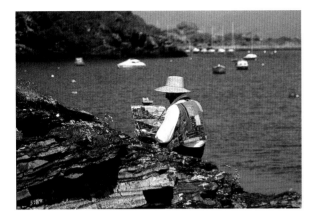

By midmorning on a hot May day we had made it to a secluded coastal village in North Wales. It was a quiet location, ideal for those wishing to paint in the open air without being disturbed by hordes of visitors and tourists. The tide was turning when we arrived, leaving seaweed-strewn rocks bared to the sun, boats and yachts keeled over, anchor chains exposed, and buoys beached. The sky was a pure, uninterrupted blue, as was the sea. We could not recall when last we had seen any British coastline as pure as this. Sun-blackened seaweed, soon drowned by the incoming sea, turned a magnificent gold-tinged yellow ocher, boats and yachts refloated, and we were treated to the antics of a water-skier. Who could ask for more on a mid-May outing? It was an ideal painting day and one which reluctantly came to an end at 7pm, accompanied by the sound of "popping" seaweed, exposed again by the ebbing tide.

OIL AND WATER CAN MIX

Water-mixable oil colors and media are relatively new and this tutorial was originally carried out to test their qualities. A step-by-step painting, outdoors on a sunny day, would determine if they fulfilled the requirements of a traveling oil painter; while working back at the studio would test out one of the principal reasons for their development—avoidance of possible harmful effects of evaporating solvent fumes; their suitability for those allergic to solvents; and, most important, how similar or different were they going to be, in comparison with traditional oil paints.

COMPOSITION

The shape of the canvas board predetermined the shape of the rectangle. Initially, I was convinced that an upright composition would best suit the subject (thumbnails 1 and 5). This, however, proved to place more emphasis on the foreground than expected. Horizontal formats 2, 3, and 4 were used to adjust the position of the horizon (amount of sky in the picture) and to determine exactly how much of the view could actually fit in (width). Having completed five thumbnails, I returned to number 2, now convinced this was the best.

COLOR MIXING
Where the prefix letter is shown in capitals this denotes a larger quantity of that particular color. Conversely, where the prefix letter is shown in a lower case, this denotes a smaller quantity of that particular color.
e.g.
Bp = large amount of blue-purple.
bp = small amount of blue-purple.

MATERIALS

Canvas Board
Palette (melamine-faced)
Brushes
small, medium, and large round hog hair
small, medium, and large round nylon (long handle)
Paints
water-mixable oils—6 primary colors plus
Phthalocyanine Blue
Titanium White
Water-mixable Linseed Oil
Water-mixable Painting Medium

POSITIONING

Perched on rocks at the sea's edge, with no shade cover, meant that keeping the surface of the painting out of direct sunlight was not possible on this occasion. To overcome the possible effects of working in intense sunlight, it is advisable to periodically carry your painting over to a shady place to check the colors in more subdued light.

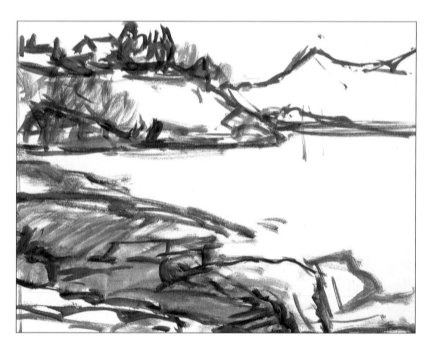

STEP 1

Having decided on the thumbnail that works best for you, transfer the masses from thumbnail to painting using a small hog brush and paint mixed purely with water. I was struck by the fluidity of this mixture and the speed at which it dried when compared to the turpsy mix I would normally have used. The foreground rocks do have some tricky shapes and are of great importance since they could lead the eye into the composition if correctly aligned. It is quite easy to wash them out with water and redraw until placed to your satisfaction.

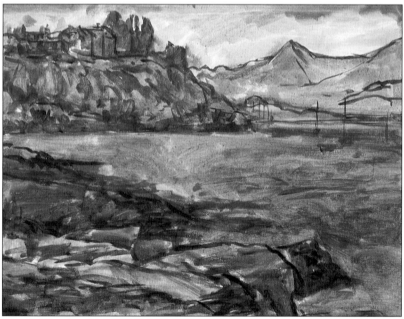

STEP 2

Apply thin washes of color using a large hog brush, to block in the masses. Colors mixed with their complementaries create colored grays against which the subsequently overpainted brighter colors can shine. Add the water a little at a time to ensure color mixes thoroughly; otherwise particles of color may disrupt the washes. I found the water was so efficient at thinning the paint it was difficult to mix dark colors. This was easily overcome by working stiffer paint into the still-wet washes. Once the whole surface has been covered with color, redraw the linework with a medium-sized, round, nylon brush.

STEP 3

Switch to using paint directly from the tube—impasto. Water is now used solely for cleaning equipment. This is when the paint comes into its own and is much more comparable to traditional oils. While its consistency is slightly more fluid, it can still be layered and mixed on the surface of the painting. Scuffing too, where stiff paint is dragged across previously laid color, is effective. This can be seen on the distant mountains (orange over purple) and on the headland (blue-green over blue-purple). Blending of wet colors (bottom edge of clouds) achieves the soft focus that is so useful in oil painting. Where overlaid colors are applied too heavily, they can be tonked to allow the underpainting colors to come through (distant shoreline trees).*

*See highlight panels in project 3.

STEP 4

Overpaint with medium to small hog brushes and work in the middle values of the headland, buildings and distant shoreline. The paint is very responsive to the pressure of application. This enables the stiff paint to be applied thinly, to allow underpainting to show through, or thickly to build textures toward the highlights. This can be seen most effectively on the headland foliage where the colors move toward thicker and warmer colors contrasting well with the thin layer of cool color beneath. For the strata of the foreground rocks, begin with small hog brushes. The way this flows, often diagonally across the rock masses, is an important element of the composition, both relieving the solidity of these masses and leading the eye into the center of the composition. Using hog bristle brushes for even the fine elements of buildings and boats ensures you do not get involved in too much detail, especially at this early stage. Leave the painting to dry.

STEP 5

In the studio, 36 hours later, to my delight the painting, while slightly tacky, was dry enough to work over, enabling me to use the water-mixable oil painting medium that is recommended to "oil out" the surface. This quite stiff medium is evenly worked across the surface with a large hog bristle brush. The reestablished surface shine restores the dark accents and thereby the freshness of color. This layer stays wet, while stiff, all day, allowing easier application of paint. Smaller brushes are used for directional (horizontal) strokes on the sea. The rocks in the immediate foreground were causing me some confusion. To correct this I laid over them a tint of blue-purple [Bp+Rp+White] thinned with water-mixable linseed oil. This held the area together once again. I was then able to continue to build the middle values of the strata, where it was catching sunlight. Because of the fluid tint beneath, these patterns of light could be blended with a medium bristle to keep the focus soft. A lighter layer was overpainted relying on the wet paint already on the surface to pull the color from the brush. Apply lighter value yellows on middle distance rocks using differing pressure to vary coverage for a more exciting surface. A tint of dull yellow-orange [Yo+bp+White+linseed oil] applied over the distant mountains dulls and softens them, so they recede further into the distance. Apply highlights to distant trees and shoreline. The boats are blocked in now, enhancing the perspective of the sea as they lead the eye into the distance and around the headland. Initially I painted several boats, but removed many of them as they were too small against the enlarged headland (which the thumbnail had demanded). Even here, at the end of step 5, you can see that some of the boats look like toys when compared to the buildings. These were scraped off with a palette knife and painted over before the final stage. As you would expect with oil paint, this water-mixable color also allows for reworking and corrections that are an essential element in the creation of any work.

STEP 6

The yacht was redrawn with line on a larger scale, ensuring it did not dominate while still providing a useful horizontal element on the right of the composition. Linseed oil was added to the color to ensure the fluidity of this line, and when correctly positioned, the yacht was painted with undiluted color. Having reassessed the negative shape of the headland against the sky, it was nibbled away with sky color to make its silhouette more descriptive. Adding middle values to highlights now give body here, bringing the headland forward into sunlight. Fine highlights in the foreground are applied with the medium-sized round nylon brush, which features the point required for detail.

COMMENT

Traveling painters who use these water-mixable oils will find it such a relief not to have to worry about transportation and spillage of solvents such as turpentine—especially when traveling abroad where the carriage of solvents on airlines is strictly forbidden.

TIP

When working outdoors, it is always advisable to take as many reference photographs as possible, just in case you have to pack up and complete the painting in the studio. If you have planned to finish your work in the studio, the first reference photographs of the subject should be taken once you have decided on the compositional thumbnail. More should be taken when you can be guided by the composition drawn out on your surface. You should also take photographs periodically of the light conditions as they change and affect the subject—for changes can be incorporated in subsequent layers

Trick of the Trade

Using oil palettes

No one wants to throw away valuable paint at the end of a session. Oil paint dries very hard on the palette surface, however, and you can soon end up with a lunar landscape of paint textures that seem welded in place [A]. This creates problems for future mixes which become involved with this distressed surface to the extent that small mixes can be entirely lost.

Scraping off dried paint can cause damage to the palette's surface [B] even to the point of removing the varnish that coats it. This results in the oil from subsequently squeezed-out paint being absorbed into the surface of what has now become an absorbent palette. While still usable, the paint will consequently be duller and weaker as the glue (oil) that holds it together and on the canvas, has been reduced in volume.

The remedy is simple. Keep the fresh tube color along the outer edge of the palette and mix in the center [C].

At the end of a session use your palette knife to remove the paint mixes from the central area [D].

Using a lint free rag, remove the small amount of paint remaining and polish up the mixing area of your palette with the same cloth [E]. The oil in the paint penetrates the wooden surface and soon you will have a smooth, glossy surface on which to mix your colors. To aid the penetration of oil into the wooden surface when doing this, avoid using turpentine or any thinner to dissolve surface paint—stick to elbow grease alone.

DIFFICULTIES MIXING GLAZES AND TINTS

Some of the glazing medium, especially the resin-based variety (Alkyds), dry very rapidly. Often, if you do not remove the paint quickly enough before it dries, you will be tempted to use thinners to remove the color. To avoid damage to your main palette it is, therefore, useful to have a separate palette for glazing [F]. This can be smaller than your main palette, as you will not wish to leave many mixes on this surface. It is also useful if this palette is made from a material that is tough and easily cleaned.

The same palette can also be used to store a mix of color scraped from the center of your larger palette. Collected and deposited with your palette knife as a heap of color it will dry more slowly than if it were left spread out [G].

TRANSPORT AND STORAGE OF YOUR PALETTE

This can often be a problem should you wish to preserve surface color. Try this solution. Draw out the shape of your palette on a piece of hardboard cut to size. Glue wooden blocks to its corners [H]. Use bulldog clips to hold the palette in place. Cover with a second piece of hardboard and hold together with elastic or strong rubber bands. Not only will this stop unwanted transferral of paint, your paint will stay wet longer in the enclosed atmosphere.

Common Problems

Mixing on an oil palette

QUERY

"Do I really need an oil painting palette, or are they just for show?"

ANSWER

The palette is an essential piece of equipment for any artist. It must be made of a nonabsorbent material or rendered so by coating with nonabsorbent material. If the paint is mixed on a surface that can absorb the oils (as in oil painting) the paint will then dry and becomes stiff prematurely. You are in effect removing the glue/medium which fixes the pigment/color to the surface. You also need a reasonably large surface on which to mix your paint. If it is too small you will spend all your time cleaning paint off, to make way for the next mix. By doing this you are also wasting paint (and money), cleaning off paint that may come in handy in a future mix. A good palette has been carefully designed with the right shape and balance to allow you to hold it for hours without straining your wrist or hand.

NOTE: Do make sure you are holding your palette the correct way. From the illustration you can see that it is easy to make a mistake. However, the correct hold supports the palette on the arm making your painting life more comfortable, no matter how long you hold your palette. It also allows the brushes to be slipped in between thumb and palette so that when you are standing, particularly out of doors they are easily to hand.

PROBLEM

"I never seem to mix enough color and constantly have to remix half way through a section of painting."

ANSWER

Undermixing is often caused by not putting enough paint onto the palette in the first instance. The bristle brush itself holds quite a lot of paint, so by the time this is filled and the first few strokes are laid, the paint on the palette has run out. Usually this is because the painter does not want to waste paint through either drying out or simply not using it during any particular painting session.

SOLUTION

[A] Stick to a limited palette of colors. You will feel better about putting out a decent amount and there will be room to do so on the palette.

[B] Don't worry about paint drying. Heaped oil paint first develops a "skin." The paint beneath stays useable for some time as it is protected from the air. Simply cut into and peel back this skin with the palette knife. Avoid getting the skin into your mixes, as it can be irritating.

PROBLEM

"When mixing colors, I always end up with too much paint, especially when trying to lighten the color."

ANSWER

Some pigments have a strong "tinting strength" in that they are very powerful and need lots of a second color in the mix to change them. This is especially noticeable when adding white.

SOLUTION

When adding the second color, do so at the edge of the first. Then you will only need to mix in as much of the first color as you require. Continue in this fashion for future changes to the mix, always adding from the side. This process has the added advantage that you keep a portion of your first mix—a useful supply should you find you have overpainted it too heavily on your painting and need to add more to rectify the error.

QUERY

"At the end of my painting sessions I have lots of mixed paint on my palette. Do I have to scrape it all off and waste it?"

ANSWER

If you feel you can use the same color again soon, then obviously scrape it up into a deep mound and store it away from the air, and on a non-absorbent surface. Colors you can't use however, need not be wasted. Transfer to another spare canvas or canvas board and spread with brush or palette knife. The thick layer of paint can be left to dry—often for 6 months or so. At the end of this time, sand gently to remove sharp edges and begin your painting on top. Irregular, nonstructured textures like this provide a superb surface, which makes for exciting brushwork. Have a look at some of L. S. Lowry's "matchstick men," in particular how these are painted over textured paint.

TIP: If you are not keen on textures, then at the very least brush a thin wash of the **leftover paint onto a clean board or canvas to give yourself a base color for a future painting,** rather than a bone-white surface.

Project 3

Water

Painting water is always such a challenge, while also being such a joy. The challenge is the principal element of reflection, and the joy is the light on its surface, which is almost as bright and as colorful as the sky that it reflects. Because of its ephemeral nature, a successful rendering of water is highly engaging to the viewer.

Where does one start? How can the shimmering of light on a fragile surface be translated through thick stiff oil paint?

Whenever we see water, the balance of elements is different on each occasion. Even while it is being viewed, the balance alters as the light changes, or the surface is disrupted. However, although the reflective surface may seem complex, it always obeys a set of very simple rules. It is only through understanding these rules that painters know what to look for. Conversely, it is only through the experience of painting water that painters can fully understand its complexities.

Oil paint is the perfect medium with which to master the painting of water and its reflections. Through the gradual building of layers toward light, the content of the reflection, its positioning, and nature can be accurately observed and translated.

The dark underpainting, or those areas not painted with highlights, naturally translates as those areas of the water which, receiving no light, are transparent. Through these areas can be seen glimpses of the depths, whose dark values provide all the contrast that is required to make the nearby highlights shine.

The workshop concentrates on a contained area of small pools between rocks, while the tutorial demonstrates how to deal with a large expanse of water, stretching across a lake.

Nothing compares to painting water in situ, for greater understanding of the various characteristics inherent in the subject; nor is there anything better for learning how best to handle and exploit techniques and materials in a speedier and more spontaneous manner.

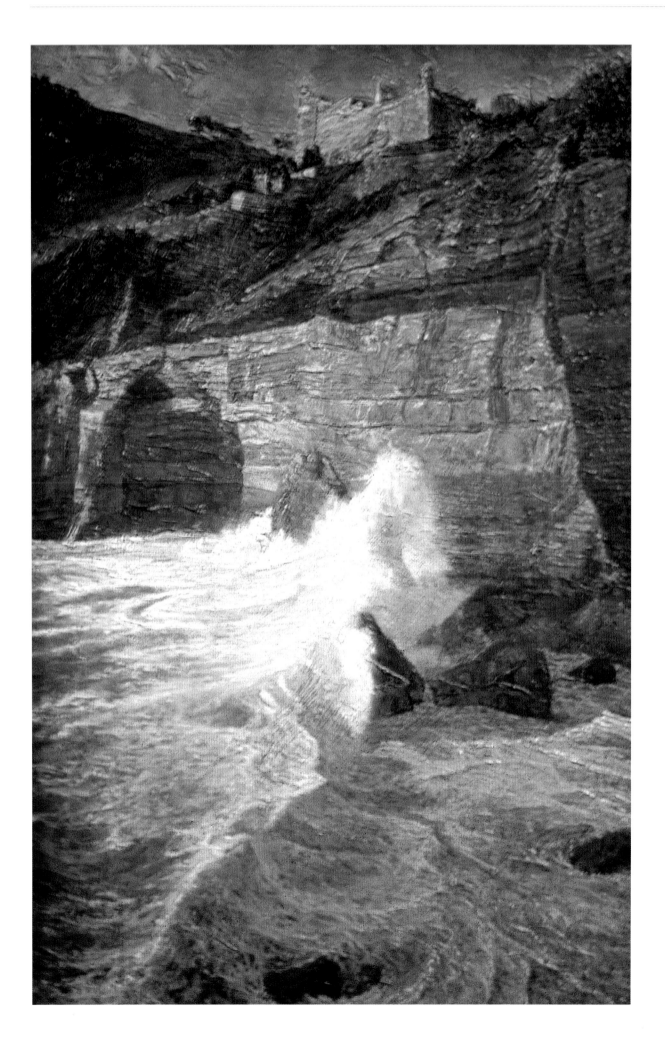

Project 3 Workshop
Rocks and water

STEP 1 Natural willow charcoal comes in various thicknesses. For fine linework with thick stick, snap and use edge.

Can be smeared or lifted with finger or totally removed with kneadable putty rubber.

Dust with tissue or cloth to remove excess charcoal before painting . . .

. . . or fix with aerosol or diffuser spray—prevents pencil smearing and/or soiling of colors.

STEP 2 On palette, mix color into edge of thinner, so pigment strength can be constantly varied.

Premixing brown and green on palette speeds up application of underpainting.

Working upright shows there is too much thinner in mix if color runs . . .

. . . and involves little movement when looking between subject and painting—stops distortion and neck ache.

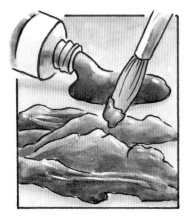

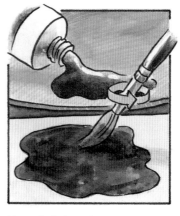

STEP 3 Using tube consistency paints creates textures naturally—impasto.

TIP: Light reflections from impasto paint create highlights especially on peaks.

For soft darks, rub paint into surface avoiding peaks.

Such a thin stiff layer is easily painted with well-laden brush.

This is an unusual upright painting which emphasises the depth of the riverbed and the geometric structure of a bridge, against which is offset the natural form of the rocks. Note how the shapes of the backlight and the water reflected in the foreground echo each other.

STEP I

The surface used here is an off-cut of hardboard. I prefer to use the smooth side, which must first be sanded to provide a "tooth" to which the paint can adhere. The surface is sized with acrylic medium to reduce absorbency and then primed with white acrylic paint. The final layer was left unsanded, as I love to work on a textured surface. Complete the drawing with willow charcoal, which swiftly covers the white ground. It also, when wiped in, exposes the texture of the surface. As the subject is complex, I elected to include only those rocks that had an interesting silhouette or negative shape between them. You should never feel impelled to make an exact copy of nature, as nature itself changes constantly.

MATERIALS

Brushes

small, medium, and large
round bristle
round nylon
nylon Rigger

Paints

6 primary colors
Titanium White
Zinc White
Phthalocyanine Blue
Acrylic White Paint
Acrylic Medium
Willow Charcoal
Linseed Oil
Retouching Varnish

STEP 2

Once you have fixed the drawing, overpaint it with thin washes of oil paint diluted in artists' distilled turpentine. Aim for a slightly warm underpainting in order to create a contrast for the cool blues and greens that are to follow. Having a green and brown premixed on the palette allows swift movement between warm and cool mixes. Mixing the two also provides a suitably harmonious colored gray.

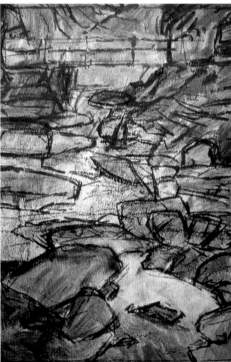

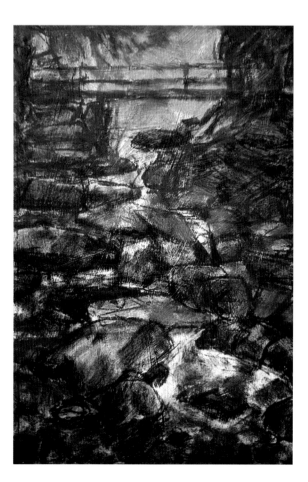

STEP 3

Here the color is used without thinners or mediums. Work the stiff paint into the surface with a bristle brush. Rubbing-in softens the focus considerably, but don't lose all of the underpainting. With softened focus the image starts to become atmospheric. Color mixes need to be as dark as possible exploiting colored grays. It is fascinating how dark you can go without losing the subject. Even the lighter areas are darkened as much as possible using complementary mixes—e.g. distant trees [Yo + Bg] + [Ro]. The darker you can go, the more contrast you will have achieved for the lighter impasto paint that is to follow.

Project 3 Workshop

Rocks and water

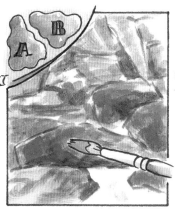

STEP 4 Dark accents are rubbed into the surface with a bristle brush.

As the brush runs out of color, it is used to blend (or rub) progressively thinner paint elsewhere—a "dry glaze."

COMPLEMENTAERY LAYERING Dark-green accents (A cool) [Bg+yg] + [rp+w] followed by orange-red (B warm) [Ro+Yo] + [bp+w] of a lighter value.

These in turn are over painted with a blue-gray (C cool) [Yo+Ro] + [bp+w] and again with pink (D warm) [Bp+ro] + [yo+w].

STEP 5 Lay tint behind rock to project it forward against its background [Phthalo Blue+Zinc **White+medium**].

Top edge of tint can be blended into background so it becomes indistinguishable.

If tint needs more color, add directly without medium and work in.

Warm glaze [Ro+Yo] + [Bp] + (medium) in foreground exposes textures. [NB glaze shown too **strong—for effect.**]

STEP 6 Directional brush strokes are important in suggesting structure and form.

Scuffs (scumbles) of fluid color (with medium) applied to top edge of rocks with side of brush head . . .

. . . are softened around form with bristle brush.

Brush strokes of stiff paint across water are broken by the underpainting (heavy scumbling) and left unblended.

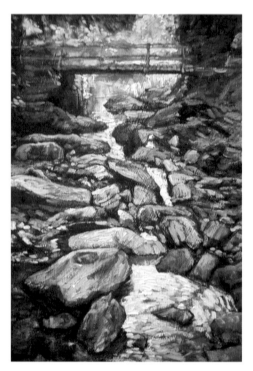

STEP 4—STRUCTURED PAINT (LEFT)

In this stage the layers of paint move from the dark underpainting, through the medium values, to the highlights. As the paint becomes lighter, it is built up more thickly. If the darks are not already dark enough these are increased. This is apparent in the foliage (top right) and in the accents all around the stones [Bp + rp + yo]. Now stiff paint is applied in layers and left brushy to cultivate texture. Being soft and deep, the paint will blend enough naturally without help from a blending brush. Concentrate on value differences. Colors that may at this point appear too similar (grays on rocks) can be subtly separated with different colors of glaze later. Don't attempt to copy each stone exactly, but follow the rhythms and patterns of color and light to suggest them. Several focal stones are concentrated on to lead the eye into the picture. The painting must be allowed to dry before proceeding further.

STEP 5—TINTS AND GLAZES (RIGHT)

Tints are color with white added plus glazing medium. They produce transparent or semi-transparent washes depending on the amount of white added and/or the opacity of the particular pigment used. Thus the tint layer is not thickened in depth to cover more, but the amount or type of pigment added to the mix is adjusted. The top two-thirds of this painting is given tints to increase apparent depth and suggest the damp atmosphere. Glazes have the same fluid mix as the tint, but do not contain any white and are thus totally transparent. The medium used in this painting is oily thinner (linseed oil plus thinner). This is very fluid, running into all the textures and is slow drying. Warm [brown+orange] glazes are used in the foreground and cool [blue] glazes for distance. The painting is allowed to dry before proceeding further.

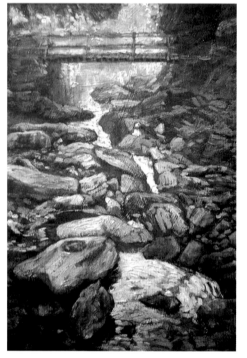

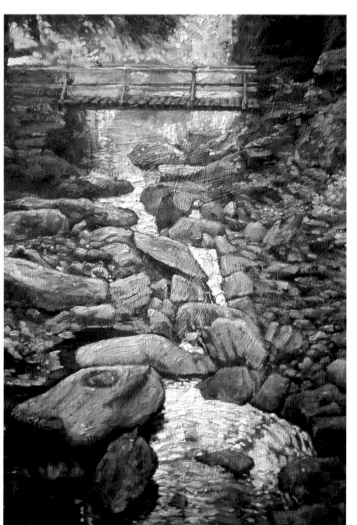

STEP 6—RETOUCHING AND FINISHING (LEFT)

Apply retouching varnish to the surface (oiling out), if it has become dull through drying. For this stage the brushes used are soft nylon rounds. These provide the control for any necessary detail. The paint is mixed with either oily thinner or Liquin, depending on the fluidity of the brush strokes required. Dragging here, edge on, across the textured surface creates scuffing. Where these are over heavy they are dabbed off (tonked) with clean white tissue paper. When all the textures, either transparent or opaque have been created, thick paint is built up for the final highlights—see top edges of the rocks and the pool in the foreground.

Project 3 Tutorial

Water

COLOR REFERENCES
Yellow-orange [Yo]
Yellow-green [Yg]
Red-orange [Ro]
Red-purple [Rp]
Blue-purple [Bp]
Blue-green [Bg]

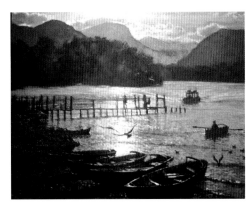

It is only by going to Derwentwater in the Northern Lakes in England and seeing this sight for yourself that you can truly understand the lustrous quality of such a late afternoon in autumn. A day that started out bathed in the shimmer of an early morning mist through which sparkled the sun, came to an end with these golden hues. Dramatic light across Derwentwater is the basis for an introduction to this oil-sketching technique. I have found this approach to be a new and exciting one for those who already paint in oils and for those who paint in other media, but wish to try their hand at oil painting. For the latter the beginning of the study is akin to the laying of washes in watercolors. I term this a sketching technique to ensure that my approach is kept free and loose. However, it is an admirable technique for a more finished approach when required.

COMPOSITION

The composition hinges on the distant hills and foreground being quite large to give the water the largest possible contrasting area against which to shimmer. In any painting featuring light, you must have dark to give the lighter areas prominence.

MATERIALS
Canvas Board
Brushes
small and medium round
bristle
round nylon
flat nylon
nylon Rigger
Paints
6 primary colors
Titanium White
Zinc White
Acrylic Paint
Linseed oil
Artists' Distilled
Turpentine
Alkyd Resin Gel
Medium

TIP

Oily thinner can be bought ready-made or you can make your own from equal parts artists' distilled turpentine and linseed oil. This is a very traditional painting medium which requires a long drying period.

STEP I

Many artists prefer to begin their oils on a colored ground. Because much of the finished composition is to be dark and soft, I covered the board in a layer of dark purple (warm) acrylic paint. Acrylic is chosen as it dries faster and provides a very stable layer on which to build the oil paint. Having colored the surface, Draw in outline shapes of the composition with a thinned down mix of Bp and Ro oil paint. The line drawn around the edge shows what will be lost under the frame and has particular significance in this composition. Look how close the hills come to the top of the board and the importance of the shape of the sky between them and the top of the rectangle. This would be half covered by the frame if you did not compensate at this very early stage. Corrections can be made constantly, large ones blocked out with blue-white.

STEP 2

The purpose of this layer is to get some color onto the surface so that the majority of the underpainting is reduced in power. Once you have covered as much as you can at this stage, you can really judge the masses and balance of the picture. To do this, apply thinned down washes of colored gray (using oily thinner), looking at each area and establishing its principal color on which to base each colored gray. Don't be frightened of using color here, for a surface featuring all the same gray will look boring. Directional brush strokes (e.g. trees) make color masses more than just silhouettes. Only now can you effectively redraw and make any large changes necessary to the composition with relative confidence.

STEP 3

The redrawing element makes this stage reminiscent of line and wash in watercolor painting. A round nylon brush can be used with the fluid color. Medium toned highlights are worked into the shadows of the boats with the same brush and quantity of medium as the dark line. Very fluid washes of light color (again oily thinner) are worked over the hills and tonked off. Sometimes the color comes off to the ground [purple]—it all depends on the fluidity of the paint and the pressure of the tonk. You must go with the flow. Enjoy the experience and open your mind to the possibilities. The tonk to the foreground boats is interesting as the applied color has more medium added into the distance. This thereby comes off more easily and brings off underpainting with it, giving variation to the texture, suggesting aerial perspective in this difficult triangular shape. Leave the painting to dry overnight.

TONKING

As you read through this step-by-step you will come across the terms— tonk, tonked, tonking, tonked off. To tonk, is to apply a fluid layer of oil paint to the surface (paint on the palette mixed to a fluid consistency by the addition of a glazing medium), over which a piece of semiabsorbent paper is gently pressed down and lifted off, taking some of the paint with it. The degree to which the paint is lifted off is determined by the consistency of the paint applied. In this way an opaque (non see-through) layer can be rendered semitransparent and a transparent area can be made irregular or seemingly textured in a unique fashion. The very lack of control is made up for by the delight in the unplanned results.

COLOR MIXING

Where the prefix letter is shown in capitals this denotes a larger quantity of that particular color.
Conversely, where the prefix letter is shown in a lower case, this denotes a smaller quantity of that particular color.
e.g.
Bp = large amount of blue-purple.
bp = small amount of blue-purple.

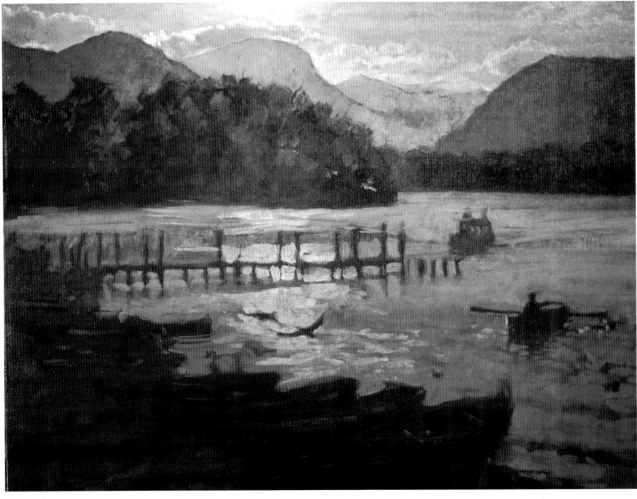

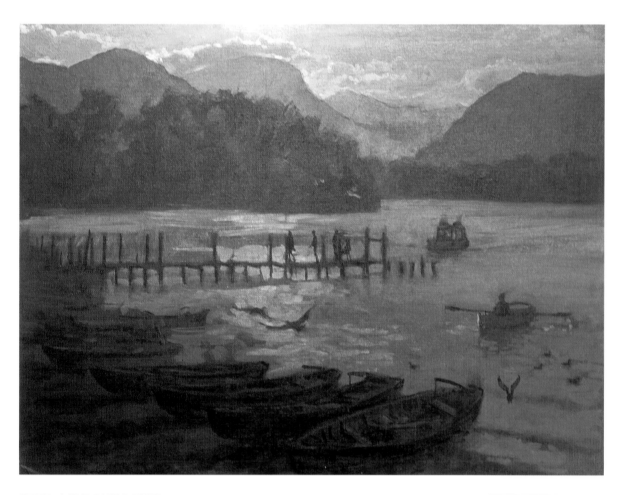

STEP 4 (ABOVE LEFT)

Change your painting medium to the fast-drying alkyd resin gel. This is stiffer and much faster drying than the linseed oil. The paint layer is also much more flexible, less likely to crack, and can be laid on more heavily. At this stage the mountains are overlaid with lighter, and often contrasting, tonked layers. Note how these nibble away at the tree line, giving it more character. Now turn to the sky, using Zinc White (the most transparent of oil whites) in the yellow mix (to make a tint) and work outward from the sun, adding more medium to the tint as you paint, to achieve the glow of the sky. Highlights to clouds are thinned with medium to improve the flow of application and blended with a bristle brush to achieve softness.

STEP 5 (LEFT)

Lay a tonk of complementary yellow-green [Bp + Yo] + [Ro] over the purple-red trees. Orange-green lights applied to the top of the trees should be tonked to add character to the texture. Distant trees are made cooler [Bg + Yg] + [Rp], duller, and slightly lighter to indicate distance. Very thin tints [Bp + Ro + W] are to be laid with a flat nylon brush over the distant hills and the lower slopes of those closer. This makes them recede and creates more color contrast against the sky. A graduated tint [Bp + Ro + progressively more Titanium White] is laid over the water and into the distance to suggest depth. This will provide a contrasting complementary underpainting for the pink highlights to follow. A thinned down brown [Ro + Yo] + [BP] is worked into the foreground with a bristle brush. Then as it progressively recedes, more blue and white are added. The two boats are included in this recession.

STEP 6 (ABOVE)

Redraw with the nylon Rigger brush and a dark color [Bp + Bg + Ro]. Just enough drying gel medium should be added to make the color fluid, yet not transparent. This is to be made more blue for shadow and blue plus a smidgen of white for accents. The jetty and the figures on it are painted as silhouettes using the same mix.

TONKING EXERCISE

Get a scrap piece of canvas board, preferably one that is clean of paint. Take whatever color you have on your palette and mix into it some glazing medium. Apply a wash of this onto your board. Get a piece of newspaper or white tissue paper and lay it gently onto the paint. Now press lightly with your finger and lift the paper away. You will see on the paper the paint that has lifted off and what has happened to your wash on the board. Keep repeating this exercise, varying the amount of glazing medium you add and the pressure you apply. Move from the clean board to a pre-painted board, on which you have applied a layer of textured paint, showing brush marks—this must be dry. Now follow the same process and you can see the effect of this technique on textured paint and the different colors underneath (the wash remaining the same).

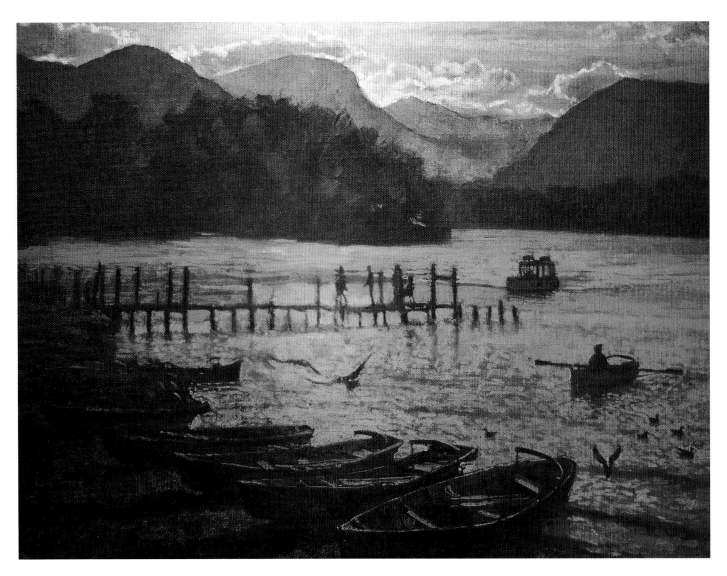

STEP 7

Yellow-orange tonked highlights are laid across the water in sections, to avoid paint drying out before it is tonked. Mix this progressively warmer towards the center of the reflected sunlight. An oily thinner version of the yellow-orange is laid over the central highlight area—figures, birds, water, and boats— and tonked off. The texture established by this tonking imparts a shimmering movement to the water's surface. On the bank apply a very fluid tonk of similar color, and by scratching the back of the tonking paper, while it is still over the paint, using the end of your brush handle, you will create a linear texture. This suggests the uneven texture of a stony waterline. The shadows of the boats, while not being entirely correct in perspective, exaggerate the diagonals of the boat shapes to draw the eye into the picture. Some highlights inside the boats are picked out with the Rigger and some warm washes of thinned-down mixes also added. All are tonked to allow for final highlights in the last stage.

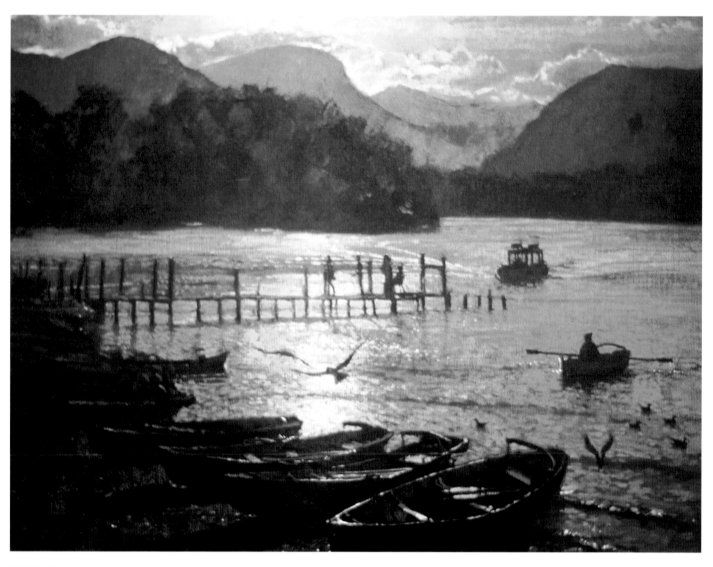

STEP 8

For this final stage, color is used straight from the tube. Apply highlights to the jetty and sparkles to the foreground, along with the birds and the boats and on the water. The water around the jetty (its negative space) is carefully painted with yellow-oranges to give a dramatic silhouette. These have more yellow-green and white progressively added toward the central corridor of light. Finally, super highlights were placed on the water and boats. These should be created with impasto paint (built up texture) to yield the most protruding points of paint, which therefore catch ambient light so they really seem to glow.

Tricks of the Trade

Go bristle

Bristle brushes on first inspection seem stiff and unwieldy, when compared to the soft bounce and point of a watercolor brush. However, with experimentation you will learn to use them and discover that they offer just as much versatility. Here, we look at some of the different ways in which they can be exploited. Try them for yourself and discover on your own.

LINE
Drawn with a fine bristle, a line can be extended by first pulling the brush along the direction of the line and then by rotating the brush as you go [A and B]. It takes a little practice, but creates a continuous brush stroke you wouldn't expect.

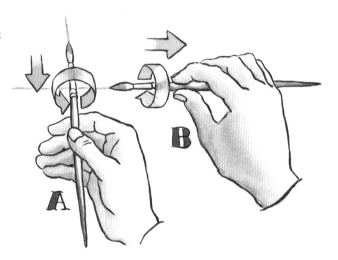

SHARPLY DEFINED EDGE
When painting an object that requires a sharply defined edge, pulling the brush down this edge may not be as distinct as required [C]. Try rotating the brush toward this edge as you complete the stroke. You will discover that a tiny wall of paint is built up, giving you all the definition required [D].

X = cross section of brush stroke, showing wall of paint at edge of stroke.

LIGHT TOUCH

If you require a really light touch when either scumbling or working into wet paint, here are a few brush strokes to try [E, F, G, and H]. Each is gentle as the brush is held only with the thumb. Hold the brush almost level with the surface and pull in the direction of the stroke.

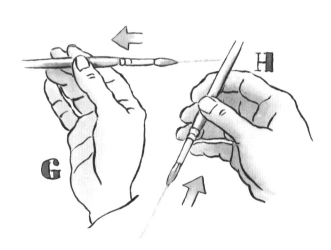

FLUID STROKES

Pull the brush in the same direction as underlying brush strokes, so the bristles will easily travel along the valleys of these textures filling them with paint [J].

TIP

For the most effective scumbling (scuffing), consider carefully the dry texture over which you are painting.

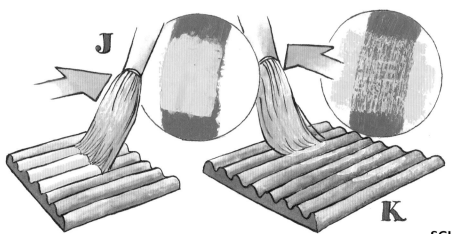

SCUMBLED STROKES

If, on the other hand, you work across the dry strokes, the paint tends only to be deposited on the peaks, leaving the valleys dry [K]. This gives extra contrast, makes the brush strokes more visible and the scumbled thus more effective

Common problems

Bristle brushes

QUERY

"I buy the best bristle brushes and clean them after every session, but they now have a hard center, which is making them less flexible—what is wrong?"

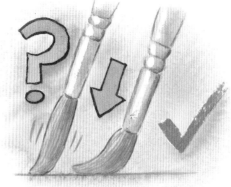

ANSWER

Despite the fact that you are cleaning them regularly, you are not being as thorough as is necessary. Unless you remove every bit of paint it is going to dry and eventually your brush will become a stick. This is usually more noticeable if you have not used your brush for some time, giving it the opportunity to thoroughly dry out. The resultant stiff brush is a useless tool as without flexibility the brush cannot deposit colors [1], but instead will scoop paint from the surface [2]. You can try to soften them in turpentine or, if really hard, in a paint solvent. However, I must warn you that a brush in which paint has dried is usually irrevocably damaged. Your best bet is to take extra care with cleaning in the first place.

CLEANING ROUTINE

Once you have finished painting remove color on a lint-free cloth and flush in turpentine. Go to the sink to thoroughly clean your brushes. Use soap and your fingernails (see diagram) to get the color out of the very base of the bristles. Your brush isn't clean until the soapsuds carry no more color out. Then rinse well in cold water and stand upright in your jar to dry. Be eternally vigilant, for if even a small amount of paint adheres to your brush, more and more paint will stick to it in time. As the brush becomes stiffer the damage becomes increasingly difficult to halt and impossible to reverse.

QUERY

"My bristle brushes don't last very long, can I prolong their life?"

ANSWER

Bristle brushes do wear down during painting. This is especially true, when painting dry areas of paint. This dry paint acts like sandpaper. The more pressure you apply the more damage you will do.

> **TIP**
>
> Brushes with a worn point often produce shapes that are quite unique [C and D] and you may find that for certain jobs they do better than a new brush. However, when a brush wears down to a point where it is no longer flexible [E] then the only use left for it is as a back scratcher!!

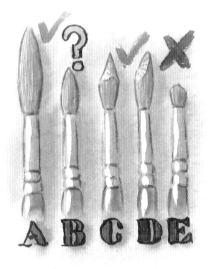

SOLUTION

Keep your brush strokes as gentle as possible. Use the side of the brush head wherever possible, rather than the point. As bristle does inevitably wear, it makes sense to buy brushes with as long a head as possible [A]. You will find short brush heads [B] in your art store, but as your long heads wear down to these, why buy them in the first place.

PROBLEM

"I can't build up impasto (thick textured) paint with my bristle brush—it just sticks to the brush."

ANSWER

This is usually caused by not having enough paint on your brush. Always remember that the paint will move from the surface that has the most paint to that which has less. It stands to reason then that your brush must always carry more paint than the surface. If you are not getting enough on your brush it probably means you are not putting out enough color on your palette. Be generous with your paint and begin to enjoy the luxury of juicy impasto oil painting.

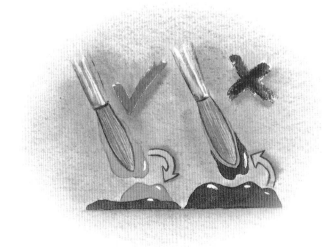

Project 4

Detail and figures

Trees hold a certain fascination as subject matter for painters, as do human figures; yet many painters are wary of tackling the latter. This is predominantly down to lack of confidence and the misguided notion that the human form is very difficult to paint.

Admittedly, should an element of a tree be slightly incorrect in the painting, if it were the wrong shape, it would be less noticeable. Were the same to happen to a human figure, there could be little chance of passing it off. Being intimately familiar with the human form, the viewer would notice there was something inherently wrong with the painting, though not necessarily precisely what.

As with any subject, however, it is all a matter of familiarization with the techniques that are best employed, and honing those techniques through patient practice.

Going back to basics is the key, looking at the figure as if it is something that is being observed for the first time, just as one would when analyzing any subject. For at any particular moment in time, the form of the subject is unique to the position of the painter and angle at which it is being observed.

Simplifying the subject is paramount, the trick being to break it down into masses, enabling the painter to look below the surface detail and construct the underlying form from blocks. These masses could be translated into boxes, squares, ovoids, rectangles, triangles—anything; as long as they enable the painter to segment the form, and create its volume, from which the rest of the figure can be carved.

Thus the drawing and the shape come from accurate observation and careful distillation in the form of drawing or making shapes on the surface that accurately represent or suggest the object.

This project deals with both trees and figures, but demonstrates that the painting process for each is absolutely identical. Traditional painting techniques are followed in both cases, from the initial drawing, through underpainting, to impasto, and finally glazing.

The colors might be different, as are the masses, but the painting process is one and the same. Once a painter has mastered the art of painting one, the other will fall into place.

Project 4 Workshop

Painting a tree

COLOR REFERENCES
Yellow-orange [Yo]
Yellow-green [Yg]
Red-orange [Ro]
Red-purple [Rp]
Blue-purple [Bp]
Blue-green [Bg]

Sketch-in masses with a turpsy colored gray [Rp+Bp]. Use largest brush possible to avoid overdetailing.

Keep shapes bold and simple with interesting silhouettes.

Solid masses have uninteresting silhouettes. The negative space (black area) is not fully utilized.

Lots of bays and inlets allow background (negative space) to work as an interesting shape.

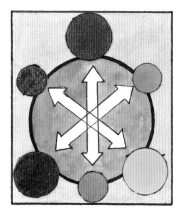

Complementary colors and color mixes play an important role in green foliage.

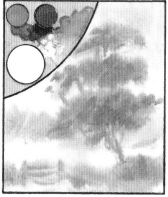

Mix together with white to create green grays. Excellent for depicting mist.

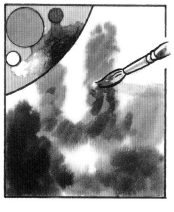

With less white and red, dull dark mixes are created, excellent for underpainting.

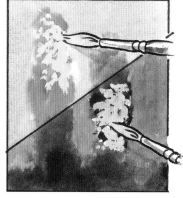

Duller and darker underpainting creates more contrast for subsequent layers.

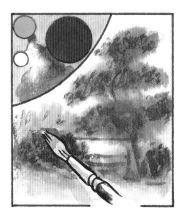

Mixes with more red may look strange when first applied . . .

. . . but will create extra contrast when subsequent green layers are applied.

Paint can be thinned down with artists' distilled turpentine for underpainting . . .

. . . to create easily and swiftly applied layer which evaporates to leave thin layer of oil-based pigment.

COLOR MIXING

Where the prefix letter is shown in capitals, this denotes a larger quantity of that particular color. Conversely, where the prefix letter is shown in a lower case, this denotes a smaller quantity of that particular color.

e.g.

Bp = large amount of blue-purple.

bp = small amount of blue-purple.

MATERIALS

Brushes	Acrylic Medium
small and medium round bristle	Acrylic Texture Modeling
round nylon	Paste
Paints	**Alkyd Medium**
6 primary colors	Linseed Oil
Titanium White	Artists' Distilled Turpentine
Zinc White	Clean Tissue Paper or
Acrylic Paint White	**Newsprint**

STEP 1

Rather than using an oil board, oilpaper, or canvas, try something different and prepare your own surface. Use up off-cuts of mounting card for instance. Absorbent surfaces must be sealed first—acrylic medium is ideal for this. Then add texture with a bristle brush and acrylic texture paste, finished with a layer of white acrylic. This is an excellent method for priming card for smaller oil studies, especially if you already work in acrylics, either on their own or as underpainting for oil. Once the surface is fully prepared and dry, sketch in the main masses with a turpsy mix of Ultramarine [Bp] and Cadmium red [Ro].

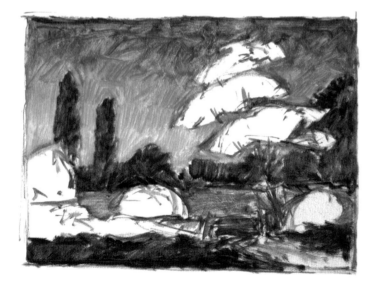

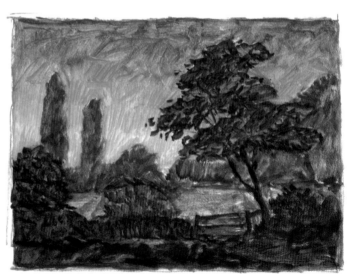

STEP 2

The first layer should be painted with a dull dark equivalent of the final colors, through the addition of relevant complementary color. So, for example, add a little orange [Ro + Yo] to the blue sky [Bp & TW]. Grade colors to ensure contrast.

NOTE: *Both the sky and the ground should become lighter toward the horizon, allowing the distant trees to be darker than both. Initially, upright objects such as trees block the skylight and therefore appear darker than the sky.*

STEP 3

The trees and shrubs in the foreground are now painted in warm colors. These are complementary to the final colors and are used here to create contrast. Inevitably, if you use a limited palette of greens they begin to look boringly similar across the painting. Unusual underpainting such as this can relieve the problem. Watch these spaces carefully, as greens are overlaid in later stages of this study. This completes the filling in of the masses. Any spots of remaining surface are eliminated using a turpsy brush holding thin color. As a final accent and to establish a little more control, draw into the foreground foliage and wall with turpsy dark colors.

Project 4 Workshop

Painting a tree

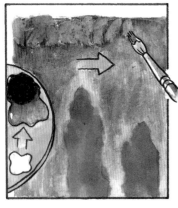

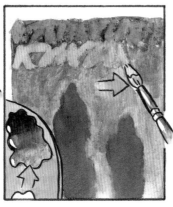

GRADUATED APPLICATION OF COLOR Paint a "line" of sky using multidirectional strokes (gaps expose underpainting).

Paint second line slightly overlapping first, adding a little more Titanium White.

Apply third line, but leave gap for the tree; again, add more Titanium white.

Continue process down to horizon, adding a touch of yellow with the white to final few lines.

LAYERED APPLICATION OF COLOR First indication of sunlight appears on leaf masses.

With clean, dry brush blend along inside edge, to create volume, softness, and suggestion of movement.

Yellow added to most colors will create atmosphere of sunlight (see cross section bottom right).

Intensify color by increasing thickness of paint layers or by progressively lightening layers, while . . .

. . . directional brush strokes in upper layers create rhythms and movement in grass.

Using gentle pressure, pull brush parallel to surface, which being wet pulls paint from brush head.

SGRAFITTO With brush handle scratch down to dark underpainting to restore accents and/or increase texture.

Dipping and pulling into and out of a mound of paint produces fine points—excellent for highlights and linework.

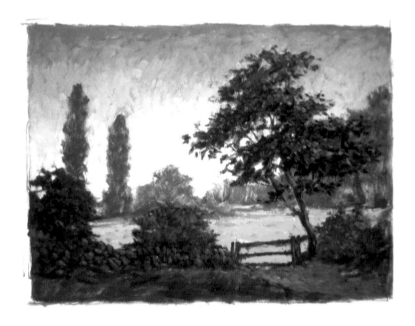

STEP 4

In this stage you need to apply color in two distinct ways. Both the sky and the field require graduated color and value. Other areas need the first one or two layers of what will be layered paint. These layers are to move from the dark underpainting colors you see now, up through middle tones to the highlights. In both methods of application, keep an eye on the amount of underpainting allowed to show through, right up until the final layer. The blue-green highlights on the trees are reflected highlights from the blue sky. You can see (especially in the foreground) that these hit the leaf masses on the opposite side to the actual sunlight. Reflected highlights are of great importance in creating form in shadow.

> ## NOTE
> The painting up to and including step 6 could be produced "all in one go" without allowing layers to dry. You may be quite content with the painting as it now stands. However, you will miss the subtlety available through using those often-neglected added techniques of glazing and tinting that come next.

STEP 5

Now the trees are to receive the first hint of sunlight with mid-yellow-greens falling on the left-hand side. This is blended into the underpainting, especially on distant trees where the resultant softness helps to suggest depth. The field, although already graded, has a second, lighter graded layer applied. Now it contains the sunlight ingredient, yellow, and has more white added into the distance. White not only lightens colors, but also mutes them (creates pastels). This muting reinforces the feeling of aerial perspective.

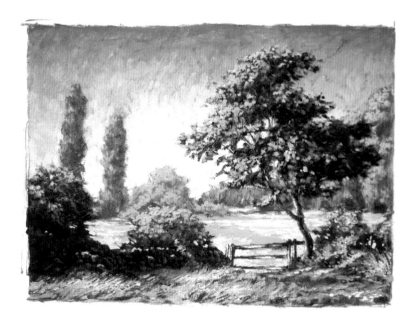

STEP 6

All the trees and bushes are to be given a lighter burst of yellow-green to enhance the sunlight effect. Make an effort to vary these with additions of red or blue, even though they will begin to look a little similar again. Glazes will be required to differentiate them once again at the next stage. For the moment concentrate on the change of value (dark to light). Note how the foreground trees have very distinct darks and lights, not so apparent for distant vegetation. This variation is essential for aerial perspective to work effectively. The foreground greens should also be blended less. Being more focused they will appear to stand forward. Sunlight is worked in the tree trunk, the gate, and the pathway by progressively adding yellow in layers until final highlights are nearly a pure white.

Project 4 Workshop

Painting a tree

STEP 7 TINTING Mix color with required amount of Zinc White. Add glazing medium from side; avoid excess quantities of mix.

Tints are often frightening to begin with, as they seem to obliterate your painting.

But as you work them across and into your surface, they become more transparent as they thin out.

Working a tint away from foreground edge can make a background object appear distant without loss of detail.

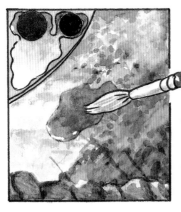

STEP 8 GLAZING A thin glaze of a complementary nature will quiet the intensity of the color it overlays.

To restore over-dulled highlights, lift off glaze with rubbing action of finger.

Check if painting is dry by pressing with thumbnail (top). If still wet underneath rubbing can smear paint (bottom).

Unwanted glaze (light purple here) can be easily removed by washing over with distilled turpentine and lifting-off with a cotton rag.

STEP 9 TONKING A tint or glaze mixed from alkyd medium can be applied quite heavily. Try round nylon brush.

This can be dabbed (tonked) off with tissue paper, newsprint, or end of finger.

While the glaze is still wet, highlights can be added using smaller nylon brush for detail.

These can be built up toward lighter values or blended (smeared) into the wet surface. (Brush not to scale.)

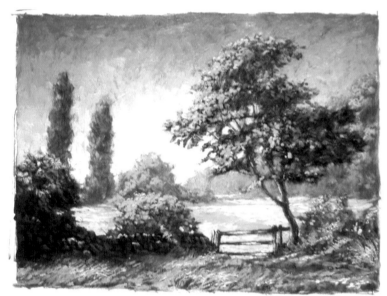

STEP 7 TINTING

As the majority of the physical texture has been created, from this stage use nylon brushes. Once the painting is dry enough to be overpainted without damage, I like to soften quite large areas with tints. Here these are mixed from a color, plus Zinc White, and painting (glazing) medium. In this instance the medium used was an alkyd gel medium. This creates a mix that is stiff and easily manipulated to avoid total obliteration of underpainting. Tints are employed as follows:

Distant trees—blue [Bp]
Field—yellow [Yg]
Gaps in large tree—blue [Bp]
Gaps in bushes—yellow [Yg]
Foreground grass under the wall and the wall itself—blue [Bp]
Lower sky—red [Ro]
Top sky—orange [Ro+Yo]
Tree and bush highlights—yellow [Yg]

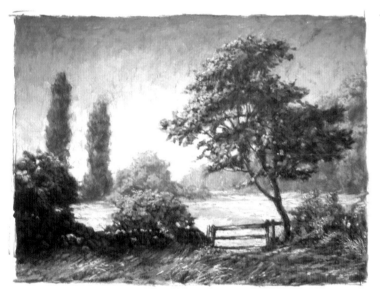

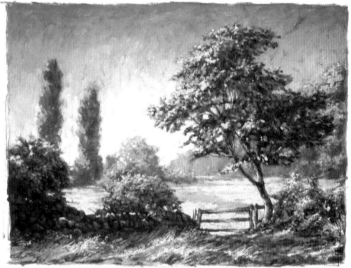

STEP 8 GLAZING

The tints must be completely dry before glazing. Glazes are composed of color plus painting (glazing) medium. In this case I used oily thinner as my medium. This is a mixture of the traditional medium, linseed oil, and distilled turpentine. Linseed oil should never be used on its own as it makes the paint layer brittle, which leads to cracking. This particular medium takes a while to dry and is very thin on application. It allows plenty of time to rework while wet and runs into and exposes every nook and cranny of the paint texture already developed. Glazes are employed as follows:

Sky—brown [Ro + Yo + Bp]
Poplars—blue [Bp + Bg]
Middle and distant tree, gate, and path—
 orange [Ro+Yo]
Large tree, background trees, and bush
 (foreground right)—crimson [Rp]
Middle bush, bush left foreground, and
 wall—purple [Rp + Bp]
Grass and tree trunk—dull blue [Bg + Ro]
Field—orange [Yo]

STEP 9

The glazes must be completely dry before the next stage. This involves either adding the highlight colors directly, often as a texture (scumble), or by wetting the surface first and then working into this with the highlight colors. The latter allows blending into a surface that would otherwise be dry. For this purpose the surface could be wet in sections using a retouching varnish or a glaze. Often I work into a tonk (see Artstrip). Here the painting medium used to mix the glaze was an alkyd medium, a fast drying gel, which is much stiffer than oily thinner. Reflected blue highlights, as well as the yellow sun highlights, can still be added at this stage (see large trees, path, and grass). The final touch was to add some flowers, cool in the shadows and with added yellow in the sunlight.

Section of painting showing effects of glazing.

Project 4 Tutorial

Figures

While the traditional head and shoulders portrait certainly has its place, a conversation piece such as this can actually better portray the true character of the sitter(s). Here is a young girl with her grandmother. The child is very bright and inquisitive, and is at the stage in her life when everything is fascinating. Her stroll around the garden stops at the pool where the bright colors of the various plants catch her eye and the questions start.

CHOICE OF SUBJECT

You could paint this subject, but better still, select something that is more personal to you, for this will heighten the pleasure in working on the painting. It will also, most importantly, encourage you to work harder at the techniques involved so that you achieve a result that pleases you.

CHOICE OF SURFACE

I atarted this painting on a piece of canvas board cut to size. When working on an off-cut or piece of canvas board in this way, it is essential that all cut edges are sealed. Here these were painted with acrylic medium to stabilize and protect them.

MATERIALS
Canvas Board
Brushes
small and medium round
Bristle
round nylon
nylon Rigger
Paints
6 primary colors
Titanium White
Zinc White
Oily Thinner
Turpentine
Glazing Medium
Acrylic Medium

STEP 1—BASE WASH AND DRAWING OUT

Reduce the stark white of the canvas board with a wash of turpsy dull color. Use the Rigger and fluid paint diluted with thinner [Ro + Bp] to draw in the main composition. The fluidity of line available from the rigger and the wetness of the surface allows for loose scribbled linework, which is a wonderfully relaxed way to get into your painting. Getting the pose correct is an absolute essential for figure painting. At this stage try to forget that you are looking at people, and try in your mind's eye to reduce them to geometric shapes. The adult figure is roughly the shape of an "F." Look also at the shape between the figures (negative space). If you get this shape right, the figures will naturally be correct in relation to each other.

STEP 2—BLOCKING IN MASSES

Now that the masses are correctly positioned within the frame, color is blocked in. Thinner reduces the paint to a very fluid mix for swift coverage with the largest possible bristle brush, which deters detailing. Keep colors at this stage either warm [R + Ro] or cool [Bp + Yo] to differentiate the areas and create dark accents, against which the overpainted colors will contrast. Each of these mixes should be dull; by keeping plenty of pigment in them, will ensure they remain dark.

TIP
A line drawn around the edges when beginning a painting indicates how much would be lost under the frame. On a painting of this size— approxlimately 9 in. (22cm) square—you can see the area which would be lost in the frame is considerable, and must be taken in consideration when drawing in the masses.

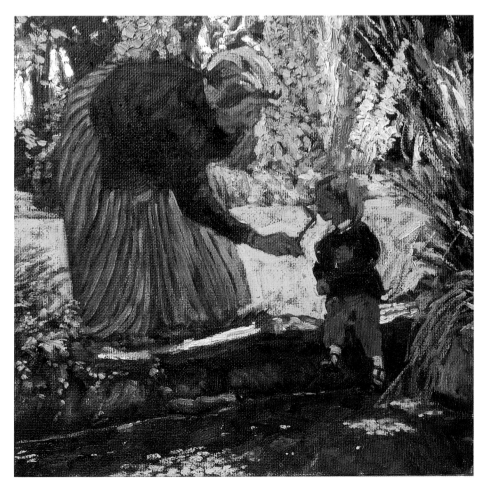

STEP 3—FIRST LAYER IMPASTO

For the first time we now begin to move toward the correct colors. Hold yourself back. Ensure that this first layer achieves only the middle values, although you are using stiff color (no thinner). Begin at the top, or back, of the painting so that, as you move forward, the shapes will naturally overlap each other, suggesting depth. Concentrate on building the textures. Once you reach the figures, don't panic. Try not to identify them as figures in your mind, or you will begin to look for recognizable features. For now, try to think in terms of slabs of color. Apply the faces and hands with as few brush strokes as possible and then move on. At this stage they are no more important than a blade of grass or a rock. Be bold with corrections at this stage. Nothing is set in stone and making changes will not destroy any detail. So if something annoys you, change it. If you start to get so much paint on the surface that it is difficult to work, scrape off with a painting knife and start again.

STEP 4—SECOND LAYER IMPASTO

When dealing with important focal areas, such as the faces and hands, you will now need to tighten up on the drawing. Use a Rigger loaded well with dark color to redraw, before building the thick layers of lighter color with a small round bristle brush (progressively adding Titanium white). If the features become too heavy or sharp, blend gently with a soft round nylon brush and then replace the thick highlights. Don't worry about pasty complexions—build the light structure now and darken later with glazes. Grandmother's skirt was a great challenge. Detail such as this is incredibly satisfying if you take the time to get it right. Again, don't worry about achieving exact colors, but build the color very gradually towards light using a fine bristle brush. The right-hand side of the skirt is actually pure Titanium White. It sticks up from the surface in deep ridges, which will become rich with texture once the glazes run into them. I always find it fascinating that as the surface becomes more and more heavy with texture, the resultant effect is light and airy. Initially, the grass behind the figures looks like a simple slab of color. Note, however, that it becomes lighter and more yellow toward the front. It also has deep textures that will be filled with glaze. Each brush stroke applied now will suggest a dozen blades of grass with glazes applied later. The red on the child's pants should also be textured, but at this stage I added yellow [Yo] as well as white into highlights. Once you've finished the second layer allow the painting to dry.

STEP 5—TINTS AND GLAZES

Here you really can see how the tints soften and evoke depth for the distant trees. The glazes, on the other hand, begin to identify individual brush marks in the dress, foliage, and hair. Look at the light passing through the trees. The tints are concentrated here, giving a glow as well as a sense of distance. Each figure also has a halo of tint, which is gently blended away as it leaves the silhouette. This successfully separates the figures from their ground. The tint can be more solid around highlights, such as those in the hair. Now the light seems to bounce from the soft surface and hang in the surrounding air. Both tints and glazes are mixed with alkyd medium which improves the flow and dries swiftly. Thus, later glazes can be added allowing only a few days for the earlier tints to dry. Test the surface for tackiness with a finger before reglazing or retinting. Often the surface can be strengthened with a layer of retouching varnish, which, if applied in a thin layer, will dry in half an hour. Glazes enrich the color throughout the painting, but you can see them more powerfully here on the grass, foliage, hair, and background tree masses. Look also at how an Ultramarine glaze glows along the pool wall, behind the child's legs. There is little texture here, apart from that of the canvas itself, but look at the intensity of color and the beautiful contrast it provides for the surrounding colors.

STEP 6—TONKING AND STIFF PAINT (WITH SOFT BRUSHES)

Once dry, the surface of the painting presents us with a number of different surfaces. The grandmother's skirt, at one end of the scale, is very textured. At the other end, the wall of the pool, which still features the canvas finish, is relatively smooth. Both can be tonked. The opaque fluid paint (mixed with alkyd medium), applied with a soft round nylon brush, is subsequently tonked from the surface using a piece of white tissue paper. With the dress the effect is one of holding together the brush strokes. On the pool wall the tonk creates a characteristic texture of its own. While the pool wall was left at this, the tonking on the skirt provided a wet surface onto which further stiff paint could be layered and blended where necessary (including the spots of red pattern). If tonks prove too opaque, swiftly add more medium directly to the surface and tonk again. Soft, round, nylon brushes now give all the control you need for detail work to focus areas such as faces and hands. They are also excellent, used side on, to drag across dried textured areas, to create scumbles. Made to lay smooth paint, they can nevertheless expose already present texture. Use their fine points for soft highlights on faces and hands, blending with a clean brush into the colors below. Even the pure white sparkling lights can be applied with these brushes, providing they are well loaded with stiff paint. Scuffing (scumbles) can be seen on the distant trees and flowers, grass, hair, and sunlit stonework. Bright thick highlights are reserved for the sunlit edges of the two figures and if you cast your eye across the picture as a whole you will see there they are the lightest colors of the whole composition. Note, the amount of color present on the brush dictates the different effects that can be produced when scuffing. The distant hedge behind grandmother's hair, for example, had a well-loaded paint scuff. The soft purple flowers below were much less heavily loaded, and so, are much lighter and softer in finish.

TONKING

The technique of applying a fluid layer of oil paint (paint on the palette mixed to a fluid consistency by adding of glazing medium), over which a piece of absorbent, or semi-absorbent, paper is gently pressed down and lifted off, taking some of the paint with it. The degree to which the paint is lifted off is determined by its consistency. In this way an opaque (non see-through) layer can be rendered semi-transparent and a transparent area can be made irregular or seemingly textured in a unique fashion.

STEP 7—FINISHING OFF

Highlights such as those at the bottom of the dress, across the stone slab, dotted on the waterweed, and added to the grasses (right), were taken all the way through to white. While this white adds that sparkling final light, do be cautious. Overindulgence in applying these exciting ticks can soon appear as snow. When judiciously placed however, they have no equal and are well worth all the work involved in the underpainting to get there. The child's red trousers needed one final glaze of red [Ro] before adding a light yellow [Yo + Tw] and then a final pure white to the top of the sunlit folds. Highlights to the seed heads and the stalks bring a fine curtain of light forward, against the darker backdrop of the hedge. This stiff paint is dribbled from the brush, and although a time-consuming technique, provides a unique quality of light to the top, right-hand corner of the painting.

FINISHING HIGHLIGHTS

Dip brush into mound of paint and pull out to form dribble of paint that can be "laid" to produce highlights and linework.

Tricks of the Trade

Oil mediums

Visiting an art store for materials can be very confusing for the new artist, particularly when confronting the shelf that contains the oil painting mediums. There are so many different names and bottles that even the most experienced artist might experience a moment of hesitation. Here we look at what you might find on that shelf and sort out the useful from the exotic.

The purpose of an oil medium is to make the paint more fluid, so we shall start with thinners.

THINNERS are transparent and very fluid. They evaporate swiftly from the surface, leaving a very thin layer of paint behind.

Those new to painting often use turpentine substitute [A] or white spirit, both of which are readily available. While these are very cheap, they will leave behind an oily residue in the paint, which may discolor after a period of time. Both of these thinners should be used mainly for cleaning hands and brushes [B].

Artists' distilled turpentine [C] or artists' white spirit evaporate fully and are the correct thinners for oil paint. Should you dislike the smell, odorless thinners are available.

You may not want to thin down your paint, but you may want to extend it by adding more oil as in glazing, for example. This is where oily mediums come into play.

OILY MEDIUMS Traditionally you can add more linseed oil, the oil usually mixed in tube paint. However, the addition of too much linseed oil can, in time, lead to brittleness and cracking of the dried paint. Therefore, a mixture of a thinner and an oil is combined to create a glazing medium [D].

One example of this is a mixture of 50 percent of each of artists' distilled turpentine and linseed oil referred to as an "oily thinner" [E] which, while fluid, is much slower to dry than the thinner alone.

You will find an array of premixed oil painting or glazing mediums made from different oil and thinner combinations [F]. Some of the oils in the mix may be fast to dry or may even have special drying agents added. This gives oil painters a choice of fast to slow drying, matte or gloss finishes, and different degrees of fluidity. Every artist will have his/her preference, so you should try out different mediums until you find one that suits you.

For an even greater choice there are synthetic oil painting mediums. These are actually based on a resin, rather than oil, and were introduced as mediums for alkyd paints. However, as they are compatible with oil paints, they provide a fast-drying, flexible alternative to the more traditional oil-based mediums. Usually you can find these in different degrees of fluidity (viscosity).

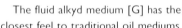
The fluid alkyd medium [G] has the closest feel to traditional oil mediums.

Alkyd gel media [H] are stiffer.

Impasto mediums [J] give rise to "buttery" mixtures which can even be applied with a palette knife, and retain their texture.

TIP

1. Don't worry that a particular oil medium may be amber in color. Its color is not powerful enough to affect the dominant color of the pigment in the paint.

2. While in the bottle, alkyd (resin) mediums can become milky when exposed to sunlight. Don't worry; this has no adverse effects at all during painting or on the finished result.

Common Problems

Brushes for oil painting

QUERY

"I hear so much about layering oil paint, but I just seem to cover everything with each layer of color. How can I learn to hold back on the amount of paint I apply?"

ANSWER

The overheavy application of paint has two main causes. (1) If the brush is presented at too sharp an angle [A], the paint is automatically pushed into the surface textures. This surface may be the canvas weave or dry impasto paint that has been built up earlier and allowed to dry. (2) Amazingly, this is often due to not enough paint being mixed. At first this would seem to be a contradiction. When, however, there is not enough paint on the brush, the natural tendency is to apply more pressure to deposit what color is available. This extra pressure unfortunately ensures that the paint is forced into all of the surface textures, resulting in even coverage on the "hills" of paint and in the "valleys" on the surface.

SOLUTION

(1) Move the brush at a more level angle [B] to deposit paint onto protruding texture, while leaving the "valleys" dry. This will preserve the colors of the first textured layer, while exposing or even exaggerating its texture. Practice holding the brush underhand to achieve the necessary flat angle [C]. This may seem strange at first, but you will soon acquaint yourself with its positive qualities and you will begin working this way without thinking. Holding the brush this way can cause you a problem when working with a table easel. A long-handled bristle will hit the table top on any downward stroke [D]. Again, the natural tendency is to angle the brush head more sharply to allow for this. This leads to the same problem of overcoverage as the point of the bristles pushes the color into the dry paint texture [E]. The simple answer is to bring the table easel level with the table edge. Once the painting hand can go below the table level the angle of the brush to the painting surface can be as gentle as you require [F].

(2) Squeeze a good amount of color out onto your palette so that your brushes are well loaded throughout the painting session.

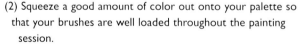

PROBLEM

"I do not like bristle brushes. Their bristles stick out in all directions so that I just can't control where the paint goes!"

SOLUTION

Clean and store your brushes well to ensure that they don't become misshapen between painting sessions. You will often be given the advice to not mix paint with your bristle brushes and, without doubt, this does cause a certain amount of brush damage. However, mixing with a brush does produce streaky mixes [G] that are much more exciting than the flat color often produced when mixing with a palette knife [H]. The most frequent problem is that of mixing with the tip of the brush. For very small quantities this is acceptable, but for most of the time you are mixing good quantities for impasto (textured) work. In this instance you should make sure that you are mixing with the full body of the brush [J]. Now the paint will fill the brush head, which will help to keep it in shape. Control the shape of the brush head by rolling it on the palette [K] or pulling it across [L].

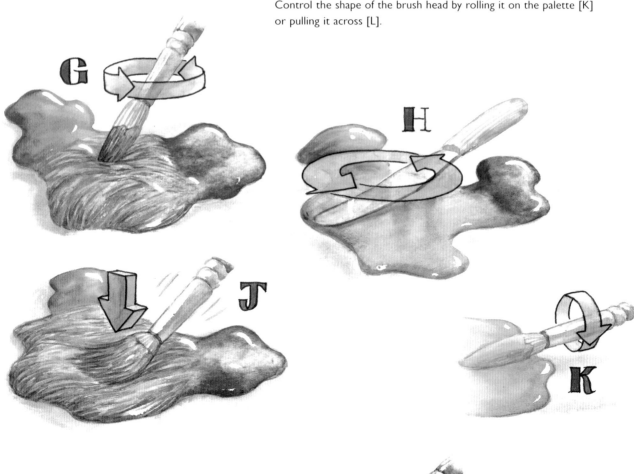

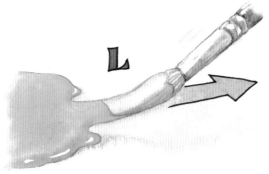

Project 5

Transparent subjects

One of the most frequent questions asked of me by painters is how to interpret transparent subjects, such as water or glass. Just as early alchemists wished for a chemical that could turn everything to gold, so most painters wish for a tube marked "transparent surfaces."

Of course there's nothing as simple as that, but achieving transparency is not difficult. As with everything, the key lies in careful observation of the nature of the transparent subject and its inherent structure.

Transparent subjects such as glass and water distort the shapes, colors, and values of the elements behind them. The shape of the distortion directly echoes the shape of the transparent object. If the transparent item is curved, the object behind will appear curved. If it is fractured, the object behind will appear fractured. Often contrasting values that may be some distance apart, can be visually squeezed together by the transparent item, especially in tight bends. Nevertheless, these values must be present somewhere behind the surface in the first place.

Reflections on the surface of a transparent object, are however, another matter altogether, the joker in the deck. They can bring colors from some distance away — the sky, for example. Nevertheless, they are from the same environment. In observing reflections one should always identify the source of the reflection. More often than not, the reflected shape will have something in common with the original source. A window reflected in a curved glass surface, will often be a tiny window, much diminished, but still recognizable as such.

The oil painting process provides an excellent vehicle for painting transparency. Since the first layers are dark, they provide the colors coming through from behind. The lighter colors and highlights are laid on top. The progressive build up of values natural to the subject match those natural to the medium, a perfect combination.

The workshop tackles a simple still life to demonstrate the basics of the process. The tutorial, however, takes as its subject the ephemeral of an imaginative creature, with gossamer wings.

Project 5 Workshop

Painting glass objects

COLOR REFERENCES
Yellow-orange [Yo]
Yellow-green [Yg]
Red-orange [Ro]
Red-purple [Rp]
Blue-purple [Bp]
Blue-green [Bg]

Glasses are symmetrical objects. The central axis (in red) creates a mirror image of each half.

Make sure it is vertical against—equidistant from—edge of canvas.

Mark proportions of glass down central axis. Draw lines at right angles on which to construct ellipses.

Use a pencil or brush shaft to measure proportions of ellipse. Compare its height to its width.

Once these are marked out, take curved lines through their extreme points to begin ellipse.

Hold brush shaft in front of glass edge to visualize and check the negative shape.

Push first stiff layer of color into linework to tighten up. Turn brush toward line to deposit color sharply.

Use medium size bristle for texture. Use small bristle to work color into corners.

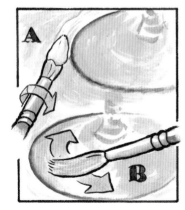

Edges can be hard [A] or soft [B] depending on whether you deposit [A] or blend [B] color.

Eventually, line becomes edge as one side blends into wet background.

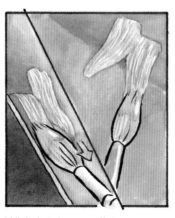

While bristles are efficient at depositing quantities of paint . . .

. . . it is sometimes useful to finish off with a nylon brush to achieve a smooth surface that is more suggestive of glass.

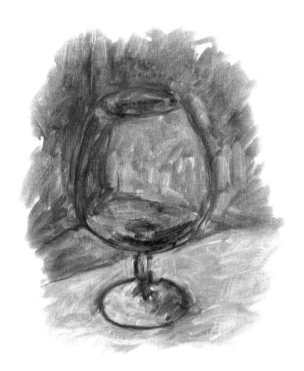

STEP I

Use a nylon Rigger brush to complete the initial drawing with a thinned down mix of gray-purple [Bp + Ro]. The curves and proportions are so sensitive that it is quite natural to have to make several alterations as you proceed. Don't be put off by this process, just make a start and slowly whittle away at the shape until you get it right. Once the drawing is acceptable, block in thin washes of color, until all the white canvas is covered. This is extremely important, for if any white remains at this stage, the highlights that you are going to build on the glass will not work. The colors are exaggerated— more intense—versions of the grays that can be seen. They wipe away lines that are incorrect and leave those that are satisfactory. This means you are still drawing even when applying masses.

> ### COLOR MIXING
> Where the prefix letter is shown in capitals, this denotes a larger quantity of that particular color.
> Conversely, where the prefix letter is shown in a lower case, this denotes a smaller quantity of that particular color.
> e.g.
> Bp = large amount of blue-purple.
> bp = small amount of blue-purple.

> ### MATERIALS
> **Canvas Board**
> **Brushes**
> small, medium, and large round bristle
> round nylon
> nylon Rigger
> **Paints**
> 6 primary colors
> Titanium White
> Zinc White
> Underpainting White
> **Alkyd Medium**

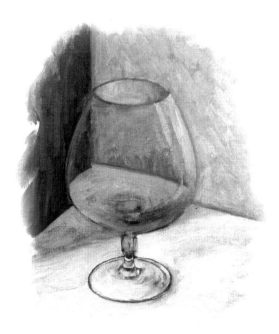

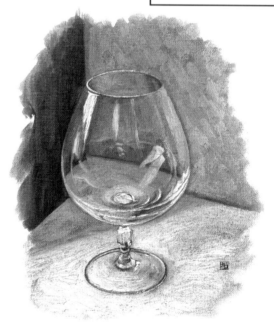

STEP 2

Distortion of colors and shapes behind glass

To draw transparent objects involves observing how the shapes and colors of the background are altered as they are seen through the transparency. At this stage, all reflections on the glass must be ignored, as they are indications of the glass surface itself. As the paint becomes lighter and stiffer it is this background that is abstracted from all the other information that is available. Colored grays are exploited, as is the use of cool over warm and warm over cool colors (see the wall on the right—pink over green). You must have patience not to move to the highlights too soon. At this stage, the darks dominate and they will be needed if the glass is to sparkle.

STEP 3

Reflections of shapes and colors in front of glass

Now start with the soft lights that mold the form, making them lighter and cooler than the background. They follow the form of the glass and partially obscure the background (see brown mass to the left). Paint lights on the rim, warm over cool, and then add bright highlights. Try to create large highlights on the glass side as a juicy brush stroke that has hard, sharp edges, rather than rubbing them on. Rubbing will pick up the texture of the canvas and will not help in suggesting the smoothness you require. Nylon brushes are much more effective in producing this sort of stroke. If the brush stroke edges are still rough, then they can be blended into the wet paint beneath with a bristle, or you can work up to them with a dark color matching the background tone. The meeting edges will then be soft and smooth (highlights from a reflected window, top left). Final highlights on lights are yellow-white, rather than white alone, the true color of sunlight.

Project 5 Workshop

Painting glass objects

STEP 1 Once again, the symmetrical shape works around a central vertical line (axis).

Measurement down this line can be equated to the depth of the stopper—as can width.

Hold a pencil in front of decanter to determine angles of perspective across it's form.

SIMPLIFYING PERSPECTIVE Imagine pencil as small hand of clock. Equate the line it follows to the hour on clock face.

Transfer this angle to the drawing.

Draw in any other perspective lines that can help with the "grid" of the cuts in the glass.

STEP 2 Middle value brush strokes begin to eliminate dominance of drawing.

Keep colors soft by blending. Sharp details can be added later.

Small alterations now made to drawing make a difference and are essential for development.

Colors from the background sharpen silhouette and are also seen through the glass.

STEP 3 Note how colors from center of decanter are carried to other areas of the glass.

While soft-hair brushes could provide detail, better to persevere with small bristle brushes to achieve texture.

Having tackled the basic essentials of
making a smooth glass transparent, we
now turn our attention to cut glass.

STEP 1

*Place your glass object carefully in the light to
fully illuminate the cuts. After the initial drawing
and blocking in of thinned turpsy color, redraw
with great care. The pattern of light is to be captured in a bold, painterly fashion, so get
the structure and form correct at this stage. If you have to make large changes later because
your proportions are wrong, then some of the immediacy and excitement will be lost. Draw and
redraw, making corrections, until you have a strong skeleton over which to apply the thick
structural paint of the next stage. Note the value changes around the silhouette of the decanter.
These contrasts already make the interior of the glass seem luminous.*

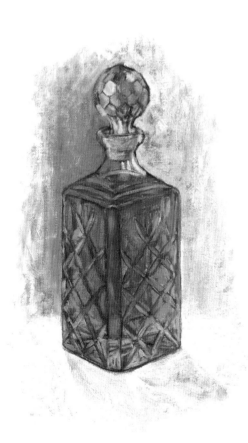

STEP 3

*At this stage you can see how the glass surfaces capture and
redistribute the color. The strong red in the center is actually reflected
off a car below my studio window. The orange colors of the whiskey
are scattered through the thick glass base and out across the white
surface on which the decanter stands. Don't be put off by the
complexity of the subject. You cannot capture every nuance of light as
these will change with the available light and with every movement of
your head. Instead, go for those that are exciting and best exploit the
subject. As you move through the middle values toward your highlights,
don't be tempted to use soft brushes. Stick to your bristles, even if you
do allow yourself some of the smaller sizes. In this way, the highlights
will remain textured and ready to come to life with the addition of
glazes at the next stage.*

STEP 2

*Lighten background colors by applying thick strokes of whitened color. Using
underpainting white in the mix will ensure stiff impasto textures and fast
drying. These colors, laid from cool (blues) to warm (reds), are not only
exciting—by painting tightly up to the glass edge, you will in essence be
redrawing and creating focus. Applied along the outside edge of the vignette,
these pale colors help the background to recede, bringing our attention
firmly back to the decanter. Colors from this background begin to appear
inside the glass; note the dull red and the light orange on the neck and the
stopper. On the glass itself, apply blue-gray brush strokes to suggest the light
reflected from the sky outside the window.*

Project 5 Workshop

Painting glass objects

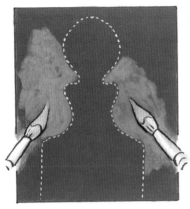

STEP 4 Tint of Phthalo Blue over background creates recession (painting simplified here to show overpainting of tints).

[A] Tint follows sharp edge exactly.
[B] Tint covers edge to suggest rounded surface.

Tint over shadow and glass (bottom edge).

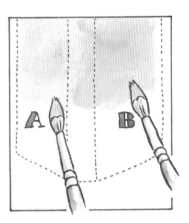

First glazes:
[A] cool [Ro + Yo + Bp]
[B] warm [Ro + Yo + bp].
i.e. less blue in B.

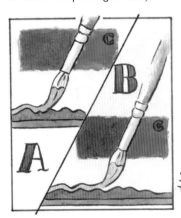

STEP 5 [A] Warm glaze over cool undercolor. [B] Cool glaze over warm. Both give colored grays [C].

[A] Warm glaze over cool ground. [B] Cool glaze over warm ground. (Painting simplified here to show glaze colors.).

Look at how these colors of glaze affect the overall color (see opposite page).

Red [Rp + Ro] glaze down the center of the decanter holds together colors and textures.

STEP 6 [A] Warm and cool tints to the background—tonked [B].

Yellow [Yo + Yg + TW] tint applied with medium size nylon brush for control [A].
Tonked [B].

[A] Stiff (tube consistency) highlights blended into still-wet tonk [B].

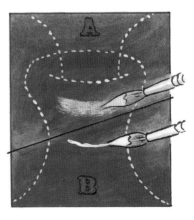

[A] Blue-white [Bp + TW] soft highlights catching impasto underpainting.[B] Final dribbled stiff white [TW] highlights.

STEP 4—TINTING

Once the impasto paint has dried, it is inevitable that some parts of the painting will have become dull as the oil sinks in. Use a thin layer of retouching varnish to oil out the whole surface. This will also refresh the colors. Now the painting is tinted using an alkyd medium, in this instance for its stability and fast-drying qualities. Zinc White is used in all mixtures, being the most transparent and translucent of all the whites. To separate tinting into one layer like this is a little artificial, as tinting can go on throughout the final layers of an oil painting. However, as they are very difficult to see in reproduction for printing, squeezing them all into this stage is the best way to illustrate their qualities.

STEP 5—GLAZING

Again, an alkyd medium is mixed with the color to create these glazes. Keep the glazing in this exercise very simple, applying only one on each area. In practice you can allow glazes to dry and then overglaze with another color. Really exciting colors can be built up, especially when layering warm over cool, and cool over warm. The final "temperature" of color applied will dictate the final warmth or coolness of an area of paint. Slowly, the painting will darken and so glazing must be balanced against the richness and texture of the color that develops.

STEP 6—TONKING & HIGHLIGHTS

This is the stage of the painting when you need to show considerable restraint. It has taken some preparation to get here and when you begin to add color directly from the tube on top of the glazes, the contrasts are exhilarating. Consequently, everyone tends to overdo the highlights, eventually applying too much. This has the consequence of covering too much of the glazed underpainting and the contrasts disappear. Another danger being the strength of contrast which can be too much and usually it is better to add a slightly lighter layer than the undercolor and then the highlight. This first level of light can be achieved with a scumble or a more fluid application which, when tonked, gives a semitransparent brushstroke.

Project 5 Tutorial

Transparent subjects

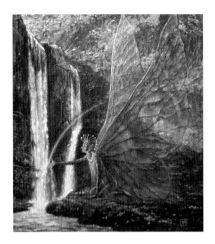

I have always held a fascination for the subject of winged creatures, ever since the day, when at a tender age, I became lost in a world of fluttering blue butterflies at the bottom of my grandmother's garden—although I have to admit that they were seen only by me. Finally I created my own genre of fairy folk—the Elphen. One thing led to another; a suite of paintings was created, the story written, and the limited first edition book, *Elphen Chronicles*, printed and bound.

So often I am asked how an artist captures light in paint. Better still, how does an artist capture something transparent or translucent. What about those shimmering effects?

Here I show how to tackle each of these elusive qualities through a step-by-step painting in oils of one of my Elphen characters. This is Spectrum, collector of rainbows. Here we see him harvesting his raw materials to store in his wings. Whenever you spot a rainbow, Spectrum is sure to be about. Listen attentively and you may catch his tinkling giggles emanating from the undergrowth; but you will have to be very fast to catch sight of this creature as he shimmers past.

CHOICE OF SURFACE

First you must select a surface on which to paint. This painting is quite small at only 6¾ in. x 6 in. (170 cm x 150 cm), and as the details are quite fine, you must be wary of the texture of the surface. I chose a piece of canvas board cut to size, but you might use a piece of hardboard or plywood properly prepared. The smoother the surface, the easier it is to control the detail.

MATERIALS
Canvas Board
Brushes
small and medium round
bristle
round nylon
nylon rigger
Paints
6 primary colors plus
Phthalocyanine Blue
Titanium White
Zinc White
Oily Thinner
Turpentine
Glazing Medium

STEP I—BASE WASH AND DRAWING OUT

Cover the whole of the surface with a layer of dull red—here I used acrylic paint, but you could use oils, which must be allowed to dry. Red is chosen as it is a complementary to the greens that are to play such an important role in the painting. Red will also provide an excellent contrast for the subsequent colors to work against. Sketch in the outline with a turpsy color [Ro + Bp], paying particular attention to the Elphen body. Note the line around the perimeter of the painting. It is so important in a small painting to be aware of just how much will be lost under the rebate of the frame.

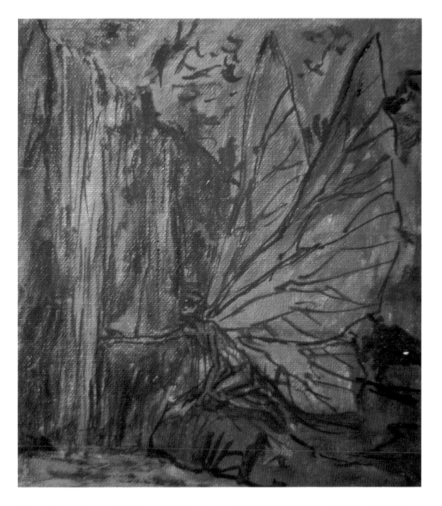

Spectrum's translucent gossamer wings present quite a challenge. In working through this step-by-step you will learn so much about how to imbue an oil painting with light with the added challenge of tackling a transparent subject.

STEP 2—BLOCKING IN MASSES

Fill in the masses of the composition with a series of colored grays, created with complementary mixes. Redraw with a Rigger, again using turpsy color. Allow the underpainted red to show through as a foil to the cool dull colors that are being applied. Now we can see the strong diagonal of shadow in the composition. Cutting through the strong verticals of the wings, this diagonal will soften their possible over-dominance.

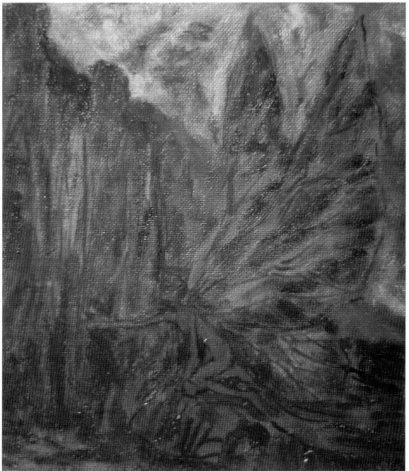

STEP 3—FIRST LAYER OF COLOR

Color is now used directly from the tube without the addition of thinners or mediums. Use bristle brushes and "rub" a thin layer of the paint into the gently textured surface. This technique has a useful side effect of imbuing the image with a soft, unfocused quality, which is very apt for this stage. Note that the red underpainting is still apparent through these dark, stiff, yet thin, layers of color.

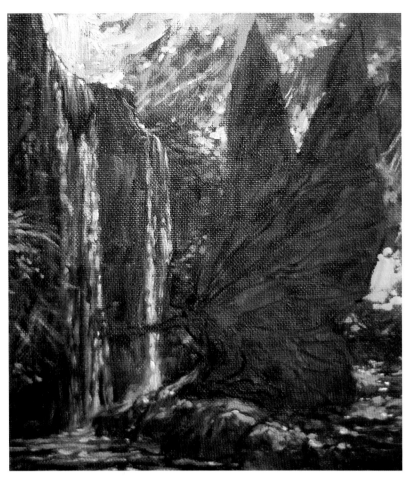

STEP 4—DARK TO LIGHT: BACKGROUND

In this stage you need to build up the paint from dark colors, through the middle values, to the highlights, increasing the thickness of the layers as you go. This creates structure in the paint, which physically catches light, making the highlights bright because they stick away from the surface. Begin at the top of the painting and work down to avoid catching and smearing with your painting hand, as you work. By painting the background first and the Elphen later, you will be painting the Elphen in front of the landscape. The figure will become focused and, therefore, the principal subject, no matter how complex the backdrop. Let your eye wander around the edges of the wings and along the top of the waterfall. Note how the contrasts constantly change (in some places the background is dark, in others light). This natural play of light makes these negative spaces more exciting.

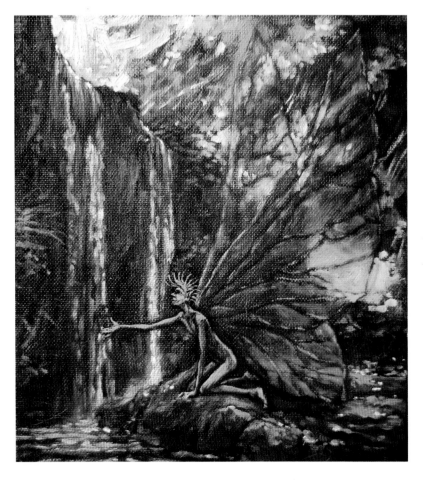

STEP 5—ESTABLISHING FORM: BODY AND WINGS

A wonderful addition to your color palette at this point is Phthalo Blue, which will yield the luminescence required for painting the Elphen wings. First paint the wing cells, thus forming the veins from the dark colors left showing between (negative painting). As you work up to the lighter colors, blend these patches and the wings themselves along their edges. This keeps the wings soft and can suggest the blur of movement. Touch some of the veins with a blue highlight, especially when they have a dark color behind, against which to contrast. For the body, redrawing can now take place using the Rigger and a fluid dark green, achieved with the addition of oily thinner. The body's values are now built up using an unthinned green mix, working from light to dark, to model the form.

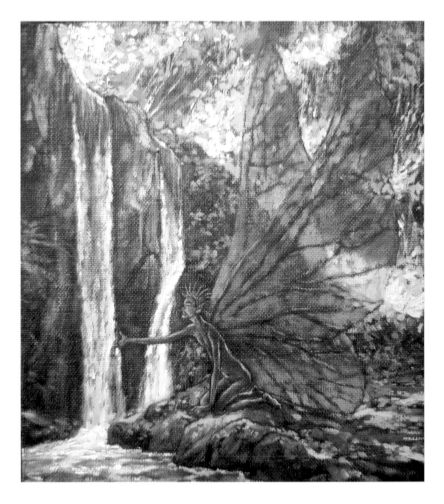

STEP 6—HIGHLIGHTS AND STRUCTURE

Work further highlights into the background, including the foliage in sunlight or shadow and the waterfalls. Exploit the texture of the paint already in these areas, whether wet or dry, by dragging paint-laden bristle brushes across the surface. The thicker areas of paint will naturally take more fresh paint from the brush. One of the joys of impasto paint (not thinned) is the way in which it then affects the application of subsequent layers of paint (scumbles). Note warm, yellow-green highlights in sunlight and cool, blue-green highlights in shadow. Also note the red berries, placed irregularly to give complementary contrasts to all of the yellow-green. Gently build up the rocks behind the fall, avoiding really thick paint that might cause unwanted highlights in these rich dark areas. Their structure is suggested in cool greens and warm browns, with a reflected blue highlight. Rocks under the Elphen are given highlights that are carried through the lower wing to suggest its transparency. At this point I could see that the figure required some reworking; to this end it was covered with a thin layer of stiff gray-green [Bp + Yo + rp], gently worked into the surface with a bristle brush. This played down all the highlights and detail, while providing a wet surface into which I could redraw and rework toward light. The light is orange down the front of the figure, which reflects the light from the waterfall he is facing. The light down the back is yellow, describing reflected sunlight from the background foliage. The painting has to be left to dry, which can take quite a long time—this took seven days.

STEP 7—TINTING AND GLAZING

Dry, complementary tints can now be used across the majority of the surface to tone down and soften the painting. Up to this point the original painting had become too garish. Tints are normally a color plus Zinc White, mixed with a glazing medium to ease application. Here the medium is eliminated so that the paint can be rubbed in with a bristle brush. Applied in this manner the tint layer is very stable and can be immediately worked into. The gentle scrubbing action of the bristle has the bonus of removing dust and fluff that may have landed on the painting during drying. A more traditional tint using Phthalo Blue, Zinc White and oily thinner is painted into the wing cells with a soft round brush and then tonked to create an uneven texture across the wings and tighten up the veins.

STEP 8—TINTING AND GLAZING

Apply a light pink tint to the wings and tonk off. Move on to the Elphen face, which should now be redrawn and rehighlighted. The gossamer garment is first suggested by applying a thin tint of Phthalo Blue, and then highlighted with fine scuffed lines applied with the nylon Rigger. Points of light are reestablished around the body, reflecting light from the waterfall, the jewels, or from above. Even at this stage, definite changes can still be made. Note how the right foot disappears—I felt it was in the wrong position. Allow the painting to dry for a few days before adding warm glazes to the background behind the Elphen's head [Ro + Yo + bp] and to the head itself [Yg + Phthalo Blue]. Apply a dull green glaze (Bp + Yo + ro) to darken and enrich the rock on which the figure sits. Phthalo blue tints to the background foliage give some space between it and the wings. This tint is strengthened considerably and used to add a glow around the neck jewels.

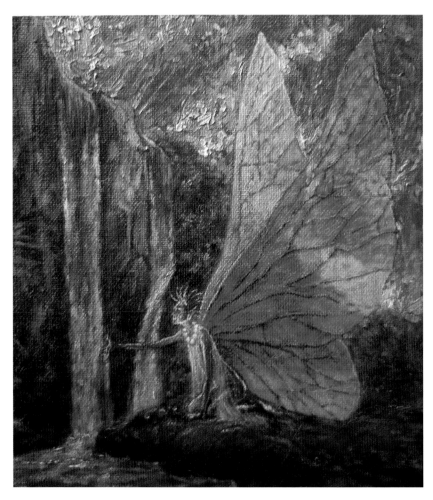

STEP 9—ENHANCING TOUCHES

Now add warm glazes [Ro + Yo + bp] to enrich the background. A blue-green tint [Bg + yg + Zinc White] over the figure softens its contours once more. Using a soft round brush, with stiff paint, enhance the leaves by scumbling through the background and those scattered around the Elphen. These should be worked through several values towards highlights and carried through the wings to enhance transparency. These scumbles are used in both sunlight and shadow areas (warm and cool respectively). A blue tint over the orange water of the falls can again soften them in preparation for further textures. The red berries on the left, which were strengthened at this late stage, provide complementary accents to the greens. These berries also help to break and relieve the solid rock vertical on the left of the painting. Red bands on the Elphen body, together with highlights, not only achieve more structure and volume for his body, but again provide a complementary accent to the green skin. Redrawing around the face can still continue with a dark warm mix [Ro + Yo + bp] and oily thinner—note eye and smile. Highlights to the jewels, hair, and wings, begin to add a real sparkle to the creature's personality. The wings are first treated with a blue-purple plus Titanium White rubbed across to soften the veins before working through to light blue highlights.

STEP 10—FINISHING OFF

The painting will now need to be left for several days to dry. Overbright highlights on the wings can be reduced with a dull green tint [Bp + Yo + Zinc White]. The rainbow is painted, before completing the waterfall to ensure adequate contrasts against which it can shine. The colors of the rainbow are painted first as glazes, and then stiff color is added and blended in toward the hand. A yellow tint over the top left of the waterfall will add extra light across the most distant foliage. The same foliage in shadow, down the right of the most distant fall, is given a blue tint. This pushes it back and consequently brings the head of the figure forward. Final highlights are added to the face, arms, body, and the jewels. The waterfall is scuffed with lighter colors using a small bristle in order to retain scumbled brush marks, which will suggest movement. Finally, and well worth waiting for, the rainbow effect in the wings is achieved with tints of color, gently blended. The end result is shown at actual size.

Tricks of the Trade

Oil painting varnishes

It is unusual, although not rare, to put glass in front of an oil painting when framing. While on larger works vast areas of glass would cause unwelcomed reflections, on smaller pieces it is more acceptable, especially where there is a possibility of physical contact with, or damage to, the painting's surface. Usually, rather than putting glass in the frame to protect an oil painting from the ravages of our atmosphere, it is varnished.

Today, varnishes are made from materials that can easily be dissolved with thinners. Thus, when the surface varnish becomes clogged with dirt, it can be washed away with other impurities. This is the process of cleaning or restoring, when the full glory of a painting is exposed on removal of dirt-laden varnish. It is not a job for the uninitiated as very old varnishes, in the main, require expert removal, for they are not easily dissolved. An inexperienced hand, particularly if too aggressive, may find the paint has lifted off with the dirt.

Artists can, however, protect their own work for the future, with the best varnishes, of which there are several available on the market.

RETOUCHING VARNISH is an absolute must for every oil painter. It can be used at the completion of a painting to provide a temporary protective layer. Even when dry, retouching varnish allows air to pass through its surface to the paint beneath [A]. Given that a really thick layer of oil paint can take as much as a year to dry, it is essential that air be allowed in from the front, so that the chemical reaction involved in the drying process can occur. Should air be prevented from entering from the front, the painting will dry from the back, resulting in the paint layers drying unevenly. The stresses built up by this process will cause the paint to fracture and crack. Retouching varnish can be used on the paint immediately after it is dry to the touch.

Often, during the process of painting, an area may become dull and lose all depth. This is particularly noticeable with earth colors and one is tempted to repaint to compensate for this. Unfortunately, however, the area will soon become lackluster again. The solution is a thin layer of retouching varnish, which will restore shine and the freshness to the color. This process is known as "oiling out." Generally I find this extremely useful throughout the structural layers of the painting, when using stiff paint. Once glazes are applied the oil-rich surface is usually sufficiently lustrous to display all the depth in the color.

FINISHING VARNISH A painting varnished with retouching varnish will slowly dull down and can be revarnished several times before being ready to take a finishing varnish.

To test whether the painting is ready or not to varnish, press a thumbnail gently into a deep brush stroke near the edge of the painting. You can tell by the "give," if the paint beneath the surface is still wet [B].

It is preferable to apply finishing varnish [C] in several thin layers, rather than one thick one. I prefer to apply varnish to my painting with it standing upright as this prevents pooling. Excess varnish will run and this forces one to keep the layers thin. A 2 in. (50 mm) flat bristle brush is used to apply the liquid.

It is best to avoid creating too many bubbles (bloom) in the wet surface, so the brush head is kept low against the surface and is applied gently [D].

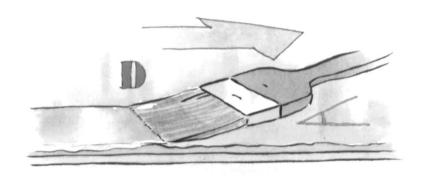

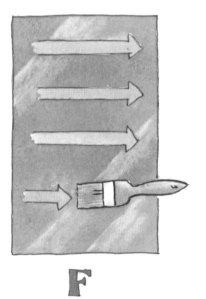

I usually apply the varnish in vertical bands [E]. When the painting is fully covered, run the empty brush across the surface horizontally to even out [F] any irregularity.

Both retouching and finishing varnish can be bought in aerosol form. Again, the secret here is several thin layers, each allowed to dry before the next application. Retouching varnish is by necessity, gloss in finish. Finishing varnish can be gloss or you may plump for a matte finish, depending on the subject, or particular preference.

WAX VARNISH One of my particular favorites. This gives a real luster to one's oil and the surface can be worked up from matte to gloss, depending on individual taste. When doing this, it should be remembered, however, the finish must be consistent across the whole surface. Wax varnish (not unlike neutral shoe polish) is applied gently with a soft, lint-free cloth. With the pressure needed for its application, it is necessary to support nonrigid surfaces—such as canvas—from behind [G]. This is left to dry matte and then buffed up with a clean, soft, lint-free cloth to the degree of shine sought after (support the canvas during buffing). It does not reach the brilliance of a gloss varnish, but achieves a subtle glow, which gives an extravagant look to your oil surface.

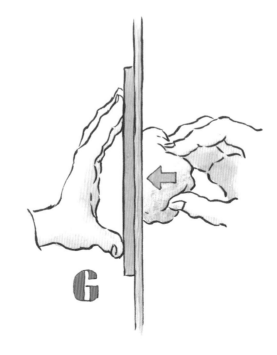

Common Problems

En plein air

The problem of how to transport a wet painting, wet palette, and wet brushes back after a day's painting outdoors prevents many a painter from even considering the idea. This is such a pity as there is a great deal of enjoyment to be had from doing so, quite apart from the fact that a great deal can be learned from the experience. In oil painting particularly, the dynamism of working alla prima comes into its own, when a painting completed in one day is the aim.

PROBLEM

"I would love to work outdoors in oils but I can't imagine how I get my work home, still wet, without an accident."

SOLUTION

Canvas carriers are essential for carrying wet work, but as so few people know about them, many stores do not stock them. If they do, in many cases they don't know how they work. A pair of canvas carriers comprise two separate clips that keep two surfaces apart (canvasses or boards). One clip fits on the bottom edges of the surfaces, while the other, with its carrying handle, fits on the top. The length of the drop of the two surfaces has to be equal, but they can be of different thickness and length across, making the carriers simple to use.

METHOD

STEP 1

The two surfaces are placed on one edge, with their wet surfaces facing each other [A]. Taking the clip without the handle, the screws on either side are partially undone to loosen them [C]. The clip is dropped between the two surfaces. The screw flanges [B] then slip along the central strut until they come into contact with the outer facing surface. The screws are now tightened, so the clip grips the two surfaces.

STEP 2

Now the bottom clip is firmly in place, the surfaces are carefully turned upside down, ensuring the two wet surfaces do not come into contact [D1–4]. The top clip with integral carrying handle is attached in the same manner. This produces a temporary portfolio that can be toted around.

CARRYING AN OIL PALETTE SAFELY HOME

What a waste to scrape off valuable paint at the end of a painting session away from home. Using bulldog clips, clip the palette to a piece of plywood that is bigger than the palette [E]. Protect this with a facing piece of plywood of the same size and keep apart with canvas carriers—using the same method as described for carrying wet work home [F].

DIPPERS FOR OILS

These clip onto the edge of your palette and hold small amounts of medium. When filled to the brim, paint-soiled brushes can be dipped into the contents without touching the bottom, to avoid depositing unwanted color. Dippers with caps are essential when transporting medium or to keep out air between use thereby preventing medium from drying out. Dippers are available in plastic (shown here) and also in metal with brass caps (to prevent rusting).

QUERY

"The end of a painting session outdoors is always spoilt for me, because of the problem of what to do with my dirty brushes. Do I clean them on the spot or do I carry them home dirty, with the added problem that the brushes will transfer paint to everything they touch?"

ANSWER

Don't mar your enjoyment of painting outdoors by cleaning your brushes there and then. You are likely to be tired and could become impatient and irritable, spoiling a good day's work. Collect your brushes and hold them together with a rubber band. Wrap the entire bundle in cling wrap. Not only will this protect the brushes and everything they touch on the journey home, but the stretch film will also shut out a lot of air and prevent the paint from drying on the hairs.

This method can also be applied to your palette not only for transporting back, but also when you want to preserve paint mixes between painting sessions at home.

NOTE: This method is ideal for carrying materials back from any art classes you attend.

The Essential
Pastel Painting Guide

Introduction

People are often taken by surprise when they discover that the rich portrait hanging on the wall is not an oil painting, but one completed in pastels. Most are only familiar with the colored chalks they handled in art classes at school. Furthermore, the very name pastel suggests a light and weak color. To most people, pastel painting is more generally associated with misty, light-filled landscapes; not rich and robust portraits in which the flesh tones have volume, fabrics are textured, and jewelry shines.

Pastels, far from being poor relations to the other painting media, can possess a strength and quality unique to themselves. Of all the media, I firmly believe that pastels are the least understood and appreciated. For those who have never tried them, they probably represent something that belongs in the realm of drawing. After all, being dry and in stick form, they more resemble pencils than paint. Most of this misunderstanding stems from the manner in which pastels are presented.

Pastels come in many varieties, including watercolor, oil, and dry form. Dry pastels are available in many degrees of softness and qualities. Softness is an intrinsic quality of working with dry pastels, as it dictates exactly how material can be employed. It is, therefore, essential to understand what to look for.

Frustration born of misunderstanding at the first attempt, in any medium, is one of the principal reasons that many aspirants give up and move on to something else. Pastels are most definitely worth a little extra effort and the time taken to understand them.

While some of the harder varieties could be classed as drawing tools, the soft artists' quality versions present a quite different range of characteristics. They belong alongside watercolors, oils, and acrylics, which is why their use deserves the term pastel "painting."

An artists' quality soft pastel is more or less a solid block of powdered pigment, temporarily held together by the smallest amount of gum to form it into a stick.

Unlike other painting media, this pigment laid on the surface is not viewed through a layer of medium. It is pure color that lies on the surface, delicately held in place by the texture of the surface on which it is applied. The directness of the stroke and the strength of color are unsurpassed by any other medium.

The cost of artists' quality soft pastel can prove a barrier and cheaper starter sets could provide an alternative with which to begin. However, the additional costs of artists' quality soft pastels are counterbalanced by the savings in not having to purchase tools such as brushes and palettes.

It is not necessary to start off with a vast collection of pastel colors; a limited range of colors would serve anyone starting off in this medium. It is, however, useful to have a range of tints in each color, to achieve the gradual build up from dark underpainting to highlights.

Why should working in a dry medium be considered painting, since there are no brushes involved? To achieve rich results with pastels, oil-painting techniques are borrowed with great effect, particularly that of working from dark to light, gradually building layer upon layer.

Eventually the pigment flows on as the pastel stick moves across the impacted color beneath. Working the stick begins to feel more like applying color with a brush, but with the distinct advantage that the flow of strokes is not interrupted through constantly having to return to the palette to reload the brush. Used this way pastel painting has much in common with the nature of oil painting and can be an excellent introduction to the technique of building layers of opaque color from dark toward light. Conversely, it is therefore a perfect alternative medium for the oil painter, who wishes to try their hand at something new.

While pastels are most commonly used in their original form, some can be made fluid. Brushing over dry pastels with water will make them flow fluidly across the surface. The resultant washes of pure pigment can be fixed more permanently to the surface through the introduction of additional glue (gum arabic or watercolor medium) into the water.

Watercolor pastels, however, contain additional gum in their make-up. Used dry, they are treated as any dry pastel. When wet with water, the color floats into all the nooks and crannies of the textured surface.

Oil pastels, on the other hand, can be made fluid through the use of solvents and should be treated as a medium in their own right, for they possess quite unique characteristics.

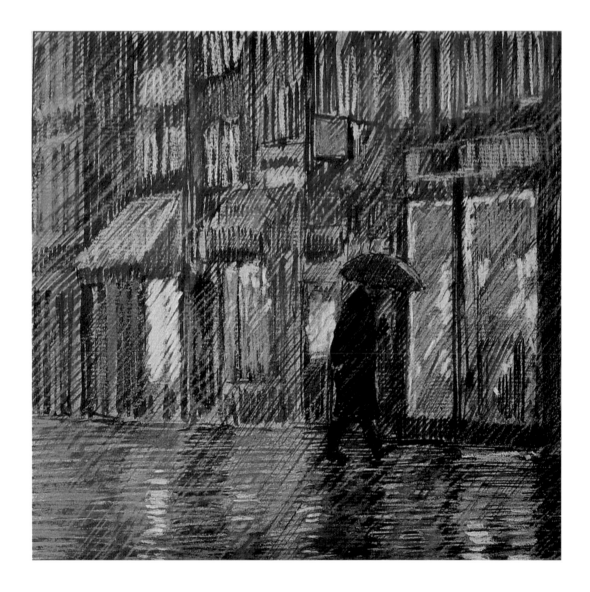

Equipment Focus

Pastel sticks

ARTISTS' SOFT PASTELS

The cream of the pastel range, these are composed of pure pigment, with only a little gum added to form them into a stick, which means they are incredibly intense. The most expensive are hand-rolled, thus their irregular shape [A] and are usually fitted with a paper sleeve for protection. This sleeve should only be removed gradually as the stick shortens.

SOFT PASTELS?

Many different varieties of pastel are termed "soft." The very softness of the artists' quality pastel is, in fact, its strength, and the amount of pigment to gum is carefully balanced to achieve the soft, yet non-crumbling consistency that is most desired. Test the softness by gently running the pastel across the palm of your hand. The test will instantly deposit color with hardly any pressure [B].

LAYERS

A hard pastel needs pressure for successful application and will disturb previously applied layers of pastel [C1]. The soft pastel, however, requiring little pressure, affords you the opportunity to build up more layers [C2]. After applying several layers, the surface will begin to feel "fluid," which can lead one to think in terms of pastel "painting."

RANGE OF TINTS

Mixing pastels is not as direct as mixing paints. It is essential, therefore, when layering, that you gradually build up the color towards the lighter values. To this end, each color has a range of tints. It is far more important to have a range of tints for each color in your palette, rather than a large range of colors. In this way you can achieve a sense of volume, depth, and light by working dark to light [D].

WARM AND COOL COLORS

Not only can you build from dark to light, but you can also overlay warm and cool colors [E]. To do this, layers are partially blended into one another with a compressed paper wiper [E1]. Alternatives for blending and smearing pastel are a rolled paper wiper [E2] or shaped-tip blenders which come with a variety of edges and points [E3].

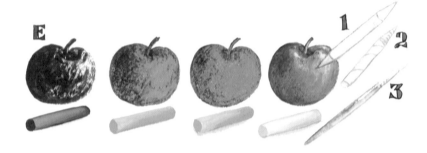

RANGE

In any artists' quality range of soft pastels the need for tints creates a comprehensive number of colors from which to choose [F]. Often this vast choice will deter, rather than excite a possible newcomer to the medium. Whereas it is possible in painting in general to start with six or seven colors, the very nature of pastel demands more colors at hand. How can you logically begin to build up a pastel range without breaking the bank?

> ### TINTS
> The gradual addition of white to the base pigment so that any one color ranges from its most intense and pure color (the darkest) to its lightest.

LIMITED STARTER RANGE

It is quite possible, in fact desirable, to start with an extremely limited range of colors. Here we have a range of tints in blue and brown [G]. With this set you can render both cool and warm areas of the painting. It will surprise you just how many subjects can be successfully executed with such a set. The colors are more or less complementary (opposites on the color circle) and when mixed, create grays. In [H1] matching values of blue were laid over and blended into their equivalent brown values beneath. In [H2] contrasting values of brown were laid over (left side) and blended (right side) into the blue. Try these two exercises for yourself and then try reversing the colors, before a third approach of applying blue over blue, or brown over brown, contrasting the values to achieve intense colors with strong textures. Really exploit all these possibilities before you add extra colors to your range. This will teach you a great deal about mixing and overpainting pastel layers.

INTRODUCING OTHER COLORS

Now you can slowly introduce other colors, ensuring you have a good range of tints for each color. The choice of extra colors could be decided by the subject for which they are required. For a landscape, greens may be selected [J], whereas oranges or brown may be the choice of the portrait painter.

Equipment Focus

Oil and watercolor pastels

OIL PASTELS

On first inspection, oil pastels appears to be a crude and messy medium. The pigment is bound in oil, and the sticks are so soft that keeping them sharp is impractical. For many years the range of colors in which they were available was quite limited [A]. That has changed, offering the artist the opportunity to build a collection with various alternatives for every hue [B].

Each oil pastel stick is protected by a tight paper sleeve, which is there to prevent soiling of your hands. This needs to be peeled away progressively as the stick wears down during use [C].

Oil pastels are prone to developing a surface "bloom" which disguises the actual color of the stick. To see this properly it is necessary to scratch through the surface—use your fingernail, a blunt knife, or rub them gently with your fingers [D].

CAUTION

When working on a painting that is not to be overpainted it is essential that thinning down is carried out with artists' distilled thinners. Cheaper substitutes may discolor or harm the ground, progressively damaging the work over a period of time.

The composition and nature of the pastels to some degree dictates the type of surface on which they can be used most effectively. Textured surfaces, such as rough watercolor paper, will inevitably break up each mark and may interfere with any attempt at detail [E]. The result, however, can be used effectively in its own right.

A smoother surface—from a hot-pressed watercolor paper, through card, to a smooth oil-painting surface—will yield a finer degree of control. On such surfaces, the physical blending of colors is rendered more easily as well as some limited line qualities [F].

On such smooth surfaces, layers of oil pastel can be overlaid and scratched through for very fine line work and detail [G].

Since the pastels are bound in oil, they can, just as oil paint, be dissolved and/or blended with oil thinners [H]. Should they be dissolved on paper, the result is likely to be one of partial absorption by the paper fibers, creating a staining effect. The non-absorbency of a prepared oil painting surface will effectively encourage the color to spread. This is an effective way to draw the composition, in color, at the beginning of an oil painting, and is a satisfactory substitute for dry media such as charcoal or for thinned down oil paint.

WATERCOLOR PASTELS

These pastels comprise of pigment held in gum, and as such, can be dissolved in water. Used dry they can be blended with a finger or stub, but once blended with a wet brush, the dissolved gum makes them more stable on the paper surface [J]. Watercolor pastels can be effectively used in conjunction with watercolor pencils, which will provide the line and detail against the pastel's ability to swiftly block in large areas of color.

Equipment Focus

Pastel paper and surfaces

Once dry pastel has been applied to a surface, it is simply an impacted dust. The gum that holds it in solid form does little to ensure its survival now, unless more glue, in the form of fixative, is added at some stage in the painting. The surface, therefore, has to provide a base on which the pastel dust can be stabilized.

On a smooth surface the pastel would easily slip off [A]. That is why a textured surface is essential [B], this texture being referred to as the "tooth."

WATERCOLOR PAPER

This is made with differing degrees of texture, from the very smooth finish known as Hot Pressed, through Cold Pressed to the more powerful Rough. The heavier, deeper surfaces will work well with pastel and also provide an absorbent surface on which it can be dissolved.

FLOCK PAPER

With a flock surface [C], the fibers are loose and exposed and provide an excellent vehicle. Alternatively, by damaging the surface of a smooth paper with fine sandpaper, unusual textures, not unlike flocking, can be achieved. Ideal for experimentation.

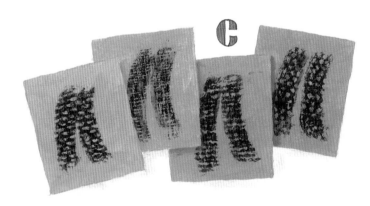

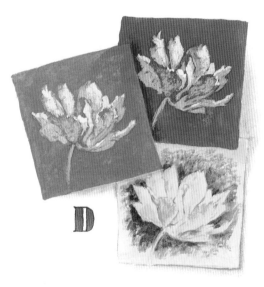

PASTEL PAPER

These are available in an extensive range of colors [D] with each manufacturer producing characteristic textured surfaces unique to themselves. It is best to try as many of these as possible to arrive at a choice based on individual preferences for style of work and nature of subject.

The choice of color can be crucial to the overall appearance of the painting and is helpful in the building of color layers. As the applied pastel is opaque, it can cover the paper, depending on the thickness and regularity of its application.

PASTEL BOARD/CARD

Pastel board/card is usually a thicker piece of card on which a specially textured surface has been applied in the manufacturing process. It is similar in feel to a sheet of wet and dry sandpaper, with a fine-toothed surface that is very responsive to, and protective of, the applied pastel [E]. Available in a variety of colors, the stiffer card makes it a more stable ground for the fragile pastels. Its thickness prevents underlying textures, such as the irregularities on drawing boards, from showing through as pressure is applied when painting on the surface.

SANDPAPER

While this is a temptingly cheaper alternative, it should be treated with caution. It is not acid-free and consequently any color change due to this or resulting from exposure to light will be accelerated. If the color beneath the applied pastels is not stable, then the whole balance and color harmony of the work may be at risk.

MAKE YOUR OWN

There are a number of interesting possibilities that produce a variety of textures. Here are just two.

Mix washed sand or, for a smoother finish, household wall filler into either acrylic medium or any PVA glue. Paint the mix onto very thick stretched paper, thick card, hardboard, or plywood [F]. When using the shiny side of hardboard, always rub down the surface with sandpaper to provide grip for the textured mixture that is to be painted over.

Acrylic texture/modeling paste can be applied to surfaces in the same manner. These pastes come in a variety of textures, such as pumice and marble dust. Pumice, being light, is excellent for laying on paper. For heavier surfaces, marble dust or others including silica, or tiny glass beads [G].

Once prepared, these textured surfaces would benefit from being painted over with watercolor or acrylic paint, to provide a base color.

Starting Off

From thumbnails to outline drawing

How do you decide on a composition? What's more, how do you start? Were you to simply commence in the middle of the paper, the chances are you would have run out of space by the time you reached the edges. It's far better to set down the compositional possibilities first as a series of thumbnail scribbles produced on a scrap piece of paper or in a sketchbook. Once the composition has been decided upon, the information is swiftly and simply translated onto the painting surface. No drawing skills are required for this starting off process, something I use all the time.

THUMBNAILS

A series of loose, scribbly sketches, produced no larger than a matchbox, the key to these being to keep the detail out of them. It is the outer frame and key elements within the composition that matter, not the detail of each element. Keep them spaced apart and well away from the edge of the paper to avoid confusion or an imbalanced composition. I find it useful to frame the view with my fingers so I can visualise the best proportions for the outer edges. It should take you no longer than ten minutes to produce six thumbnails, any

longer and you are overworking them. Change the position and proportions of the elements within the compositional frame. You can also change the shape of the outer frame of the composition. When working from a photograph, the proportions often dominate the first thumbnail, even though they may be inappropriate. Work exactly as you would if you were working in situ, moving things until you get a more balanced composition and one that you would be pleased to work up as a painting. This is the benefit of being an artist as opposed to being a photographer; you are in control of the composition, not it of you.

TRANSFERRING THE COMPOSITION

Now you need an accurate method of enlarging your chosen thumbnail to translate the composition up to a larger scale. It would, after all, be a total waste of all your previous efforts if could not achieve this successfully. Many painters using thumbnails for the first time simply start their full drawing in the center of the painting surface. This is to ignore one of the main compositional elements you have striven to exploit—the shape of the frame surrounding the composition. There are several ways in which to proceed. Here I show a measured method and by eye.

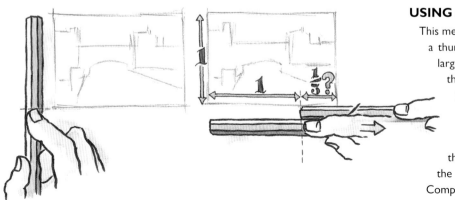

USING A MEASURED DRAWING GRID

This method is extremely useful when transferring a thumbnail or very small sketch onto a really large scale. It involves creating a grid over the thumbnail and a much larger one on the painting surface.

First you must work out your thumbnail frame proportions. Place a pencil along the shorter side of your thumbnail and mark the length by positioning your finger there. Compare the longer side of the thumbnail to this measurement. On the example shown the width of the thumbnail is approximately 1⅓ the length of its height.

Next, turn to the painting surface. The example shown is for a landscape format. You need to transfer the frame proportions to the painting surface. First, decide where one of the shorter of the two outer sides will lie and place a light pencil mark on either end of that side.

Take a large scrap of paper, lie it along the same length and mark it at the same two points. Draw a straight line between these two points so that the scrap paper now shows the identical length.

Move the scrap paper with its left point matched up to the bottom point previously marked on the surface and the straight line parallel to the bottom edge of the paper surface. Make a pencil mark on the surface corresponding to the right end point of the line.

Move the paper to the right approximately one third of its length and mark the surface. You now have the bottom side of the frame 1⅓ longer than the short upright side and in proportion to the thumbnail.

Use a set square to ensure the corners of your frame are at right angles. If they are not you will experience problems when you come to mount or frame your work.

The next step is to transfer the thumbnail elements to the painting surface. You can do this by using a simple or a more detailed grid system.

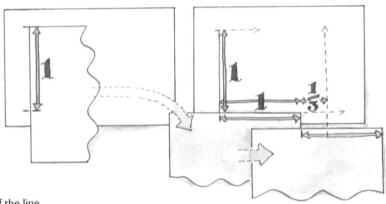

SIMPLE GRID Draw lines from corner to corner of your thumbnail and on the larger rectangle of your final piece as shown [A]. Adding another two lines through the center, parallel to the sides gives you a little more of a guide [B].

DETAILED GRID Useful when more accuracy is required. In this case the grid is composed of equal squares.

Many artists use the grid method, but it has two principal disadvantages. The grid, drawn across the painting surface, can be an irritation, as it either has to be erased (when there is a chance of paper damage) or painted over (which can lead to overworking). It is also time consuming and, I feel, particularly boring. What any artist does not need at the beginning of an exciting creative sortie is a technique that in itself can dampen one's enthusiasm.

Starting Off

From thumbnails to outline drawing

Luckily there is an alternative method of transferring proportions using the eye alone as your guide. This follows a system that everyone can master. Let us suppose then that you have just finished your thumbnails and have decided on the proportion of your painting.

USING YOUR EYE

Assuming that you want to use the maximum surface area for your painting, the first decision is which way to orient your board. In other words, is the format of your thumbnail landscape or portrait? Your drawing board should be turned to match this. This probably seems like an obvious thing to do, but it is easy to forget the obvious when you are in the heat of creativity and want to get going.

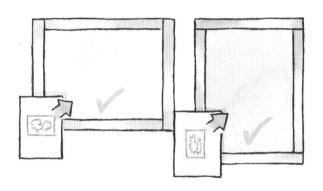

Next you need to transfer the frame proportions to the painting surface. Imagine your thumbnail placed in the center of the paper and slowly expanding until it reaches the edges of the paper. The two edges it touches first [A] are the sides to draw in first (top and bottom in example). Gently draw a line parallel to the edge of the drawing board (gently in case you have to erase it later, should you change your mind about something). Leave a space between it and the edge of the gum strip, so that a border is left around your painting. Do this for two reasons: first, color does not look well against the brown gum strip, which may cause you to upset the color balance of your painting because of the influence of the gum strip color; second, should you decide to expand your painting later on, you then have some spare space into which to do so.

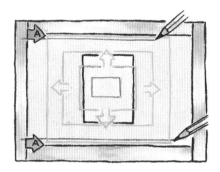

The remaining two parallel lines need to be positioned to complete the outer rectangle. To do this, place your thumbnail against one of the pencil lines, lining it up with where you feel the third edge could fall—as shown in the illustration (dotted blue lines you can see in your minds eye are not for drawing up). Mark lines with an X, the spot on the watercolor paper underneath. Holding the thumbnail in place, run your pencil in the air above the drawing board from the corner where the X is marked (this isn't drawn in place, only imagined as so), going through the diagonal on the thumbnail until you reach the opposite drawn line on the drawing board, marking this with a faint tick. To complete the rectangle, join the already drawn lines to the third and fourth edges—the starting points being the X and the feint tick.

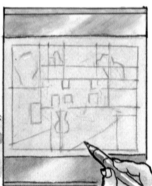

TRANSFERRING ELEMENTS TO THE PAINTING SURFACE BY EYE

- Imagine lines extending from key outlines and points in your thumbnail to cut through the sides of the frame. Those shown in the square are drawn in purely to illustrate the point.
- Turn to the painting surface and cut faint pencil marks through the sides at corresponding points.
- Extend lines inward to points where they end or meet others. Ensure the parallels or angles of the lines correspond to those on the thumbnail.
- Now you have the skeleton on which to superimpose the outlines of the principal elements and masses.

DRAW A STRAIGHT SIDE FREEHAND

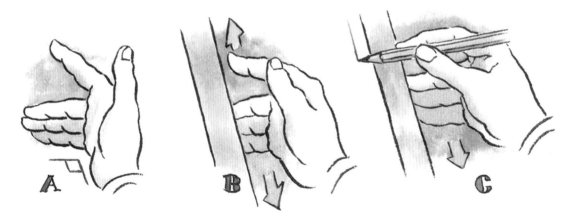

I personally don't favor using a ruler, for there is a natural tendency to push the pencil too hard. This makes the line difficult to erase later, when necessary.

The following method will need a little practice, but persevere and soon it will become second nature to you.

[A] Bend three fingers at right angles to your palm as shown.

[B] Press the flat side of these three fingers gently against the back of the board and practice running your hand up and down (keeping contact with the board at all times). These are your guiding fingers and can be lengthened or bent, depending on how far in you intend on drawing your line.

[C] Now place a pencil between your thumb and forefinger and draw the line—keeping your guiding fingers in place.

Project 1

Scratching through and limited palette

When applying pastel for the first time, many feel that it is quite a crude medium and become frustrated. Being as soft as it is, painters will find it impossible to retain a fine point on the stick, and to sharpen a point wastes valuable pigment. It seems at first that fine lines and control, especially along edges, will never be achieved.

The workshop in this project sets out to dispel this misunderstanding and demonstrates that controlled fine linework is achievable. Often pastel is heavily applied in order to selectively remove parts of it. The finest of marks can be created in this way, whittling down heavily applied pastel by scratching away its edges until the precise dimensions are realized.

Another aversion to pastels often occurs when painters feel they do not possess a wide enough range of colors to adequately do the job. Working with a limited palette is the answer, as demonstrated in the tutorial, something which in of itself is a useful exercise. For it helps the artist develop a keen eye for observing the tonal structure of a subject and the importance of value over color, when seeking to emulate light.

While the limited palette provides excellent service in the tutorial's miniature landscape, this is not the limit of its possible uses.

A whole range of subjects could be successfully treated in this way, including portraits, animal studies, still life, landscapes, and so on.

Project 1 Workshop

Scratching through

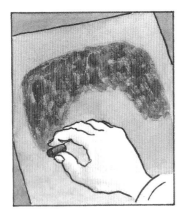

EXERCISE 1 With brick red apply first section of background at top of colored pastel paper.

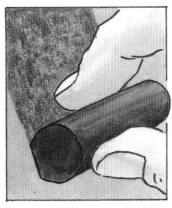

Use side of pastel segment for easy, fast coverage.

Use medium brown for second layer, dark brown for third and, end with dark blue.

Use stub to force pastel into surface of paper. Blend edges where colors meet.

Completely cover with a layer of white pastel.

Go over several times with increasing pressure, until you achieve required coverage.

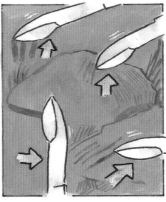

Use erasing knife to scratch through differing line widths.

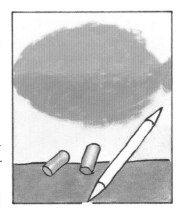

EXERCISE 2 Apply undercolors as before. Leave surround as self-colored paper.

As before, cover with white pastel, extending slightly beyond fish shape and scratch through.

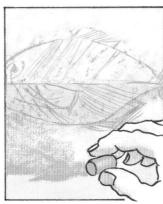

Apply second color over white on background to define the fish shape.

EXERCISE 3 Fix after first layer and after scratching through.

Add highlights using end or edge of pastel pieces.

Scratching through pastels, using an erasing knife, is a very dramatic technique to add to your repertoire. The linework is very powerful, and when used on its own, lends itself to a stylized design approach. Employed as one of the techniques being applied to a pastel painting, it offers an exciting range of approaches that can be manipulated to good effect.

<table>
<tr><td>MATERIALS
Pastel Paper
Selection of Soft Pastels
Erasing Knife
Stub
Fixative</td></tr>
</table>

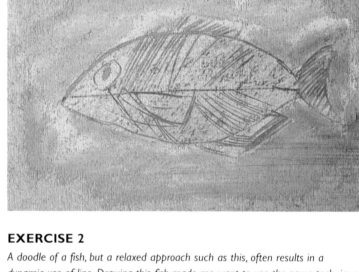

EXERCISE 1

The erasing knife is a perfect tool for this job. Having a curved blade, it is unlikely to tear the surface of the paper, even when working close to the point. Vary the line thickness by using different parts of the blade. Create texture and volume with hatching and cross-hatching.

EXERCISE 2

A doodle of a fish, but a relaxed approach such as this, often results in a dynamic use of line. Drawing this fish made me want to use the same technique for a whole underwater vista, conjured up purely from the imagination. Doodling like this ensures you stay relaxed and can help enormously in loosening your approach to sketching with pastels.

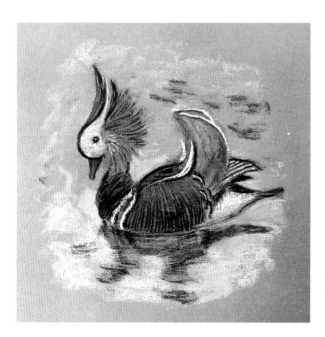

TIP

If you don't have an erasing knife, but would like to try this technique before making a purchase, use a penknife instead—the key is a curved blade, which is less likely to tear the paper surface.

EXERCISE 3

Inspired by a watercolor by C. F. Tunnicliffe, this mandarin duck is covered with a light blue second layer, rather than pure white. Once scratched through, fixing makes this second layer semitransparent, allowing the undercolor to come through and dulling the whole piece down. This is a perfect foil against which the rich colors of the subsequently overpainted pastel can shine. Note how the scratched strokes on the wing achieve roundness and volume for the body.

Project 1 Tutorial

Limited palette

You may not have a garden, perhaps you cannot get outdoors to produce a live landscape painting, or you may simply wish to develop your landscape painting skills in the privacy of your home.

Our friend, Japanese garden specialist and author, Robert Ketchell, volunteered to put together a sink garden, based on the Chinese and Japanese principles of creating Bonsai landscapes.

The art of Japanese gardens came out of China, these gardens being translated from Chinese scroll paintings of the landscape. This is why the Japanese garden is based on the same perspectives as a painting, both having a foreground, middle ground, and background. As with a painting, these gardens are designed around a fixed viewing point that draws your eye to the focal point.

As Robert will tell you when designing a garden, the Japanese follow the same principles as a painter, "It is the small that makes the large look larger; the bright that makes the dark look darker, the incomplete that makes us imagine the complete.

"The garden, like a painting, represents an idealized or conceptual vision of the landscape; it does not copy nature directly."

Here we complete the circle, the visual image of a landscape translated by Robert into miniature form, now translated back into a visual image—a painted landscape.

COMPOSITION

Robert was asked to plant up the sinkscape from an unusual perspective. Rather than the usual straight on view, he was asked to approach it from a three quarter angle, with the fixed viewing point being one corner of the sink. The painting could have been tackled in several ways.

1. From within the sinkscape whereby the painter puts him/herself inside the landscape and paints the view around.
2. A view looking over the landscape, leaving out the sink, so that it appears as a full-scale landscape.
3. As here, a living still life, with the sink in full view.

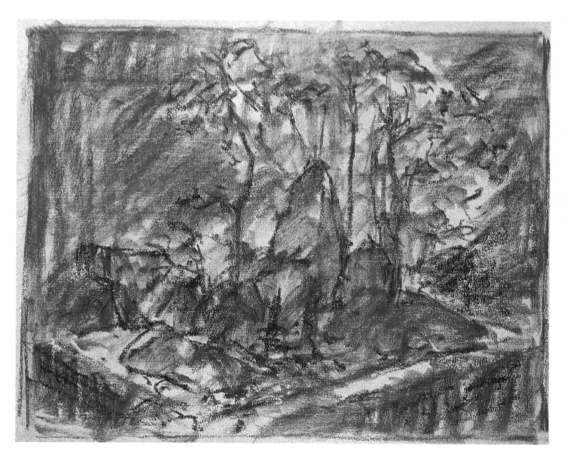

STEP 1

Sketch out and block in the composition using the darkest tint of brown. Soften with a stub into the surface. This not only softens the texture but also stabilizes the surface. With the black, redraw the forms more dramatically and lay some dark values under the areas which are to be over-painted with green, of which you will only have mid to light tints.

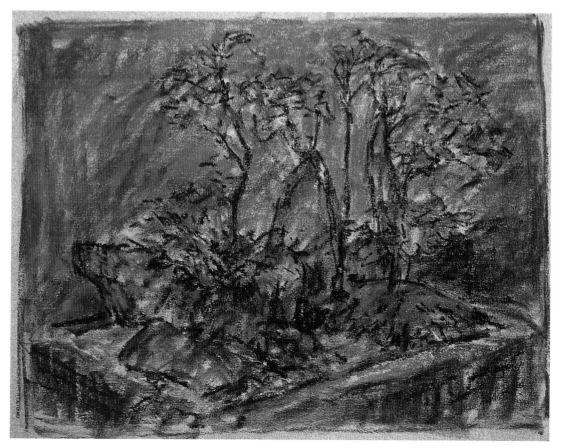

STEP 2

Apply the first layer of pastel for the leaves and mosses using a mid-tone blue-green. The negative shapes between the trunk and branches of the trees need to be reinforced with a lighter tint of the brown. Strengthen drawing and contrast, using line worked in black. As before, soften and stabilize this with the stub. It is of great importance that the work should look dark and dull at this stage.

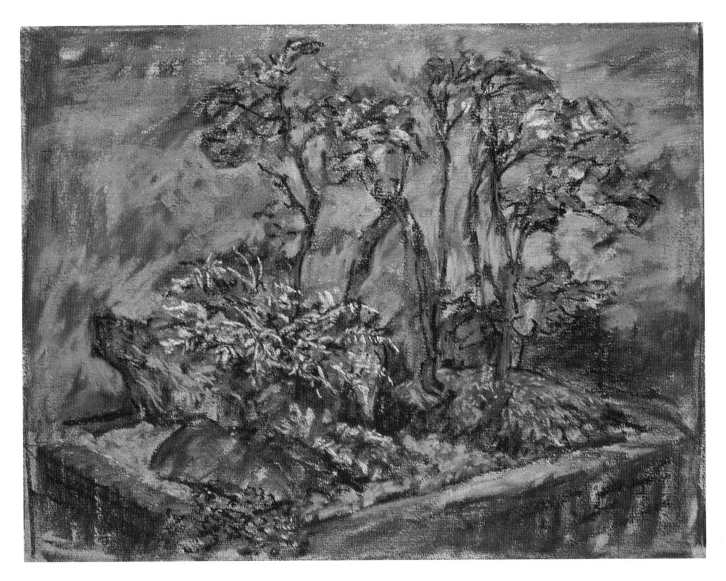

STEP 3

*An even lighter version of the brown should be applied to the background, reshaping
the trees (negative painting) and establishing rhythms throughout the soft background.
A little of this sprinkled through the foreground will hold the composition together.
A variety of texture is essential to impart visual excitement. A light blue-green highlight
applied to the foliage begins the process of bringing out form. Variety of stroke is all-
important—different angles of application and differing pressures add to the mix. Note
the amorphous silhouette of the fern versus the sharp edge of the foliage below it,
sharply delineated by the rock (bottom left). A mid-tone brown running down the tree
trunks will give them some solidity, and this should be carried across to the left-hand
edge of the sink. Completely reestablish the small plant right at the front of the sink
with black line drawing, followed by several blue-greens. Compositionally this plant is of
great importance as it lies at the meeting point of the diagonals of the top edges of the
sink. Without its softness there would be a sharp corner here, which would engage and
draw the eye away from the more important elements of the whole sinkscape.*

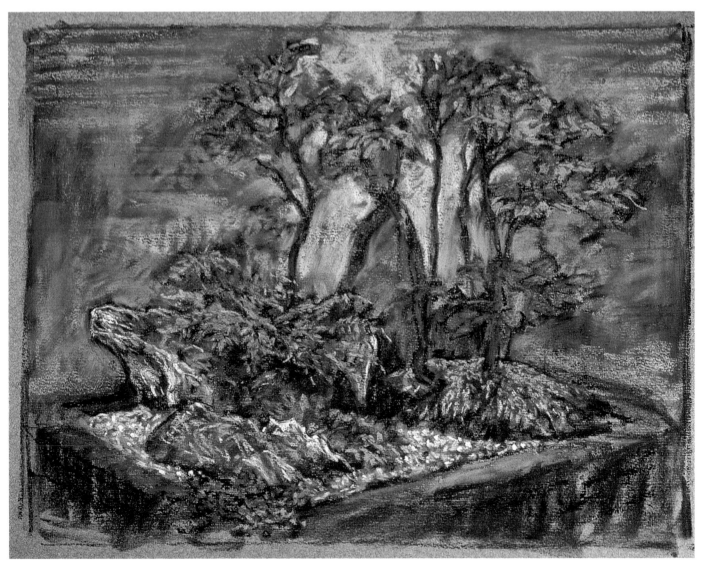

STEP 4

Use a yellow-green on the leaves, stones, and foreground foliage, and immediately follow with even lighter yellow-green splashes of light on the top of leaf platforms and rock tops. Apply a gentle tint of lighter blue-green over some points of the background to make it recede—this should be applied with the edge of the pastel to yield a very thin layer. Use a finger to blend this into the background. A few parallel strokes of the same color hint at the texture of the bamboo screen behind the sinkscape, without slavishly copying the perspective. A lighter brown is again used centrally behind the tree trunks and to highlight foreground textures.

NEGATIVE PAINTING

The painting of the space around an object. Negative space describes the silhouette of an object and is an essential element in its overall form.
Negative painting is every bit as important as its counterpart and it is important to recognize its significance. Through understanding this you will grasp a more vital impression of the subject.

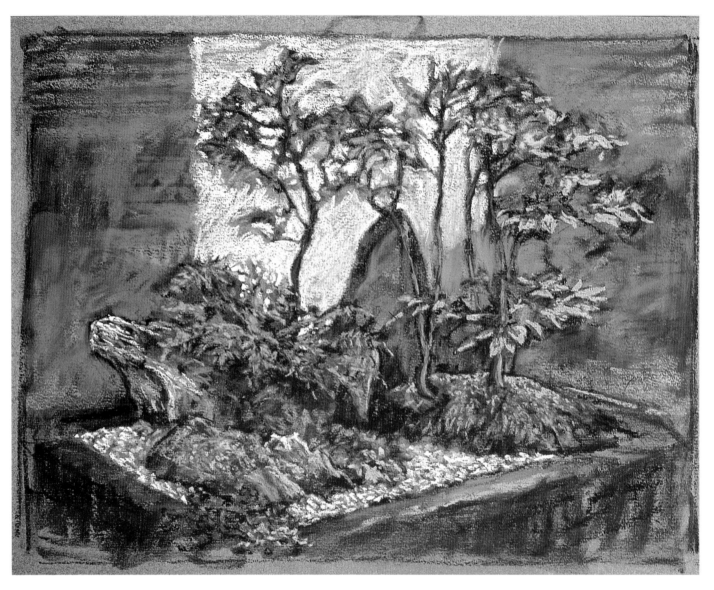

STEP 5

As the afternoon progressed, a reflected light from a nearby window lit up the bamboo screen behind the trees. This created a wonderful silhouette of these trees and the stone, and I exploited it immediately, working pure white into the central slab. Unexpected moments such as this are a good reason to work on the spot, in natural light. As the sun had been hidden behind clouds ever since Robert had planted up the sinkscape, there was no hint this would happen, and it resulted in the whole piece being changed for the better. The edges of the leaves, picked out in a sunny yellow-green, curve down the outer edges of the trees. This yellow-green follows through to the rocks and plant foliage. The lower trunks of the trees were lightened with brown. They are now light against dark at their base and dark against light further up against the reflected background (counterchange). The rock on the left and gravel were given textured highlights of pure white. (Note how all the "white" areas help the overall design by creating a patchwork of contrast.)

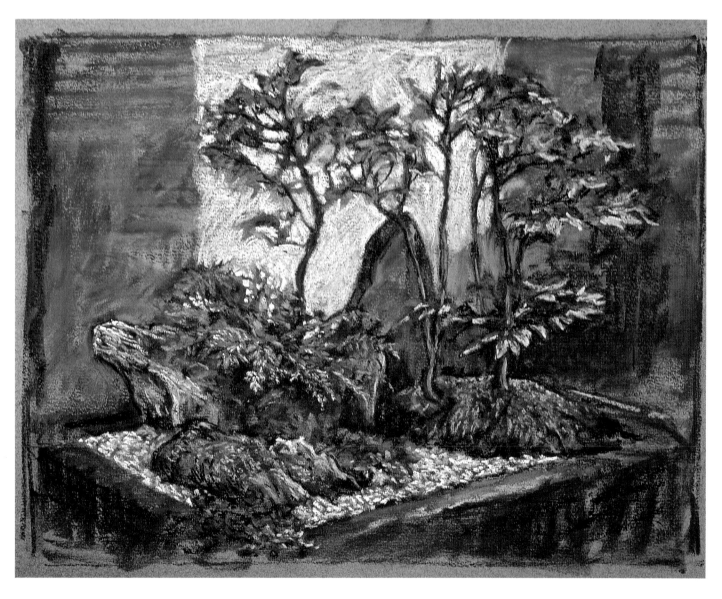

STEP 6

If you feel, as I did on this occasion, that the final green highlights are too intense, some of these can be wiped over gently with a brown. Still requiring a tonal contrast, however, the background color is darkened. The edge of the bamboo screen occurs in this area and is achieved using the dark brown in a vertical slab, echoing the white of the previous step. To balance this, a thin version of this element was introduced on the left. In theory this is the left of the bamboo screen, although in reality it is far outside the subject. From this, once again, you can see how, when working on the spot, elements can be incorporated which simply might not be seen outside the bounds of a photograph. For lack of a lighter green, white is used as a final highlight on the fern. Final black linework will delineate fine branches in the trees and textures in the rocks. This gives a slightly Oriental feel to the work, as linework is of such great importance in Chinese or Japanese art. The temptation to finish off by picking out the pattern detail on the sink should be avoided as it will only detract attention from the rocks and the trees themselves.

EXERCISE

Use this tutorial to its fullest and take sections to teach yourself these techniques.

COUNTERCHANGE can be found in the fern that sits between the two rocks, where it is dark against the background and light against the rocks.

NEGATIVE SPACE runs through the delicate trees, helps to define their delicacy.

DARK TO LIGHT is most noticeable on the moss-covered rocks in the foreground.

DIRECT HIGHLIGHTS are shown in the accents of yellow-green where sunlight strikes.

Tricks of the Trade

Fixing pastels

Being composed of almost pure pigment, pastels are one of the most direct and rich media available. With no gums or oils to fix them to the surface, they depend on the texture of the surface on which to hold fast. Lack of a suitable ground can lead to difficulties when applying the various layers, of what is, in essence, colored dust. The pastel becomes unstable and difficult to overwork and is likely to loosen off the surface. Even with a good ground there usually comes a point at which the pigment needs to be fixed, but this needs to be done with great care so that the delicate pastel qualities should not be lost.

HAIR SPRAY

Frequently used as a substitute. While this stabilizes the powdery surface, a cocktail of chemicals is also being applied that, far from protecting it, could damage the work.

ACRYLIC MATTE MEDIUM

This medium provides a very strong option and is excellent for bold pastel layers, especially when combining with other media. Dilute with up to 10 percent water. Spray your work using a plant mister [A]. Apply carefully, to avoid cockling. Keep the work flat as the "fixative" dries. Wash out equipment thoroughly after using acrylic medium, for once it dries it is difficult to remove.

DRAWING FIXATIVE

Suitable for chalks and charcoal, as well as pastel, this contains a resin that hardens to consolidate the powdery surface. It must be sprayed gently across the drawing—the general rule being several light layers, rather than one heavy one.

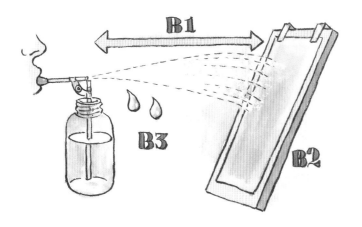

The bottled variety is diluted in methylated spirits, which evaporates swiftly after application. Use a mouth diffuser to atomize the fixative. Do not stand above the work to apply, or you may find drops of fixative landing on your drawing causing unsightly splashes, which are impossible to remove. If you spray too close to the work, the air pressure and the impact of the spray can move the pastel. Always test the distance of the spray [B1] and place your work upright or at a gentle angle at the point where the spray has just started to lose its velocity [B2] so the mist simply drifts onto your work. Any large drops of fixative should fall harmlessly away, before reaching the drawing [B3].

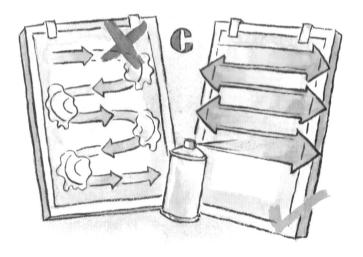

Fixative in aerosol form provides a finer mist. Start spraying at one side of your work and at the top. Move down, ensuring you do not "turn" above the work as this can cause pooling or uneven application [C]. Instead, go right across. It is advisable to place a protective surface between your work and any objects behind it that can be damaged by the fixative. Always shake the can before use and try to use it at normal room temperature. When you have finished, turn the can upside down and spray out any excess that could dry and clog the delicate nozzle [D].

GENERAL TIPS

Apply light coats of fixative to minimize color change which occurs as the pastel dust dissolves into the freshly applied, still-wet fixative. While you can make every effort to minimize the effect, you must inevitably come to terms with the result.

SAFETY FIRST

It is essential to apply all fixatives in a well-ventilated area, preferably outside. Beware of any wind that could blow the fixative back toward you.

EXERCISE

Produce a simple sketch in pastels. Cover a section with a piece of paper and fix [E]. Remove the paper. You will immediately see how much color change has occurred [F]. Armed with this knowledge, you can adapt your technique to suit. Many artists fix early layers in a painting, but leave the final layer to prevent it from changing in nature.

Common Problems

Artists' soft pastels

QUERY

"I find it very difficult to keep my pastel sticks clean and eventually it is impossible to see their colors properly. What can I do to avoid this?"

ANSWER

Pastels get dirty when they rub against one another and transfer unwanted pigments. You must evolve a method of working which keeps the pastel pieces as separate as possible.

SOLUTION

Try not to hold more than one piece of pastel in your hand at a time [A]. It is very tempting to keep three or four pieces in your spare hand while working on a specific area, which requires all of them. They will, however, begin to color your hand and consequently each other. Use a piece then put it down or, preferably, replace it in your storage box.

When choosing a new color, begin by running your nail around the top of the pastel [B], which will then snap off easily [C]. Use this piece to paint with, replacing its "mother" in your storage box. As soon as you are finished with the piece, replace it next to its mother [D]. Even if "baby" becomes dirty, "mother" will always be clean ensuring that you are always able to identify its color.

WARNING

Don't leave your pastel at the framer. Most, being concerned for the safety of the work, will fix it as soon as you are out of the door. You may not notice this once it is framed. It will, however, have lost much of its impact. Far better to ask your framer to produce a detachable back so that you can pop the work in yourself.

QUERY

"If I work too long on an area, it becomes difficult to cover. Should I rub some of the pastel off and, if so, what should I use?"

ANSWER

The speed at which the surface "clogs" will depend on the tooth of the surface on which you are working.

SOLUTION

Try different papers or boards and experiment with surfaces to find one that is suitable for the amount of pastel you like to employ. Once the surface becomes overworked, it is difficult and messy to remove with a rubber. You could gently scrape some of the pastel away, with the rounded blade of an erasing knife [E]. Alternatively, you could use fixative, which will stabilize the surface, allowing more layers to be applied [F].

Check that you have not accidentally mixed harder pastels with your soft ones. These will simply not deposit color on the soft layers beneath, but rather, the soft color will transfer to them.

QUERY

"Is there any situation in which fixative shouldn't be used?"

ANSWER

When fixative is applied the particles of pigment consolidate, the top layer merging with that below. Inevitably the dark underpainting reappears to some degree, darkening and dulling the overall color balance. This is especially noticeable on soft thin areas of color, such as those produced when the pastel has been smeared or blended across the surface [G]. Softness and subtlety are lost, leaving only bold, solid, pastel strokes [H]. While this can be infuriating, it can also be put to good use if the piece has begun to look too light and insipid. Every cloud has a silver lining! Heavy fixing will impair even the strength of powerful pastel strokes, such as highlights [J]. As a result, many artists believe that while it is useful to fix early layers of a pastel, it is prudent to leave the final layers and highlights unfixed.

QUERY

"I've been told that pastel is a messy medium and therefore have been discouraged from trying it. Should I have this concern?"

ANSWER

Pastels can be messy if you are not organized. There are two simple precautions to help cut down the problem. Don't be tempted to ever blow across your work to remove a build up of loose pigment [K]. Should you do so, the pastel dust will float away and land elsewhere, soiling furniture and fabrics. Instead, simply tap the side of your board [L] so that loose particles fall directly downward. Now you know exactly where to apply the vacuum cleaner at the end of a session. Work on an easy-to-clean surface and protect the floor beneath it. Changing footwear when moving out of the area in which you are working helps to prevent you from tramping pastel dust to other parts of the house.

Project 2

Watercolor, oil, and dry pastels

Starting with pastels does not need to cost the earth. This project covers three different types of pastel, which can be used for anything, from a quick sketch to a more finished study.

The first part of the workshop covers watercolor pastels, a wonderful stepping stone, either from drawing into painting, or from watercolor into pastel painting. As their name suggests, the pigment in watercolor pastels is bound with gum and formed into a stick. The gum is the medium that glues the pigment to the surface. Since watercolor pastels eliminate the use of a palette and allow the use of fewer brushes, they are an excellent medium to carry at all times for making reference sketches.

Oil pastels, on the other hand, are quite different and are demonstrated in the second part of the workshop. As their name suggests, these are oil-based and can also be dissolved, not in water but with oil thinners, such as turpentine or white spirit. While the household variety of both thinners would be cheaper, they are not recommended for they contain many impurities that can stain or damage the painting surface. The purer artists' quality is preferable. The workshop demonstrates the gradual build up of oil pastels, using a limited palette of neutral grays, which are then blended together.

The tutorial deals with hard square pastels, which I refer to as "sketching" pastels. Bought as a set, these provide a relatively inexpensive and easily carried option. While this set contains a limited range of colors, the palette can be extended if required.

Just as there are a variety of different pastels worth exploring, so too there are any number of painting surfaces on which to work. What may work well with one kind of pastel, may not work with another. Only through testing out the different possibilities, with various pastels and techniques can a repertoire of options be achieved.

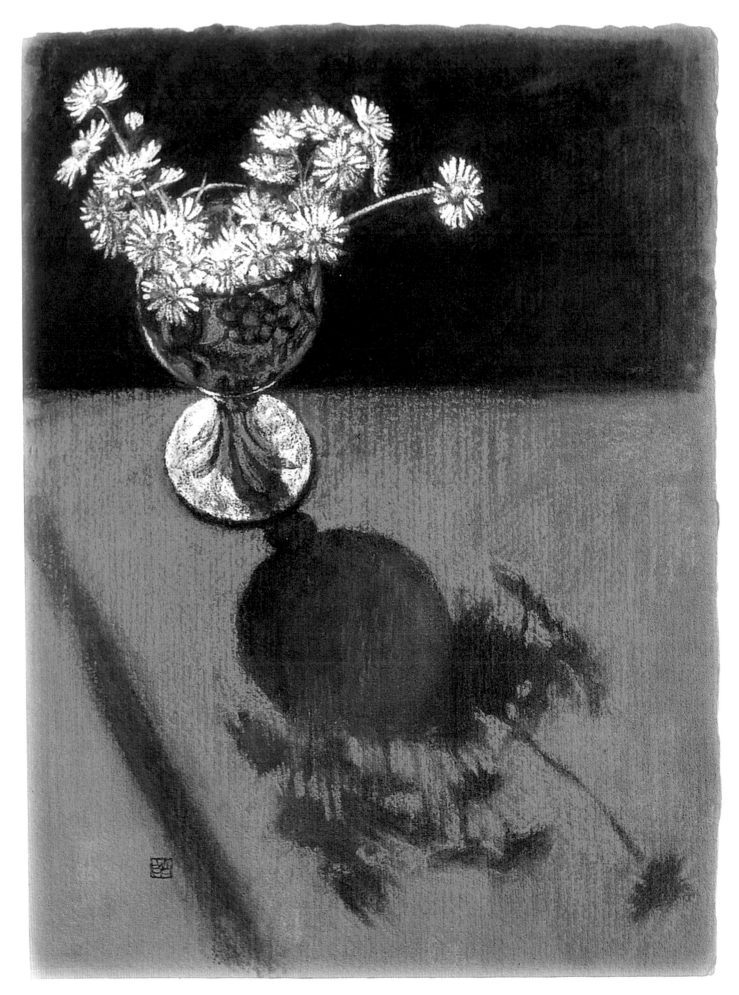

Project 2 Workshop

Watercolor pastels

From a set of watercolor pastels such as this, restrict your palette to two family of colors.

Try several paired combinations before attempting larger groupings of colors.

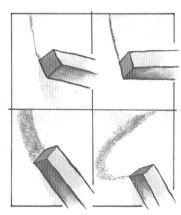

STUDY 1 Exploit the different strokes the square pastel can produce.

While dry, corrections or highlights can be reestablished using a putty rubber.

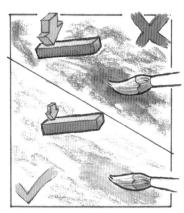

Keep pastel light, as the pigment spreads and darkens on wetting.

Use different aspects of the wet brush to generate different effects.

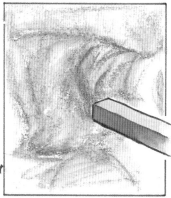

After solidifying and detailing with the brush, finish with pastel strokes so pastel dominates.

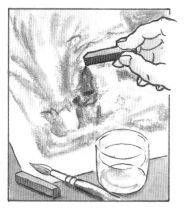

STUDY 2 Begin as above, but introduce a second color for the second layer.

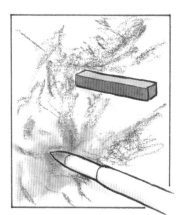

STUDY 3 Having applied the first gentle layer of pastel, blend with paper wiper.

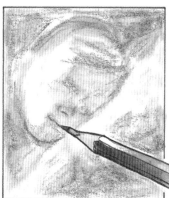

Detail can be added with a watercolor pencil.

Before either are wetted they are not fixed and can still be erased for highlights.

As both are water soluble, both could be softened with a wet brush.

While providing the dusty softness of pastel strokes, watercolor pastels can be softened into washes by adding water. These are excellent for working outdoors, on occasions when you can only carry a few materials, but still require a choice of approaches with which to capture the inspiring subject. These studies are carried out with a few colors selected from a landscape set of 12 square water-soluble pastels. Cats were chosen as the subject for they easily become bored with posing for any length of time, and a quick sketch is all that can be executed! They are ideal, therefore, when practicing the art of being fast and loose with materials and techniques.

MATERIALS
Watercolor Paper
Set of Watercolor Pastels
Round Watercolor Brush
Kneadable Putty Rubber
Watercolor Pencils

STUDY 1

In this sketch of our beloved cat Arthur, at one of his more energetic pursuits, just one color was used. After the first blocking-in layer I did notice that his head was too large. Luckily, the second layer enabled me to reduce his head and extend his hindquarters. If you look carefully at the drawing, you should discern where these changes took place. Look, for example, at how his right ear has shrunk. It bodes well for any medium that can accommodate this degree of correction without losing its overall freshness. Use this study to not only get a feel for the pastels, but also for correcting mistakes, or altering something with which you are not happy.

STUDY 2

Here we have Bumbie—a completely white cat—living up to her oft-quoted title of "princess." For this study, two colors are employed and you can see how the sanguine color (rusty color) shines through the sepia (dark brown). I personally prefer to work with a limited palette when using this type of pastel. Bringing too many colors into play often leads to them fighting one another. I believe that it is only when you are using artists' quality soft pastels, with their range of tints for each color, that several colors can be successfully applied to the same study.

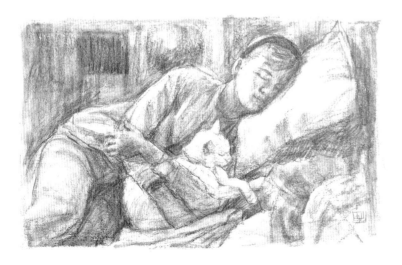

STUDY 3

This is Bumbie's brother Hodge—again completely white and with a passion for women, especially if he can curl up in their arms. For this I mixed the media by introducing a Venetian red watercolor pencil to finish off detail where necessary. I believe in mixing media only where each provides a quality unique to itself and not achievable by the others. Here the pastel yields a wonderfully soft, fluid underpainting, with plenty of suggestion, while the pencil brings focus exactly where required, around the human and cat features. Using watercolor pencils allows the possibility of simultaneously softening both their line and the watercolor pastel masses with the application of a damp brush. As it was, by the time I had applied the pencil work I decided that I had retained enough softness in the drawing and this was unnecessary.

Project 2 Workshop

Oil pastels

Being oil-based oil pastels are resistant to water.

They dissolve in thinners such as turpentine, odorless thinner, and white spirit.

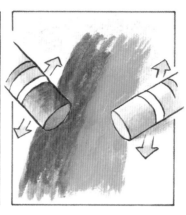

To blend, lay over or work into each other.

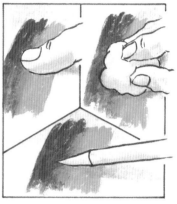

Further blending is achieved with finger, cloth, or paper wiper.

SGRAFFITO Scratch through layers with erasing knife.

COLORS Oil pastels are available in a relatively small range of colors (for pastels)—so blending is essential.

Overworking can lead to flattening of color and value.

To overcome, build color mixes with hatching and cross-hatching.

Use direction of stroke to describe form.

Start off with a limited range of grays (rendering set).

Drawing on colored paper or card gives contrast and extra dimension of color.

Surface tooth of pastel papers yields unique textural qualities.

A simple exercise using oil pastels to show the versatility and potentially dramatic nature of this medium. As with watercolor pencils, these pastels can prove to be an invaluable tool in your traveling kit, especially if you are looking to swiftly capture the character and colors in a bold view or exciting situation.

<div style="border:1px solid">

MATERIALS
Pastel Paper
Oil Pastels
white
light, medium, and
dark gray
black
Paper Wiper
Erasing Knife
Thinner
turpentine/odorless thinner
or white spirit

</div>

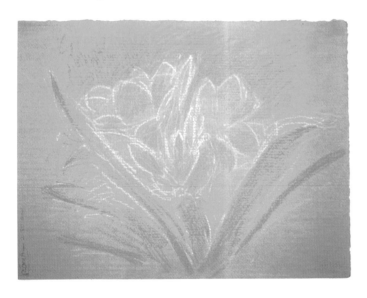

STEP 1

Use the tip of the light gray pastel to sketch in the broad masses of the flower structure. There is no point in snapping off small pieces of oil pastel, as the softness of the medium rounds off its edges very swiftly. Just work down from one end, gradually tearing away the paper sleeve as it wears down. Occasionally revolving the pastel in your grip does alter the stroke, but generally apply with gentle pressure to facilitate changes and allow overdrawing and corrections. Use the dark gray, to begin to show the silhouettes, giving some solidity to the forms.

STEP 2

Use the medium gray through the background to establish negative spaces between the leaf blades. Flower heads, by contrast, take on the color of the underlying paper. These are given some light strokes of the same value, which curve up from the interior of the flowers, expressing their funnel-like nature. Two things will now begin to happen. The extra pressure begins to fill in the paper's tooth, giving solid color. The colors begin to blend as they are overlaid. The dark gray should now be used along the petal edges adding linework and accents.

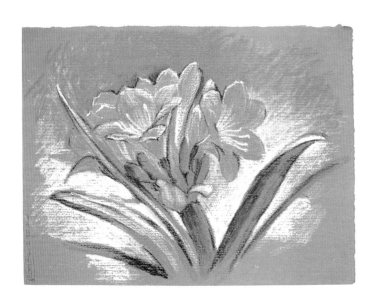

STEP 3

Strong accents of black are added in this final layer. They are added now so that they can be overlaid or blended where they prove too strong. The background is reinforced with both the light and medium gray, in some areas becoming quite solid. Save white highlights until this moment and even now, use the white with restraint. Overenthusiastic highlighting with white can be scraped away or reduced with an erasing knife. Slowly, in areas that become dense with pastel, the tones can be worked or blended together with the pastel point (e.g. grays beneath flowers).

Project 2 Tutorial

Dry pastels

I was just about to mow the grass, when a patch of daisies caught my eye, their cheeky little flower heads peeping between the blades of grass. They were soon picked and placed on the kitchen table.

SETTING UP

This arrangement came about quite naturally, the result of simply placing the flowers into a Spanish goblet laying around on a shelf in the kitchen. What I did take time over was the positioning of the goblet to make the most of the dramatically strong sunlight of the day. Placing it on the edge of a table bathed in sunlight created a dramatic shadow in the foreground, while setting it against a dark background ensured the white daisies were stunningly silhouetted. To the left, a shadow cast by the window, not only suggested the latter, but also provided another element of drama within the composition.

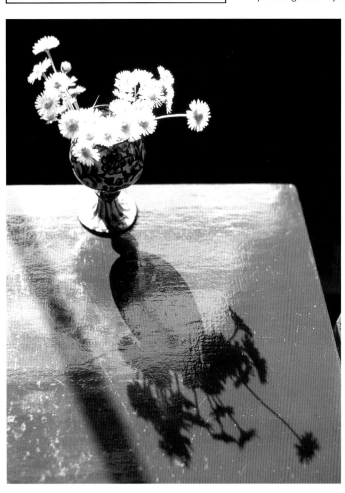

MATERIALS

I selected a set of 24 square dry pastels, which are harder than the artists' soft pastels and, being available in a limited color range, demand a bold approach. For the surface, I used a burgundy-colored sheet of pastel paper. Using the smoother side, which provides a less rigid grain of texture. The edges were left raw and torn in this instance, again for that added interest. To prevent the texture of the drawing board showing through, the paper was clipped to a piece of card, which was then pinned to the drawing board.

COMPOSITION

Note how the balance of masses was adjusted and the line of the table softened, so as not to dominate. Note also the counterchange of the flowers (light against dark) to the shadow (dark against light). As the drawing progresses, notice how the base of the goblet changes from an ellipse to a circle. This is artistic licence, for it could only truly be a circle if you were looking at it from directly above. The circle, however, is more powerful and more effectively links the shape of the goblet to its shadow, improving the overall design.

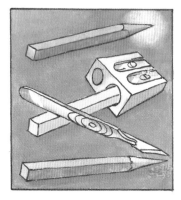

Sharpen one end of pastel stick with large sharpener or sharp knife.

Explore different ways of making lines with pastels sticks.

Try using pastel for broad strokes.

Try spontaneous strokes to explore descriptive quality.

STEP I

Working swiftly (to prevent fiddling), broadly outline the masses in mid-brown. With the same color use the flat edge of the pastel to block in the masses. Do the same for the table, using an orange. Overall, allow the color to fade towards the edges of the paper. Begin work on the flower heads using soft strokes of blue, and the outline shape of the goblet in orange, to suggest light reflected from the table. Colors are blended with the pastel blender, working from light to dark colors, so as not to dirty the light colors.

STEP 2

The limited range of colors demands the use of black as a defining undercolor. Use it for line drawing within the goblet and solid negative shapes behind the flower heads. For blending, in this case make use of the compressed paper stump, utilizing both point and edge for different effects—just as you would with brush and paint. Orange strokes applied across the table, define shadow and exploit the paper's texture, allowing the undercolor layer to show through. Some of this color is used to capture the reflected light on the underside of the bowl of the goblet. To relieve the harshness of the previously applied black, overpaint with a blue-gray pastel and work in with the fingertip.

FIXING

Fix the painting at the end of step 2. This is advisable with more solid pastels, as it helps to stabilize the surface. Subsequently applied highlights will require increased pressure, and without a stable surface this cannot be achieved. Some of the subtle blends will be partially lost on fixing (e.g. blue over black), but can be reestablished, if necessary, during the final stage. No more fixing should take place after step 2, as the gentle colors will disappear.

STEP 3

To establish the petals, begin by blending in a light blue along their length. The warm paper color beneath makes this blue a gentle gray (cool color over warm). Study closely the characteristics of these flower heads. Also note the incredible diversity of negative shapes between these heads and individual petals. Place green into the flower centers and along their stems.

Detail 1 *(Above)*

Gently color the black background with yellow around the flowers (reflected light from their surface), then grade overall background from red, above, to blue, below.

PASTEL BLENDERS

FLAT PASTEL SHAPER

Use this to soften broad areas of background or between petals.

ROUND PASTEL SHAPER

Use this to soften along individual pastel strokes or across more rounded forms.

TIP

Continuously wipe clean on paper towel or they will transfer colors rather than blend.

Detail 2 (Above)
*Overlay the daisy centers with a mid-yellow, left unblended to suggest
the texture of the stigmas. Sharpen the point of a Yellow ocher pastel
and draw in petals more carefully, varying pressure to improve shape
(warm color over cool).*

SAFETY FIRST

When using a sharp knife it is essential you
protect yourself from harm.
Never have the blade facing you. Always use a
cutting motion away from the body. Never
hold the knife anywhere near your face. Keep
your distance from other people to ensure you
do not accidentally cut someone else. Children
should never be allowed to use a sharp knife.

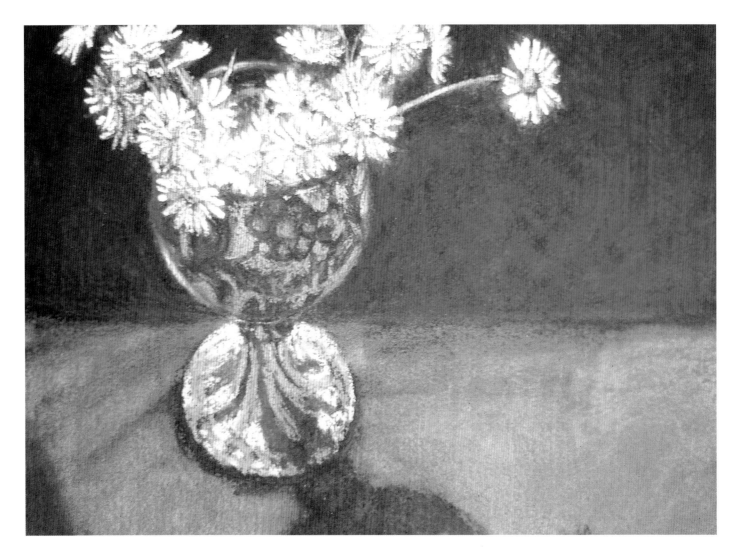

Detail 3 (Above)

Add light green to white highlights on the stems, light yellow highlights
to the flower centers, then turn your attention to the goblet. Here the
colors are worked through to light with blending being concentrated at
the edge of the bowl to suggest the receding edge of this rounded
form. Note how midtoned colors are worked onto the stem base,
before the white of the highlights. Without these, the white would have
no color, whereas on top of color, the white appears as a very light
color.

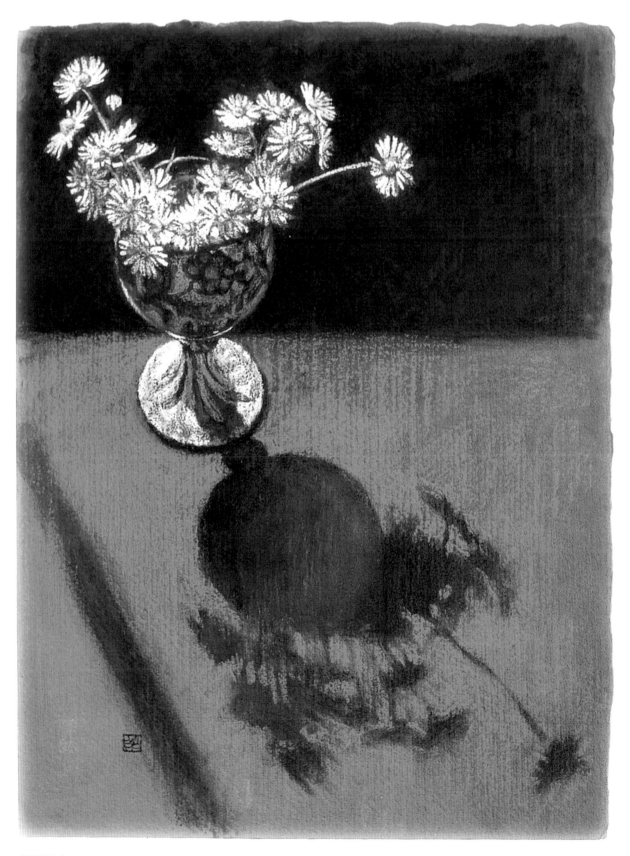

STEP 4

Finish off flower heads with white, employing varied pressure to suggest strong or gentle light. The shadow of the table is gently lifted with blue to suggest reflected light, then the surrounding orange is intensified and the silhouette reshaped.

COMMENT

I did consider adding the reflection of the window and the goblet into the table. However, at this stage, I felt it would detract from the drama of the shadow shape and stopped before overworking could undo the design.

Tricks of the Trade

Using a kneadable putty rubber

The kneadable putty rubber is one of the most versatile tools available to the pastel painter. As well as erasing, it can be used for many of the tasks that are achieved when using a brush in painting. They vary enormously in character from one manufacturer to another, with some being extremely soft and malleable, while others are somewhat stiffer. Hold one in the palm of your non-painting hand as you work and the warmth will soften those that are a little tough.

STORAGE AND USE

Between uses, store the rubber in a tin, matchbox, or jar, or wrap it in cling wrap. If left exposed to air, it will deteriorate, resulting in over-hardening or over-softening [A].

While the rubber can be cut down, with the unused section being stored for future use, don't pull the soiled parts off and discard them. Even though the rubber will become discolored, it should be turned in on itself to expose a clean part and also retain its bulk [B]. This prevents it from becoming smaller, resulting in more practical and longer use. Eventually, when it has become too dirty overall and there are no further clean parts to expose, discard it and replace it with a new one.

USED AS A "BRUSH"

As with the brush, the rubber can be used to create line, lift-off an area completely or in part. It can be used with stencils in both the removal and application of pastel, going far beyond the mere task of erasing.

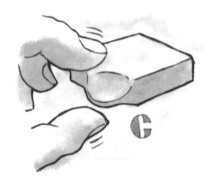

Although the rubber can be squeezed into almost any shape, the most useful by far is a flat chisel [C]. Using this shape to lift the pastel is the equivalent to the lift-off technique in painting. By applying it in different ways and different directions, a variety of marks are achieved [D]. Masking and lifting, another painting technique that can also be emulated, using paper, card, or clear acetate masks [E].

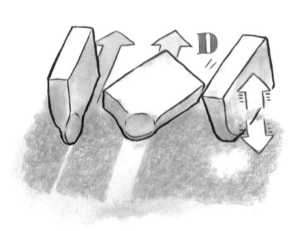

Losing edges, as in painting, is achieved through gradually removing the edge of an area of pastel. As the surface of the rubber becomes overloaded with pastel it will begin to smear rather than erase. Again, this is not unlike a brush depositing rather than removing color. Use this color-loaded rubber to create line or soft shading.

Common Problems

Protecting pastel paintings as you work

PROBLEM

"I've generally put off working in pastels as I have been told that the paintings are messy to work on and difficult to store."

ANSWER

Pastels do present their own unique problems, but then so do all media. Providing you know how to manage your working methods, you should have no problems. With no medium holding its pigment to the surface, a pastel painting is very vulnerable until you get it behind glass.

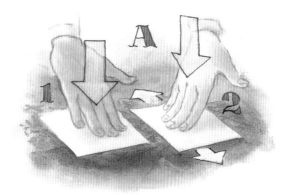

Try this for yourself. Take a piece of smooth paper or tissue paper and press it to an unfixed area of pastel color [A1]. Having pressed down, check to see how much pastel has been dislodged. Repeat the process with less pressure, but move the paper slightly on the surface as you do so [A2]. Inevitably you will find more pastel comes away with the friction caused by the sideways movement, than by downward pressure alone.

Often, pads of pastel paper are interleaved with sheets of smooth protective paper [B]. These sheets help to reduce the friction from any movement that occurs between the sheets of a pad as you carry it around.

As you build up layers of pastel, it is essential that you are able to revisit areas of the composition. To do so you must ensure that the heel of your palm does not smudge the surface by sideways movement. The easiest way is to simply insert a smooth piece of paper between your hand and the surface [C]. Once again, downward pressure will cause minimum damage, but be careful to "lift" the sheet, whenever it needs to be moved. Sliding it across the surface is exactly what you wish to avoid.

Alternatively, work with your hand above the surface. When working flat this is easily achieved by spanning the gap between two roles of tape with a metal ruler on which to rest your hand [D1]. When working upright a mahlstick comes into its own. Its head resting against the edge of the board, the non-painting hand holding the metal rod on which the painting hand rests, allowing you to get closer or further away from the surface by changing the angle of the metal rod [D2].

Storing completed pastel painting must be organized with great care. The simplest solution is a drawer in which the paintings are layered, interleaved with sheets of smooth clean paper to reduce friction [E]. It is sensible to avoid excessive pressure from above, so keep the area solely for this purpose.

Canvas carriers prove excellent for both safe storage and transport of pastel paintings. Pin the work to two sheets of stiff plywood of identical size. Adding a batten to one long length of both sheets of ply wood will help to strengthen them and ensure they are kept further apart. Secure the top and bottom sections of the plywood with a pair of canvas carriers, with the paintings facing inward.

Project 3

Study and still life

Many painters forget that their home environment can present a plethora of subject matter, covering a wide variety of possibilities. Family pets, farmyard animals, family members—all are possible sitters for figure drawings, paintings, and portraits.

Being more active and less controllable, children and animals would more than likely have to be sketched and photographed quickly to provide the necessary references. Adults could be persuaded to sit for short periods while the work progresses.

While the garden and its contents are much painted, what lies within kitchen cupboards can be equally stimulating and provide a still life. The subject for the tutorial was styled with color, texture, and light in mind, to demonstrate how to achieve different light effects and deal with a variety of surfaces from wood to metal.

Simple still-life subjects can be stunning, provided they are imbued with contrast. The delicacy and softness of a flower set against the fragility and transparency of glass can be spectacular. Objects constructed of the same material should be avoided, for they could prove very limiting.

This project deals purely with artists' quality soft pastels, the cream of the crop, to ensure a quality of finish to the painting. Volume is created through gradual build up of tints available in the range of colors used.

While the workshop is worked on pastel paper, the tutorial is painted onto a custom-made surface. Working with quality pastels requires a receptive surface featuring a good tooth, to successfully allow multiple layers to be applied without fixing.

Most pastel painters have surfaces that they favor above others. This is hardly surprising, given that strokes of pastel are dominated as much by the surface as they are by the type or quality of pastel used. It is far more profitable to experiment with the idea of creating a unique surface, than to worry about finding cheaper substitutes for the pastels themselves.

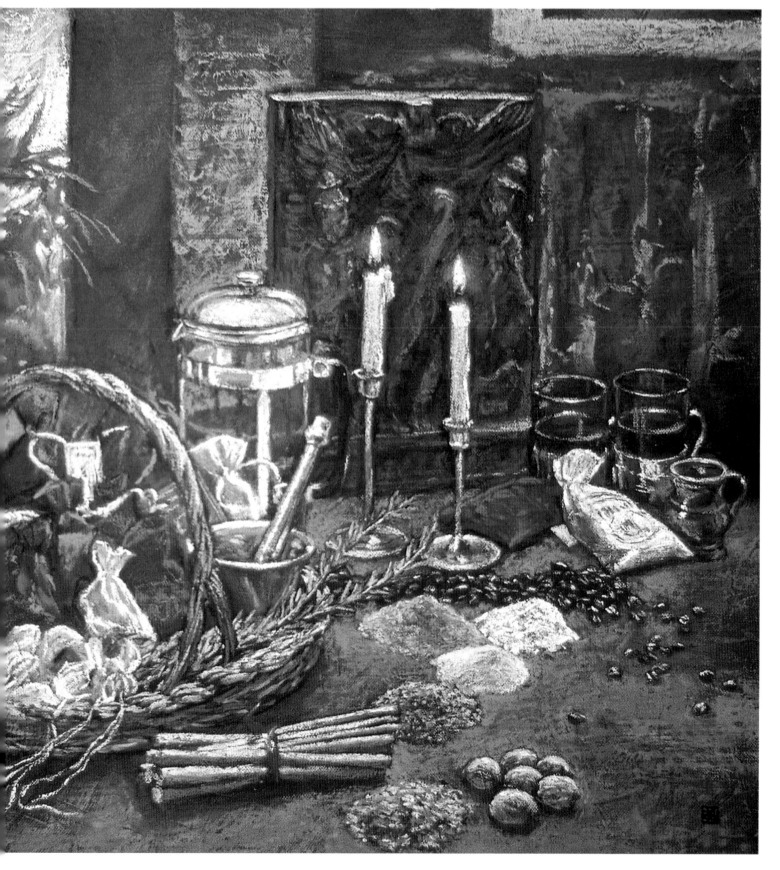

Project 3 Workshop

Study

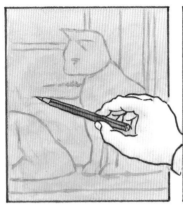

STEP 1 Hold pencil lightly and scribble in outline of subject.

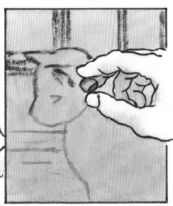

Overlay pencil linework using edge of soft brown pastel fragment.

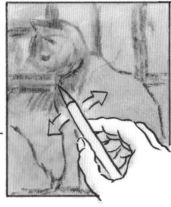

Blend pastel line with stump to fill in and create volume.

Overlay with dark blue. Use top side of pastel for coverage, bottom edge for linework and detail.

Use putty rubber to erase (top) or blend (bottom).

Fix early layers to stabilize them so more pastel can be applied. NOTE: Don't get too close or pastel could blow away.

STEP 2 Apply middle values of colors and blend where necessary.

Erasing knife is useful for removing middle layer to expose dark line (point) or shading (edge) of undercolors.

STEP 3 Magnified cross section shows pastel layers. Top layers, not in contact with tooth of paper, become unstable.

Common solution is to apply and mix colors in parallel strokes.

Directional strokes and blending suggest volume and texture.

Edges can be softened with stump or sharpened by scraping with erasing knife.

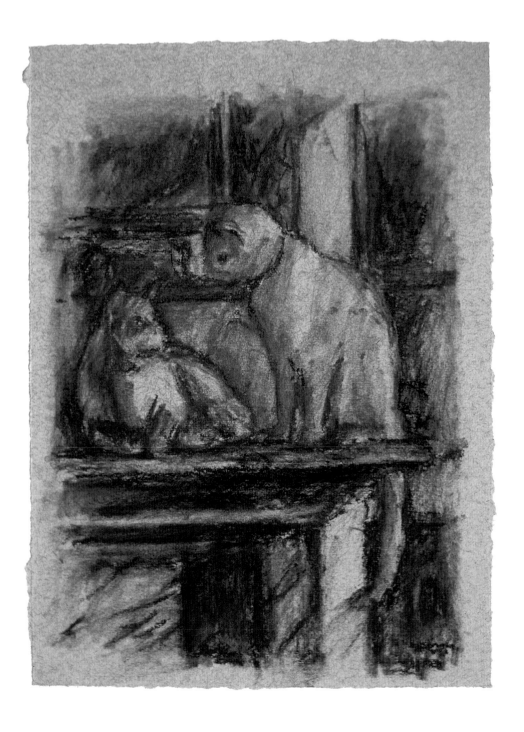

STEP 1

I enjoyed this piece as it records the first meeting between one of our white cats and a pottery cat on our mantelshelf. This study has been produced on a Fabriano pastel paper known as Tiziano. It is particularly smooth in character, but with a surprising amount of tooth. I have always been impressed with the number of overlaid layers of color which are possible with this particular make. The pastels used are of the softest artists' quality, which I refer to as "painting pastels." Using two colors for this first step (blue and brown) enables you to lay either a cool or warm ground. Alterations can easily be seen and when the two colors are blended together, being opposites (complementaries), they will tend to neutralize, or "gray" one another down. Gently scribble in the outline and block in masses as shown in the Artstrips to create the dark underpainting. This study is produced working from dark to light, just as one would an oil painting. Directional strokes and blending create texture, volume, and form, emulating the strokes and lost edges of brush strokes.

MATERIALS
Pastel Paper
Artists' Quality Soft Pastels
with range of tints in each color
2B Pencil
Kneadable Putty Rubber
Fixative
Erasing Knife
Stump

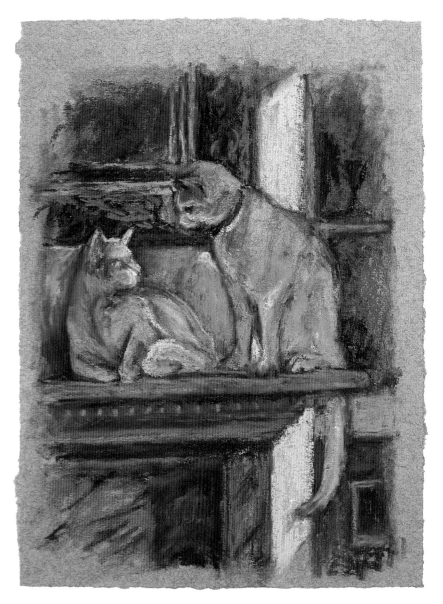

STEP 2

The trick in the second stage is to move swiftly across the surface applying the second layer. Don't attempt to finish off any area, no matter how tempting. Broad, bold, vigorous strokes are required allowing the composition to develop overall, rather than in a patchy way. Make sure that you keep the middle values of colors as long as possible, as leaping too swiftly to highlights will dazzle, not allowing the softer volumes to develop naturally. Try not to overwork. The ground color of your paper should be exploited (see back of cat). Color is enhanced when warm colors are placed over cool (fireplace and picture frame).

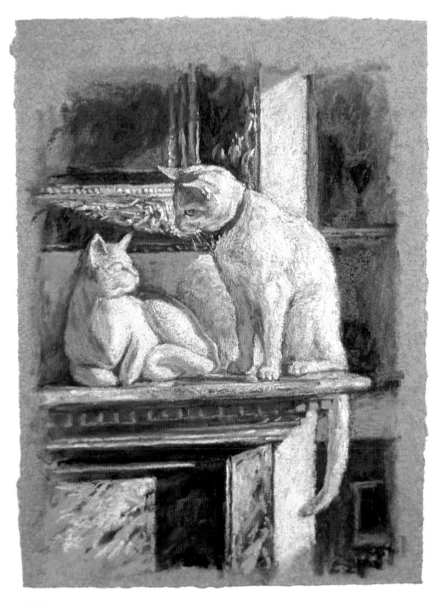

STEP 3

Now apply all the light colors up to the white highlights. Increasing pressure must be applied, as the pastel layers become deeper, to ensure that sufficient color is delivered. Final white highlights (e.g. cat's back) I refer to as "pressure" highlights, as you really have to push hard to make the color stick. Note how the real detail in this study is applied to the two cats. As your eye moves out towards the edges of the study, the shapes become more simplified, perhaps even slightly abstract. In this way attention is focused on the important subjects. Do not fix during this stage or dramatic highlights will inevitably be lost.

Project 3 Tutorial

Still life

Painters are blessed with the wherewithal to evoke a nostalgic reaction. How many times have you heard someone say on seeing a painting, "That reminds me of . . ." And so it was that we decided to produce a still life that would create the right mood, the perfect ambience to evoke the colors, and aromas of an eastern marketplace. Where best to turn than the kitchen cupboard, the cupboard in which an array of ingredients can be found that bring memories alive.

MATERIALS

To create the mood being sought left me with the final choice of whether to produce this piece in oils or pastels. Pastels were chosen for a number of reasons, but principally because I wanted to evoke the tactile nature of the spices and the coffee beans, something that the inherent grainy quality of pastels can exploit. The dynamic colors in some of the raw spices, such as the turmeric, needed to be brought out in their purest form.

COMPOSITION

Why should a still life be boring? Dusty wine bottles should remain where they were consigned in the first place, the dustbin. Compose a display that creates a mood or tells a story. Think of the lighting and how it can be made more unusual. In this composition a light source was placed slap bang in the middle of the display, and it was a flickering one at that! The glow cast by the candles warms objects nearby and allows the edges of the composition to slowly melt into cool shadow. Include as many different surfaces and textures as possible to contrast against each other, thereby stimulating the eye. Try to offset the placing of the group. Avoid dead center or square-on views. This composition was carefully placed with a threequarters viewpoint, to draw the eye towards the right and upward, through the use of objects of increasing height.

SURFACE

All pastel paintings require a surface with a good tooth or texture on which to work. In this case a canvas board is used which provides a very stable ground. However, the regularity of the canvas weave is disguised by applying two layers of modeling paste with a painting knife. This must be sanded down before a thin layer of base color is applied. For this painting a black acrylic paint was scrubbed across the surface to provide a base against which subsequent colors could sing.

SUBJECT
This is a large display that invites the viewer to study each element within. Don't feel you have to be so ambitious as to tackle it all from the outset. Take several sections as smaller still-life studies first. Treat each as an exercise in different aspects—Color build-up • Layering • Reflections • Transparency • Shiny surfaces • Light • Shadows • Detail. The possibilities are extensive.

STEP 1

Using the black pastel, sketch in the outlines of the principal elements within the composition. Broadly block in the underpainting first layer using the darkest tint of appropriate colors.

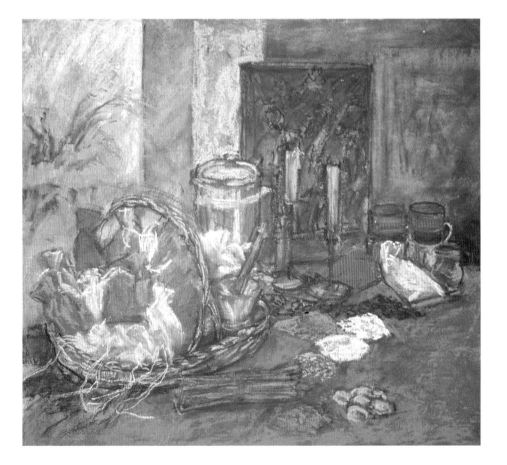

STEP 2

Turn to the background first, working on elements that will enhance the subject. All manner of things were present behind this still life, so certain elements were "abstracted" to form the backdrop and were arranged as simply as possible, to contrast with the complex horizontal positioning of the many objects that made up this display. Tighten up the drawing by reworking the objects in black pastel, followed by blending with a stump. Degas often used black as the ultimate accent in his pastel paintings. Look at how areas of black to the left, beside the basket, and to the right, beside the glasses, seem to "fix" the whole composition in place. Colors are now painted into the black drawing, working up to the midtones, with plenty of blending to soften the image and stabilize the pastel. Push the color into the surface tooth with a stump. Applying medium blue over the tabletop begins to suggest the blue light reflected from the surrounding light. Middle values should now be applied to the folds of the spice pouches and blended in with the finger. The painting is fixed at this stage, partly to dull the surface down, but also to make subsequent layers easier to apply.

403

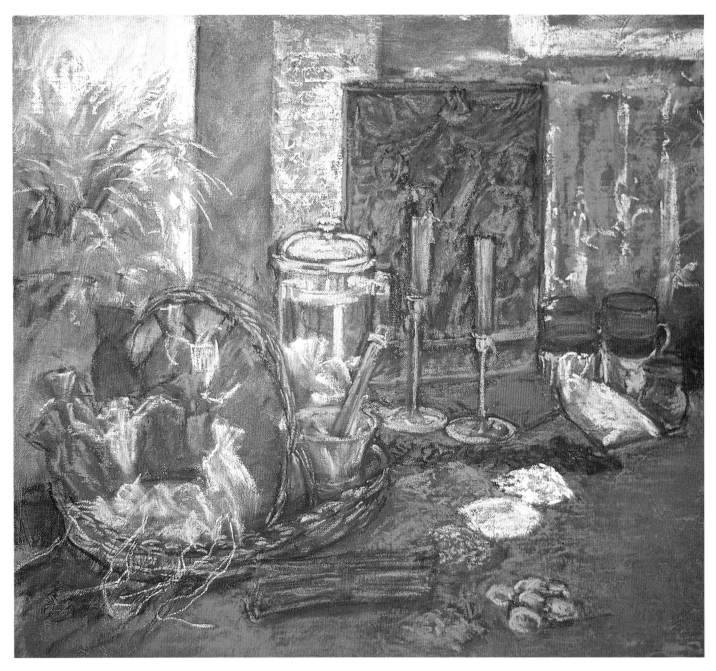

STEP 3

Work from top to bottom. Develop further the background vertical and horizontal elements. There were originally diagonal shapes but these were avoided as they would not have related to the rectangle in which the composition is contained. Apply a medium value of brown pastel to the table-top to warm it up, and in so doing this will bring the table's surface forward. This application also tightens up the silhouettes of the objects (negative painting). In both cases the pastel should be used on its side and gently scuffed across the texture of the modeling paste beneath, to produce a scumbled effect. Hard edges need blending with a finger. Mid to dark brown is used to create the main structure of the Indian carving at the rear. Lighter values of yellow are applied to the brass objects, but blending here and on the carving should be carried out with a stump for greater accuracy.

> **TERMS**
> **VALUE**—the lightness or darkness of a color.
> **TONE**—the lightness or darkness of a non-colored gray e.g.
> A color photograph is made up of a succession of values.
> A black and white photograph is made up of a succession of tones.

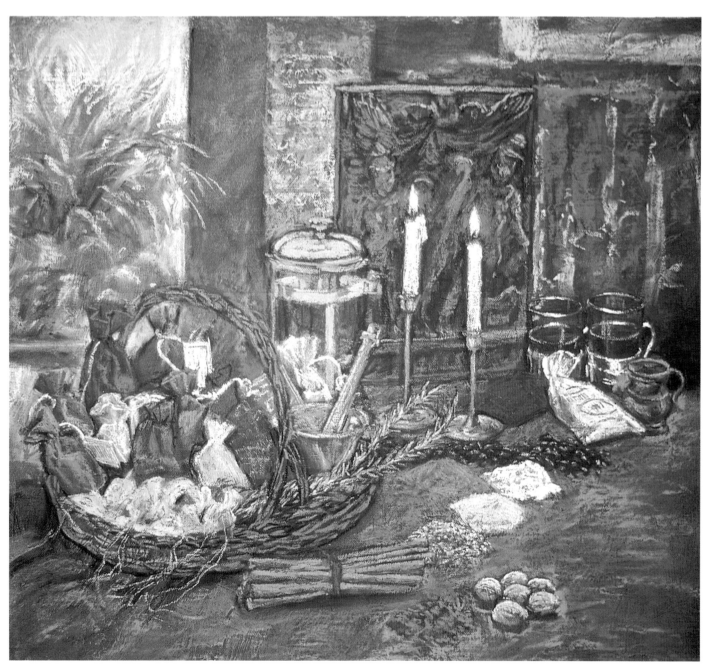

STEP 4

Turn to the candles. Draw these with an orange light at their top where the light shines through the wax and then with a light blue highlight on their right edges, where there is cool reflected light from the overall lighting. Light is also suggested on the carving as a yellow light from above, with a medium-value brown applied to the bottom section representing light bouncing back from the table-top. Candle flames are first put on in white, then yellow-orange is overlaid at their edges with a halo of darker, but intense orange. This same orange is also carried across the carving to denote the glow of the candle. Finally, a light blue highlight catches the overall light from above on protruding aspects of the carving. Mid-gray to white highlights are applied to the mulled wine goblets. The final whites should be applied generously and scraped down to fine lines and points using the erasing knife. Apply middle tones to the pewter measure and white to the bag in front of it. Detail is achieved by scratching out with the knife. A gentle blue overall light is again spread over the tabletop, to level the surface and reshape objects as before. The darkest yellow deep tint comes into its own for the brasswork. Apply dark brown followed by blue highlights for the coffee beans. Middle lights are now placed on all the herbs and spices and the pouches in the basket. Ties for the pouches are drawn on first with the lightest tint of burnt sienna, blended in to soften and then scraped back to their correct thickness using the erasing knife. Pouches on the left are painted negatively with a light purple overlaid with green, with the odd accent of black added to sharpen silhouettes in the basket. The rosemary lying in the basket is drawn in with a black line, overlaid with brown, then green.

OIL OR PASTELS?

As you will gather, this painting could just as easily have been executed in oil paints. Had it been so, the technique of working in layers from dark to light would have been no different to that shown here.

It is precisely because of the similarity between the two that I generally refer to working with pastels as pastel "painting." I use this term as a way of encouraging painters to envisage using brush strokes with their pastels, as opposed to drawing strokes, in an attempt to imbue a loose and fresh character to the work, rather than overworking with precise detail.

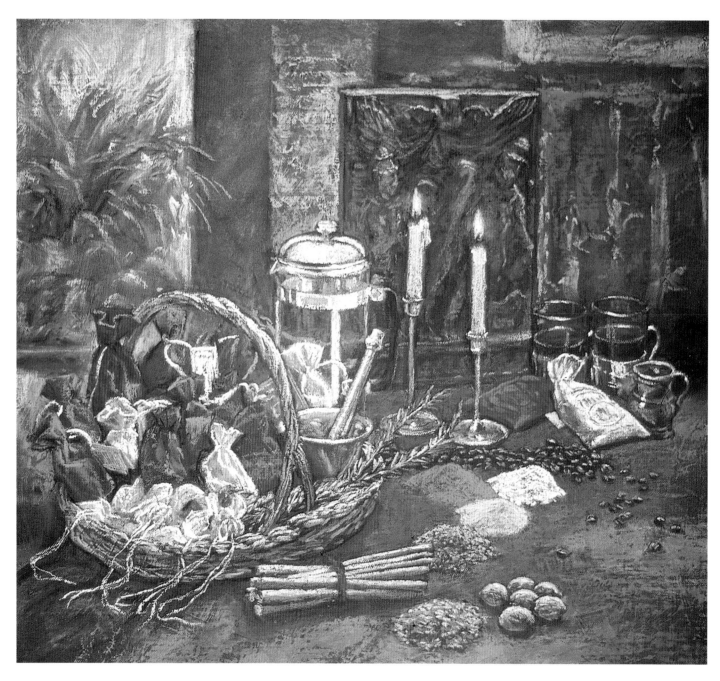

STEP 5

*Pull the carving away from the background by picking out a highlight along its top edge.
Scumble more browns and blues across the natural texture of the table top. The warm
browns partly follow the silhouette of the objects, but are extended outward to left and right
as diagonals to lead the eye inward. For the brasswork, apply layers of color from middle
values to highlights of pure white and shape with the erasing knife. Highlights to basket,
cinnamon sticks, and nutmeg should now be applied. I made changes to balance the
composition at this stage, such as enlarging the heaped orange spice in the foreground and
adding individual coffee beans in a trail down the right. Scatter middle to light values across
the pouches. Pure white highlights, applied with differing pressures, should be used on the
tie strings and the small muslin bags. Note how important the fine strings of the latter are
to the composition, giving diagonal movement and breaking the dominating sweep of the
oval basket. Again, the erasing knife is used to define detail here. The rosemary is treated to
highlights of light blue then white, and some strong scratching with the knife reestablishes
some dark accents by exposing the underpainting.*

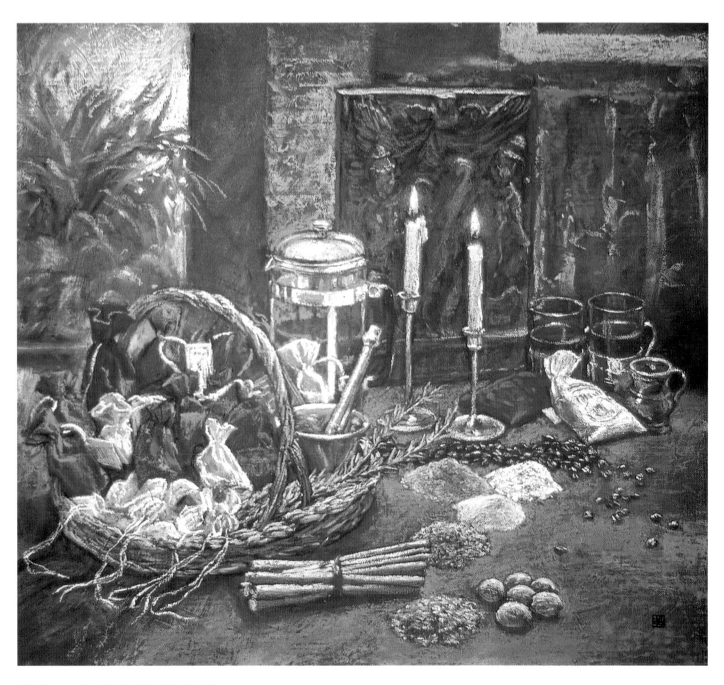

STEP 6—FINISHING TOUCHES

A final orange brown holds together the objects on the table top. Note now how the warm/cool layering of brown and blue has resulted in much colored gray over this surface. As a result the eye tends to remain within this final orange area, and though aware of the dark cool area outside, I was not tempted to make more of it. Highlights are now generally worked up. For example the white pouch on the right, the candles, coffee, herbs, and ribbon holding the cinnamon sticks. The coffee pot top, which was seen to be asymmetrical, was scraped into shape and loosely rehighlighted to show the reflection of the candlelight. A bright highlight along the top of the carving creates a distinct point to which the eye can rove at the top end of the composition before dropping again to the objects. The surface textures and the value contrasts of the background are given a gentle kick surrounding the plant and over the "L" shape, at top right, by applying a scumble of lighter colors. Checking the overall composition in a mirror, it became evident that the mulled wine cups needed their ellipses reshaped and rehighlighted. Similarly, I noticed that the central heap of orange spices was an uncomfortable shape and therefore redrew it.

TIP

The surest way of checking for any imbalances or mistakes in a painting is to hold it up in front of a mirror and check the reflected image.

Tricks of the Trade

Blends and washes

DRY PASTEL BLENDING

Dry pigment, lying on an even textured ground, is vulnerable [cross section A]. One of the physical methods of stabilizing the pigment is to apply pressure and rub it into the surface [cross section B].

Various tools afford different methods of blending. For spontaneity use your finger [C]. Finer control is provided through using paper wipers made from either rolled [D] or compressed [E] paper. Cotton balls [F] and cotton buds [G] allow medium control. Even watercolor [H] or oil painting brushes [J] will work.

Each of these tools will yield a slightly different finish and is suitable for blending at various scales. Once you have tried these, experiment with any other tools or brushes you can find, such as stencil brushes or tooth brushes [K].

PASTEL WASHES

It is often convenient to start off a composition by laying down a gentle layer of color overall. Working in this manner eliminates the harsh white of the surface and creates an early sense of depth and light across the work.

TEST 1 Scrape some pigment from a dark pastel across a piece of paper [L]. Work this in gently with a cotton wool ball as evenly as possible. You can continue by adding darks with the pastel and removing pigment with a kneadable putty rubber to create lights.

TEST 2 For more control. Take a scrap piece of paper and scrape pastel dust onto this. Use the edge of this scrap piece as a mask to create each of the four lengths of a square. Place along one length and blend dust from the scrap paper onto the working surface with a cotton wool ball [M]. By working from the four edges inward in turn, you can create a clean cut square of soft-toned pastel on which to begin your pastel painting.

TEST 3 Cut a window in a scrap piece of paper and lay it over the painting surface. Scrape pigment dust at top edge and blend downward from the top using a cotton wool ball [N]. Do not replenish the ball as you work downward to create a graded wash from top to bottom—excellent for skies or to achieve recession.

OIL PASTELS

Being more glutinous, these will not spread using pressure alone, unlike dry pastels. To turn them into washes, a thinner must be added. This can be any oil painting thinner, such as artists' distilled turpentine or white spirit. If the smell of these is too strong, substitute with an odorless thinner.

On a non-absorbent surface the resultant washes can really flow [O] and produce transparent effects, which can be juxtaposed or completely overpainted with strokes of oil paint.

Common Problems

Blending—do it yourself

PROBLEM

"My local art shop rarely has paper wipers in stock. When they do, they are often the wrong size or type."

SOLUTION

While the compressed version cannot be substituted, making your own rolled paper stumps is relatively simple and can save much frustration.

DO IT YOURSELF ROLLED PAPER STUMPS

Cut a piece of thick soft paper, such as blotting or sugar paper, approximately 5 in. x 3½ in. (13 cm x 9 cm). Start by rolling the short length around a pencil [A].

Extract the pencil and roll the loose paper tube between your hands until it tightens up [B].

When it has become quite tight, gently open it up once more and fold the end over on itself [C]. This is to be the center and point of the paper wiper, but it is still not fine enough.

Run a fingernail or blunt knife along the center of the last fold so that it begins a second fold [D] and then fold more tightly still with your fingers [E]. Now you can begin to roll the paper tightly around this central core [F].

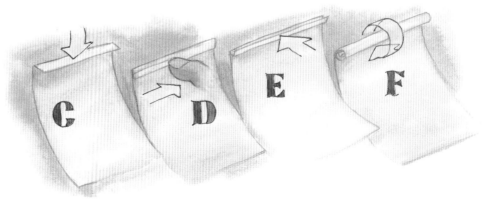

This roll will, more often than not, go slightly askew as the rolling continues, which is what you want, as it is this that creates the point [G].

Once the paper wiper is rolled successfully, it must be held in place with a piece of sticky tape. Extra stability can be achieved by folding over its base and, again, fixing with tape [H].

NOTE: The type of paper you use will also affect the thickness and length of the point. By using different papers and changing the nature of the rolls, you can build up a good selection of points, both fine and heavy, soft and hard, not unlike having a range of brushes at your fingertips.

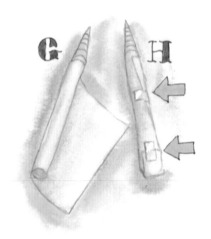

QUERY

"I love compressed paper stumps for blending, but they do get very dirty and lose their point. I've tried to sharpen them in a pencil sharpener and with a sharp knife, without any success. Do I have to throw them away and buy more?"

ANSWER

Compressed paper stumps can easily be cleaned and reformed by rubbing them on a sheet of sand paper [J]. They can even be sanded to a different shape to suit your preference.

NOTE: Unfortunately, most rolled stumps cannot be effectively sharpened and can only be wiped clean on soft tissue or paper towels.

Project 4

Capturing Light

The search for different working surfaces continues in the workshop within this project. Acrylic sand mortar is used to create the heaviest texture you would probably ever need.

In contrast, the tutorial deals with pastels applied to hot-pressed watercolor paper. Both are worked using artists' quality soft pastels.

The difference between these two surfaces couldn't be more pronounced and yet both are treated to dark underpainting as a rich contrast on which the pastel colors can be built and work against. Both subjects feature the common denominator of the effects of sunset light on the composition. To create this inner light is an exciting process and affords constant surprise and pleasure, no matter how many times it is achieved.

Watching the two paintings grow will demonstrate that the process, while not difficult, does require patience, as the light develops slowly and can not be rushed.

Large areas of each painting are kept to a low key, where all the values remain as close to black as possible. These dark, dull areas provide the necessary contrast against which the light colors can shine. However, it is not simply a matter of putting a light color adjacent to a dark color. The light values must be gradually and patiently built up to develop a glow that more closely mimics the effect of a real light source.

Along the way little tricks are employed, such as masking and complementary underpainting. All of these are valuable tools that can be used again and again under other circumstances.

Probably the most important element in the build up of both paintings is the use of the full range of tints in the colors used. By following these examples little doubt will exist as to the importance of having the right range of pastel for the job.

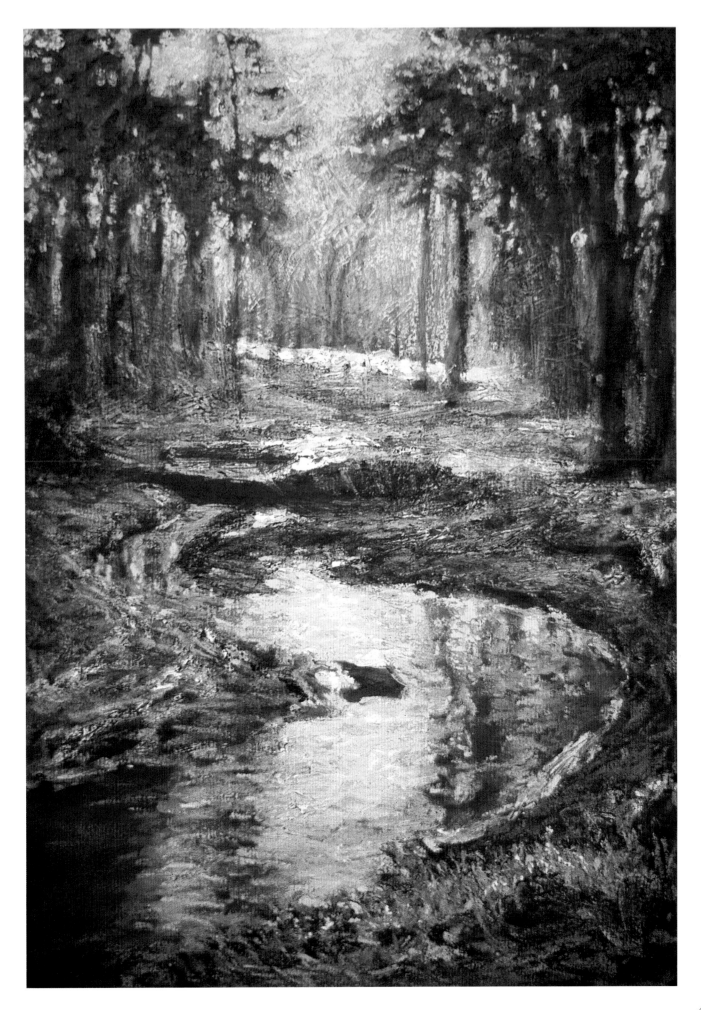

Project 4 Workshop

Capturing light

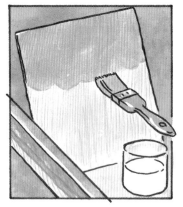

CREATING THE SURFACE
Sand a sheet of plywood and size with acrylic medium.

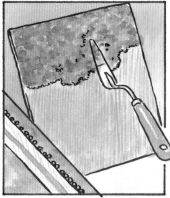

Generously cover with a layer of acrylic sand mortar.

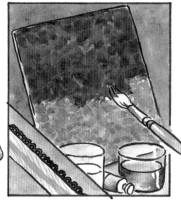

Paint with fluid black acrylic, which will run into texture and ensures dark underpainting throughout.

Compressed paper stump will wear down to a different shape but remains strong and useful.

Excess pastel dislodges by tapping, drops down and catches, creating a smear..

To prevent, hold board at an angle and tap at frequent intervals.

TIP: Two pieces of glass (ground edges) can act as a useful "easel" against a wall.

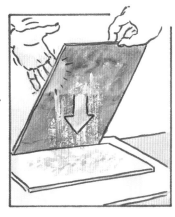

Work is then easily tilted so excess pastel can be frequently removed.

Fallen pastel can be safely wiped away to one side.

BLACK LINEWORK
Continually revolve black pastel as you draw and end will point naturally.

Check sea is level using piece of paper marked with the distance from base of the painting.

NOTE: First layer of pastel only fractionally lighter than underpainting, providing contrast for following layers.

Having a camera on you at all times is essential if you are to capture fleeting moments such as this. Returning home late afternoon one Christmas, the dark clouds parted briefly and were shot through with the most glorious sunset. Shafts of orange light cut through in great slabs of color at some points. While the clouds and distant hills were bathed in color, the foreground remained dark and mysterious, with a trail of sunlight sparkling across the water's surface.

MATERIALS
Custom-prepared
Textured Board
plywood
Acrylic Medium
Acrylic Sand Mortar
Black Acrylic Paint
Artists' Quality Soft Pastels
with range of tints in each color
Kneadable Putty Rubber
Fixative
Erasing Knife
Compressed Paper Stump

STEP 1—WORKING ON A HEAVY TEXTURED SURFACE

Complete initial drawing in a mid-value blue. This can be seen against the dark background yet will not dominate subsequent layers. This needs to be forced into the surface with a large compressed stump.

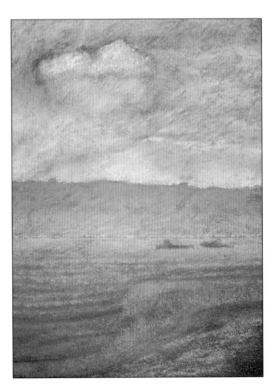

STEP 2

The warm and cool masses of the painting are boldly established—again they are wiped heavily into the texture with a stump. Much pastel is inevitably lost at this stage through the pressure required and the roughness of the surface. Redrawing in black line confirms proportions. This line is stabilized by pushing it into the surface with the stump, which also has the effect of muting the colors nearby as it mixes with them.

STEP 3

Middle values are now applied. As the pastel layers build, the streaking of falling pastel can become irritating. To avoid this, finish the top of the painting and move progressively down. The other option is to work flat, but do ensure if you do this that your hand does not smear across the fragile surface. Note how the underpainted colors are now accents for the overlaid middle tones. Also note the headland where a blue and brown mix together to create a colored gray.

Project 4 Workshop

Capturing light

Each pastel color is available in a range of tints (progressively increasing white content).

Many ranges add black to the darkest pastel creating a shade of that color.

On heavily textured surfaces darkest tints are drawn first, then pushed into crannies with a paper **wiper, called a "stump."**

Lighter tints are then applied, gently depositing pigment on upper slopes of textured surface.

Direction of strokes and blending with stump creates soft structure and movement (cloud area).

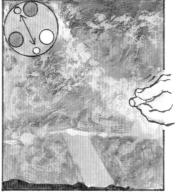

COMPLEMENTARY CONTRASTS [1] Medium-dark yellow-green excites the pinks [Rp} of the sky.

[2] Light blue-green over warm blue [Bp] mixes visually to a light colored-gray and contrasts with the sunbeam.

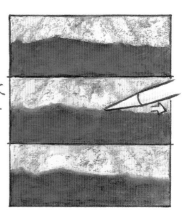

Blending along skyline causes headland to recede (soft focus suggests distance).

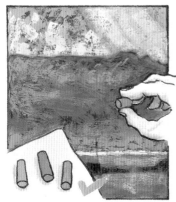

Restraint is required when building up lighter colors into the headland . . .

. . . otherwise light may disappear from the sky with reduced contrast.

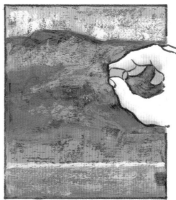

Gentle scumbles of mid-green create another complementary contrast to excite underlying browns.

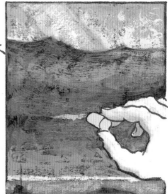

When small touches of highlight then added, they sparkle against the darker color values.

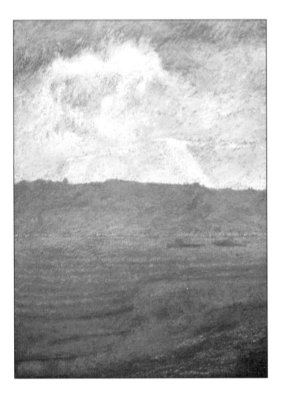

STEP 4

Continue to complete the top of the painting and work
progressively down, applying the highlight colors of the
sky. Warm and cool colors are blended together in the
sky. These applied together, and then blended on the
surface, create a light colored-gray. Beware! A little color
spreads a long way!

STEP 5

The sunlit cloud mass is extended. Focus attention on the
distant headland, which is also given complementary
layers. Redraw and reshape focus on the boats by using
pure black. Continue this into the accents of the
foreground waves and sand.

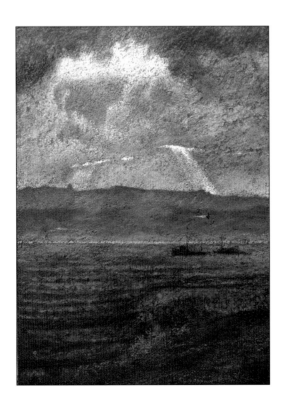

STEP 6

Apply pure white into the center of the skylight, working
in with the stump, and apply again until a shimmering
highlight is achieved. Gently scuff pink over the green
clouds to create a complementary glow within them. The
blues of the sky are generally modified, scuffing dark
green over the light areas and light green over dark.
Cloud edges are highlighted in light yellow-green. Pink
highlights placed erratically on headland add sparkle to
an otherwise dull section.

Project 4 Workshop

Capturing light

STEP 7 Boat edges are sharpened with paper masks, as dark blue is worked into black **solid.**

Negative spaces around boats can be enhanced with sharp edges in the same way.

Mast is drawn by pushing pastel between two close parallel paper edges.

STEP 8 Tear rough curved edge from heavy paper (sugar/heavy cartridge).

Use these as masks when applying highlights to foreground waves.

TIP: No need to waste small pieces of pastel; they can be held under fingernail for detail work.

Apply light blue to stump so it can act like a paint brush . . .

. . . working pigment into previously laid color, thus reducing its dark value and intensity.

Lightening and cooling colors on boats makes them recede.

STEP 9 When close to finishing, tap painting a few times on corner to remove loose color.

Check important highlights have not been lost. Reapply if necessary.

If this is not done, loose particles will inevitably fall and collect along inside of the glass when framed!

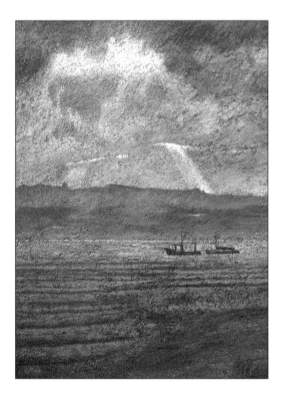

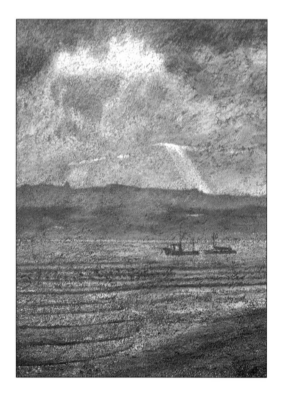

STEP 7

Apply a warm, mid-blue, blending horizontally into the foreground waves. Work gently in the foreground and increase the pressure for distance. This increase of pressure covers more underpainting. This has the effect that the sea becomes lighter into the distance (aerial perspective) creating depth. At the boats, however, employ a lighter blue making the texture less linear and more scattered. The foreground sand is lightened further back and grayed by scattering over with dark blue.

STEP 8

Apply light orange scumbles to waves. The intensity of both this and the blue beneath are reduced by their close proximity (visual complementary mixing). Now the tonal contrasts can become dominant. Use a slightly darker orange further back (you can often see this effect on afternoon cloud highlights as they become darker and richer in color with distance). Cool highlights to the wet sand are contrasted with the warm orange highlights blended into the dry foreground sand. Pure black accents to seaweed, rocks, and the front waves should be softened with the stump.

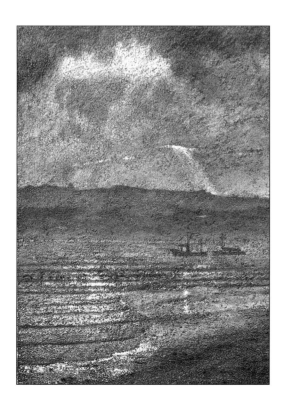

STEP 9 FINAL HIGHLIGHTS

Light yellows are applied directly under sky lights and top of the waves. Other parts of the waves receive blue reflected highlights, scuffed across the surface. Final highlights are lemon and white. Some pure black accents to the rocks and seaweed of the foreground are left sharp and unblended.

Project 4 Tutorial

Capturing light

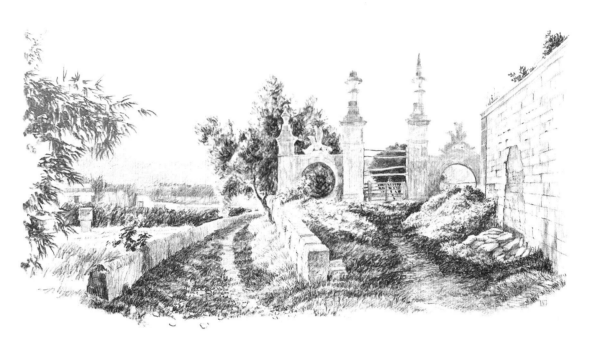

Often, when having opted to produce an original work solely using the medium of pencil, the finished result leaves you in no doubt that it would make a wonderful painting. This is precisely what happened when the drawing of this subject was completed for inclusion in a drawing tutorial.

The textural nature of the elements within the composition, coupled with the distinctive patterns of light which touched these elements here and there, cried out for either oils or pastels. The vivid nature of the colors within—an azure sky closing down for the night, the last rays of the sun emphasizing the golds in walls and stonework, the depth in the shadow areas, the luminosity of the greens

throughout—would be best translated using the purity of color to be found in my range of artists' soft pastels. And so I set to work. The end result, I hope, proves the point.

CHOICE OF SURFACE

For this large pastel painting you need to stretch a full sheet of 140 lbs. hot-pressed watercolor paper. Once a layer of watercolor has been applied, the gum in the paint will make it more receptive to the pastel. You may, of course, use heavier textured paper, but consider how the texture may interfere with the quality of the subsequently applied pastel stroke and ensure that it is to your liking.

STORING PASTELS

A very common problem, for which every artist has a solution. An economical way borrows from the kitchen—a transparent multitier storage box that is stackable, easy to clean, and most importantly, is compact. Separate the colors so that each tray holds one color band and its tints. The top tray inverts to fit neatly into the one underneath as a lid. The beauty of this system is that as your pastel collection gets bigger, you simply get another set of trays and stack them on top of those you already have. To stop the sticks from rolling around, line each tray with a corrugated shelf liner or cardboard. The fact the trays are transparent is an obvious benefit as well.

STEP 1—DRAWING OUT AND INKING IN

Scribble in the composition using the shoulder of the 2 mm 2B pencil. This keeps the drawing soft, relaxed and fluid. Concentrate on the rhythms and don't worry about mistakes as the pastel, being opaque, can easily cover them over. Once you are satisfied with the proportions finish off with an ink line. I used a brush pen, which is swift and very descriptive.

MATERIALS
140 lbs. Hot-pressed Watercolor
Paper
2 mm 2B Pencil
Brush Pen
(with black waterproof ink)
10 mm Flat Nylon Brush
Watercolor Paints
6 primary colors
Range of Artists' Quality Soft
Pastels
with tints for each color
Stump
Kneadable Putty Rubber
Erasing Knife

SKETCHING
Use shoulder of pencil to keep drawings
loose and fresh.
To loosen strokes, hold pencil further away
from lead.
To gain more control, hold pencil closer to
lead.

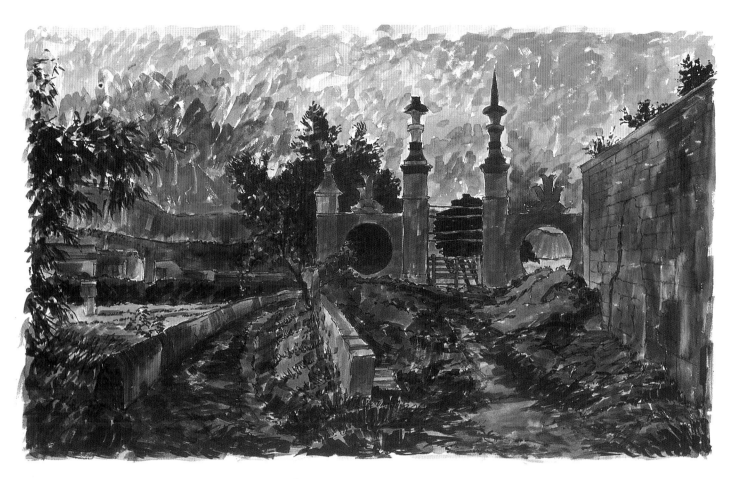

STEP 2—UNDERPAINTING

The depth of color in this subject requires a very strong underpainting layer against which the contrasts and lights can work. This would be difficult to achieve with pastels alone, for so much pressure and so many layers would be needed. To get around this problem, the base layer can be carried out in watercolors or thinned-down acrylics. By using watercolor I was able to still see the ink line underneath, thanks to the transparency of the paint. You need to apply the underpainting as powerfully as you dare, as this provides the strong contrasts for the lighter colors of pastel which follow. Complementary colors will, of course, produce an even more dramatic contrast, and these are used first in the sky, where orange is used to underlay the blue. The green of the grass and distant hills also benefits from a warm (purple/ orange) underpainting, which prevents the finished greens from all looking the same. In order to avoid becoming too detailed, apply this underpainting with a large brush such as a $\frac{1}{2}$ in (10 mm) flat nylon. This will develop brush marks that echo the nature of the pastel strokes to be overlaid.

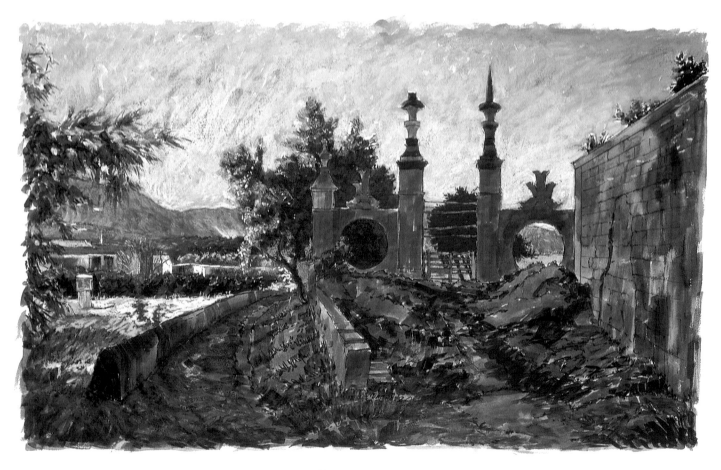

STEP 3—BACKGROUND: AERIAL PERSPECTIVE

Switch to the pastels and work from the top left (if left-handed, from the top right) to prevent smearing the pastel. In general terms the already painted dark areas need only small amounts of pastel, usually cool colors (greens, blue etc.). The principle is to let a good amount of underpainting show through. Light or highlight areas are built up layer upon layer, leaving only tiny accents of the original watercolor. Apply the graded color of the sky and blend, but do note the orange accents left unworked, giving vigor and extra intensity to the blue. The stump is used here, not only for softening and merging the strokes but also for carrying color into and along edges of overlapping shapes, such as building or trees. Blend pastel strokes on the distant hills and tree with the putty rubber; which smears or lifts color, depending on the pressure you employ. Dark underpainting is always there to be revealed in case of over enthusiastic application of pastel. Note how much watercolor underpainting is left in the trees near and far. Note also that where pastel is applied the texture of the watercolor paper distributes the pattern of masses in a very natural manner. Notice the exciting color contained in the dark tree behind the gate. Here a dark crimson is gently rubbed in as the first layer, followed by dark olive green texture. These dark complementaries add richness to an otherwise possibly dull area. Orange applied over the purple ground between the bars of the gate really sparkles with contrast.

REFLECTED HIGHLIGHTS
Caused by light not directly emanating from the sun. Direct sunlight would be yellow as the sun is yellow. The rest of the sky reflects light from the sun, but this is blue or blue-gray, depending on the state of the sky at any particular moment.

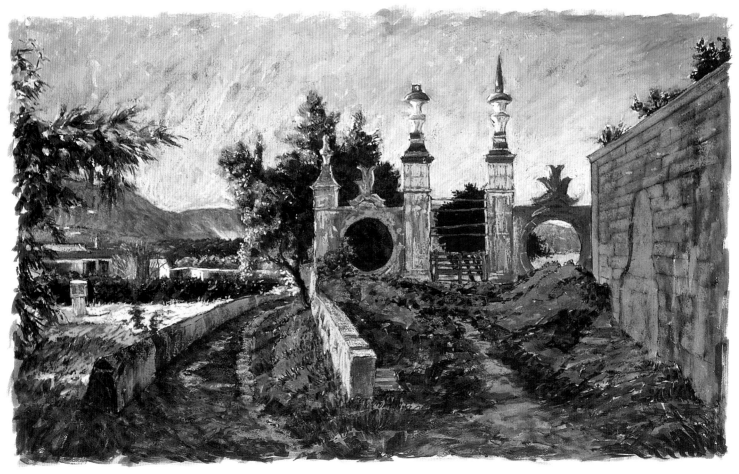

STEP 4—FOREGROUND AND WALLS

It is easy at this stage to lighten the colors too rapidly. If this occurs, the quality of light will disappear with a resultant lack of contrast. Start with a slightly darker value of the color than you might believe it to be. Test a dab on your painting. Only then should you go slightly lighter if necessary. This holds true for the majority of the foreground in this painting. If it becomes too light now you have no chance of capturing the sunlight later on. Build tonal layers of burnt umber across the gate structure. Now use the flat of an erasing knife to open up or give structure to surface texture. Scuffs of burnt sienna and yellow ocher can now be applied—see [A] and [B] below. Make use of counterchange across the walls (light against tree, but dark against sky), and the warm lights on the left-hand side of uprights reflected from the bright wall to the right. Give all the walls projecting forward various amounts of burnt orange. On the right you can begin to develop shadow as well as sunlight. The left-hand wall is blended into the distance, while the center wall also has vivid cadmium yellow and orange added to its sunward faces. Develop the pathway with burnt sienna, using lighter values for distance. Add some contrast into the grass by layering cool mid-greens into areas which will be eventually warm (sunlit), and warm into areas to be cool (shadow).

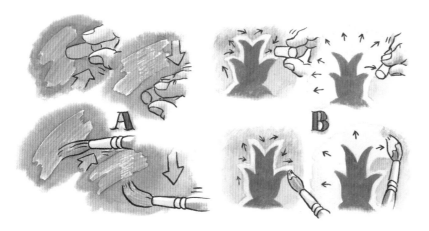

PASTEL PAINTING?

Similarities to oil painting are numerous; here are just two:

[A] **SCUFFING** both pastel strokes and brush strokes raised from the surface can be scuffed with a second color.

[B] **DRAWING** round a sharp edge using a point can be followed by filling in with broad strokes.

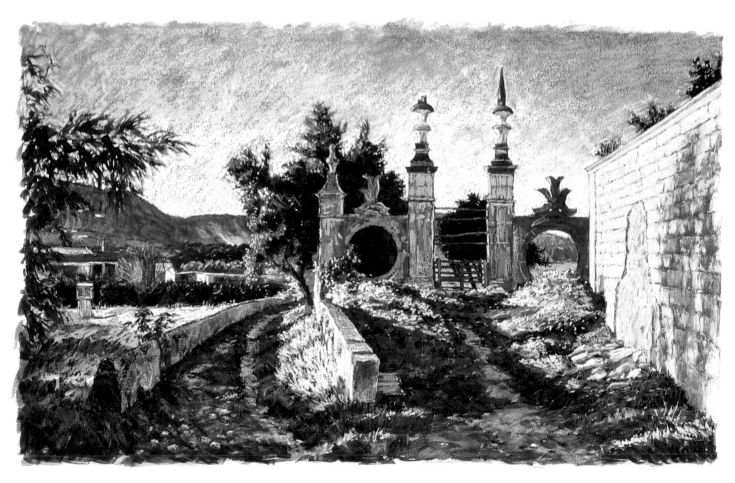

STEP 5—FINISHING OFF: FOREGROUND SUNLIGHT

*The simple graded color of the sky and the negative shapes it makes against the silhouettes of the trees
and wall structure are key elements in the composition. Develop and shape the edges further, with light
values of lemon yellow, burnt sienna, and warm blue. The variety of silhouettes along the horizon now
capture the eye, while the overlaid colors of the sky will excite. Build sunlight on the grass from mid
yellow-green to lemon yellow. Yellow is the secret here, for our sunlight is yellow, so be bold with its
application. In the shadow the grass can be given cool blue-green reflected highlights. Don't overwork
these darker areas. They do not require focus and where detail is not required it is exciting to leave them
brushy. Stones, foreground left, are mid-brown, blended along their bottom edges, and then highlighted
along their top. Now to the walls; at left is medium burnt sienna to light orange, blended in the distance;
on the middle wall create strong sunlight with the lighter values of cadmium yellow. On the wall at right
mid-cadmium yellow is blocked in for sunlit stones and blended vigorously at shadow edges. Within these
shadows burnt umber reflects lights and some dark green accents define fallen rocks. Finally, some
vertical hatching of the lightest value of lemon yellow add "sparkles" of light. The shadow to the right
edge contains the eye within the picture as does the dark tree at the left edge. Orange light to the tree
trunk (central tree) is softened with a putty rubber to avoid overcoverage of dark underpainting. The
negative space (orange-yellows) and highlights around the gate need some careful attention, as this really
is a focal point to which the eye is drawn by the path and clumsiness here will stand out.*

Tricks of the Trade

Achieving dark colors

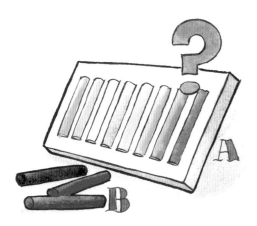

Many would-be pastel painters purchase, or are bought, a mixed set of pastels. The problem with these, more often than not, is the lack of dark colors [A]. The darker the pastel stick, the more pigment it contains [B]. Pigment is expensive and when putting together a reasonably priced set, the manufacturers are often unable to include enough darks. Sadly, this becomes even more of a problem in really cheap sets, leading to terrible frustration and ultimately disappointment. Without dark values, it is impossible to create light, as there are no contrasts.

CHOICE OF QUALITY

By starting off with good pastels, you will find that for every hue (color) there is a range, going from the darkest, most heavily pigmented mix, to the lightest, containing lots of white [C]. Some makers do add black to their darkest value, which again is cheaper, but can dull or change the hue of the color.

It is certainly true that for pastels, the most expensive are those with really dark color in their range. These are the most versatile and certainly worth the additional outlay, for they provide all the richness and intensity of color you will need. What, however, if you don't want to start out at the expensive end of the scale, but still need dark colors? Where do you start?

ALTERNATIVES

The answer lies in creating a dark underpainting just beneath the light pastel layers. Black itself is a powerful color and has been much loved by several masters of pastel painting in the past. It must be treated with great respect however. While its use for fine dots and accents can be rich, if mixed with another pastel color, it may look dirty [D]. Used beneath a color, however, the result can be excellent. The top color retains its intensity, with the black beneath darkening the whole down [E].

Charcoal is an excellent and cheaper substitute for black pastel. Both benefit when drawn onto a colored surface and blended in with a paper wiper. This both visually and physically solidifies the stroke, as it fills the textures, making the stroke more stable and less likely to mix with the overlaid color [F].

Dark watercolor and/or ink underpainted colors also provide an alternative. You will probably have to stretch the paper to prevent if from cockling [G]. If the paper does buckle it will soon become difficult to work evenly with the subsequently applied pastel sticks. A watercolor layer is especially useful, since the gum therein, once dry, will accept the pastel strokes more readily. A second advantage is that dark watercolors can be applied with great vigor, since 95 percent of their surface will be overpainted with the pastel.

Dark acrylic underpainting is even more useful and exciting. Acrylic paint can be built up in thicker layers and the resultant textures create brushy marks with the pastel strokes applied over them [H].

Common Problems

Gradation, volume, and tints

QUERY

"Why can't I get the same sense of depth and volume with pastels as I achieve with paint? The colors seem far too crude and flat."

ANSWER

Pastel colors can provide some of the most intense colors possible, since you are often looking directly at a pigment without any interference from a medium such as those which carry the pigment in paint.

The most common reason for pastels looking dead is that the full range of their tints is not exploited [A]. Whenever we view a composition, we are first aware of color. It is, however, the lightness and/or darkness of the colors which provides a sense of volume and light. Even a single object, such as this teapot, will possess powerful highlights and strong dark shadows. Rendering these values in pastel will be difficult if you only possess a single or a limited range of values in the colors required.

VALUE
The degree of lightness or darkness of a color.
TONE
The degree of lightness or darkness of a neutral gray.
HUE
A bright primary or secondary color of the basic color circle.

It is possible to surface mix, or underpaint, to some degree, adding white or a darker color to lighten or darken the value of the color required [B].

However, the mixing of pastel is not as fluid as the mixing of paint and the results are far more limiting. What you require is a range of different values for each color. These are provided as a range of tints in artists' quality pastels [C]. Here the darkest color is the pure pigment, becoming progressively lighter with the addition of an opaque white.

Obviously, to buy a range of tints for each of your colors would prove expensive, yet the tints are essential. The answer is initially to limit your color range, while expanding your tints [D]. Start with a selection comprising the widest possible range of tints of the three primary colors—red, yellow, and blue—along with the three secondary colors—purple, orange, and green. Set out in the relevant position on the color circle, you will be constantly aware of color families and complementary colors (dotted lines). Use only these colors for as long as you can, concentrating on changes of value, rather than hue. Naturally, you will eventually want to expand your color range, as you progress. When adding specific colors, therefore, you can ensure that you acquire the range of tints for each. Since this is only done when you actually need a color, you will not be adding colors unnecessarily and are much more likely to use them in the future. There is nothing more depressing or wasteful than buying materials which are never used.

Good organization and a set of the right materials will allow you all the versatility you need to create volume and fill your work with contrast and light [E].

Project 5

Figures and structures

Figures always provide the artist with ample challenges and the choice for the workshop is certainly no exception. A dancing figure, frozen in motion, must be imbued with balance, light, a feeling of movement, and an airiness of touch to instill in the viewer the belief that the dancer floats on the page.

The tutorial of a view seen through an archway, presents a composition wherein lie buildings mainly in shadow that must be filled with light and depth. Shafts of sunlight are required to keep it airy and the visual textures, while a necessity, must not overwhelm.

Although the aim in each is similar, the approach is quite different.

The light in the figure study is executed through means of texture. Acrylic paint with the heavy addition of texture paste provides the impasto underpainting over which the pastel is subsequently laid.

Textures created in previous projects have been arbitrary in nature, a wall on which to hang the pastel medium. Here they become structural, following the form of the figure. The texture is modulated in tune with the part on which it is being worked, heavy for clothing, while smoother for flesh.

In comparison, the archway scene is gentle. Here there is no physical texture, only the pastel paper surface, yet the contrasts necessary for sunlight have to be achieved. These come more gradually and depend on contrasts of color temperature, as much as on color value.

Whilst perspective is important in this composition, it is by no means an essential. The viewer's eye should be caught by the colors and the dancing movement of the linework seen between the dappled strokes.

Project 5 Workshop

Figures

COLOR REFERENCES
Yellow-orange [Yo])
Yellow-green [Yg]
Red-orange [Ro]
Red-purple [Rp]
Blue-purple [Bp]
Blue-green [Bg]

STEP 1 Line through head indicates center of gravity. Figure off-balanced between steps. Left arm counterbalancing.

STEP 3 Scrape painting knife along flat palette and scoop texture paste along bottom edge.

Trowel onto surface (top). Each stroke begins with hard edge— exploit this at the edge of figure.

Painting knife strokes have distinctive smooth surface and sharp edges that pick up paint/pastel in a particular way.

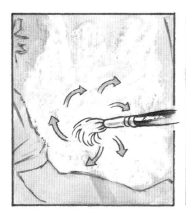

Use bristle brush to scrub texture paste into surface . . .

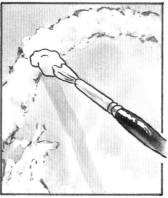

. . . or to really slap on some heavily textured brush marks (impasto).

As water evaporates out of paste the surface inevitably loses some of its depth . . .

. . . and so a second layer can be added, if/where necessary, as soon as the first layer dries.

Round nylon brush creates a smoother texture than bristle, but still has more character than a painting knife.

Soft directional strokes can be achieved . . .

. . . once thick layer of wet paste has been established. Use brush handle for sgrafitto (scratching).

Wipe thumb swiftly across impasto edge to soften (knee).

STEP 1

This vigorous subject requires a strong, dramatic approach, so I decided on pastel underlaid with both acrylic paint and texture paste. Stretch a piece of colored pastel paper and sketch in the twisting form of the young dancer. Note the line down through the head and how it exposes the off-balance nature of the pose. This line represents the center of gravity and as it does not fall through the legs, the figure must be moving swiftly to counterbalance, or she would simply fall over. The position of the legs is particularly difficult, but checking the negative space between will help to resolve the problems. So too does dropping verticals from the torso and dress above.

MATERIALS
Pastel Paper
Acrylic Paint
Acrylic Texture Modeling Paste
Painting Knife
Bristle Brush
Nylon Round Brush
2B Pencil
Waterproof Ink
Artists' Quality Soft Pastels
with range of tints in each color
Kneadable Putty Rubber
Fixative
Compressed Paper Stump

STEP 2

Using the pencil drawing as a guide, rework the whole drawing with ink. Loosen up and be confident with your strokes as even this strong line can be overlaid with pastel where necessary. On the other hand, it is strong enough not to be overwhelmed immediately the pastel is added. This aggressive approach is particularly apparent in the dress where I began to work out the fall of light and shadow across the white fabric. Defining the rectangle and the shadows in ink will help with the balance of the full picture. The shadows are an important horizontal element against the vertical figure.

STEP 3

Apply acrylic texture paste to create a physical texture which will both support and imply structure to the pastel layers to come. In the background it is applied with a painting knife, dragging from the edge of the figure. The need for the strong linework is now apparent, as it proves difficult to overwhelm with the paste layer. The colored ground allows the thickness of the layers to be accurately judged. Switch to a bristle brush to continue with some areas of the background (around the left arm) and carry through into the flower hoop. Using a round nylon brush, will achieve smoother texture for the face. When applying texture you are not creating tones (lights and darks) but texture (which can, as a matter of course, pick up light as it sticks out from the surface).

433

Project 5 Workshop

Figures

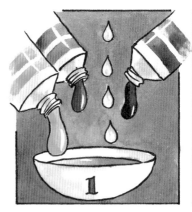

STEP 4 Mix fluid brown acrylic wash from Ro + Yo + Bp.

Should be fluid enough to run into textures exposing their structure.

If modeling paste does not cover paper, paper is very absorbent becomes very dark. Good for accents.

Color should not be so strong that it covers your linework and detail.

STEP 5 Make second mix of fluid acrylic with same colors plus more blue.

These two brown mixes [1 and 2] are now on either side of black.

Areas given layers of equal amounts of both mixes result in a black on colored gray.

More of mix 1 = warm color [B]. More of mix 2 = cool color [A].

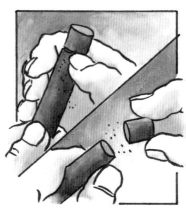

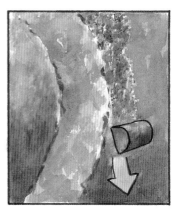

STEP 6 Score around top of dark blue pastel with your nail and snap off. Work with small piece.

Use nail to score around small piece and snap in half.

Use flat surface or edge of these pieces to block on strokes of pastel in brushy way.

Lighter blue suggests light reflections from ground.
NOTE: Some underpainting is left to show through strokes.

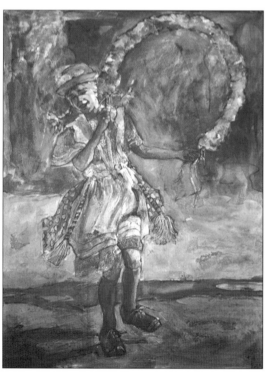

STEP 4

Apply washes of warm brown acrylic paint (or watercolor if you don't have acrylics) using a large nylon round brush. A sable would be inadvisable as painting across the dry texture could be damaging. Not only is the nylon more resilient, but also cheaper to replace if damage does occur. Have a second brush on hand to loosen edges, but allow your brushwork to be extremely free as any mistakes can easily be corrected by the opaque covering of pastel. You will discover that the different surfaces absorb the color to different degrees, so a second or even third wash of this color is acceptable and will dry speedily. Note the counterchange along the edge of the figure affecting light falling on the right. The main function of this layer however, is not to create highlights but to ensure soft accents (dark) against which the lighter pastel color can contrast.

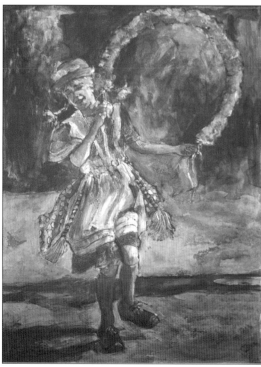

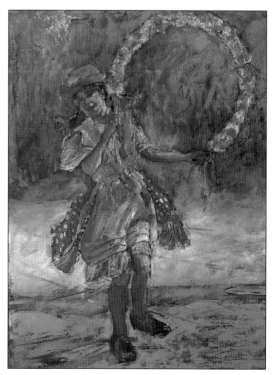

STEP 5

A cool brown mix now increases depth by introducing darkness, dullness, and coolness into the shadows. The resultant effect with a variety of values (light to dark grays) and its warm and cool colors already suggests much of the light and depth of the final piece. Color at the next stage is an added bonus, bringing vitality to the surface. Most of this layer, painted again from the back of the composition to the front, is painted wet-on-dry. This ensures the solidity of the wash and thereby some really strong dark accents.

STEP 6

Use blue pastels in the background and allow it to impinge gently on the figure, so that it becomes part of the picture, rather than seeming to be stuck on top. Movement can also be suggested by the blurring of edges in this way. An Indian red gives warmth to the flesh tones. Keep this thin so it is thereby partially transparent. Apply warm mid-browns in a similar way over the hat and dress. A complementary accent of light pink should be scuffed gently over the blue spotted dress. Dark red is dotted onto the handkerchiefs and brushed around it with a stump. Accents of dark brown and blue are laid into the hair, shoes, flowers and hoop handle. The surface should now look brushy and will provide an excellent surface to blend into.

Project 5 Workshop
Figures

THIN COLOR A small amount of Indian red is gently applied to the face . . .

. . . and spread with a compressed paper stump into a thin transparent layer.

Excess pastel is removed with a putty rubber and lost highlights or accents are reestablished.

Fixing can easily kill subtle thin areas of pastel. Not much fixing needed when heavy tooth or modeling paste is used.

LAYERING DARK TO LIGHT Orange reflected light to left of face blended across contours of features with stump.

Sunlight to right of face blended to the left across features.

Redrawing is possible with a brush pen. Soften with stump to reduce harsh linework.

Lighter yellow and white to sunlight highlights.

FINAL TIPS Pink highlights are not enough. Use bright red. Underlay orange before final pure red.

Pure white worked into surface with gentle rubbing movement mixes with color on surface (top-apron, bottom-ground).

TINTS A gentle layer of light color can partially obscure dark accents, reducing contrasts and increasing depth.

IMPACT HIGHLIGHTS If final highlights prove difficult to apply they can be "smacked" into the surface.

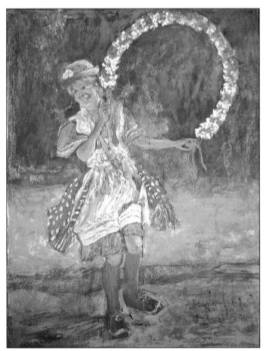

STEP 7

Edge on strokes of mid-brown pastel are applied to exploit the complexity of the texture under the blue background. Vary pressure, denser at hip level and gentler towards the foreground. Generously apply as vertical strokes to the top half, and horizontal strokes to the bottom, to suggest the level of ground on which the figure dances. Scumble reflected light of mid-blue over the dress and mid-brown over white smock and flower hoop. These, coupled with blending, suggest impressionistic brushwork. Here, variation in surface is again suggested by different pressures employed in applying the color. Blending does occur however in softer areas, such as the skin tones, using either a stump or an erasing knife. A green (cool over warm) light is placed on the hat and blended inward. Parallel strokes of Indian red and yellow mix visually to give a textured orange for the hair.

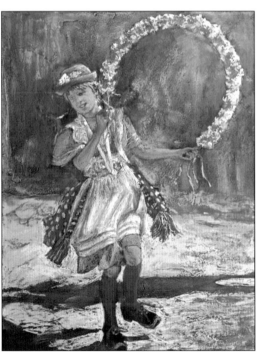

STEP 8

Avoid fixing as you work in order that a surface can be produced into which color can be blended or worked quite easily. This surface really begins to feel painterly. Now work yellow into the ground with the edge of a newly cut pastel. Pulling this into the background really feels like using a brush. Use the flat of an erasing knife to remove excessive light and restore/enhance some of the darker texture. A light green is laid softly and gently over the background and blended with the thumb or scraped with the erasing knife. Apply a light orange highlight to the flesh and blend around the forms, adding a pink as a reflected highlight. Where this disguises important features more pen drawing can be added being softly blended into the unfixed pastel with a stump. Further highlights containing yellow are placed on the flower hoop and the white smock, the hat and the hair.

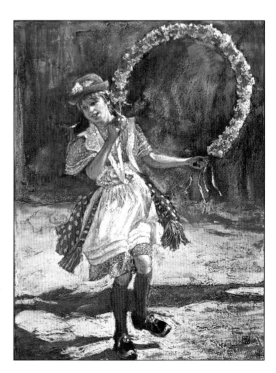

STEP 9

In the final layer we concentrate on highlights. There are two main problems to overcome. First, if white alone is used, all the lights will look the same. Second, the highlights need to cover the undercolors to be bright enough.

- The first is resolved by either layering different colors just beneath, or over, the final white highlight, for example, **undercolors**:
 SMOCK pink under reflected highlights and sun highlights.
 ALL REDS yellow orange under pure red.
 FLESH yellow under white, blended or scratched to shape where necessary.
 Overcolors are final yellow over the white flesh highlights. All other highlights are pure white.
- Secondly, coverage is achieved by pressure or impact with the surface. This type of highlight is seen on the dress, the flower hoop, the shoes, the hair and as light brown (shadow) and white (sunlight) spots on the blue dress.

Project 5 Tutorial

Structure

MATERIALS
Pastel Paper
2 mm 2B Pencil
Brush Pen
with black waterproof ink
Round Nylon Brush
Watercolor Paints
6 primary colors
Range of Artists' Quality Soft Pastels
with tints for each color
Stump
Kneadable Putty Rubber
Erasing Knife

The previous evening, the sky had glowed red as the sun set and I was reminded of the saying, "Red sky at night, Shepherd's delight." I decided that evening that, come what may, I was going to spend the whole of the following day painting outdoors.

The alarm was set for 6:00 am and I set off bright and early to make the most of the bonus of a long day of light. The red sky held true, it was a stunningly beautiful, sunny summer's day when I pointed my car toward the Cheshire village of Knutsford. A village full of the most interesting and diverse architecture. There was one particular view that I had wanted to paint for some while.

I set up my easel at the gateway entrance to a cobbled lane in which nestled a row of mews cottages with their gardens brim full of cascading flowers. I was not disappointed, the sun streamed through and into this cobbled recluse, picking its way over the various textures of the different elements that made up this view. A particularly attractive feature was the arched gateway which served to frame the composition.

CHOICE OF MATERIALS

Mixed media, as its name suggests, is a combination of often quite different elements such as oil and pastel or acrylics and collage. It should never be used as an excuse or an afterthought. For example, it is counterproductive, if having run out of ideas in one medium, you switch to another in a desperate attempt to bring a spark of excitement back into the work. I have found that this is more often than not doomed to failure. Instead, the relative qualities of both media should be considered before the work begins. Can more be achieved using two media rather than one? Pastel, for example, is rich in color but has no physical texture. An underpainting of acrylic, especially with a dash of acrylic texture paste, creates textures that will enhance the quality and durability of the pastel layers to follow. In this tutorial the watercolor provides spontaneity, the dark values and the surface stability over which the pastel can be exploited and seen at its best.

COMPOSITION

My initial instinct was that the composition would be better upright, due to the height of the arch around me. Surprisingly, once I had completed my thumbnails a square format leant more importance to the middle distance and the flowers therein. A resident who stopped to chat, explained that the sun only caught the wall in the morning and so I immediately made a note of its position and strength, in order that I had reference for it later in the day, when the position of the sun would change dramatically and possibly disappear altogether.

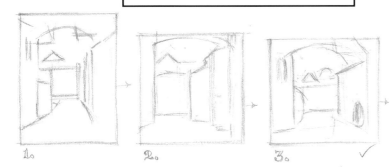

1. 2. 3.

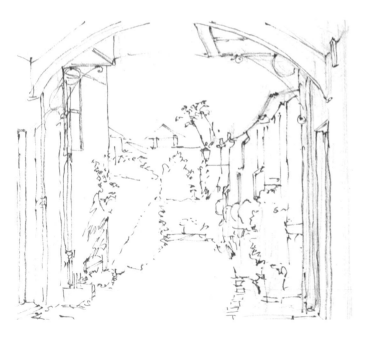

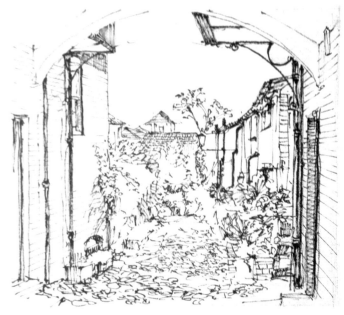

STEP 1—DRAWING OUT AND INKING IN

Sketch in the elements of the composition onto your previously stretched pastel paper and consolidate rough silhouettes with the brush pen. Be relaxed about inking in, as any mistakes will be easily covered by the opaque pastel to come. The brush pen features an actual brush head with the ink supplied by an in-built cartridge. It is a superb instrument for ink line drawing and allowed me to indulge myself in more loose detail, in the knowledge that corrections can easily be made. An alternative to a brush pen could be a rigger and waterproof drawing ink. In this case you may decide to opt for colored rather than black linework.

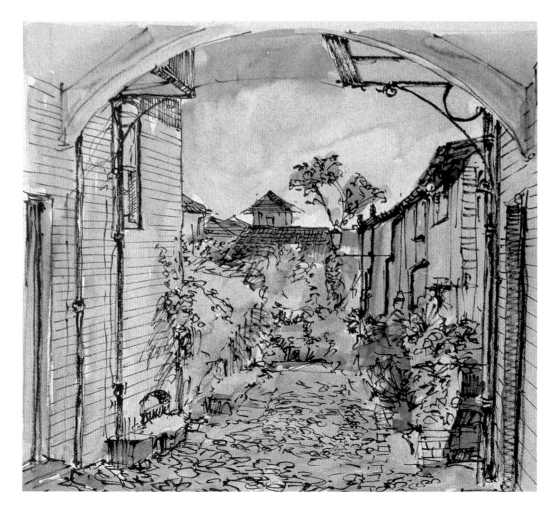

STEP 2—BLOCKING IN MASSES

Gentle, but dull, watercolor washes should be applied with great freedom across the majority of the surface. The masses of the composition can now be judged more easily. This is the last stage at which large changes of composition can be accommodated. So step away from the painting and check it before proceeding further. Note how aerial perspective on the path is achieved by adding blue to the mix to cool down the warm brown as it moves away into the distance. The variation of color temperature on the wall is also important. These vary from a yellow, where the warm light is reflected on the walls, to a blue to indicate shadow or distance.

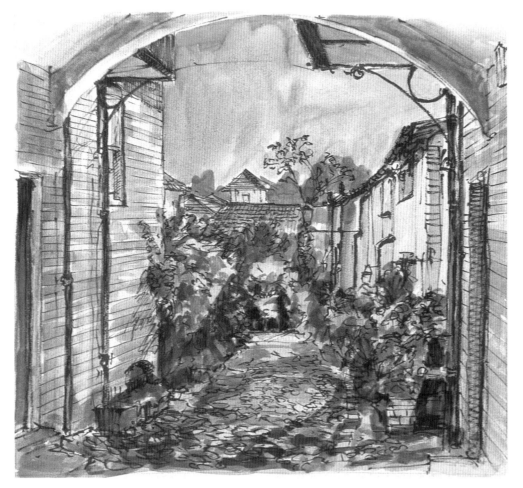

STEP 3—SECOND LAYER OF WATERCOLOR

Continue with watercolor washes to provide complementary color accents on those washes already laid. This can be seen more easily on the white walls where purple accents have been laid over the previously laid dull yellow. All painting should be completed using the wet-on-dry technique to facilitate speed on the absorbent paper and knowing that any resultant unwanted hard edges can be eliminated at the pastel stage.

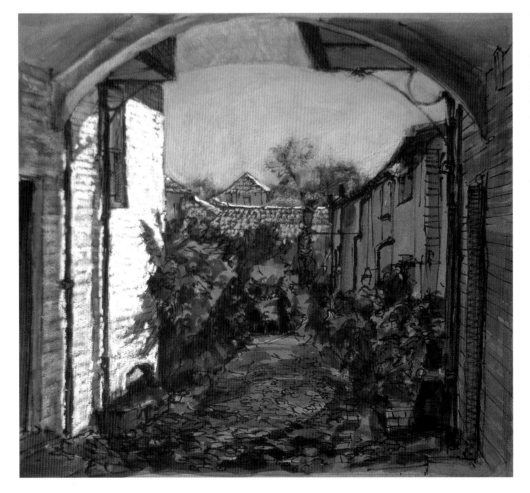

STEP 4—PASTEL LAYERS

Switch now to your artists' quality soft pastels. As usual, begin at the back of the picture with the sky and work forward, overlapping shapes. The metalwork at the top is drawn in more heavily with the pen so that it can appear more easily through and between the dominant strokes of ensuing pastel. Where necessary, it should be scratched back with the erasing knife. The sky itself moves from a blue at the top to a yellow toward the horizon. Blend the two colors together with a stump to soften the gradations. Distant trees need only yellow-green highlights of pastel to contrast against the dull green watercolor shadows. Yellow-orange on roofs again make use of watercolor beneath for contrast. At this stage, fearing that the sunlight on the wall (left) would disappear, I began building up the lighter tones right through to white. Color underlying this white creates warm color rather than a neutral white, much more reminiscent of sunlight.

The brush pen actually has a white nylon brush head (becomes black when ink comes through). Don't confuse with solid felt tip brush pens.

With the point you can achieve a wonderful variety of line—very oriental in feel.

Moving the brush swiftly across the paper and/or using the brush side creates scumbles, especially on textured paper.

While applying the first layer of green over the dark watercolor, note how yellow-greens suggest sunlight.

These early layers can be blended to create soft depth and allow undercolor (watercolor) and linework to show through.

Build highlight slowly with warm (yellow) greens over warm green and cool (blue) greens over cool green.

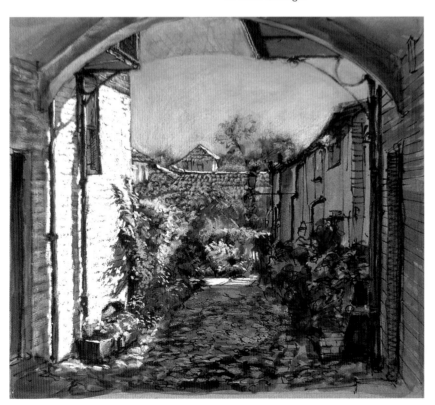

STEP 5

Build up foliage under the flowers in layers of green that become lighter and more yellow toward the sunlit highlights. First layers of color, both here and on the ground, are blended into the surface with a stump to soften edges and spread pastel, creating a thinner, semi-transparent layer so the watercolor shows through. Subsequent layers are blended less until actual highlights are left sharp. This semi-transparency can be seen best in shadow areas, where underlying watercolor is utilised to the utmost. Establish flowers as a dark red mass, then highlight with yellow. A lighter red applied over this yellow will give the warm red light necessary for sunlight.

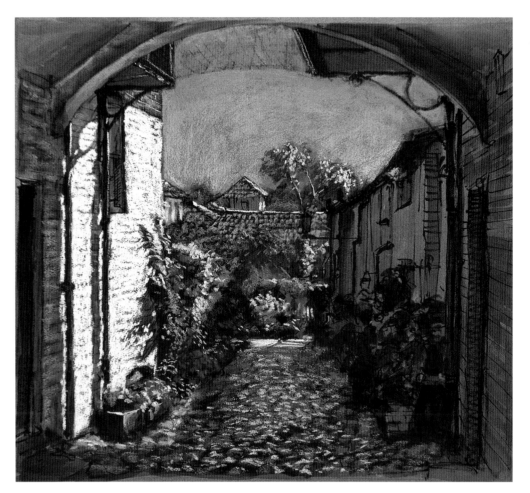

STEP 6

Apply cool blue highlights to the cobbles, followed by white. For the large tree in the background apply a warm, then yellow green, layering pastel through to a sharp white highlight.

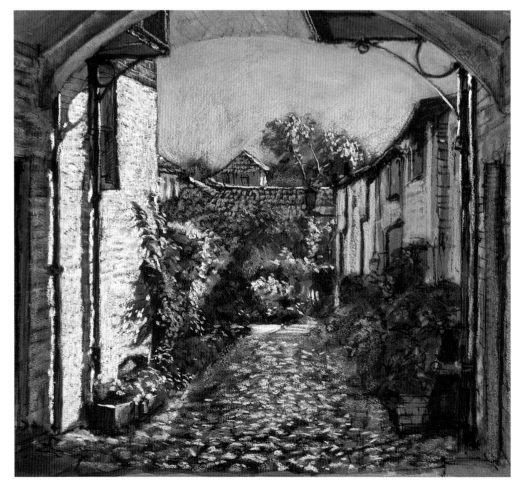

STEP 7—TINTING AND GLAZING

Layer blue and blue purple pastels on the warm watercolor washes of the buildings to the right. To ensure the closer brickwork appears nearer, cool colors are replaced by warm browns in the foreground. Details are lifted off this brickwork with a putty rubber, exposing dark watercolor underpainting where necessary. The down pipe is highlighted on the right, excess pastel being scraped off with an erasing knife. This is frequently necessary for fine highlights, especially linework where the pastel alone may create too crude a mark initially and may need refinement. The foliage from hanging baskets and plants is now suggested, concentrating on rhythm and pattern, rather than any individual leaf forms. Distance greens are made to recede by gently using the edge of a light blue pastel and working the resultant tint into the surface with a finger.

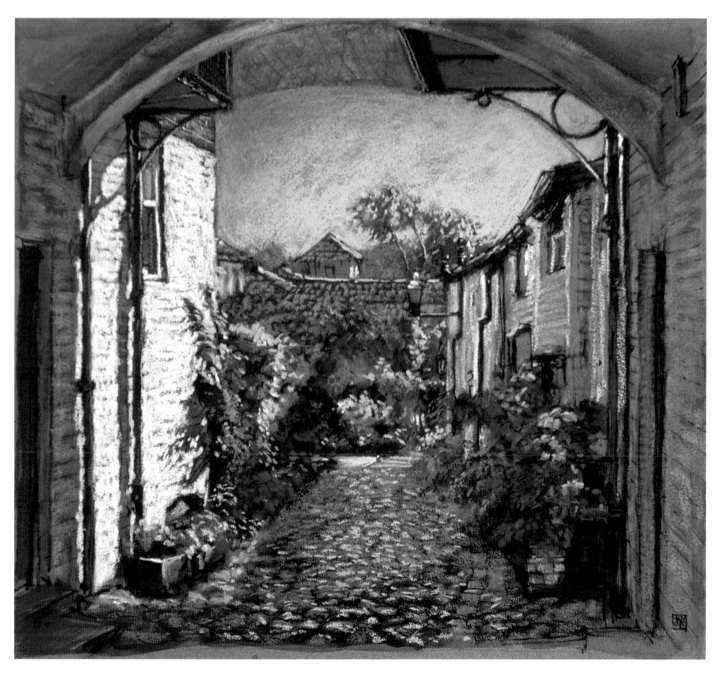

STEP 8

Even at this stage you can introduce some accents and drawing using the brush pen—here these were added into the foreground. Thus details of gutters, downpipes, wrought ironwork, and cobbles can be given that little extra focus. Some of the distant colors on trees, for example, are reduced slightly with a gentle hint of gray pastel and then highlighted again. These final changes may be subtle, but can easily affect the overall depth and balance of the picture. Finally, the flowers on the right are painted avoiding the warmer yellows and oranges so that they remain intense yet still appear to be in the full shadows of the buildings.

Tricks of the Trade

Pastels into watercolors

The pigment in artists' watercolors and pastels is the same [A]. Only a small amount of gum, with water, is added to the pigment powder to ensure that the color will compact to a paste and form a stick when dry. Much more gum is added to watercolor in order that it can glue the color to the paper surface once dry. While watercolor is diluted in water, pastel remains dry, depending on the texture of the surface to give it stability. On a basic level, therefore, it stands to reason that if you add more gum and water to a pastel, it can be turned into watercolor. One difference has to be allowed for, however. The lighter values of pastel have white added, which makes them opaque, as opposed to watercolor, which is transparent. They therefore have more in common with gouache, which is an opaque form of watercolor.

Notwithstanding this, it is very useful for watercolorists to carry the odd stick of pastel, together with a bottle of gum water (watercolor medium) [B].

Imagine having to paint a bed of purple flowers. It is so easy to dab on spots of purple pastel, even over some of the dark areas of paint. These can be left as pastel touches (mixed media) or dissolved on the surface with a solution of watercolor medium applied gently with a brush [C].

SAFETY FIRST

It is essential to apply all fixatives in a well-ventilated area—prefereably outside. Beware of any wind that could blow the fixative back toward you.

For the pastel painter, the watercolor medium can be used more solidly on, or across, the first layer or layers of pastel. Water alone will turn the pastel pigment fluid, but on drying, the pastel will once again become loose. With gum in the solution, the pastel wash, once it has dried, becomes fixed to the surface. There are several advantages to dissolving the first pastel layer in this way [D]. It spreads the pigment solidly, evenly and swiftly. The layer being fixed by the gum is more stable than smeared pastel pigment. Additionally, the gum, when dried on the paper surface, usually makes the surface more receptive to applied pastel, than the paper alone. Pure pastel strokes applied over the washes are quite different from the soft washes beneath. More variety yields more visual excitement. Soft areas are out of focus; sharp edges are more solid and static.

The opacity of these pastel washes is more visible on a colored surface [E].

CAUTION: Some pastel boards feature a prepared surface that dissolves in water and are not suitable for this technique.

Aerosol fixative is used to seal powdered pastels, and can be used over a watercolor with pastel touches to fix small or large areas. This will not affect the watercolor already on the surface or any washes you may wish to add. Fixative from a bottle can be applied by brush, not unlike the gum water. This dries more aggressively and does not carry the color as far as the gum solution, leaving more solid fixed strokes, than its watery equivalent [F].

Common Problems

Finishing off

QUERY

"I'm never sure whether to use fixative on my pastels. Some say it spoils them. But surely I should protect the delicate pastel surface in some way?"

ANSWER

Fixative is an essential tool for every pastel painter, but to use it effectively you must understand exactly how it works so that it can be used when appropriate. Unlike all other painting mediums, pastel has virtually no glue (medium) to stick it to the surface. A glue or gum can be sprayed on to the surface of applied pastels to fix it more permanently.

Take a pastel that has been built up in layers, with dark colors beneath the light layers [cross section A]. When the top layer is sprayed with fluid the powdered pigment will not only spread, it will partially mix with the colors beneath [cross section B]. The top layer seems to become more transparent the more fluid it is made. On drying, the pigment will be welded together into a stronger layer. Thus, while the fixative will protect the pastel, it will also slightly darken and dull down the pigment. Strengthening the surface is beneficial for it allows more layers to be added. On the one hand, darkening can be good if the painting has become too light overall. On the other, it is bad if it means the subtleties and bright highlights are lost.

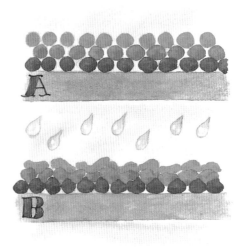

As a general rule, it is sensible to fix early stages of a pastel painting, but to leave the final layers unfixed. The finished painting will now have a delicate top layer, that really should go behind glass as soon as can be managed. It is best to remove any loose pastel dust before the work is framed. With the painting still in place on the drawing board, hold the board vertically and gently tap the board. Any loose pastel will fall away from the surface. You will see immediately if any more stable color need be applied. By doing this you will also prevent loose color dropping down and collecting behind the glass when framed [C].

QUERY

"Why do pastels need mounting for framing, and are there any other tips about framing pastel you can pass on?"

ANSWER

A mount keeps the pastel painting away from the glass [D] in the frame, which even though smooth, could squash the delicate pastel finish.

Never use acrylic instead of glass for framing pastels. The electrostatic charge that can build up as you **wipe the acrylic may attract the pastel and eventually** a dirty film will build up on the inside of the glass. This spoils the clarity of the colors and damages the painting.

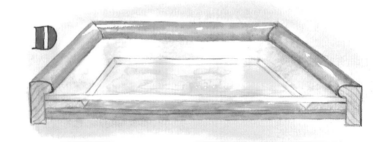

It is advisable not to leave an original pastel painting at the framers for a number of reasons. Apart from the possibility of the work being damaged, many framers will automatically apply fixative to the work as added protection, and in so doing will alter the nature of your final pastel layer and the overall painting. Have the mount and frame made to the correct aperture size, take the painting back home for safe-keeping and when your frame is ready, have it assembled under your supervision, or assemble it yourself. The frame can be made with flexible tabs [E], which allow for removal and replacement of the backing board without the need for pins—knocking in pins once the pastel is in place can also unnecessarily loosen pastel powder, damaging the work in the process. Seal the gap between frame and back with gum strip. To do this, gently lie the painting face down. Wet the gum strip and ensure you run it between two fingers to squeeze off any excess moisture, which could run inside the frame. Cut the gum strip longer than the frame length and with a sharp knife or scissors, cut the gum strip where it meets the corner, to give a tidy finish [F]. Press home with a clean tissue. Leave to dry thoroughly, before moving and hanging.

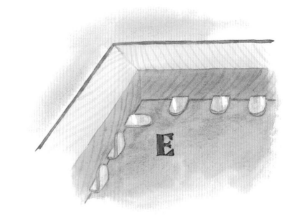

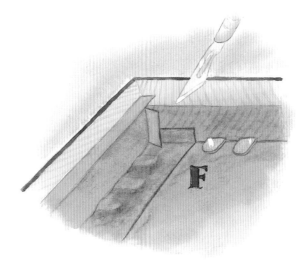

Acknowledgments

Without the support of so many, over a number of years, this book would never have come to be. Apart from those closest to me to whom I owe a debt of gratitude, my life has been touched by so many more. As an artist I rely on collectors discovering and keeping faith with my work, to them I say thank you from the bottom of my heart. But for their continued support I would not be in a position to share my love of painting with others who wish to take up the pursuit. Thousands have joined my courses, painting days, and painting house parties and it is only through working with these painters directly that I have learned how to help them get as much out of painting as possible. To them I also say thank you for enlightening me. If this, my latest book, encourages more people to take up painting and helps those who already do so to stay enthusiastic, then it will have been worth all the effort put in by my publisher Jo Messham, her editorial, design, and sales teams. Their faith in me is much appreciated.

Paul Taggart

Information

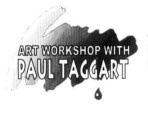

Art Workshop With Paul Taggart is the banner under which Paul Taggart offers a variety of learning aids, projects, and events. In addition to books, videos, and home-study packs, these include painting courses, painting days out, painting house parties, and painting holidays.

Log on to the artworkshopwithpaul.com website for on-site tutorials and a host of other information relating to working with watercolors, oils, acrylics, pastels, drawing, and other media.

To receive further and future information write to:

Art Workshop With Paul Taggart / EPG
Promark
15 Lynwood Grove
Sale
Cheshire
M33 2AN
UK

E-Mail: paul@artworkshopwithpaul.com

Tuition & Guidance
For the Artist in Everyone